DESERT AMERICA
Territory of Paradox
Published by Actar

In a landscape where nothing officially exists (otherwise it would not be "desert"), absolutely anything becomes thinkable, and may consequently happen.
Reyner Banham, *Scenes in America Deserta*, p 44

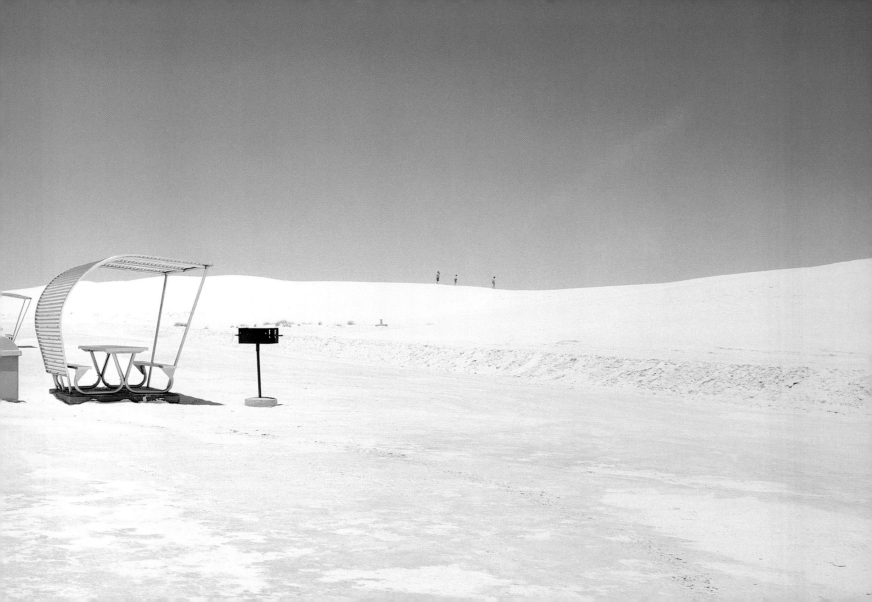

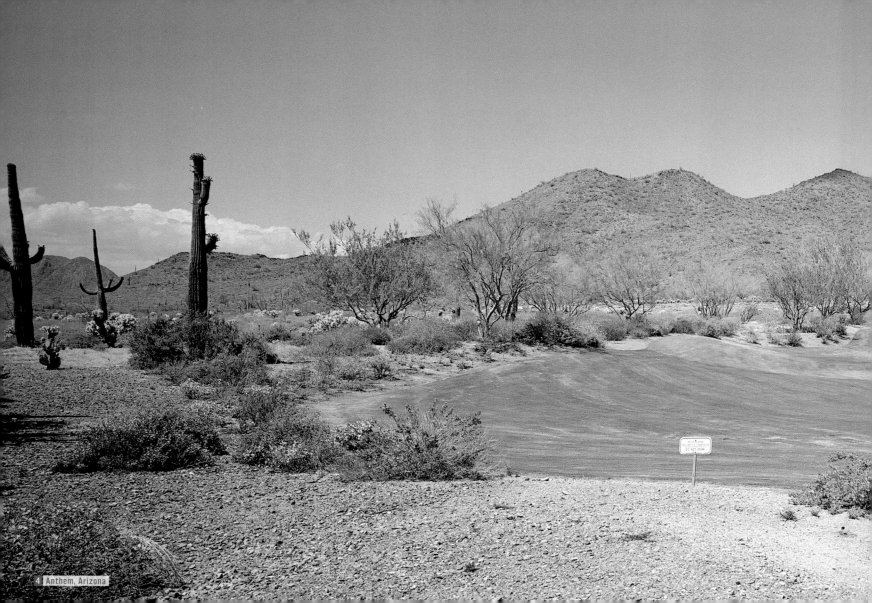

4 Anthem, Arizona

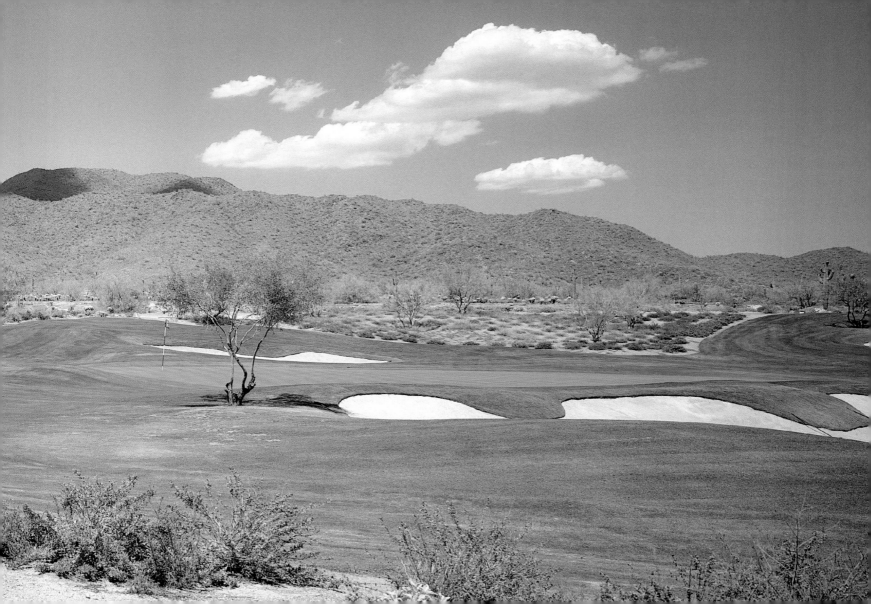

This book grew out of our fascination with a paradox. In contemporary culture, the American desert stands as a monumental symbol of emptiness, a vast, seemingly infinite landscape that has traditionally served as a powerful embodiment of the "natural," the untouched and the sublime. But a journey through the space of the desert reveals that the experience of its immensity and silence is just a mirage. Just beneath the muteness of its outward appearance, the sounds and traces of all kinds of activities, experiments, mysteries, fictions and utopias can be heard. Far from its "empty" appearance, the desert is full of activity: a different, parallel, uninhibited, excessive activity – in both good and bad terms – that encompasses everything from oases of entertainment, consumerism and play to the secret staging of military power. Far from what might be thought, the most hostile and seemingly uninhabitable of environments turns out to be an ideal setting for action.

Like the desert itself, this book is filled with phenomena. It attempts to move beyond the immediate experience of the desert landscape to describe the vast amount of processes taking place underneath its surface appearance, to narrate their histories and dynamics. Everywhere you scratch the desert ground, it seems, there are stories: tales of civilizations that have come and gone, of natural resources and their exploitation, of the elemental struggle to control water and power, of monumental technologies and their unintended consequences. Above all, there is information. The true scale of the desert can be measured only through the incredible volume of figures and statistics that seem to surround everything that takes place there: ample evidence that, for all its "wildness," the desert is an intensely controlled space, deeply permeated by the networks, processes and flows of an industrial society that has transformed it into a privileged space for extreme uses at a monumental scale.

The story of the American desert is fundamentally one of technology. What distinguishes it utterly from the other deserts to which it is superficially similar – and what gives it its fascination for us – is this chemical reaction between the raw material of a landscape and the modern sciences that have occupied and acted on it, producing a hybrid space that is both the most natural and the most artificial of territories. The better-known protagonists of this tale are the legendary engineering projects that have fundamentally altered the ancient topography of the desert,

the massive dams and power plants that have allowed its harsh environment to be inhabited and absorbed into the productive space of the American continent. The negative and perhaps more extensive side of this history is formed by the sinister technics of the military that the desert has housed since the Second World War, a territory that today forms the primary staging ground for secret uses that depend on space and isolation for their secure conduct. The major innovations of the Cold War – the atomic bomb, supersonic flight, the intercontinental ballistic missile – all were developed here, their traces found everywhere, in monuments both intentional and unintentional: nuclear test sites, underground missile installations, vast open-air fields of military aircraft, radio dish arrays, space capsules… Indeed, it could be said that the antagonistic virtual space of the Cold War was in many ways the environment of the American desert: a hostile, extensive horizontal space of events, crossed by dynamics flows of information and structured by "hot" nodes of extreme activity.

If the space of the desert is still haunted by the specter of the nuclear age, it has also been the ideal setting for contemporary utopias: 21st century worlds of consumerism and leisure, from rapidly expanding cities of hedonism and

spectacle to isolated gated communities each obsessively devoted to a particular pleasure, whether golf or guns. Seemingly without any reference points or inhibiting factors, the desert landscape encourages the proliferation of these contemporary "ideal cities," with all of the idealized geometric urban forms – circles, pentagons, grids – that this implies. Indeed, part of the paradox of the desert is the sense that different epochs are simultaneously present here, from Cold War relics to the utopias of the 21st century, from the 19th century religious dream of the Mormons to the remnants of the Native American tribes brutally displaced by American expansion. Rather than any process of accretion or historical layering that might be typical of other environments, in the desert these epochs are arrayed equally, laid out in a homogeneous horizontal space and preserved, museum-like, in the dry desert air. All are available for inspection (that is, consumption), from the most decadent to the most apocalyptic. In their hybrid nature – between natural and artificial, open and closed, empty and full – and their operation across scales from the most intimate to the most monumental, all of these diverse phenomena lie outside the categories of architecture, landscape or urbanism (even beyond that

recent designation, "landscape urbanism"), transcending them all, or at least rendering them inadequate to explain the processes that take place there.

An attempt to understand the American desert thus requires new approaches, combining photography that captures the intense primary experience of the landscape with other forms of information - maps, data, and text - capable of revealing the depth of the processes taking place behind it. Of course, the vast territory surveyed here has already inspired its own particular literary forms. A well-established way of describing the American desert has been by means of the route or the "road trip," the first-hand narration of an idiosyncratic, often nomadic journey across its distinct and irreconcilable spaces. This is the format of some of the accounts that have most influenced our contact with the desert, in particular the architectural-historical search undertaken by Reyner Banham in *Scenes in America Deserta* (but also more extreme accounts of the excesses of the desert landscape, like Hunter S. Thompson's *Fear and Loathing in Las Vegas*). As a literary structure, the road trip is necessarily born of the conditions imposed by the desert, suggesting that its immense scale and the disparate worlds scattered across

it can only be synthesized by means of a fragmentary, subjective understanding that makes no attempt at a totalizing or "complete" survey of the territory as a whole. In this sense, our experience of the desert has been no different. The material for this book was collected on a series of trips conducted between 1998 and 2004, each time with a shared vision modified by different visitors, different trajectories, and different perspectives. While the book does not adhere to the format of the travelogue, it is just as much a record of our attempt as architects and designers to understand, by means of images and information, the strange, disparate and yet somehow related events that take place across the vast desert expanse.

As with the "road trip," this book makes no attempt to give a complete account of the "history" of the desert or its landmarks; either would be, by definition, impossible. Instead, what follows is a collection of stories: the sites of the desert are organized here not geographically or chronologically but thematically, in seven "books" that reveal different, parallel strata of the occupation, appropriation, and transformation of the modern desert landscape. Taken together, these "books" or chapters map an arc: from the epic story of movements, conquests and displacements

(Promised Lands) to the struggle for control over the forces of nature (The Elements) that has allowed the creation of both utopias (Eden) and dystopias (Hostility); the current consequences of this proliferation, from the extension of desert technologies to the reaches of outer space (Other Worlds) to the internal pressures of relentless urban growth (Expansion); finally, the continued presence - in spite of this expansion - of "pristine" spaces that constitute the last refuge of the sublime (Isolation), a parting image of the desert that is conditioned by the knowledge of all the phenomena that surround it. Within each "book," contributing authors offer more detailed accounts of specific sites that reveal the deep connections across these themes, linking the space of the desert in overlapping trajectories that blur the distinction between the visionary and the excessive, the utopian and the militaristic, the decadent and the dystopian. If the tone occasionally recalls the two-thousand year old tales of journey and struggle from that other, more legendary desert, perhaps it is because the modern record of man's elemental attempts to control the American desert has been just as epic in its scope and consequences - a collection of biblical allegories for the 21st century.

In the end - as the title of the book suggests - a look at the desert reveals something about the character of America itself. Just as the expansive forces of a technological society have found their ideal host environment in the desert landscape, so the visible lessons of that occupation extend beyond the territory to reflect back on the society that it hosts, as a space where its cultural dynamics are taken to their extreme, seemingly free from the conventional constraints of space or geography. Once the limiting frontier of the American expanse, a hostile and non-navigable (hence sublime) space, today the desert functions as a vast laboratory of contemporary culture, the most truly "American" of spaces: its ideals and its excesses, its greatest scientific triumphs and its most toxic failures, all present themselves here as limited cases of an advanced technological society entering the 21st century. If we want to know the future of America and its current excesses, a starting point might be to look here, in its "empty" landscape: not as our predecessors did, as a vast expanse to be filled with the products of an expanding empire, but as a territory that is already incredibly, fascinatingly full.

Michael Kubo

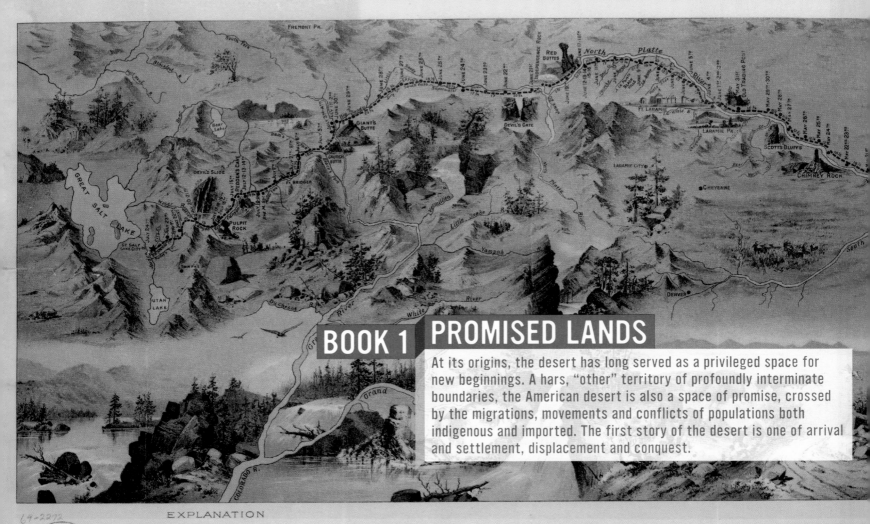

BOOK 1 PROMISED LANDS

At its origins, the desert has long served as a privileged space for new beginnings. A hars, "other" territory of profoundly interminate boundaries, the American desert is also a space of promise, crossed by the migrations, movements and conflicts of populations both indigenous and imported. The first story of the desert is one of arrival and settlement, displacement and conquest.

EXPLANATION

The Route is represented by
Camping places are shown by ● ● ● ● ● ●
Date of each Camp opposite ● ● ● ● ● ●
Figures between ● ● ● ● ● show miles travelled daily.

July, 1847.

ROUTE OF THE MORMON PIONEERS

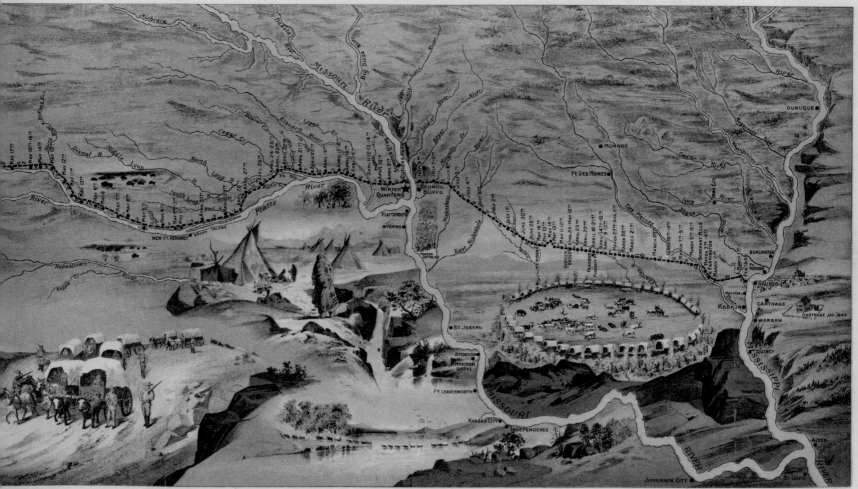

NAUVOO TO GREAT SALT LAKE. Feb'y, 1846.

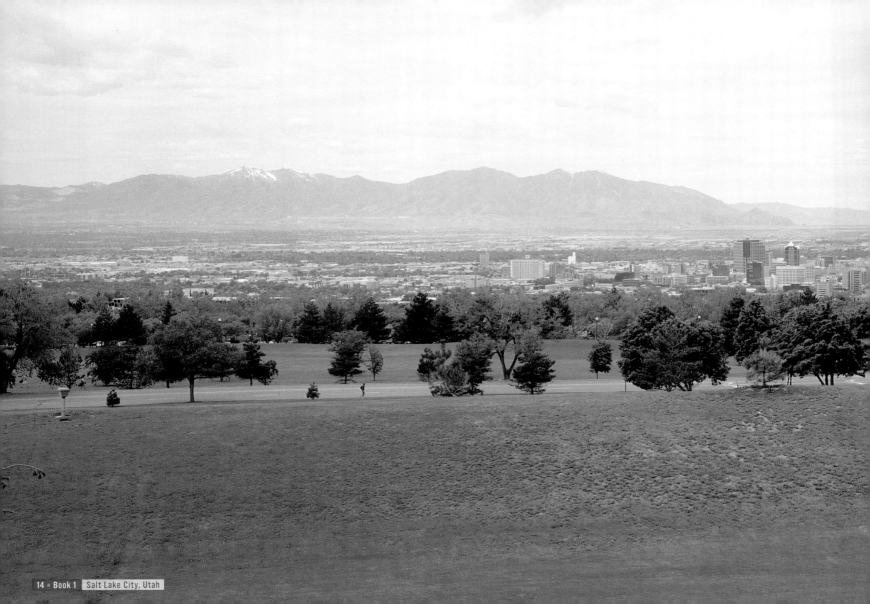

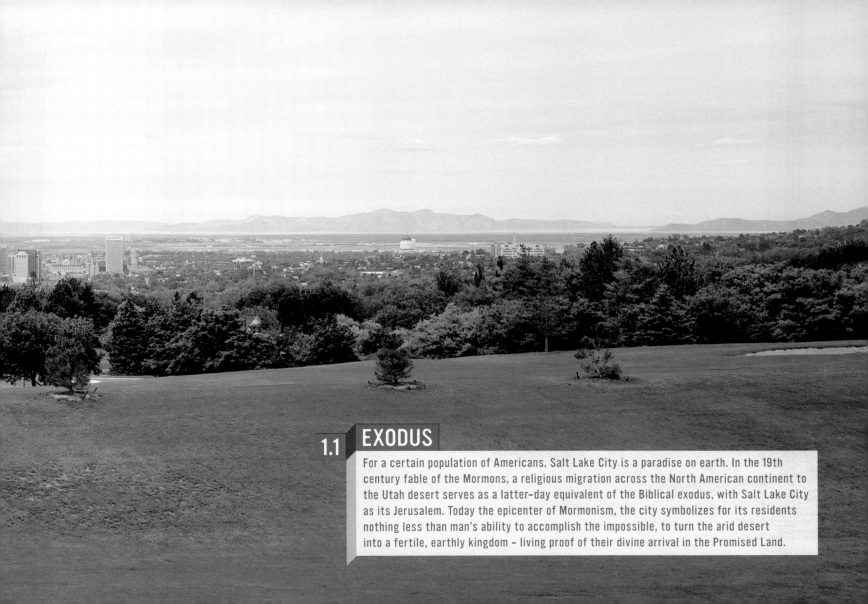

1.1 EXODUS

For a certain population of Americans, Salt Lake City is a paradise on earth. In the 19th century fable of the Mormons, a religious migration across the North American continent to the Utah desert serves as a latter-day equivalent of the Biblical exodus, with Salt Lake City as its Jerusalem. Today the epicenter of Mormonism, the city symbolizes for its residents nothing less than man's ability to accomplish the impossible, to turn the arid desert into a fertile, earthly kingdom - living proof of their divine arrival in the Promised Land.

MIGRATION

In July 1847, the first Mormon settlers arrived in the Salt Lake Basin after completing a 1300-mile journey from their original settlement in Nauvoo (Commerce), Illinois. Led by Brigham Young, successor of the Mormon prophet Joseph Smith and founder of the Church of Jesus Christ of Latter Day Saints (LDS), Mormon faithfuls left Nauvoo in the hope of escaping the growing levels of persecution and violence directed towards them by local residents of Illinois and Missouri. Considering themselves among God's chosen peoples, the Mormons drove westward to establish their celestial city, a separate kingdom of "Saints" on the American Continent. Salt Lake City was built as the fifth incarnation of "New Zion," a new Jerusalem, envisioned as the reclamation of the wild frontier, a land, according to the Book of Mormon (Ether 2:7), "of promise, which was choice above all other lands, which the Lord God had preserved for a righteous people."

Members of the LDS community refer to Salt Lake as "Deseret," a neologism from the Book of Mormon whose meaning, "honeybee," has become a symbol of industriousness and the Mormon belief that the welfare of the community is more important than individual well-being. This belief, coupled with the conviction that they were preparing for Jesus' earthly return, allowed Mormons to endure the harsh conditions of their new home. The success of the Mormon faith was tied directly to the settlement and domestication of their new homestead. For Mormons, not only did their desert Zion (Salt Lake City) offer an escape from the surrounding social and religious oppression of the east, but the harsh surroundings and remoteness of the Great Basin provided a protective deterrent against outside intervention and interest. Thus the spiritual decrees (revelations) that form the basis of the Mormon faith directly captured and echoed the essence of nineteenth century manifest destiny and American cultural values of self-sufficiency.

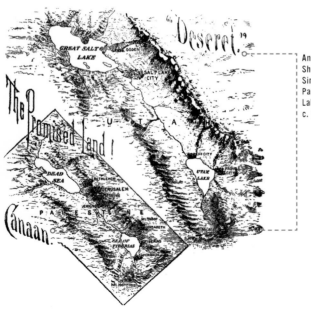

Anonymous, Map Showing the Striking Similarity Between Palestine and Salt Lake Valley, Utah, c. 1900

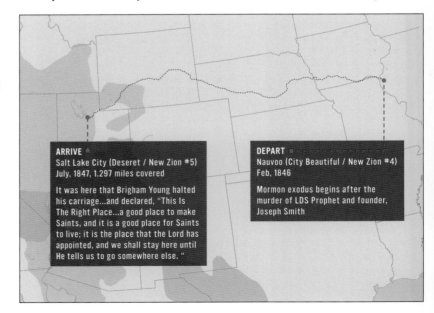

ARRIVE
Salt Lake City (Deseret / New Zion #5)
July, 1847, 1.297 miles covered

It was here that Brigham Young halted his carriage...and declared, "This Is The Right Place...a good place to make Saints, and it is a good place for Saints to live; it is the place that the Lord has appointed, and we shall stay here until He tells us to go somewhere else. "

DEPART
Nauvoo (City Beautiful / New Zion #4)
Feb, 1846

Mormon exodus begins after the murder of LDS Prophet and founder, Joseph Smith

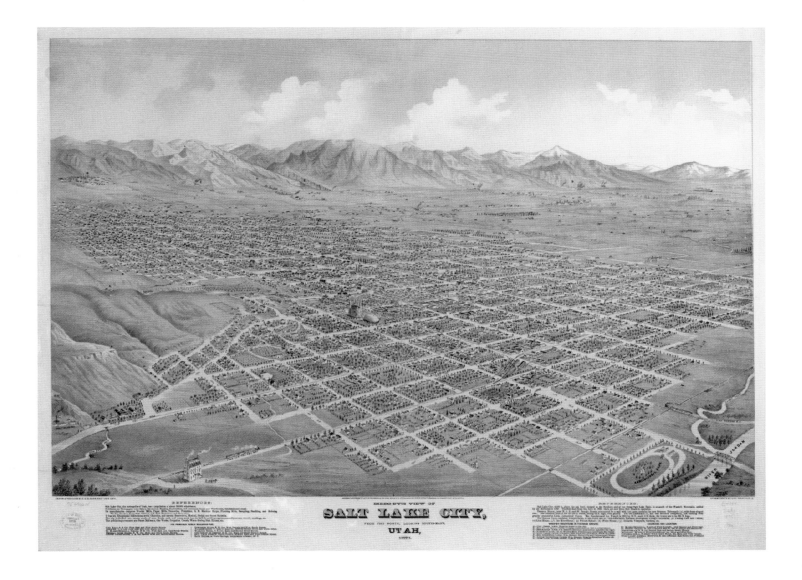

BIRD'S-EYE VIEW OF
SALT LAKE CITY,
FROM THE NORTH, LOOKING SOUTH-EAST,
UTAH,
1875.

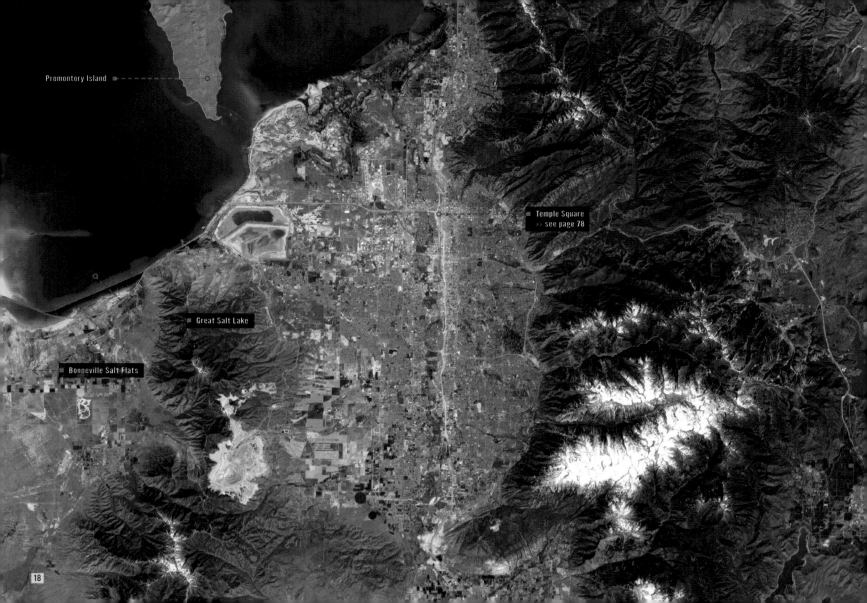

Promontory Island ----------○

Temple Square
>> see page 78

Great Salt Lake

Bonneville Salt Flats

The original City of Zion plan (Independence, Missouri) designed by Joseph Smith has been the basis for the plans of over 500 Mormon communities.

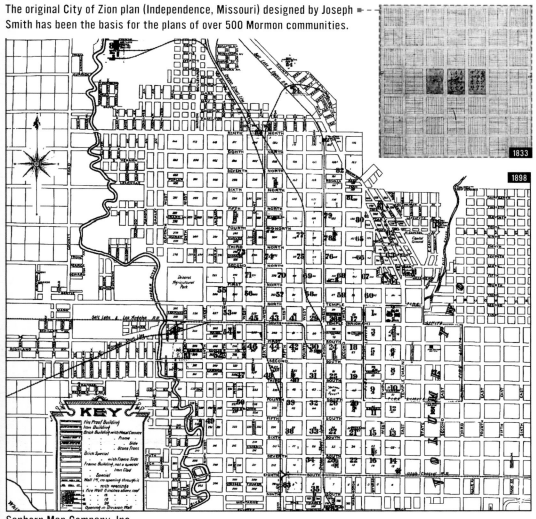

1833

1898

KEY

Fire Proof Building
Iron Building
Brick Building with Metal Cornice
Frame
Side
Stone Front
Brick Special
with Frame Side
Frame Building, not a special
Iron Clad
Special
Wall 14' no opening through it
with openings
Fire Wall 8 inches above roof
18
Openings in Division Wall

Sanborn Map Company, Inc.

CITY PLANNING
>> for "Ideal Cities" see page 114

The same religious beliefs that inspired and sustained the Mormon westward exodus also helped to order the social and physical structure of their communities. In 1833, upon his arrival in Jackson County, Missouri (site of the Mormon garden of Eden, or "Adam-ondi-Ahman" = holy land of Adam), Joseph Smith outlined his "Zion" city plan for the town of Independence. This ideal Mormon city is organized into a series of rectangular lots that were originally allotted for residences and farms. These lots fall within a precise grid and all subsequent Mormon settlements (numbering over 500 worldwide) closely follow this original model. According to Joseph Smith's outline, the establishment of each new Mormon settlement begins with the dedication of the site of the main LDS Temple. In Salt Lake, Brigham Young completed this task four days after his arrival and immediately thereafter established the basic planning diagram of the town. A slight variation of the original City of Zion plat, Brigham Young's plan for Salt Lake City adheres closely to the core principles of Mormon city planning. The city is laid out in an even grid of 10-acre blocks (660 ft²), each containing 8 identical 1.25 acre lots; all streets measured 132' in width, and all homes sat 20' from the street. Smith stressed the importance of physical and social density in Mormon communities. He felt that tight-knit communities would ensure the rapid construction of an urban infrastructure, as well as provide a much higher level of security and protection unavailable to the typical nineteenth century homesteader - individuals who lived in extreme isolation.

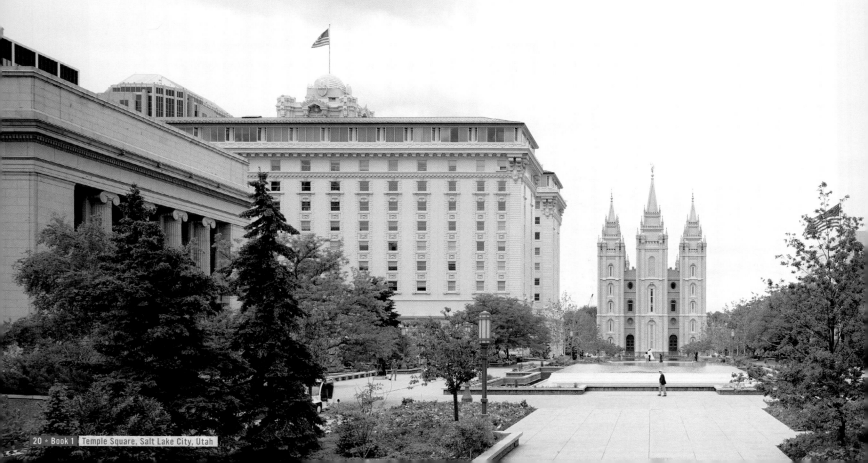

Verily this is the word of the Lord, that the city New Jerusalem shall be built by the gathering of the saints, beginning at this place, even the place of the temple, which temple shall be reared in this generation.

Mormon Scriptures, *Doctorine & Covenants 84:4*

At the center of every Mormon grid city, the temple square forms not only its spiritual center, but the physical point of origin for the city grid. All city streets are named according to their proximity and direction from the Square (800 West is 8 blocks west of Temple Square; 1500 North is 15 blocks north), a system that allows anyone in the city to immediately locate their position relative to the city center. Salt Lake City's main temple square serves as the spiritual nucleus of the Mormon faith and contains the Salt Lake Temple (spiritual center), Church Office Building (administrative center), Joseph Smith Memorial Building (social center), the Mormon Tabernacle (home of the Mormon Tabernacle Choir), and Assembly Hall. The Square also contains a meticulously maintained series of 250 gardens which are redesigned and replanted every six months with the help of hundreds of volunteers. In 1970, the city resolved an enduring glitch to Brigham Young's original plan. The main streets bordering Temple Square had been named North, South, East and West Temple Street; all subsequent streets radiating from the city center were numbered from these streets, leaving an entire swath of city blocks that lacked a directional indicator. A process of standardization reset the intersection of Main Street (East Temple) and South Temple as a new baseline for the grid, necessitating the readjustment of all street numbers and addresses in Salt Lake City.

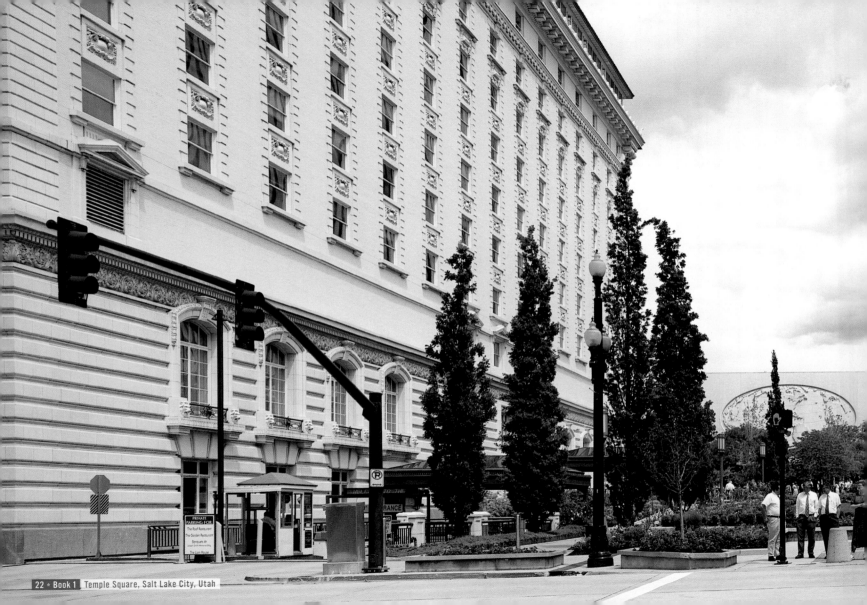

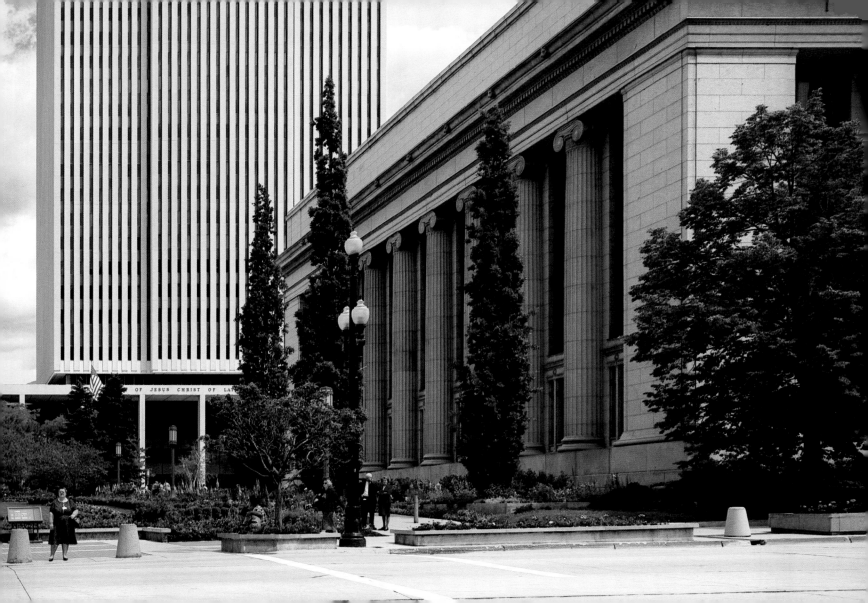

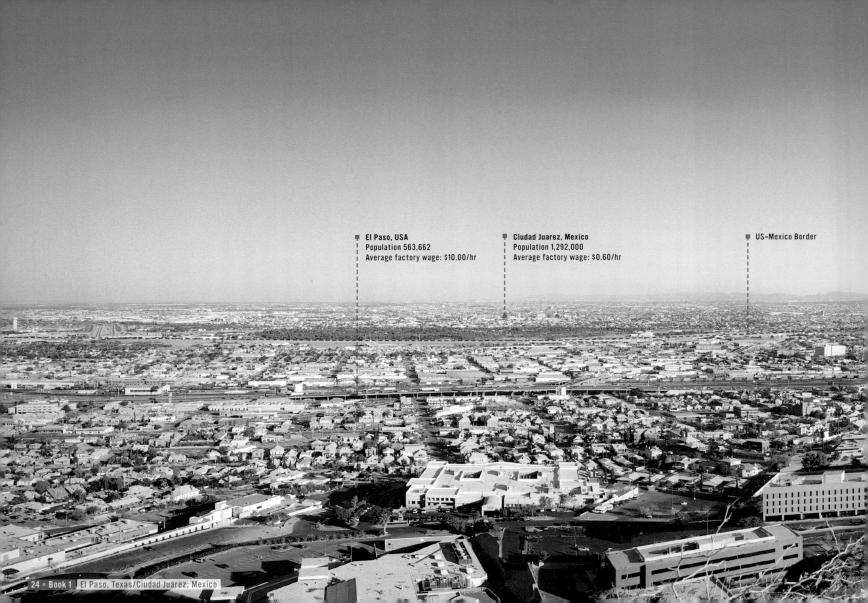

El Paso, USA
Population 563,662
Average factory wage: $10.00/hr

Ciudad Juarez, Mexico
Population 1,292,000
Average factory wage: $0.60/hr

US-Mexico Border

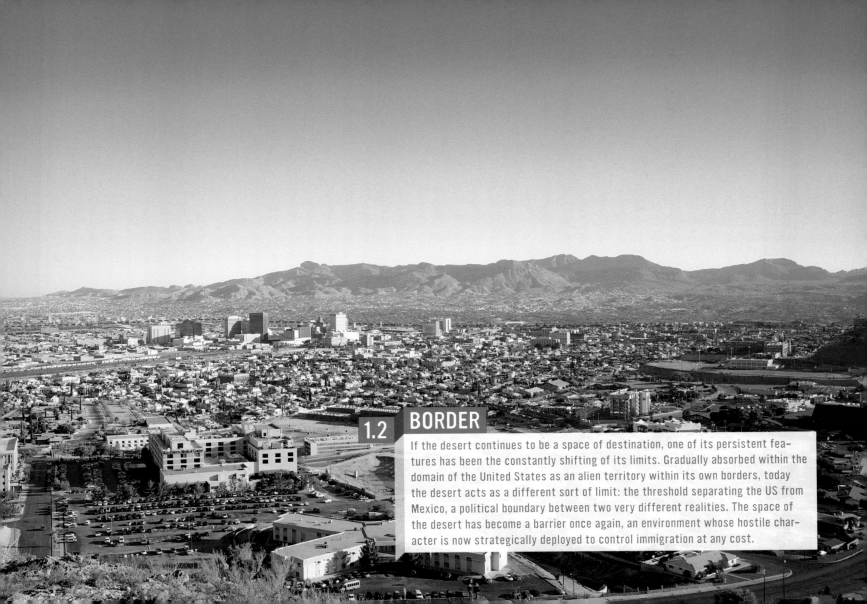

1.2 BORDER

If the desert continues to be a space of destination, one of its persistent features has been the constantly shifting of its limits. Gradually absorbed within the domain of the United States as an alien territory within its own borders, today the desert acts as a different sort of limit: the threshold separating the US from Mexico, a political boundary between two very different realities. The space of the desert has become a barrier once again, an environment whose hostile character is now strategically deployed to control immigration at any cost.

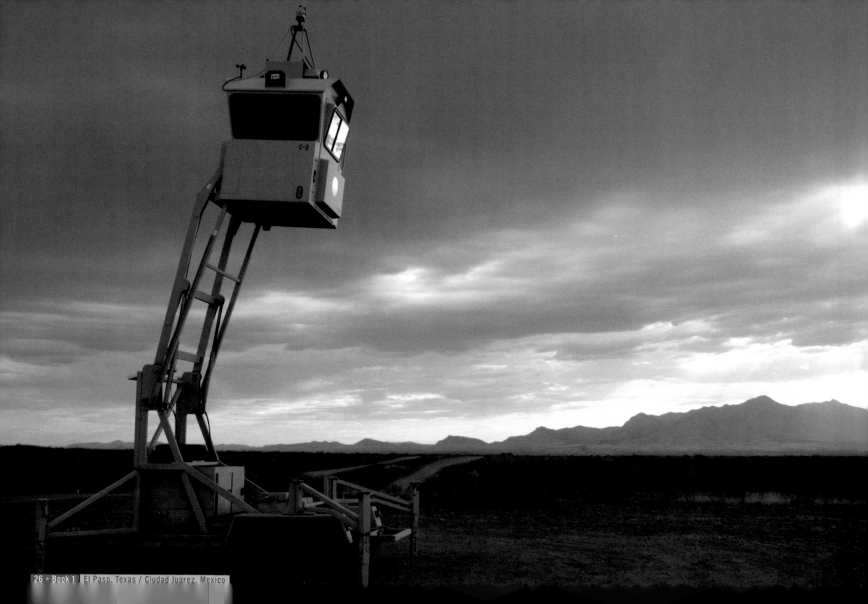

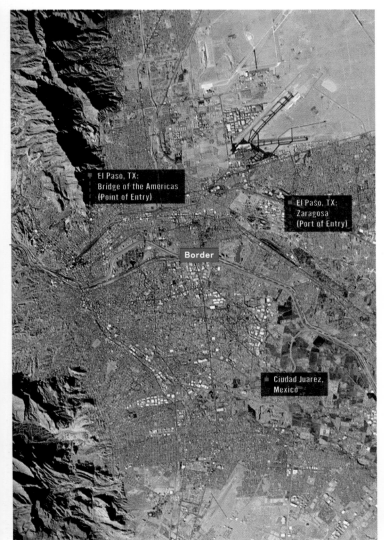

El Paso, TX:
Bridge of the Americas
(Point of Entry)

El Paso, TX:
Zaragosa
(Port of Entry)

Border

Ciudad Juarez,
Mexico

CROSSING

The US–Mexico border stretches for 3140 km and is policed by 11,000 border patrol agents. Since the signing of the North American Free Trade Agreement (NAFTA) in 1994, the US government has tightened urban border crossing points at El Paso and San Diego, deliberately forcing migrants to concentrate their efforts in more remote and less patrolled crossing zones located in the Sonoran Desert, at the Arizona/Mexico portion of the border. In these areas, there is frequently little more than barbed wire separating the political divide between Mexico and the United States – nothing except for the vast, harsh expanse of the desert itself. While border patrol officials assumed that the harsh conditions of the desert and the lengthy crossing distances would act as a natural deterrent, a strategy whose end result has not yielded a reduction in illegal crossings, but an increased death toll of those trying to cross. In the Sonoran desert, ground temperatures often reach 130°F as early as May or June and human survival in these conditions require a minimum of 1 gallon of water for every 5 miles walked. Trying to travel lightly and quickly, most migrants attempt the entire 40 mi. journey with a mere 2 gallons of water, a burden exceeding 17 lbs.

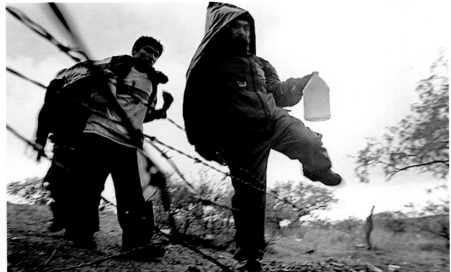

HUMANE BORDERS

The vast scale of the desert and the problems of migration have spawned a range of independent, non-governmental groups to action: both those who seek to alleviate the dangers of desert crossing, and those who seek to assist the government in "defending" against illegal immigration.

Humane Borders is a humanitarian organization that was formed as a response to the alarming rise of the migrant death rate along the desert stretches of the US-Mexico border. Hoping to "take death out of the migration equation," group founder Robin Hoover and other volunteers have installed dozens of water stations along more traveled sections of the Sonoran Desert. These water stations provide passive humanitarian aid to those migrants who are unlikely to survive the five-day trek, succombing to dehydration and exhaustion. The construction of the water stations is basic: two 60-gallon barrels painted blue to reduce heat gain, provide visibility, and prevent algae blooms. The barrels are refilled weekly and maintained entirely through donations and volunteer contributions. Though the annual death count may reach four to five hundred, agents of the US Border Patrol have so far made over half a million recorded arrests of illegal border crossings. In spite of many repeat arrests, this number helps to convey the magnitude of the migrant traffic now present in Sonoran Desert. On the flipside of the ongoing border debate, other groups, such as the Minuteman Project, have become outraged with the growing migrant influx along the Arizona section of the border. These volunteer groups, equipped with night vision goggles, vehicles, firearms and even small aircraft, will camp in the desert for days patrolling the movement of migrants at the border. These groups resent the growing accumulation of trash, both manufactured and human waste, which may fatally injure grazing cattle, as well as cause damage to private ranch property.

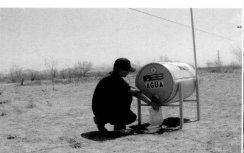

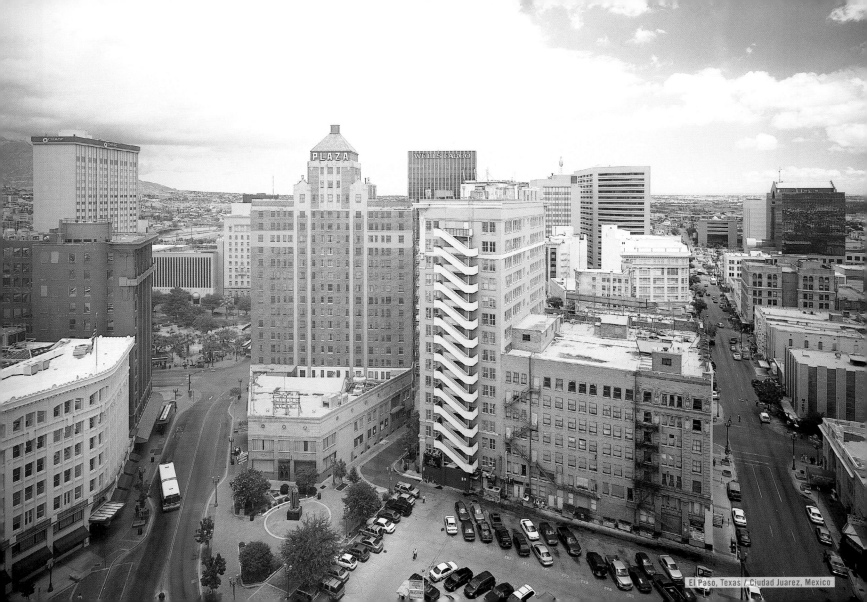

El Paso, Texas / Ciudad Juarez, Mexico

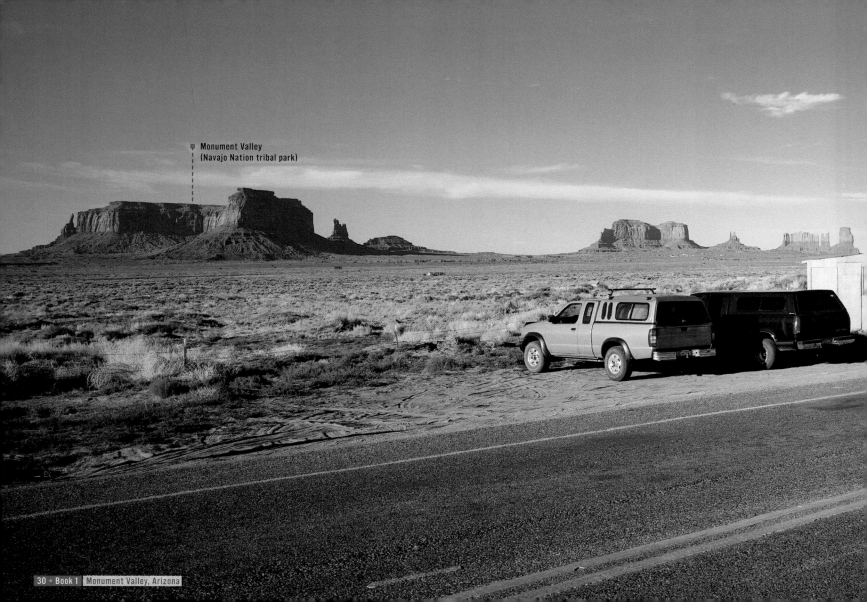

Monument Valley
(Navajo Nation tribal park)

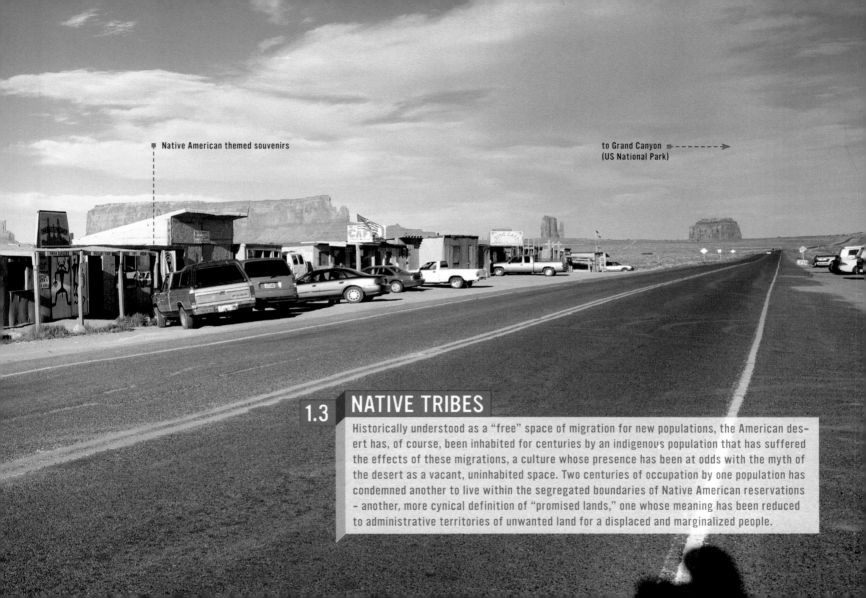

Native American themed souvenirs

to Grand Canyon ⊳- - - - - - ->
(US National Park)

1.3 NATIVE TRIBES

Historically understood as a "free" space of migration for new populations, the American des-
ert has, of course, been inhabited for centuries by an indigenous population that has suffered
the effects of these migrations, a culture whose presence has been at odds with the myth of
the desert as a vacant, uninhabited space. Two centuries of occupation by one population has
condemned another to live within the segregated boundaries of Native American reservations
– another, more cynical definition of "promised lands," one whose meaning has been reduced
to administrative territories of unwanted land for a displaced and marginalized people.

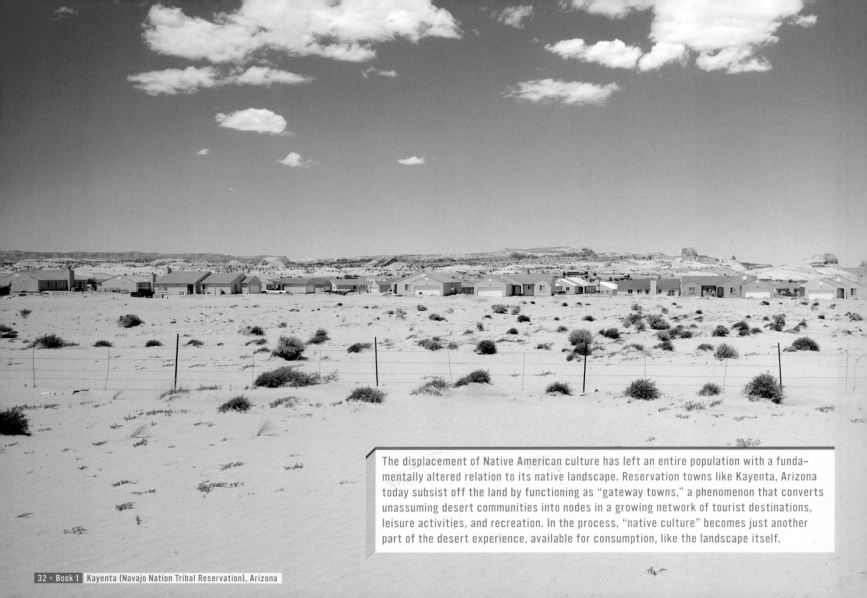

The displacement of Native American culture has left an entire population with a fundamentally altered relation to its native landscape. Reservation towns like Kayenta, Arizona today subsist off the land by functioning as "gateway towns," a phenomenon that converts unassuming desert communities into nodes in a growing network of tourist destinations, leisure activities, and recreation. In the process, "native culture" becomes just another part of the desert experience, available for consumption, like the landscape itself.

Kayenta's proximity to Monument Valley (a Navajo Nation tribal park) has proven to be its primary natural resource, transforming the community into a so-called "gateway town." Typically, towns located within Native American lands are marked by extreme poverty, the average per capita income of less rarely exceeding $10,000/year. In marked contrast, Kayenta's revenue is highly supplemented by the substantial tourist population visiting Monument Valley. Uncharacteristically for a town of its size and location, Kayenta hosts its own tourism website, two fast food restaurants, four motels, a post office, police department, and airport.

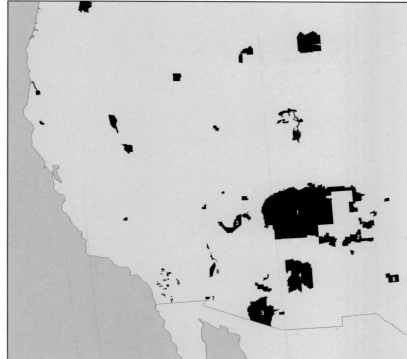

1 Navajo Nation **2** Zuni **3** Hualapai **4** Fort Apache/ San Carlos **5** Tohono O'Odham
6 Mescalero **7** Fort Yuma Reservation **8** Colorado River Reservation

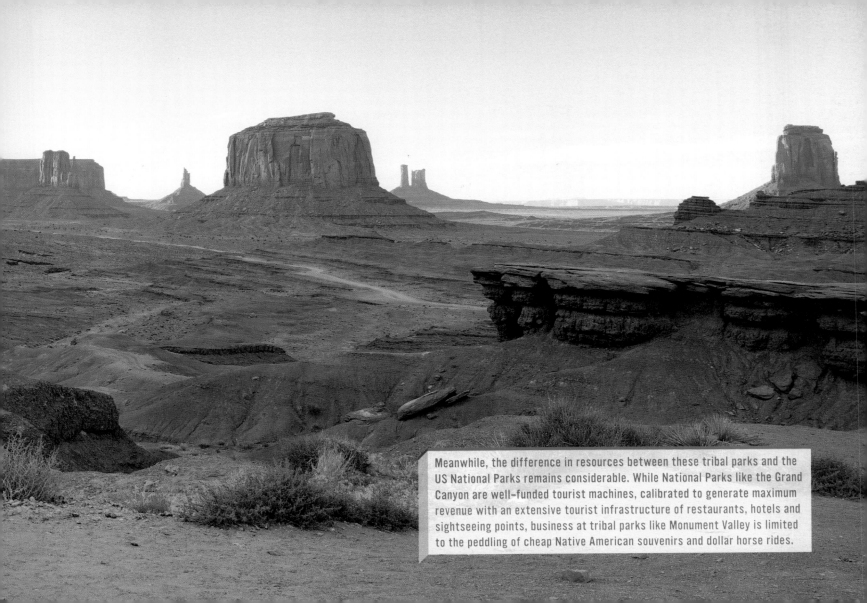

Meanwhile, the difference in resources between these tribal parks and the US National Parks remains considerable. While National Parks like the Grand Canyon are well-funded tourist machines, calibrated to generate maximum revenue with an extensive tourist infrastructure of restaurants, hotels and sightseeing points, business at tribal parks like Monument Valley is limited to the peddling of cheap Native American souvenirs and dollar horse rides.

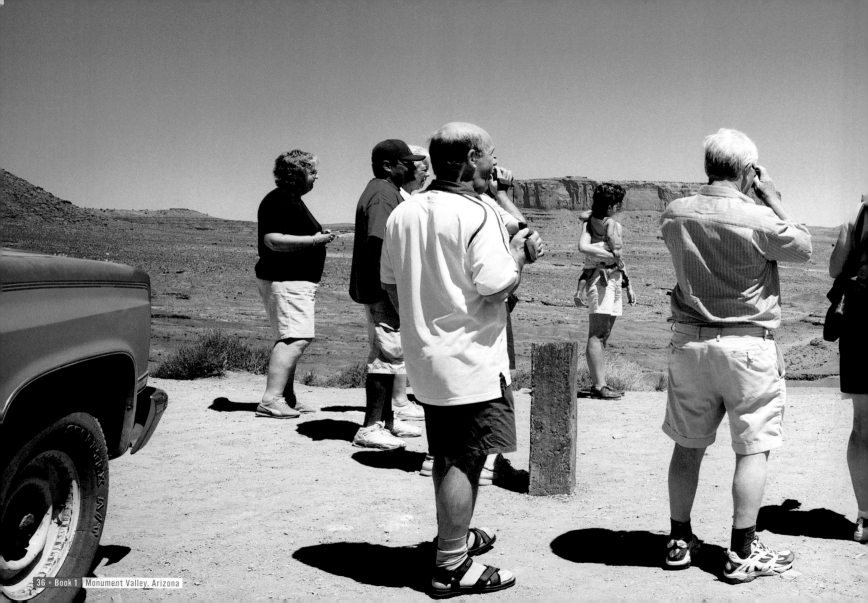

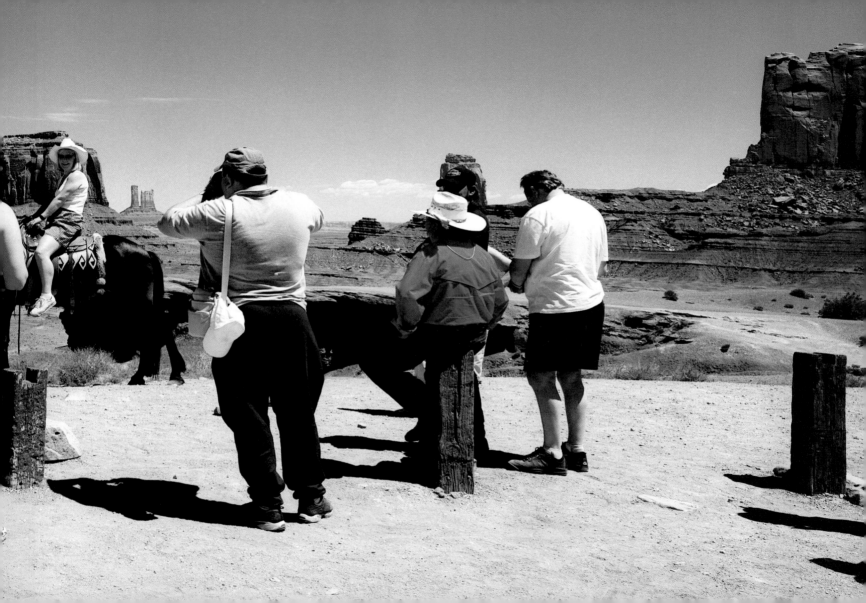

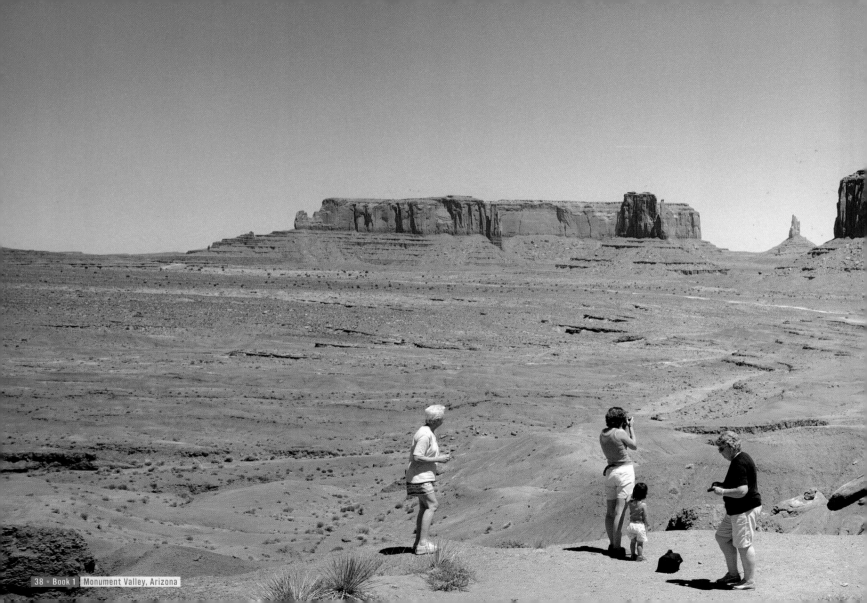

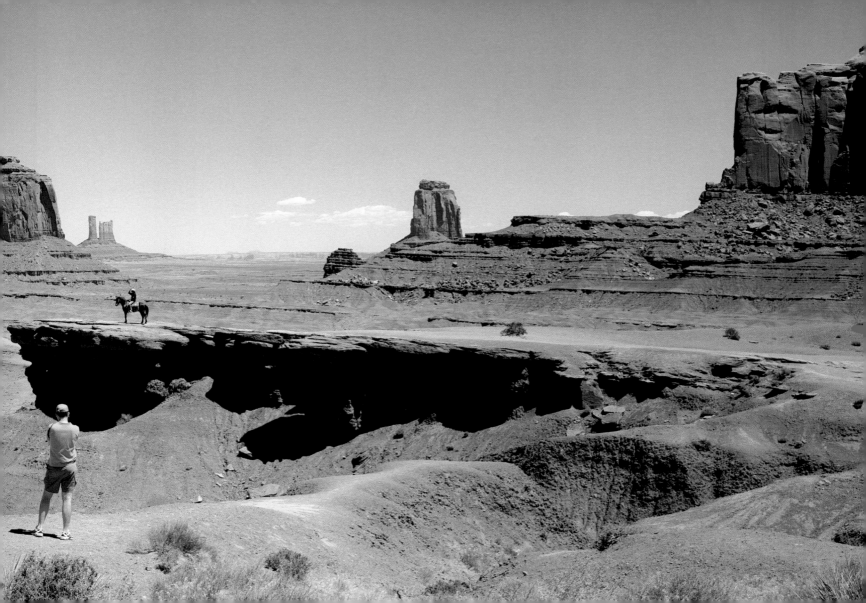

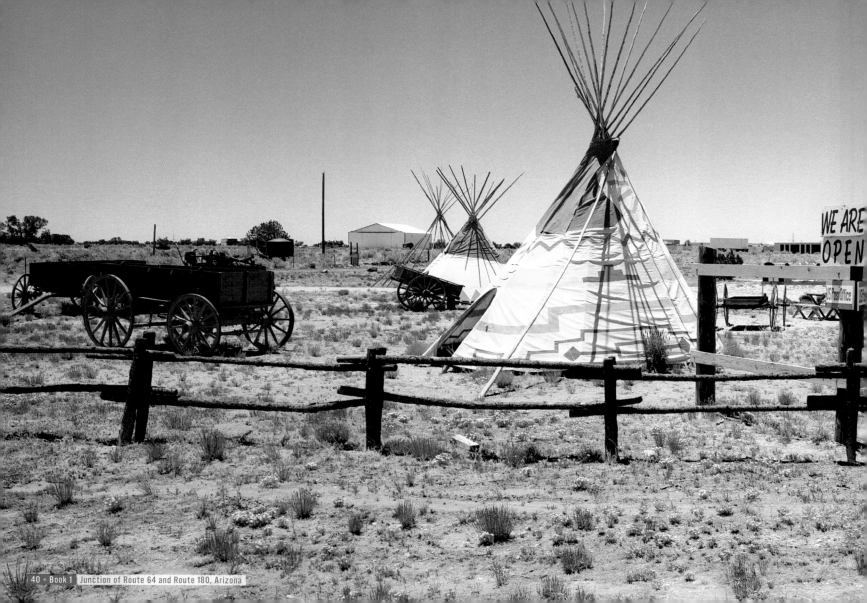

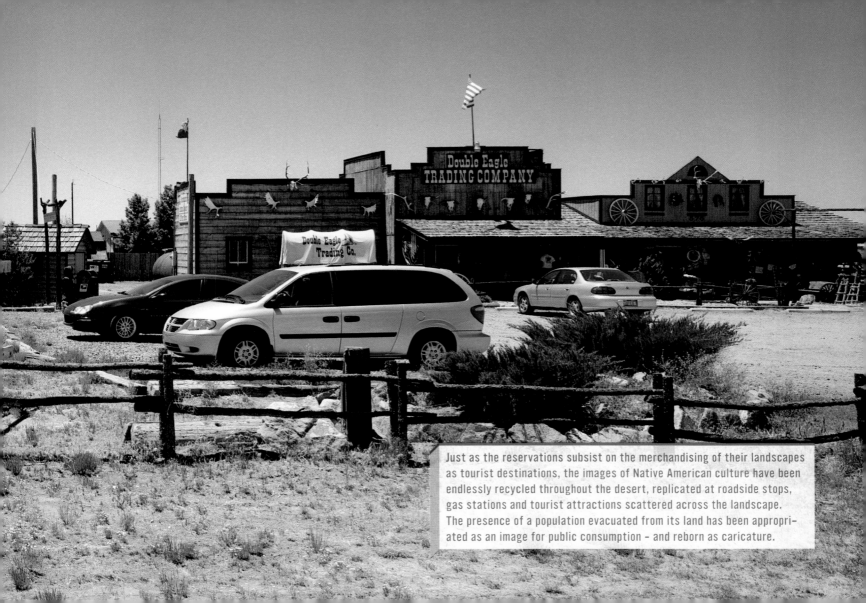

Just as the reservations subsist on the merchandising of their landscapes as tourist destinations, the images of Native American culture have been endlessly recycled throughout the desert, replicated at roadside stops, gas stations and tourist attractions scattered across the landscape.
The presence of a population evacuated from its land has been appropriated as an image for public consumption - and reborn as caricature.

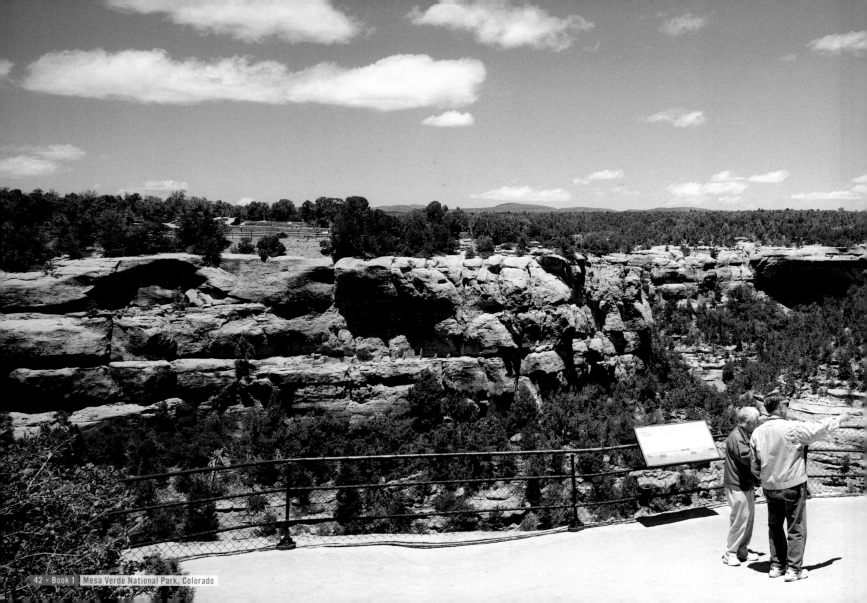

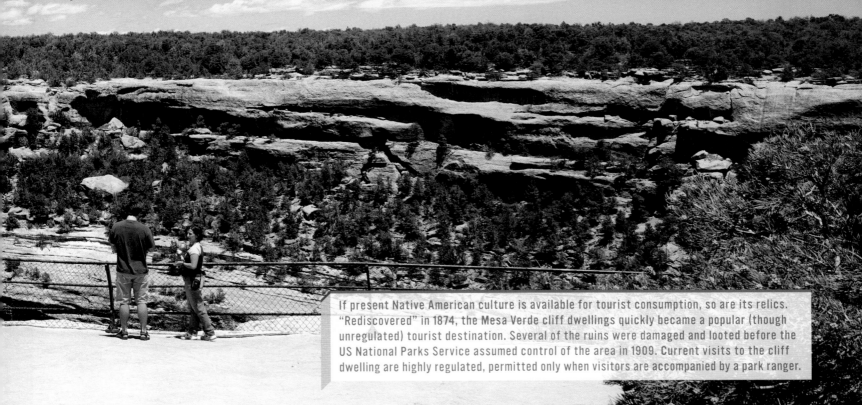

Looking down from the canyon edge on the so-called Cliff Palace... I could only feel a sense of distance that far exceeded the actual number of yards between myself and the miniature ruins. They were more remote, because inaccessible, than Pompeii or Ostia, less comprehensible, and therefore... heartbreakingly desolate. At Mesa Verde, the sense of human emptiness was absolute, obviously deepened by the inability to enter the ruins and my general sense of separation from all Indian culture, ever. I had come to the end of one of my personal worlds, and had peered, incomprehending, into somebody else's abandoned future.
Reyner Banham, *Scenes From America Deserta*, 122-123.

If present Native American culture is available for tourist consumption, so are its relics. "Rediscovered" in 1874, the Mesa Verde cliff dwellings quickly became a popular (though unregulated) tourist destination. Several of the ruins were damaged and looted before the US National Parks Service assumed control of the area in 1909. Current visits to the cliff dwelling are highly regulated, permitted only when visitors are accompanied by a park ranger.

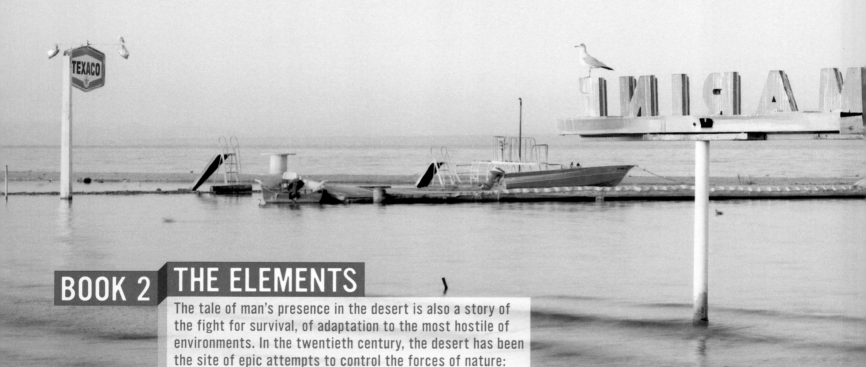

BOOK 2

THE ELEMENTS

The tale of man's presence in the desert is also a story of the fight for survival, of adaptation to the most hostile of environments. In the twentieth century, the desert has been the site of epic attempts to control the forces of nature: the manipulation of earth, water and air through advanced technology to generate resources that make the harsh desert landscape not only inhabitable, but productive.

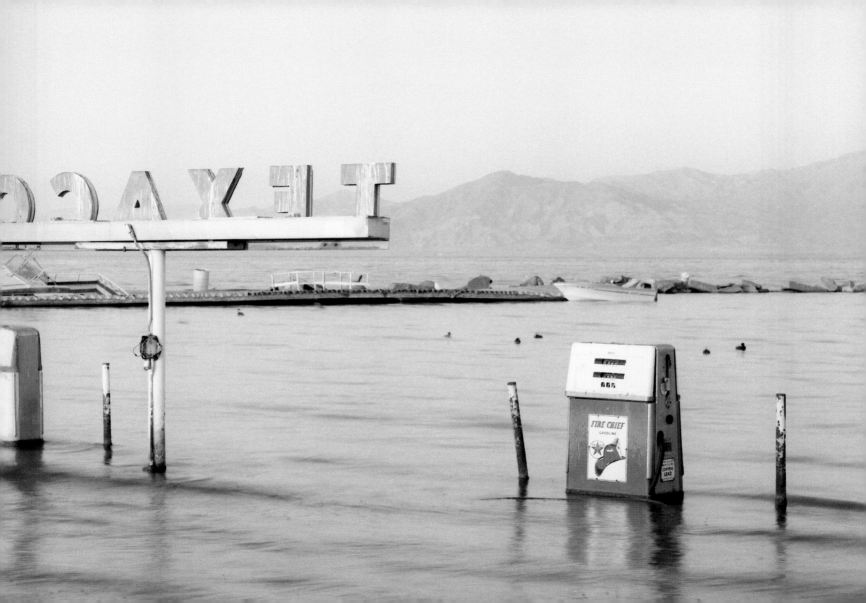

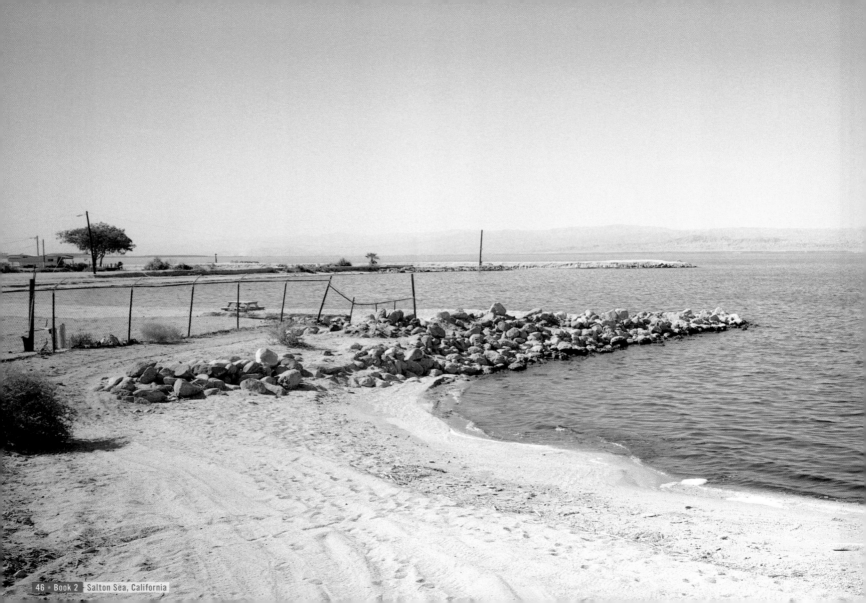

2.1 THE FLOOD

The Colorado river is the lifeline of the American desert. The history of the desert is in large measure the sum of attempts to control and channel its route, to temper the river's unpredictable flows and harness its tremendous power. These efforts have resulted in both monumental successes and catastrophic failures, a set of manmade legends that begins with the tale of the Salton Sea: a massive lake created by accident in the middle of the desert, today an ecological disaster of monumental proportions.

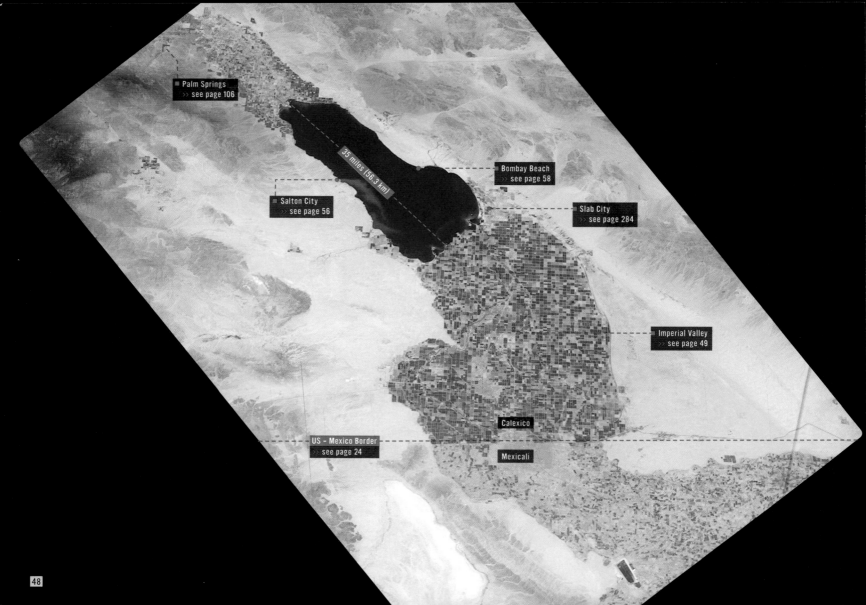

Palm Springs
>>> see page 106

35 miles (56.3 km)

Salton City
see page 56

Bombay Beach
>> see page 58

Slab City
>> see page 284

Imperial Valley
see page 49

Calexico

US - Mexico Border
>> see page 24

Mexicali

ONE MAN AND HIS SEA

Inspired by a desire to transform desert into paradise, one man, Charles Rockwood, effected a geological transformation of biblical proportions. In 1900, Rockwood, an engineer, envisioned the transformation of the 1600 square mile Salton Sink (a barren section of the Colorado Desert Valley) from a huge swath of uninhabited sand into the "Imperial Valley," a new agricultural zone in Southern California. Rockwood's company, the California Development Company (CDC), supervised the creation of nearly 650 km of irrigation canals and waterways that redirected the natural flow of the Colorado River west into the Salton Sink. Initially, this re-routing was a tremendous success. The constant sunshine and endless supply of freshwater transformed the Salton Sink (a dry, powdery desert) into the richest agricultural zone in the Southwest. Three years after their construction, heavy silt loads had severely clogged the canals and irrigation ditches maintained by the CDC. In early 1905, Rockwood's company dug a quarter-mile long bypass ditch

that restored the flow of water into the Imperial Valley. This provisional bypass lacked an adequate headgate, which is used to regulate a canal's water flow. Overwhelmed by a series of unexpected, massive floods, the banks of this bypass channel quickly eroded as the swelling river ripped through the sandy soil with breakneck efficiency. The canal intake widened from 40 feet to nearly half a mile, and an ever-increasing flow of river water collected in the Salton Sink basin at a rate of over 10,000,000,000 liters per hour. It took engineers nearly two years to devise a way to "plug" this breach and restore the natural flow of the Colorado. In the end, the solution proved simple: 60,000 cubic meters of rock were hauled in by train and dumped into the break in a mere fifteen days. But the Colorado Delta had already undergone a monumental geological transformation in these two years that would have naturally required a millennium to occur. The newly formed Salton Sea, resting in the deepest section of the Salton Sink basin, measured 65 km long by 21 km wide, covering a 1000 square km section of once-arid desert.

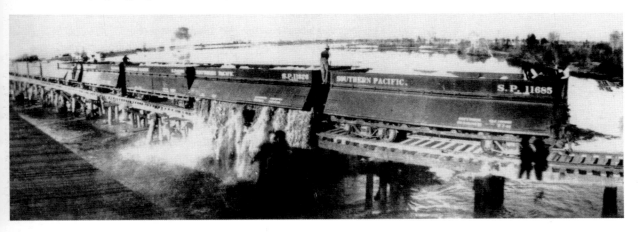

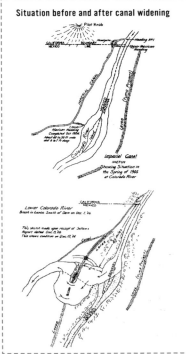

Situation before and after canal widening

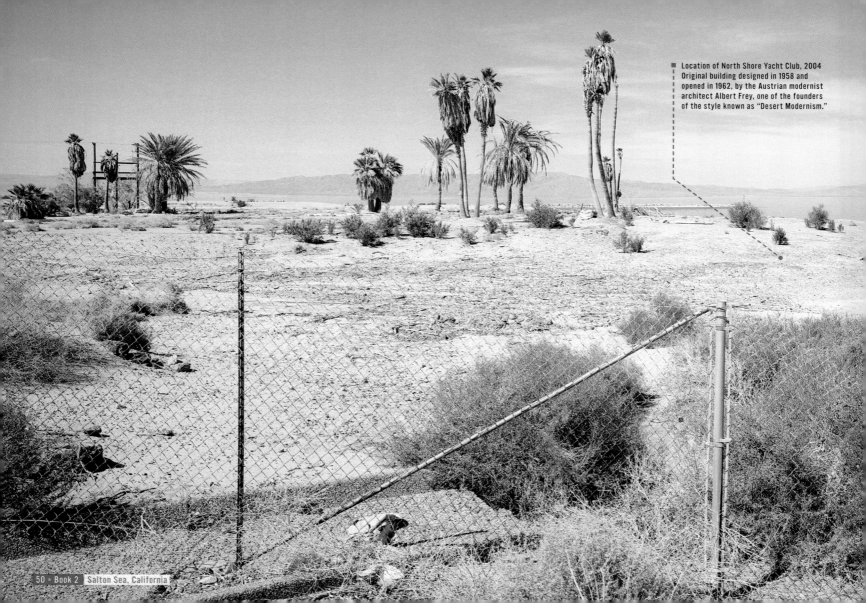

Location of North Shore Yacht Club, 2004
Original building designed in 1958 and
opened in 1962, by the Austrian modernist
architect Albert Frey, one of the founders
of the style known as "Desert Modernism."

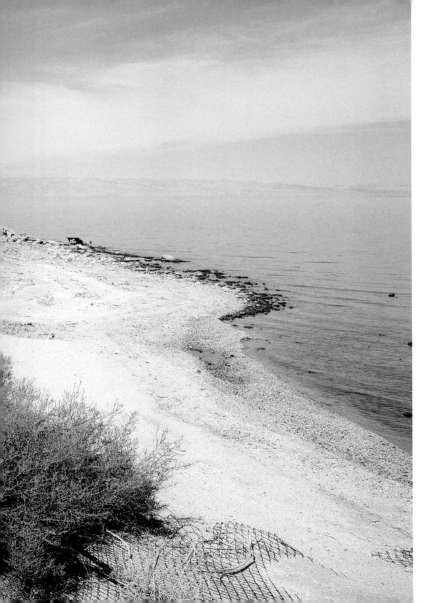

As the largest inland lake in California, the Salton Sea enjoyed some years as a popular tourist destination, attracting celebrities like Frank Sinatra and the Beach Boys to the various clubs and hotels dotting its beaches. With no natural outlet, however, for the past half-century the Salton Sea has served as a giant repository for the irrigation runoff generated by the agricultural industry of the Imperial Valley (now successful thanks to later, government-funded engineering project like the Hoover Dam - ›› see page 68). Any water lost to evaporation is quickly replaced by these nutrient- (and pollution-) rich inflows, which sustain a constant escalation of both the Sea's elevation and its salinity. The property damage from repeated flooding, and the stench emanating from the sea's increasingly uninhabitable waters, eventually ensured the abandonment of the vacation and retirement communities built by real estate developers during the mid-century tourist boom.

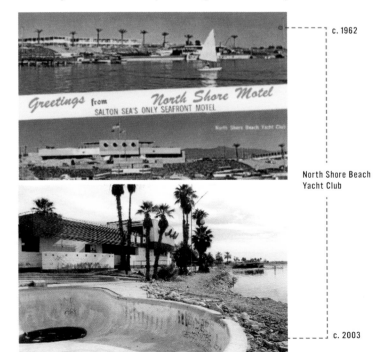

c. 1962

North Shore Beach
Yacht Club

c. 2003

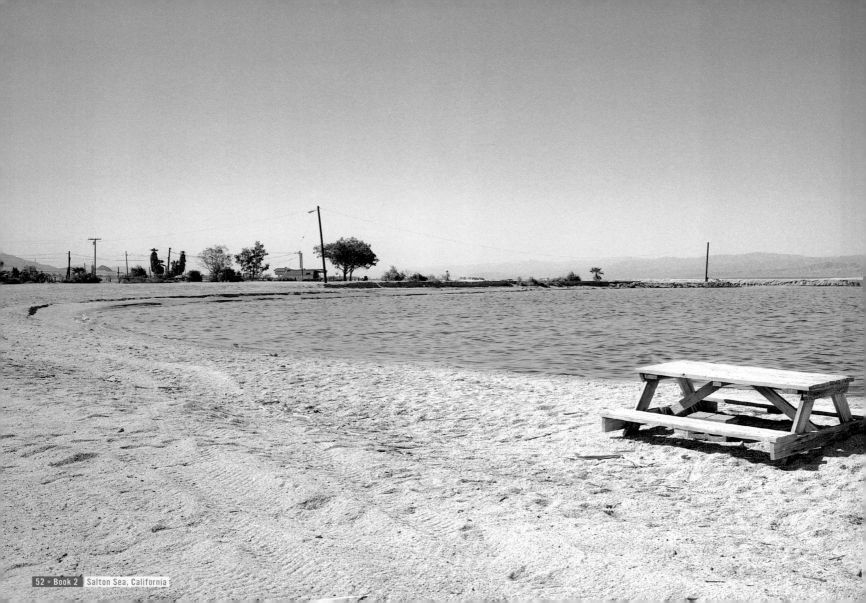

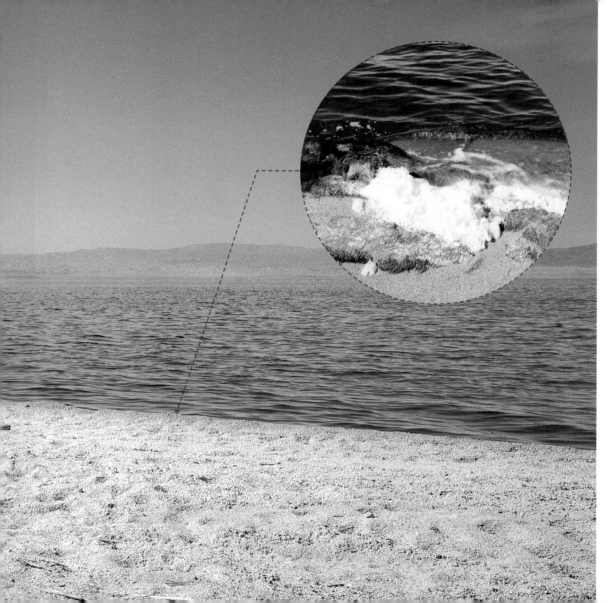

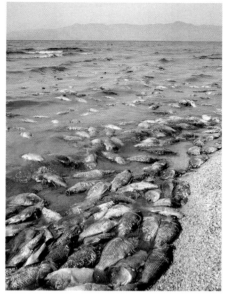

Now a bygone summer destination for sunbathers and sport fisherman, the Sea's largely abandoned beaches are periodically littered with the rotting remains of these surviving fish populations, who perish by the thousands during spikes of de-oxygenation triggered by large algae blooms (periodic explosions in the lake's algae population) and the decomposition of the heavily organic sediment that constantly washes into the basin. These "blooms" rapidly lower the sea's oxygen levels, choking the fish populations that currently inhabit the waters. During these dips, as many as 8 million fish may die in a single day.

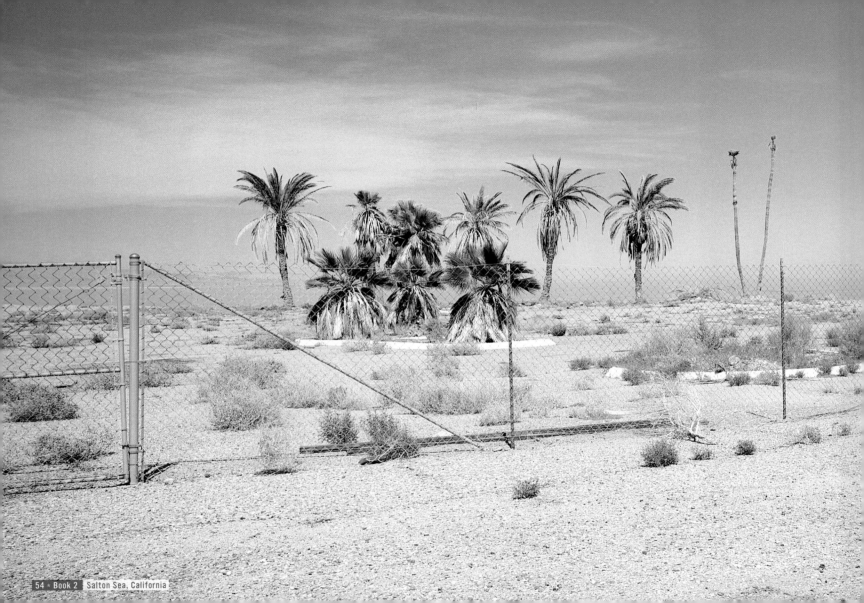

"...a wonderous playground of swimming pools, beaches, harbors and golf courses."
M. Penn Philips, founder of Salton City

SALTON CITY

Salton City was founded in the 1950s by M. Penn Phillips, a successful developer of desert communities. His vision for "a wondrous playground of swimming pools, beaches, harbors and golf courses" included the half-million dollar Salton Bay Yacht Club, a mile-long landing strip, and an infrastructure investment of over 20 million dollars. Although in street maps, this "Miracle City by the Desert Sea" appears to be a considerable municipality, few of the thousands of property owners ever built homes on the still mostly empty lots. Planned as prime beachfront property, the reality of its abandoned, undeveloped streets contrasts with the optimistic planning of the street grid, still visible in GPS maps.

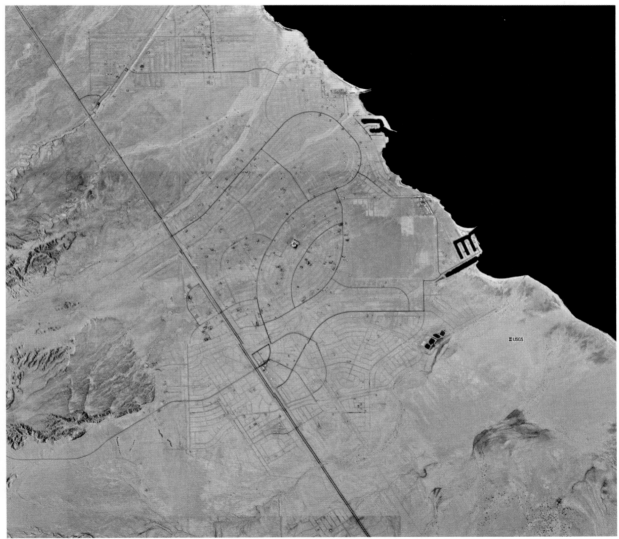

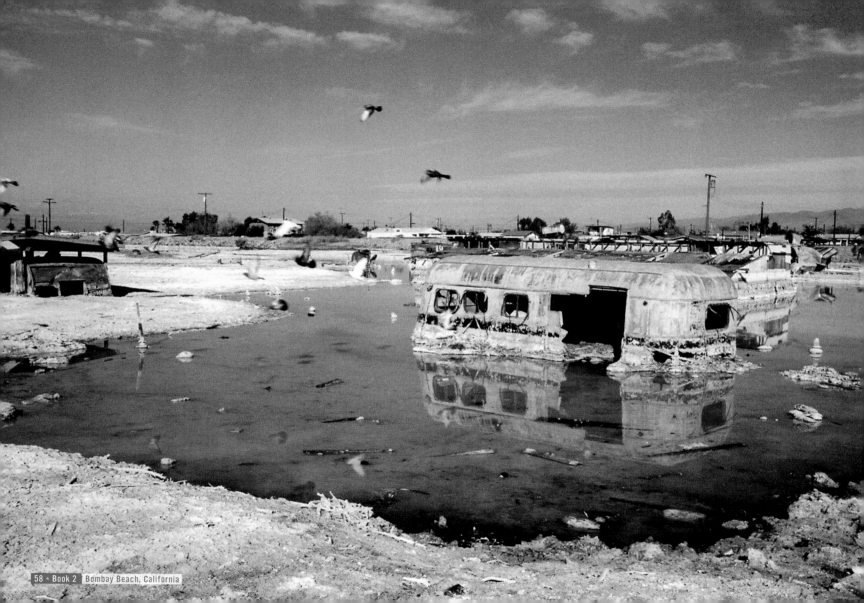

BOMBAY BEACH

Located on the opposite side of the Sea from Salton City, Bombay Beach is a community with an official population of 336. Bombay Beach was originally founded as a tourist and retirement destination, but has suffered the same pattern of decline as the rest of the Salton Sea area: steady growth and development of the Bombay Beach community has been repeatedly thwarted by extreme and unpredictable flooding. These rising waters have submerged as much as 40% of the town's original lots, destroying several established RV (recreation vehicle) parks. Currently, Bombay Beach caters to a small group of campers and fishermen, providing them with unregulated (free) RV docking, and amenities like drinking water and chemical toilets.

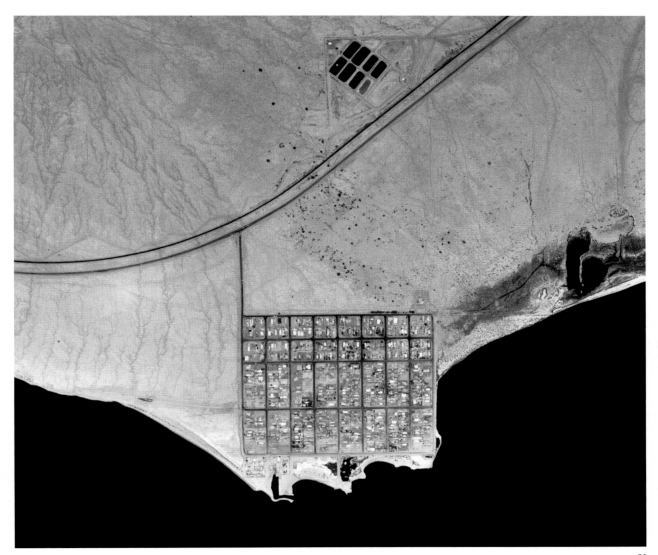

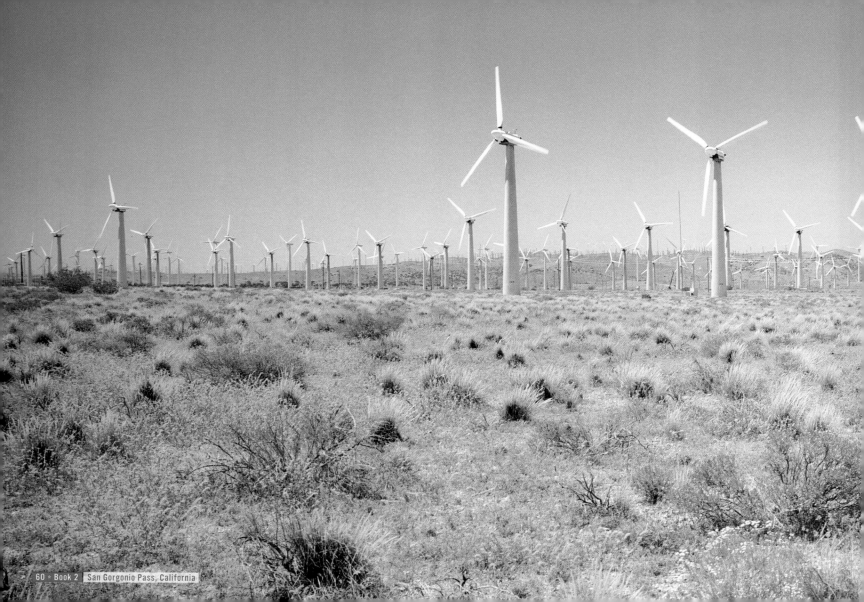

2.2 ENERGIES

The barren, inhospitable environment of the American desert, seemingly devoid of natural assets, turns out to have an abundance of resources all its own. The three largest wind farms in the country are located here, along with one of the nation's largest photovoltaic generating plants. The magnitude of the primal forces of wind and sun have produced alternative sources of energy whose productive capacities are enough to sustain remote territories far beyond the desert sands.

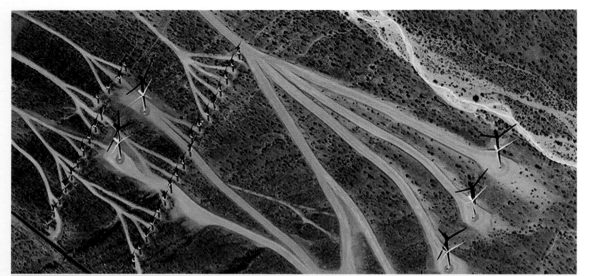

WIND POWER

Along the drive to Palm Springs sits the San Gorgonio Pass Wind Array, a natural wind tunnel formed by the bordering San Bernardino and San Jacinto mountain ranges. In a quest for natural, sustainable sources of energy, the State of California has installed thousands of windmills in an effort to reduce the millions of pounds of carbon and sulfur dioxides that are released from the burning of fossil fuels. At San Gorgonio, 3500+ windmills produce 600 million kilowatt-hours of electricity per year, enough to meet the consumption demands of 250,000 people. (It remains unclear if wind farms pose a danger to flocks of migratory birds that pass through San Gorgonio.)

Driven by tax incentives granted to the alternative energy industry in the aftermath of the US Energy Crisis (1970s), private investors have installed over 4500 windmills in the greater Tehachapi area, which ranks as the world's largest wind farm, churning out 1.4 billion kilowatts of electricity per year. As wind turbines become larger and increasingly efficient, the cost per kilowatt hour continues to drop, making wind energy progressively more viable. In the race to improve efficiency and output rates, many older generation wind turbines such as the "Storm-Master" and "Windmatic" are now abandoned, some having been derelict for more than a decade. These carcasses remain dismantled and untouched, as Kern County has no provision requiring their removal.

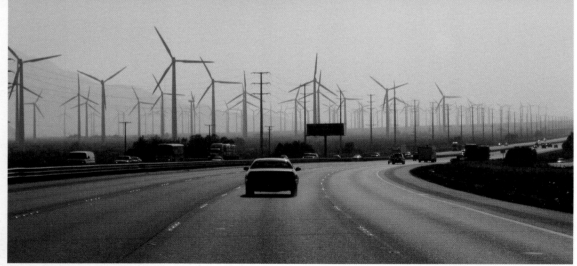

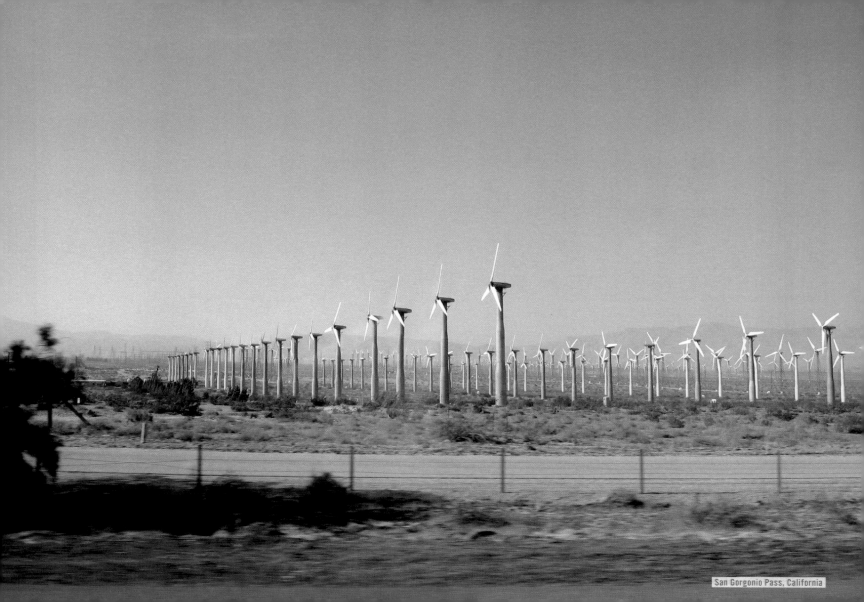

San Gorgonio Pass, California

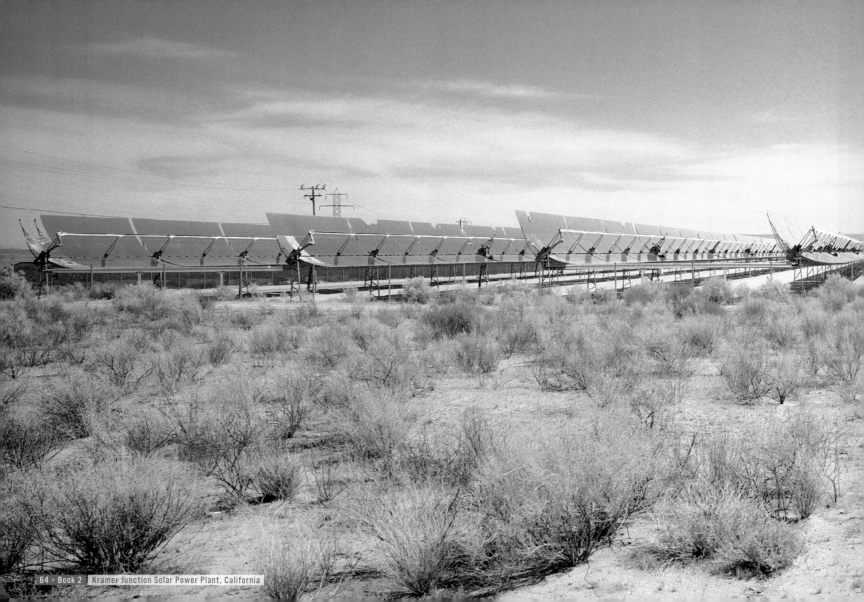

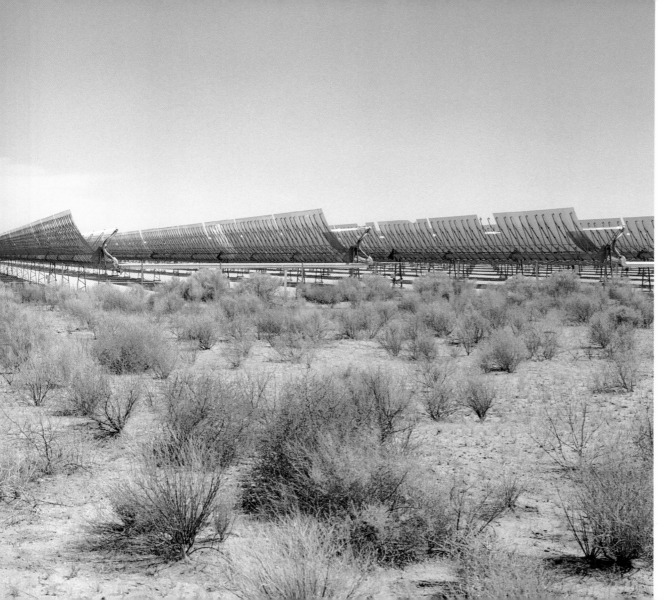

WIND POWER

The desert is also home to the largest solar electric generating facility in the world. The network of five Kramer Junction Solar Electric Generating Systems (SEGS III, IV, V, VI, VII) produces a combined annual electrical output of 354 megawatts, enough to power 350,000 Southern Californian homes. "Parabolic trough" collectors (developed at Sandia National Labs in conjunction with the US Department of Energy) convert sunlight to heat energy, which is harvested and used to power on-site steam generators. Although production at Kramer Junction represents 99% of the US's solar energy output, solar power continues to meet only a tiny fraction of the country's overall energy demands. Moreover, all but one of the solar energy plants in the Mojave Desert area are hybrid plants, which rely on the traditional burning of fossil fuels to maintain plant operations.

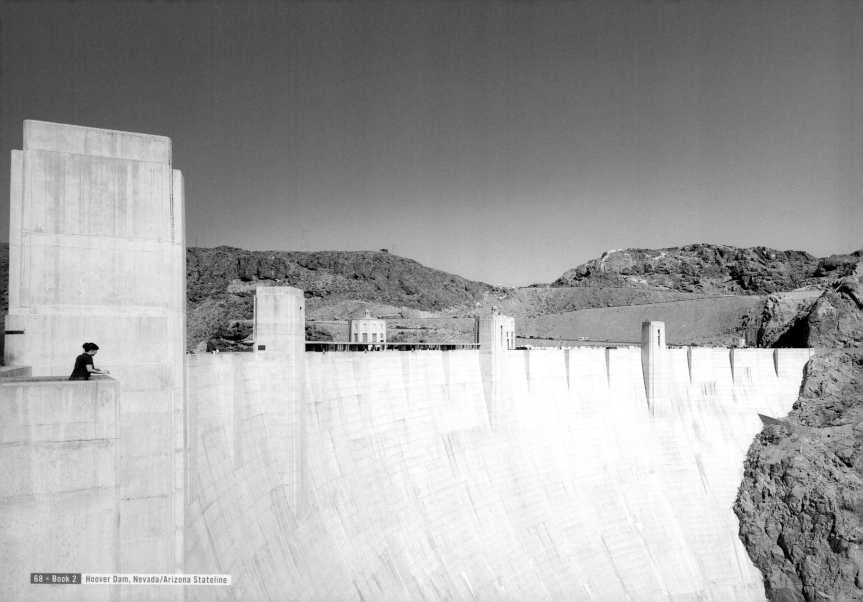

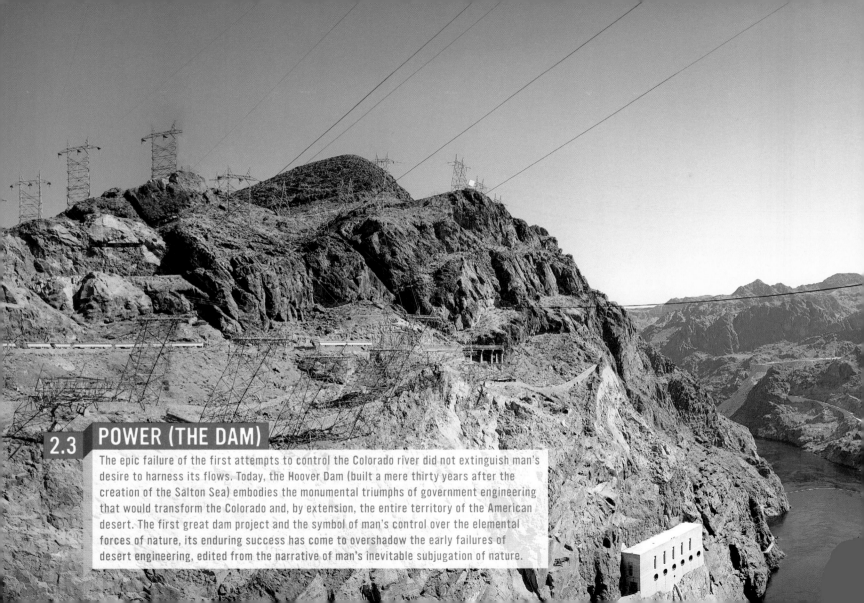

2.3 POWER (THE DAM)

The epic failure of the first attempts to control the Colorado river did not extinguish man's desire to harness its flows. Today, the Hoover Dam (built a mere thirty years after the creation of the Salton Sea) embodies the monumental triumphs of government engineering that would transform the Colorado and, by extension, the entire territory of the American desert. The first great dam project and the symbol of man's control over the elemental forces of nature, its enduring success has come to overshadow the early failures of desert engineering, edited from the narrative of man's inevitable subjugation of nature.

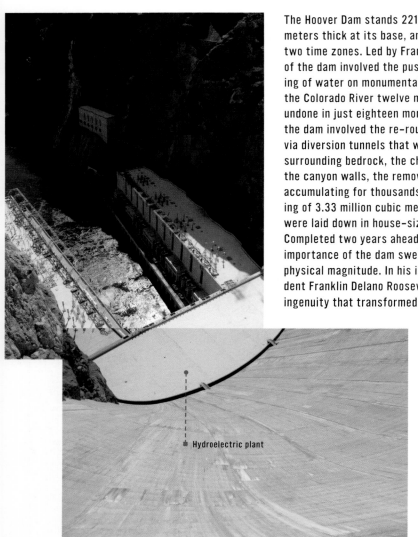

The Hoover Dam stands 221 meters tall, sits 200 meters thick at its base, and straddles two states and two time zones. Led by Frank Crowe, construction of the dam involved the pushing of earth and the dividing of water on monumental scales; what had taken the Colorado River twelve million years to carve was undone in just eighteen months. The construction of the dam involved the re-routing of the Colorado River via diversion tunnels that were blasted through the surrounding bedrock, the chipping and smoothing of the canyon walls, the removal of soft silt that had been accumulating for thousands of years, and the pouring of 3.33 million cubic meters of concrete, which were laid down in house-sized, interlocking blocks. Completed two years ahead of schedule, the symbolic importance of the dam swelled beyond even its colossal physical magnitude. In his inauguration speech, President Franklin Delano Roosevelt spoke of the American ingenuity that transformed the "bottom of a gloomy canyon... a cactus covered waste" into a "twentieth-century marvel." The construction of the dam mobilized a work force of 5000 men, working day and night, one bucket of concrete at a time, a communal symbol of national recovery during the doubt and insecurity of the Great Depression. The dam also changed the trajectory of America's national perception of the desert from an inhospitable no-man's land into a major natural resource, "a vision of lonely lands made fruitful." The once rogue river (now tamed by technology) could be effortlessly controlled with a flick of a switch: a national faucet delivering an endless supply of fresh water magically washing over barren dust, leaving fertile farmland in its wake. In the end, the difference between the Hoover Dam and Salton Sea is not so great; both stem from the desire to channel the force of the Colorado to new ends, to transform the desert itself. The difference is no more than 30 years of technology, and massive government intervention.

▪ Hydroelectric plant

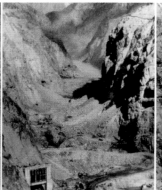
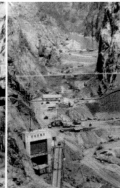

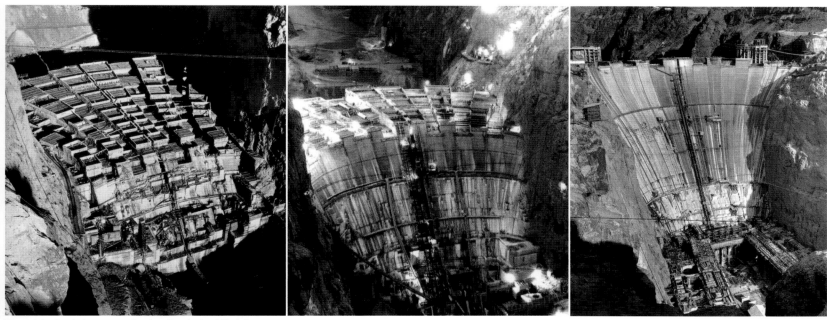

Views of the dam during construction, from Nevada rim of Black Canyon.

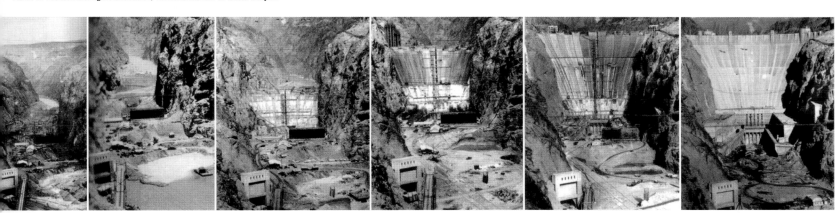

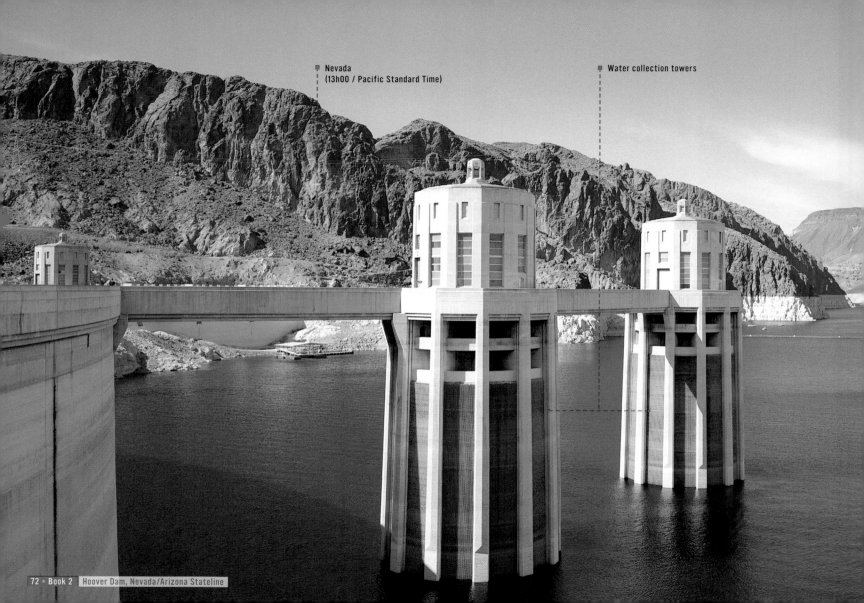

Nevada
(13h00 / Pacific Standard Time)

Water collection towers

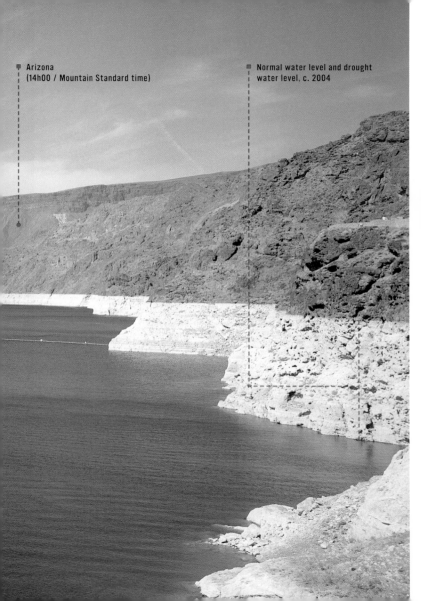

Arizona
(14h00 / Mountain Standard time)

Normal water level and drought
water level, c. 2004

SUBMERGED

For the first time in 80 years, drought conditions have unveiled the remains of St. Thomas, Nevada, a former Mormon settlement turned aquatic ghost town. The community of St. Thomas was founded in 1865 and grew to a population of 500 residents who made their living from railroad and highway traffic. The town was reluctantly abandoned in the years after the completion of the Hoover Dam as rising waters of the infant Lake Mead slowly consumed the town, which eventually lay under 64 feet of water.

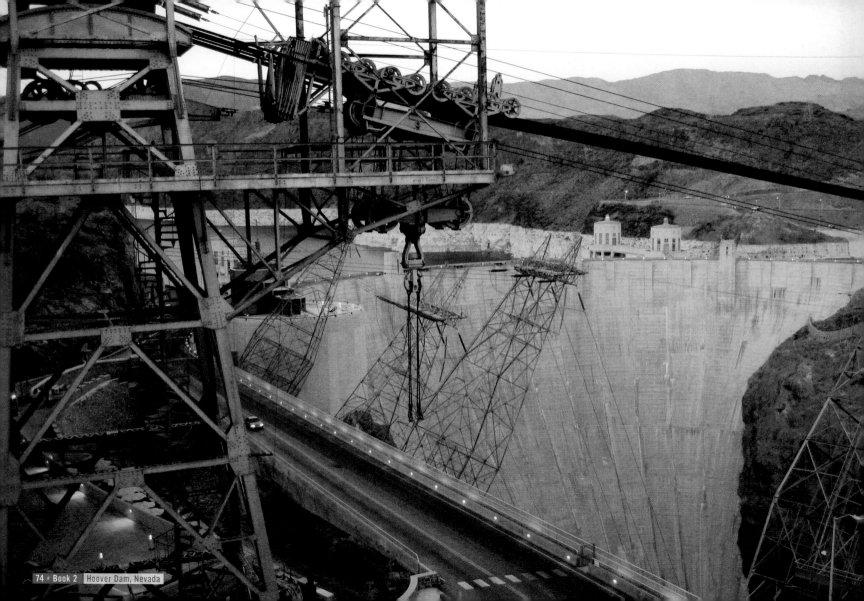

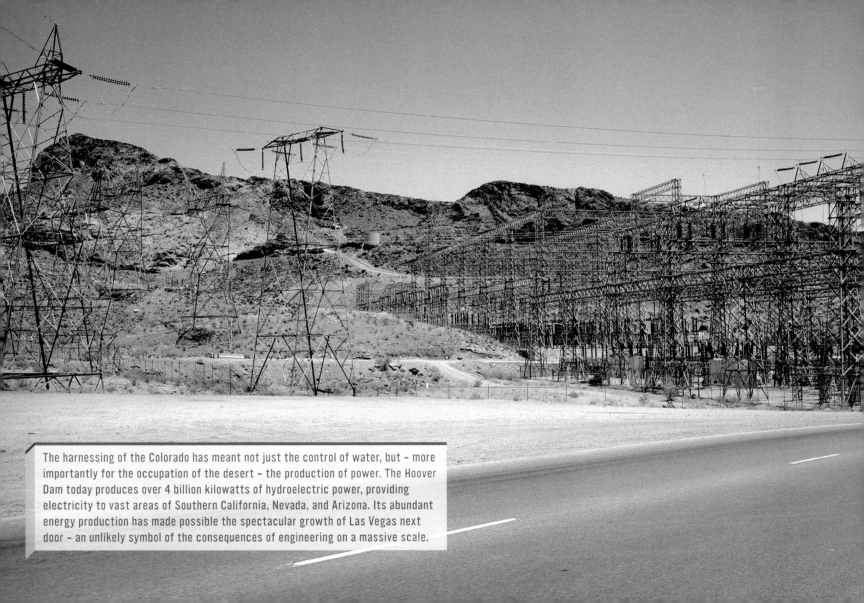

The harnessing of the Colorado has meant not just the control of water, but – more importantly for the occupation of the desert – the production of power. The Hoover Dam today produces over 4 billion kilowatts of hydroelectric power, providing electricity to vast areas of Southern California, Nevada, and Arizona. Its abundant energy production has made possible the spectacular growth of Las Vegas next door – an unlikely symbol of the consequences of engineering on a massive scale.

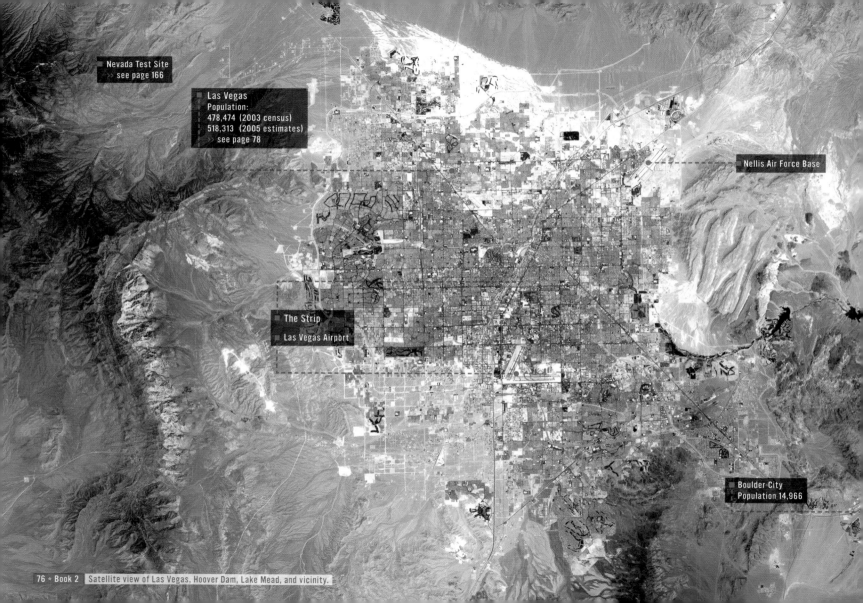

Nevada Test Site
>>> see page 166

Las Vegas
Population:
478,474 (2003 census)
518,313 (2005 estimates)
see page 78

Nellis Air Force Base

The Strip

Las Vegas Airport

Boulder City
Population 14,966

Satellite view of Las Vegas, Hoover Dam, Lake Mead, and vicinity.

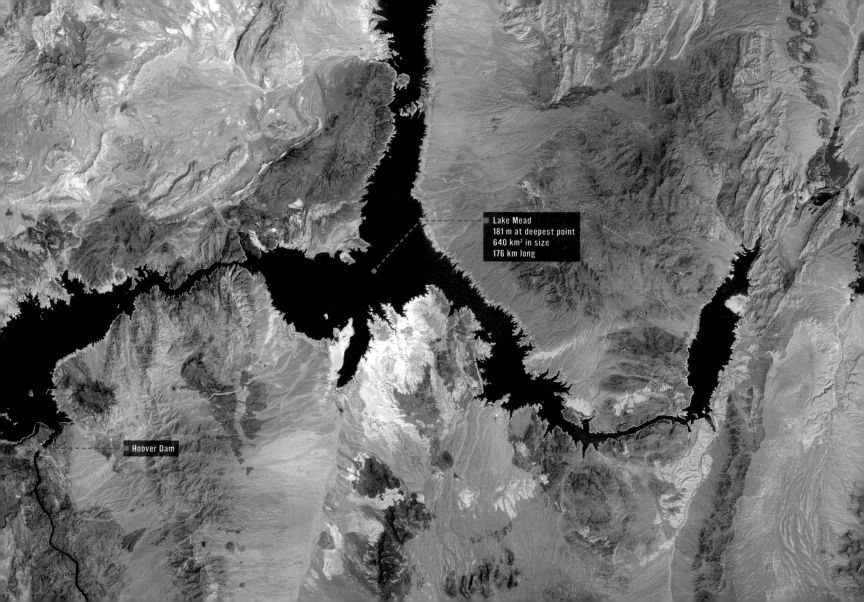

Lake Mead
181 m at deepest point
640 km² in size
176 km long

Hoover Dam

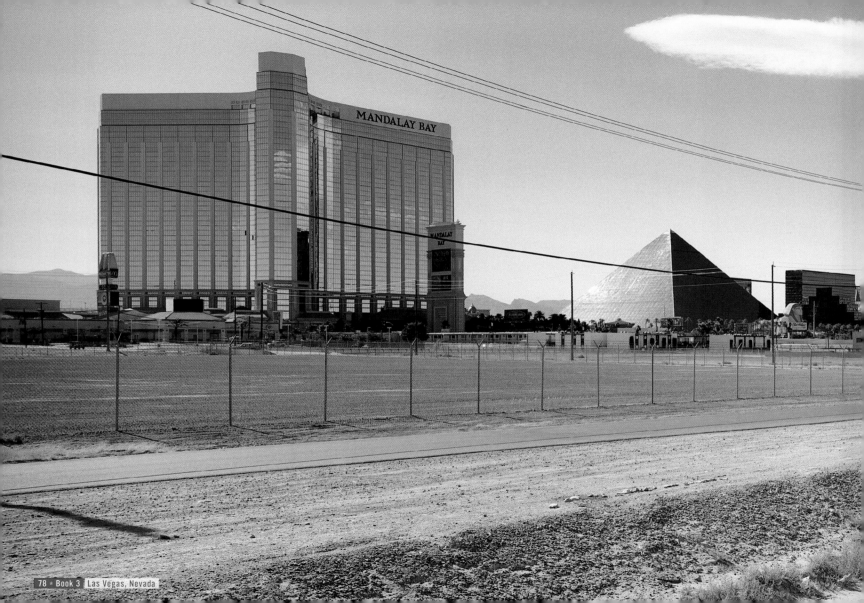

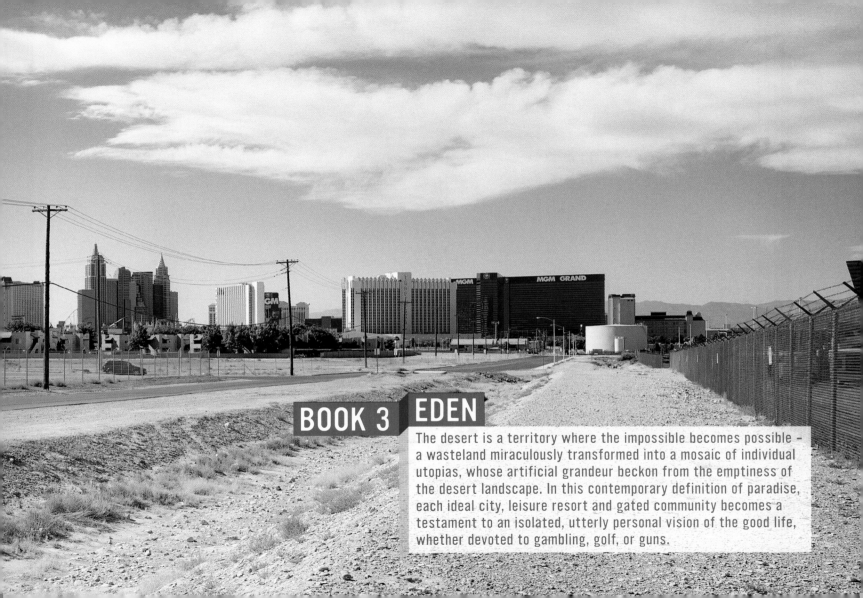

BOOK 3 **EDEN**

The desert is a territory where the impossible becomes possible –
a wasteland miraculously transformed into a mosaic of individual
utopias, whose artificial grandeur beckon from the emptiness of
the desert landscape. In this contemporary definition of paradise,
each ideal city, leisure resort and gated community becomes a
testament to an isolated, utterly personal vision of the good life,
whether devoted to gambling, golf, or guns.

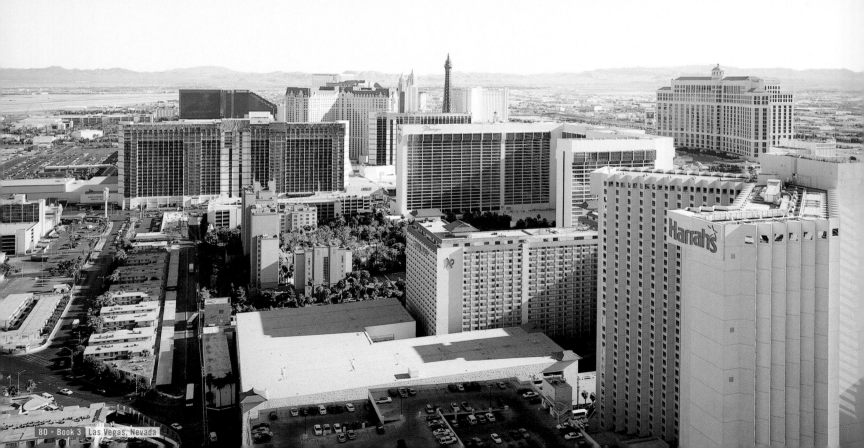

"Las Vegas is sort of like how God would do it if he had money."
Steve Wynn, Las Vegas property developer

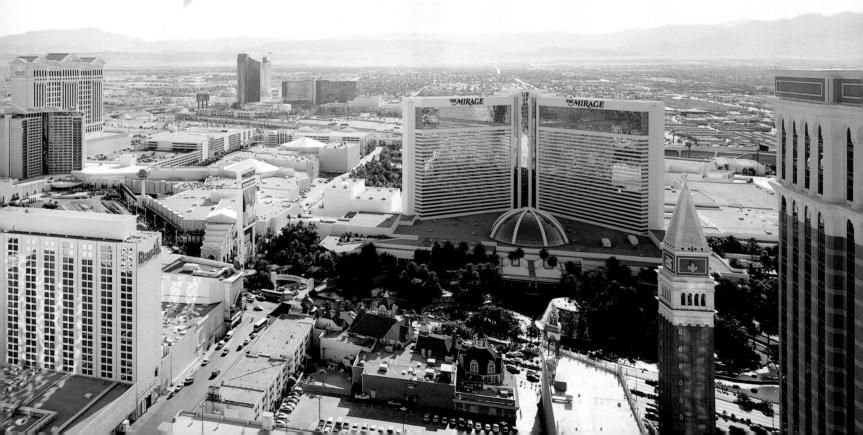

3.1 MIRAGE

Las Vegas is a city that has made the most of its situation. Founded in the middle of the desert, it is a city forever in flux, constantly reinventing itself to best take advantage of its remote location. Far beyond the reach of disapproving governing authorities, Las Vegas has become the hub for all kinds of illegal activities (such as gambling and prostitution), celebrating its success with blinding enthusiasm and extravagant hyperbole. Visitors eagerly make the journey to Vegas in order to experience firsthand the astonishing transformation of their wildest dreams into reality, freely partaking of pleasures forbidden elsewhere.

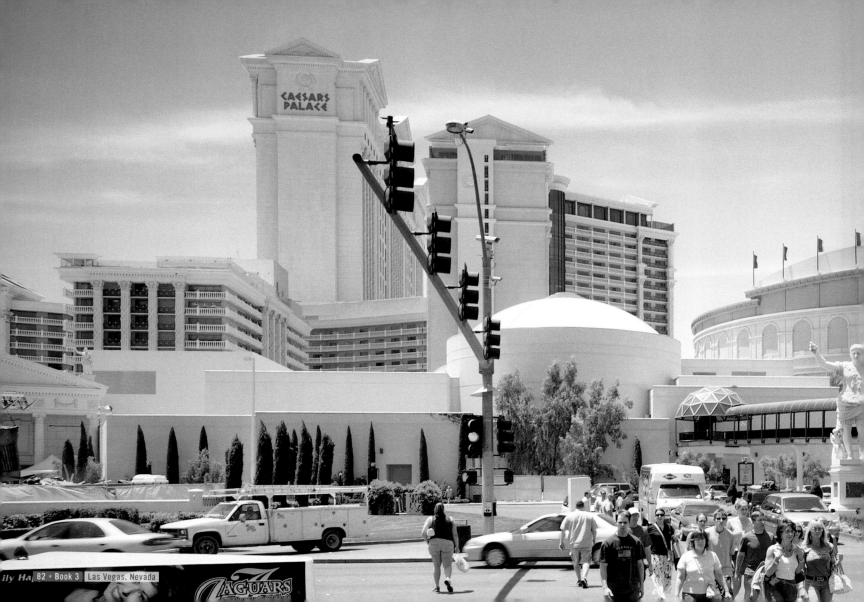

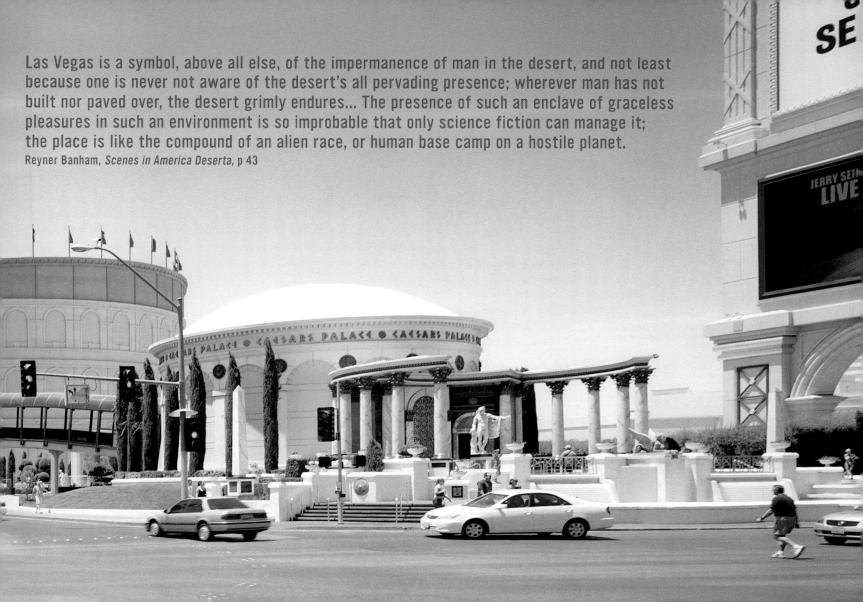

Las Vegas is a symbol, above all else, of the impermanence of man in the desert, and not least because one is never not aware of the desert's all pervading presence; wherever man has not built nor paved over, the desert grimly endures... The presence of such an enclave of graceless pleasures in such an environment is so improbable that only science fiction can manage it; the place is like the compound of an alien race, or human base camp on a hostile planet.

Reyner Banham, *Scenes in America Deserta*, p 43

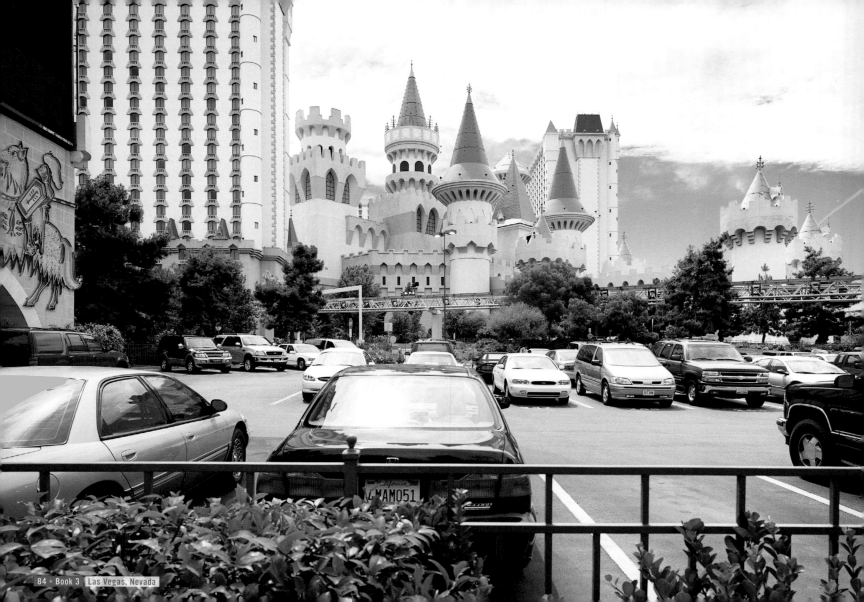

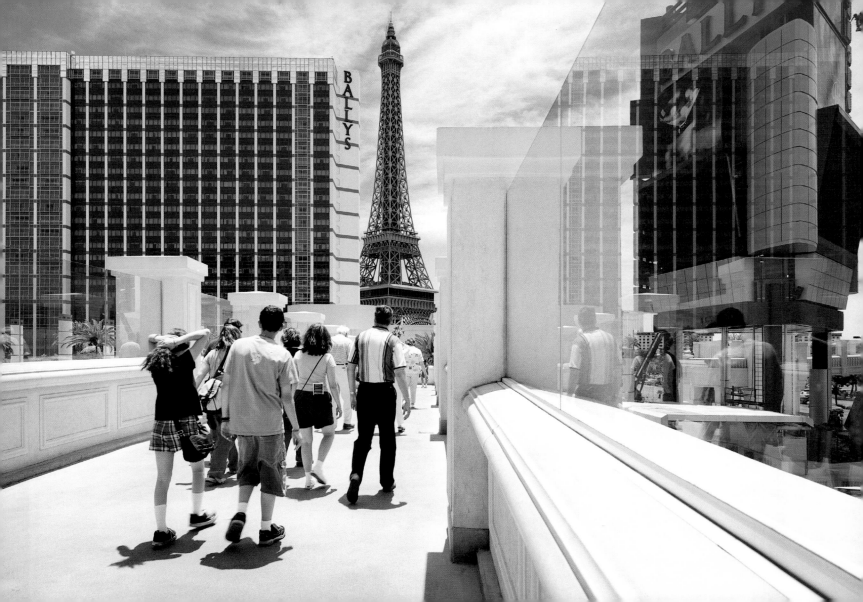

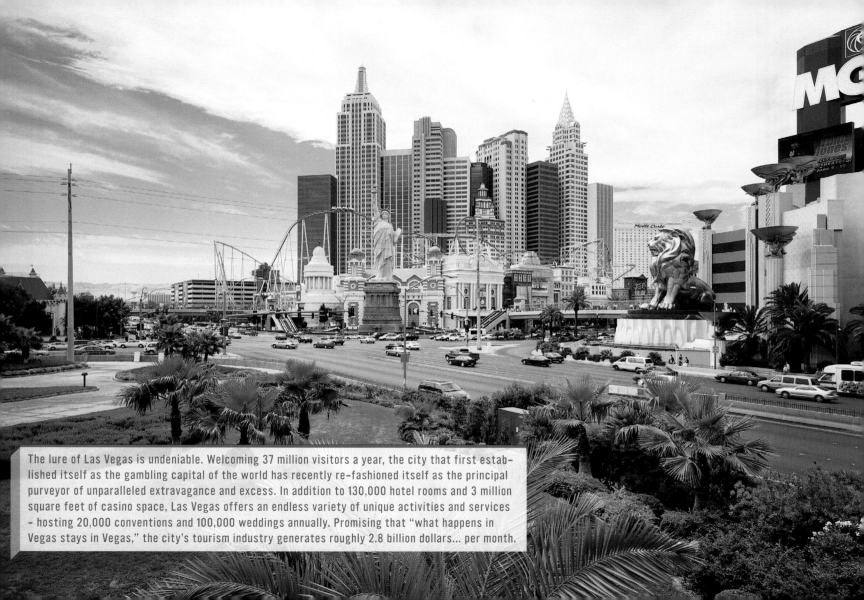

The lure of Las Vegas is undeniable. Welcoming 37 million visitors a year, the city that first established itself as the gambling capital of the world has recently re-fashioned itself as the principal purveyor of unparalleled extravagance and excess. In addition to 130,000 hotel rooms and 3 million square feet of casino space, Las Vegas offers an endless variety of unique activities and services – hosting 20,000 conventions and 100,000 weddings annually. Promising that "what happens in Vegas stays in Vegas," the city's tourism industry generates roughly 2.8 billion dollars... per month.

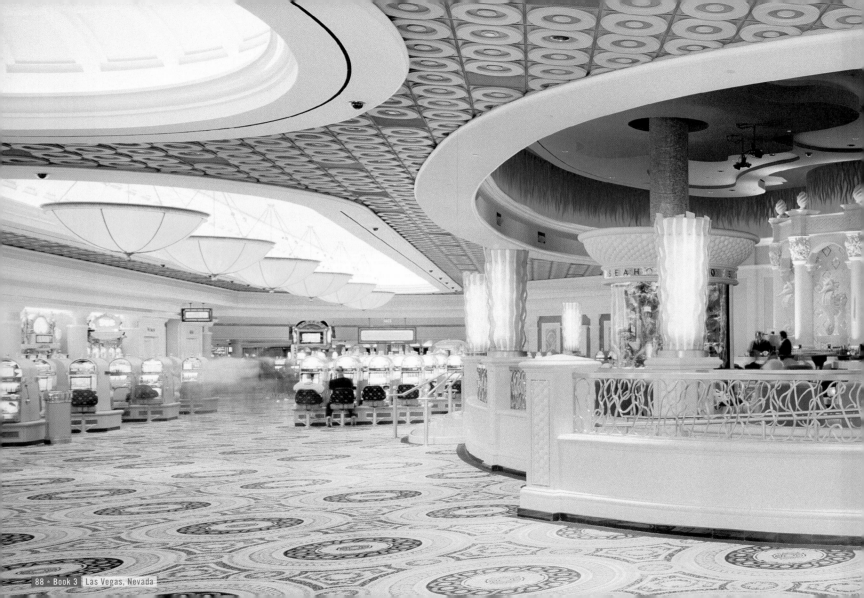

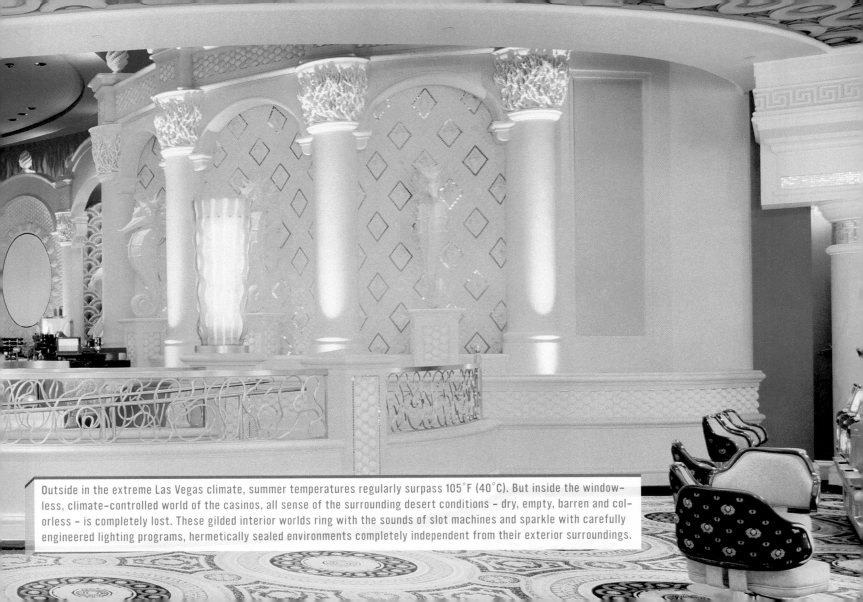

Outside in the extreme Las Vegas climate, summer temperatures regularly surpass 105°F (40°C). But inside the windowless, climate-controlled world of the casinos, all sense of the surrounding desert conditions - dry, empty, barren and colorless - is completely lost. These gilded interior worlds ring with the sounds of slot machines and sparkle with carefully engineered lighting programs, hermetically sealed environments completely independent from their exterior surroundings.

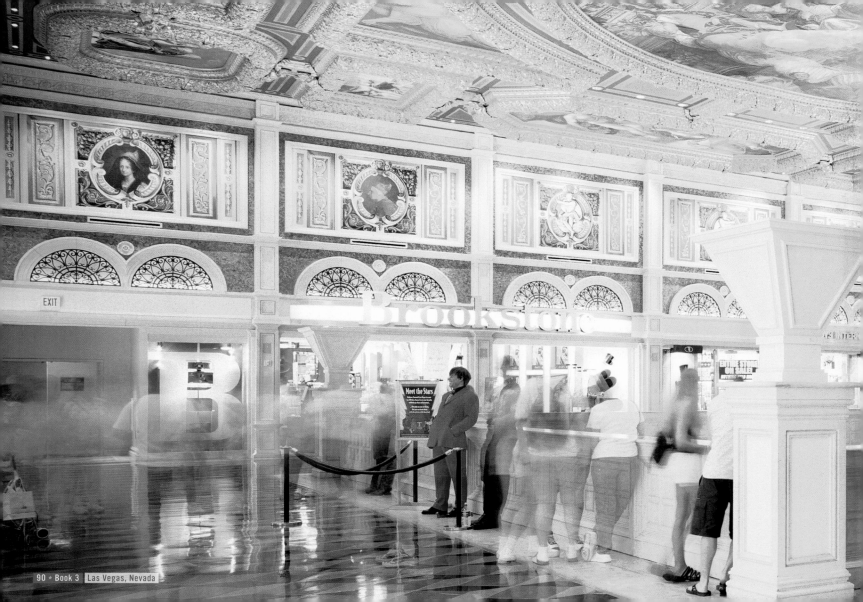

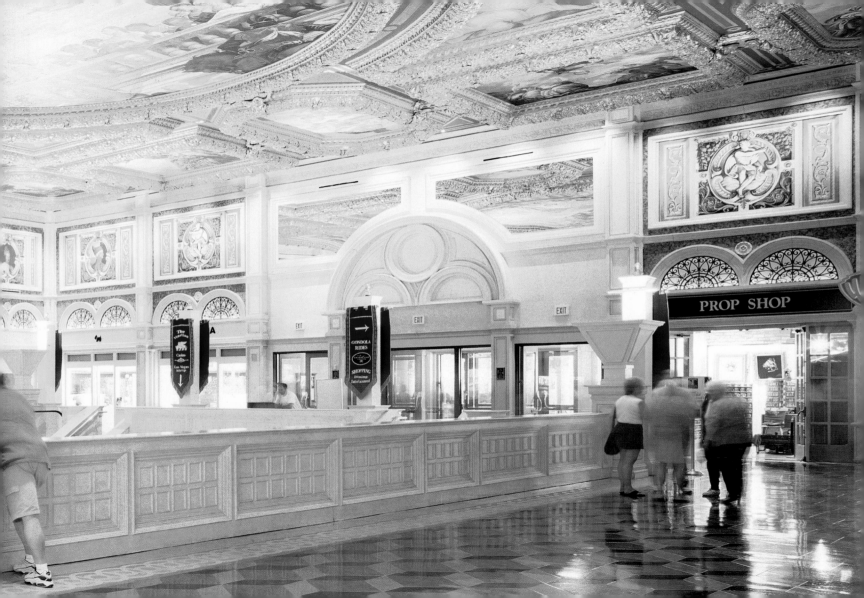

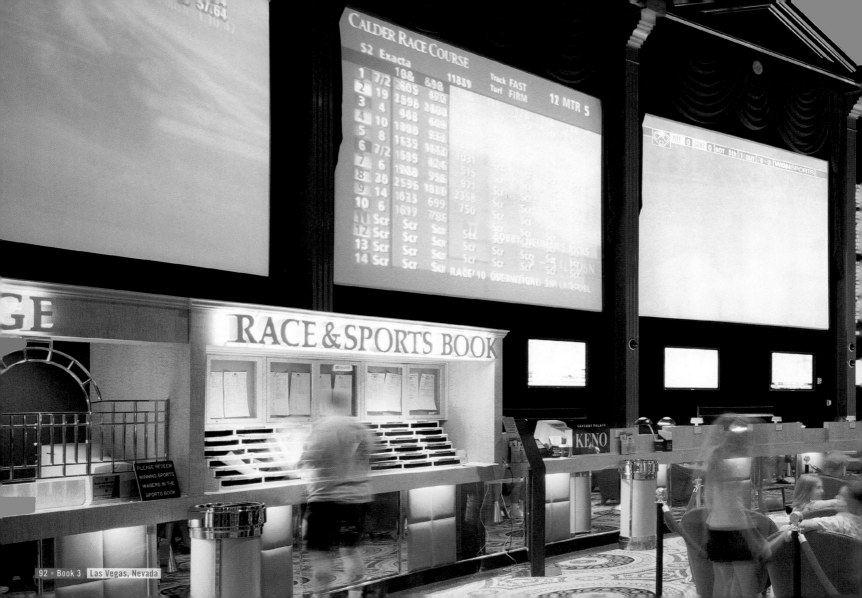

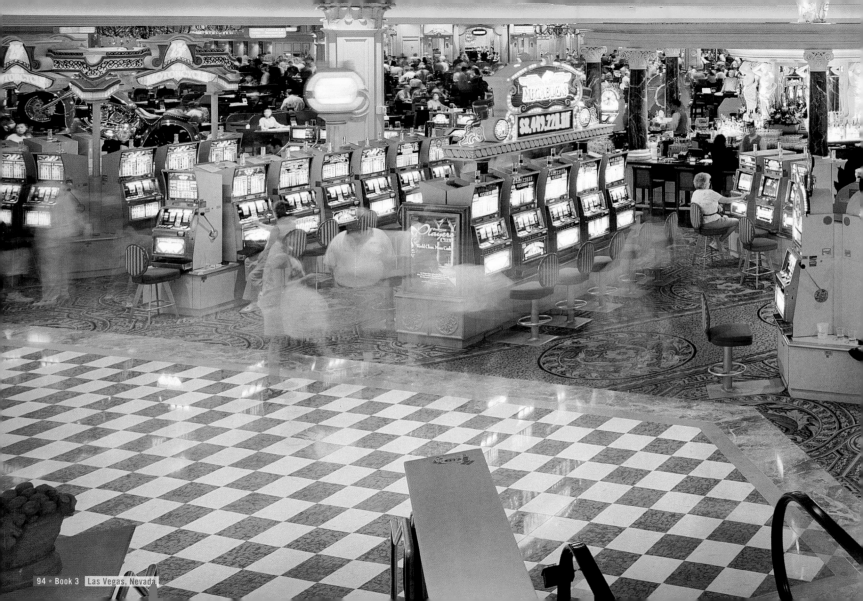

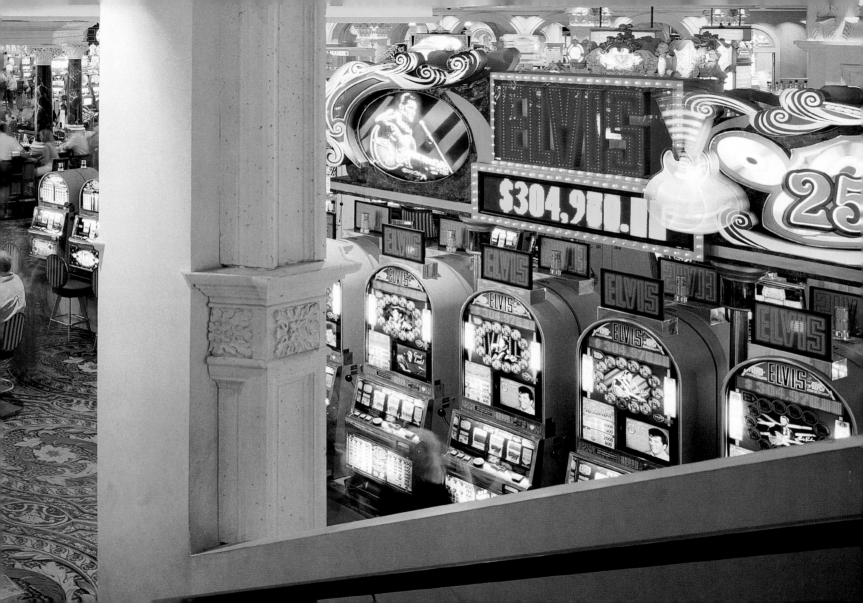

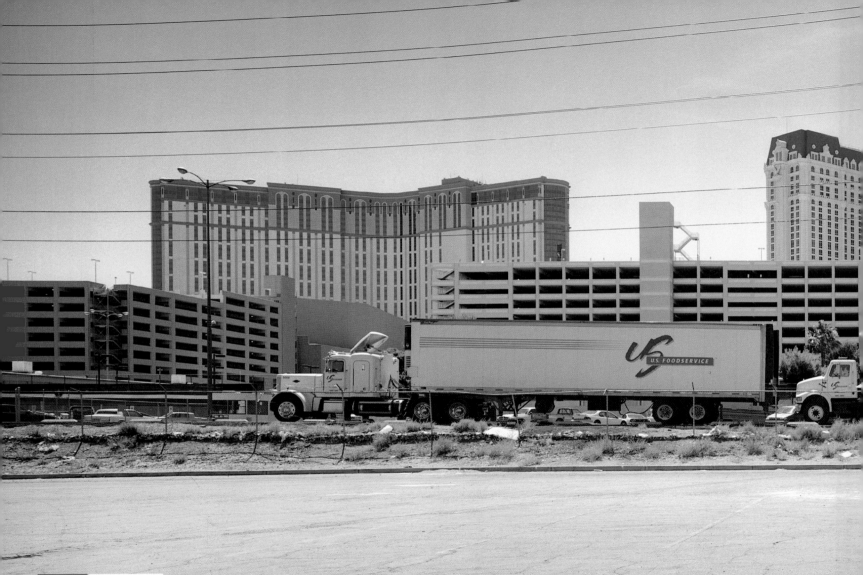

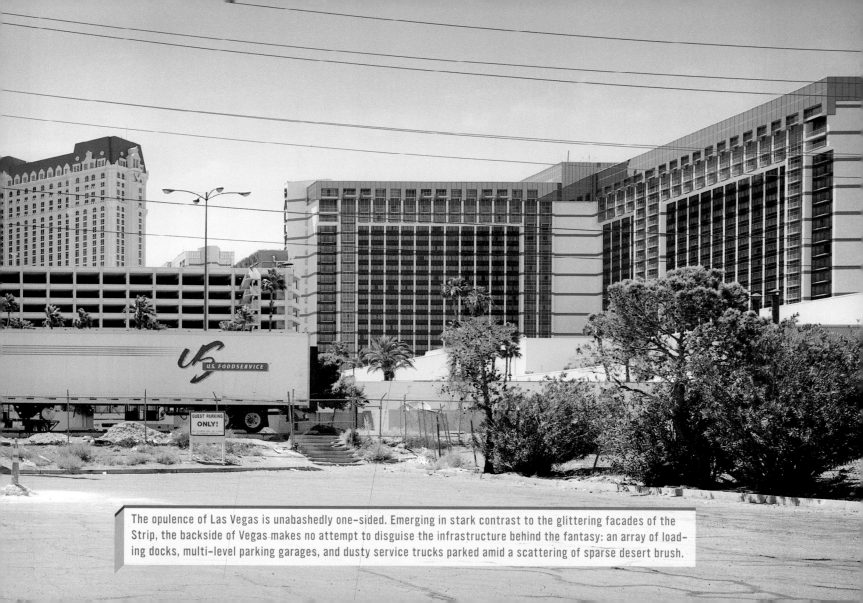

The opulence of Las Vegas is unabashedly one-sided. Emerging in stark contrast to the glittering facades of the Strip, the backside of Vegas makes no attempt to disguise the infrastructure behind the fantasy: an array of loading docks, multi-level parking garages, and dusty service trucks parked amid a scattering of sparse desert brush.

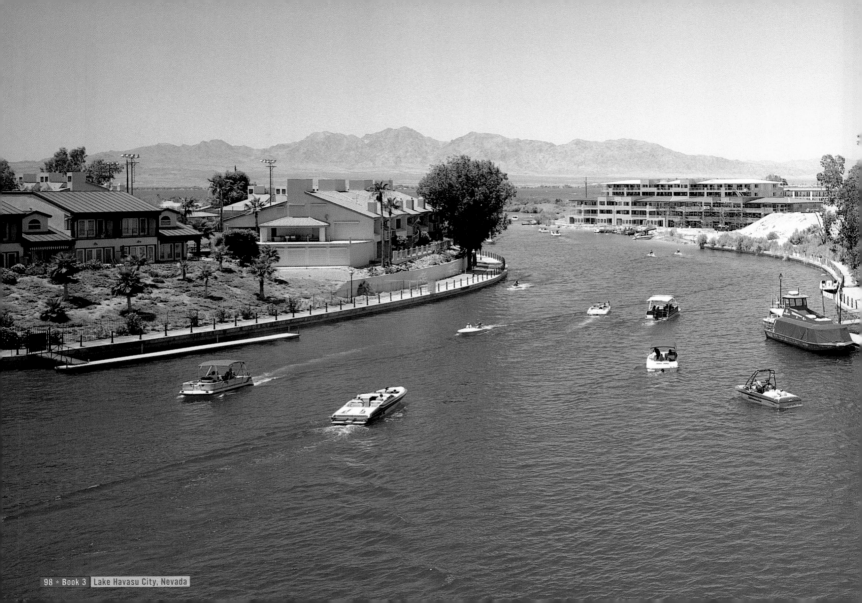

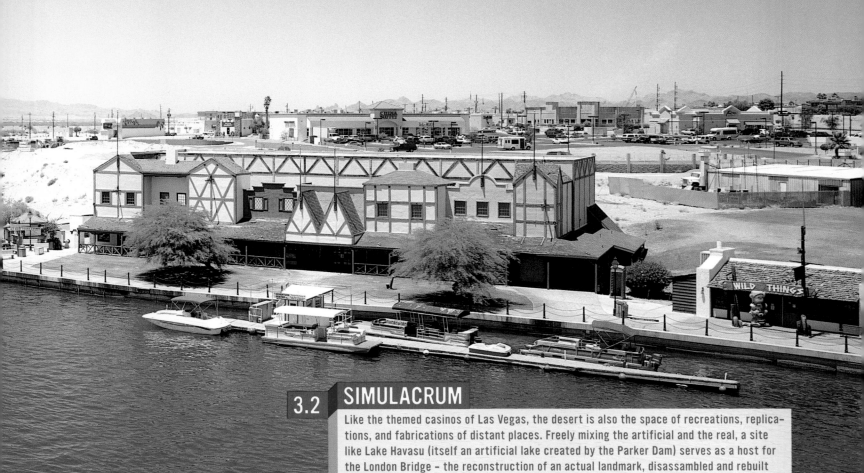

3.2 SIMULACRUM

Like the themed casinos of Las Vegas, the desert is also the space of recreations, replications, and fabrications of distant places. Freely mixing the artificial and the real, a site like Lake Havasu (itself an artificial lake created by the Parker Dam) serves as a host for the London Bridge - the reconstruction of an actual landmark, disassambled and rebuilt 5300 miles away in a (real) desert landscape (artificially) modified to receive it.

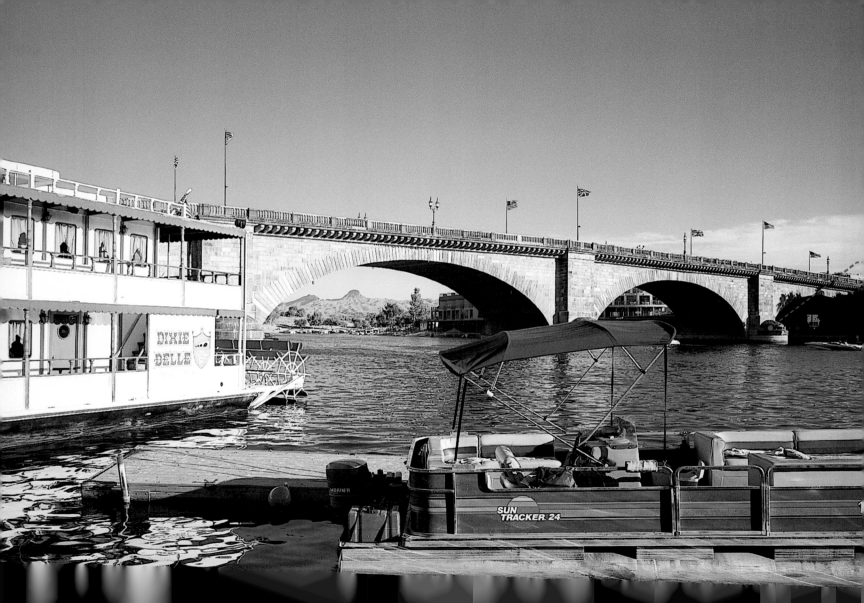

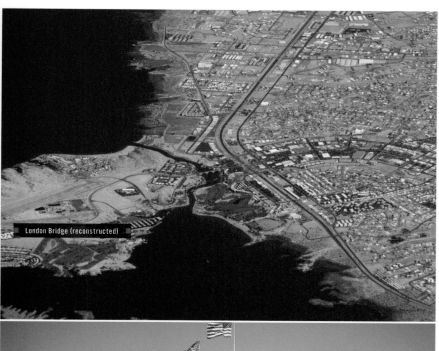

London Bridge (reconstructed)

THE BRIDGE

Robert McCulloch

Lake Havasu City sits on the western bank of the Arizona-California state line, set by the winding path of the Colorado River. In the 1930s, the creation of the Parker Dam formed a huge reservoir that became Lake Havasu ("blue water" in Navajo).

It is reported that Robert Paxton McCulloch (who made his fortune from the worldwide sales of his one-man, lightweight chainsaw) first became enamored with the Lake Havasu area during a test-site scouting trip for his outboard motors.

In 1963, McCulloch purchased 26 square miles of lakeside property and immediately began offering free flights (on the newly formed McCulloch International Airlines) to prospective home-owners interested in settling in the Lake Havasu area. To populate his newborn city, McCulloch paved McCulloch Boulevard, built a hotel and three chainsaw manufacturing plants, and dug a mile-long, 8-foot deep channel that severed Pittsburgh Point Peninsula from the mainland to create Lake Havasu "Island." The final and most spectacular piece in McCulloch's transformation of Lake Havasu City was the purchase of the London Bridge in 1968. The 130,000 ton bridge was dismantled, packed into crates, and shipped to California via the Panama Canal; from Long Beach, the crates were trucked to Lake Havasu and reassembled. Inaugurated in October of 1971, McCulloch paid $2.4 million for the bridge and then another $7 million for its relocation. Today, the Bridge is a tremendous tourist draw, attracting thousands of visitors a year. It has been credited with the city's steady growth as well as the establishment of hundreds of British-themed business (including a double-decker ice cream parlor), two regional newspapers, and a local community college. Meanwhile, Lake Havasu has become the Daytona Beach of the desert, a favored destination for spring break students and watersports enthusiasts - a place where boats frolic on the water while temperatures on land routinely reach 110°F.

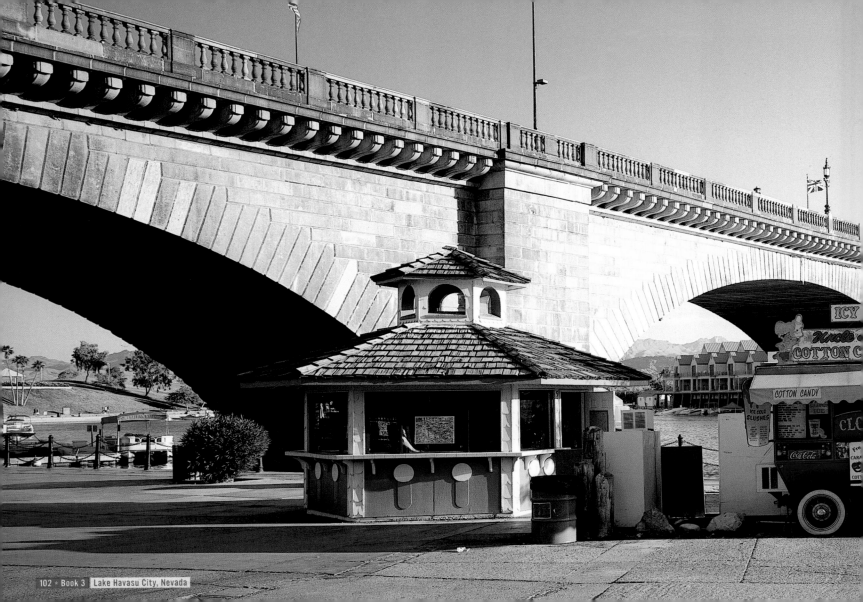

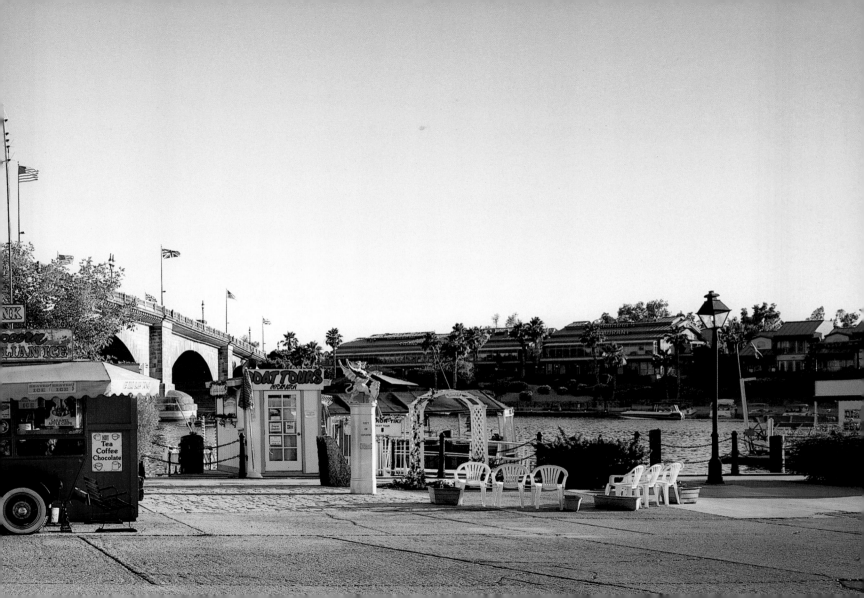

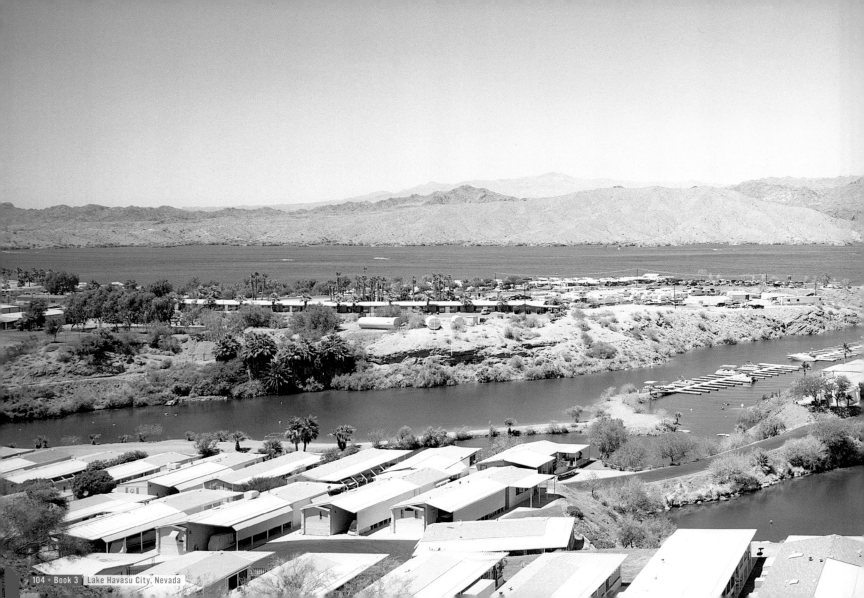

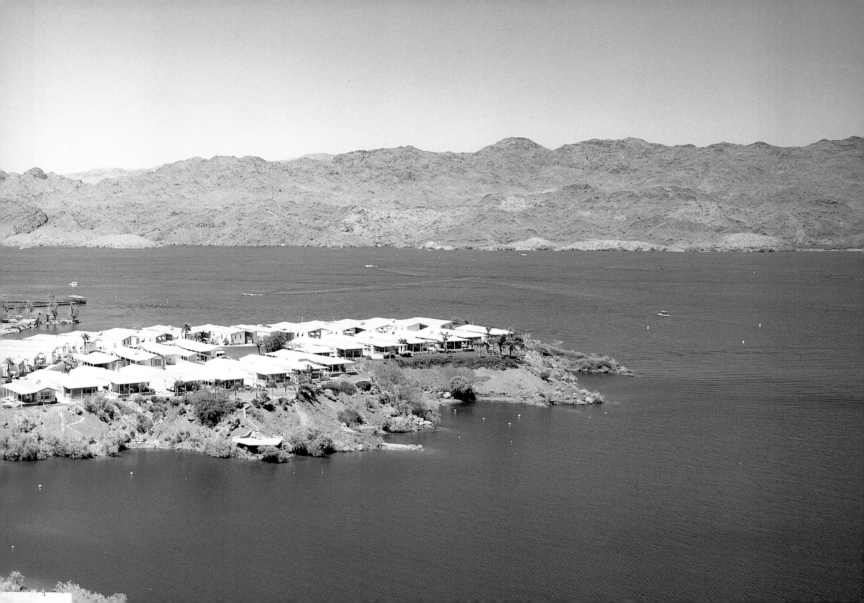

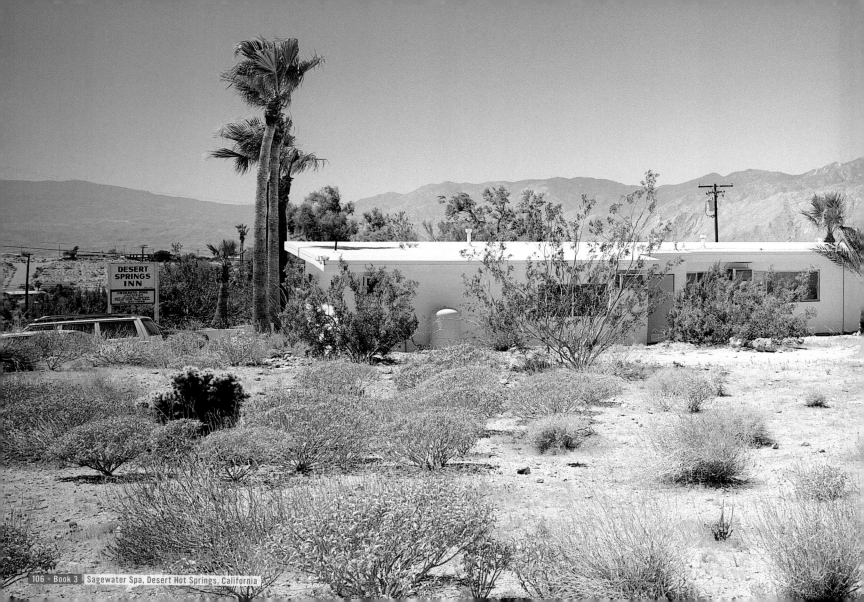

DESERT
SPRINGS
INN

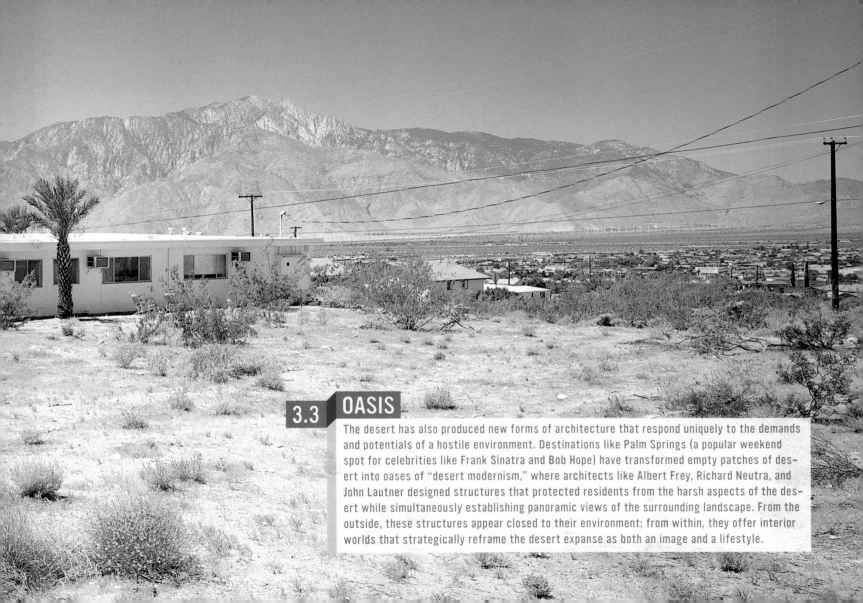

3.3 OASIS

The desert has also produced new forms of architecture that respond uniquely to the demands and potentials of a hostile environment. Destinations like Palm Springs (a popular weekend spot for celebrities like Frank Sinatra and Bob Hope) have transformed empty patches of desert into oases of "desert modernism," where architects like Albert Frey, Richard Neutra, and John Lautner designed structures that protected residents from the harsh aspects of the desert while simultaneously establishing panoramic views of the surrounding landscape. From the outside, these structures appear closed to their environment; from within, they offer interior worlds that strategically reframe the desert expanse as both an image and a lifestyle.

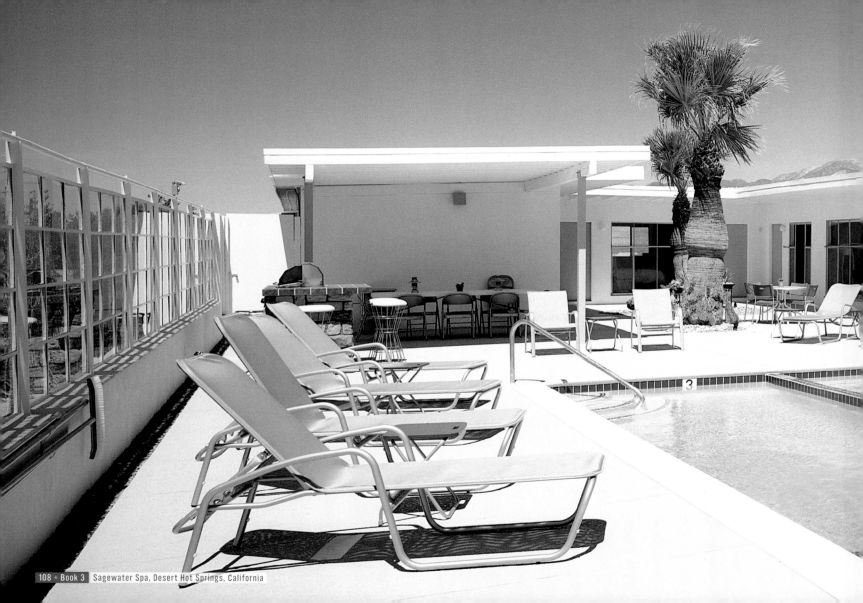

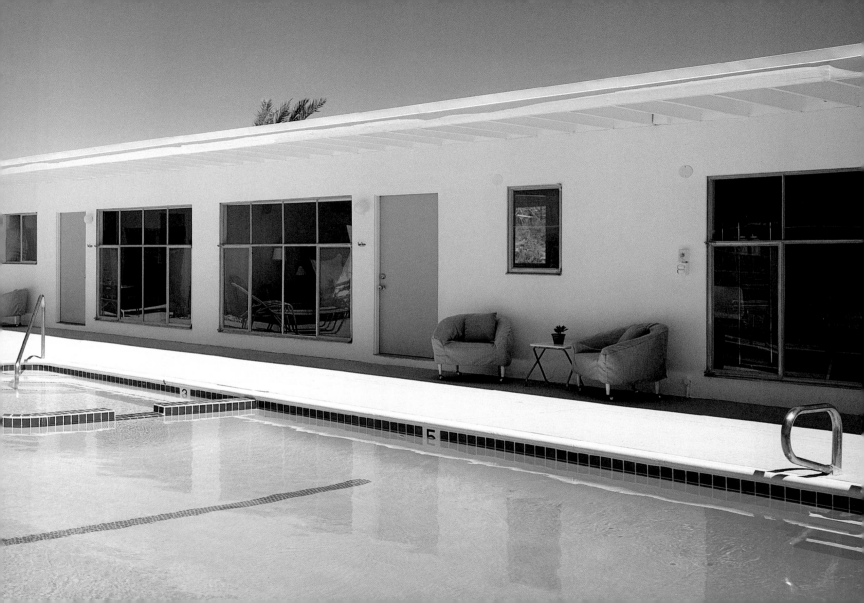

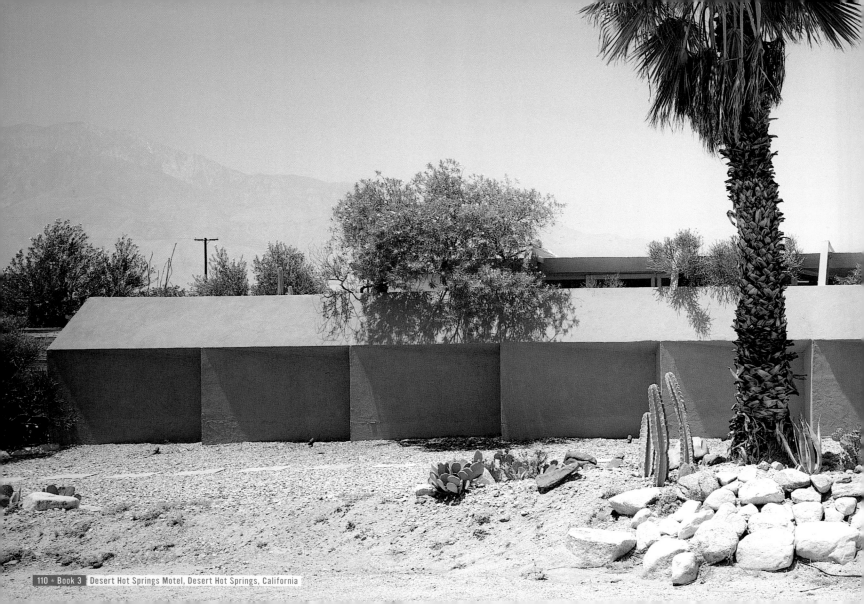

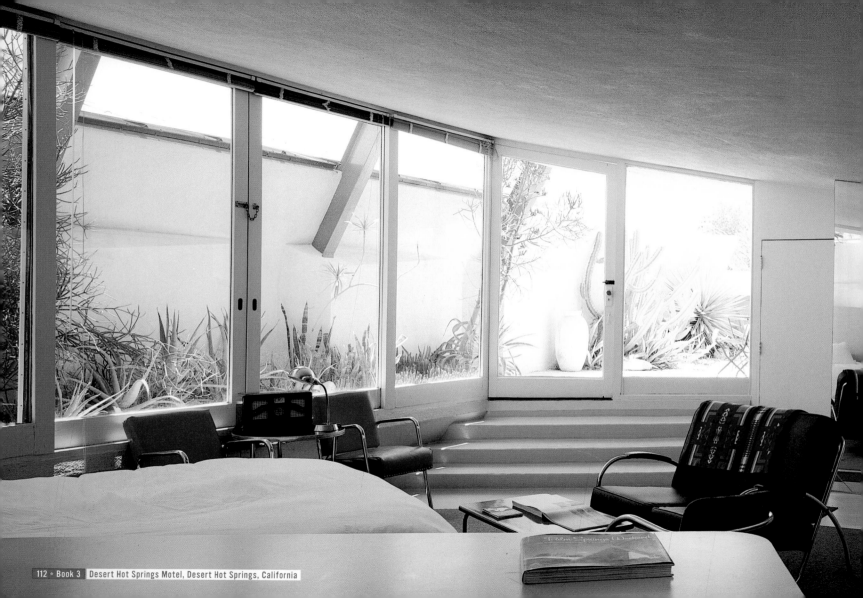

Built in 1947 for Hollywood producer and writer Lucien Hubbard, the Desert Hot Springs Motel is located just off of Highway 10, the route that separates the resort town of Palm Springs from its smaller cousin, Desert Hot Springs. Hubbard originally purchased the motel property in 1927 with plans to develop it as a private ranch to share with friends and colleagues; Later, architect John Lautner, a former student of Frank Lloyd Wright, completed a small motel of four suites and a set of swimming pools (demolished in the 1970's). The motel is constructed of steel and gunnite (a spray-on concrete) and each suite has its own raised, private cactus garden. Though the structure seems monolithic from the exterior (locals originally mistook the motel for a secret government project), the interior is defined by wide expanses of glass and light, the intense desert sun filtered and controlled by clerestories and glass walls opening outward to a private garden and patio. In a 1982 interview, Lautner explained his use of a heavy gunnite/steel structure as a response to an overnight stay in a "typical" Palm Springs motel, one that rattled incessantly from the strong desert winds.

3.4 IDEAL CITIES

If God created man in his image, the private communities of the desert represent man's earthly quest to create his own, personal version of paradise. The blank, undifferentiated desert floor has become a modern-day tabula rasa where every developer has the freedom to establish gated communities with perfectly tailored demographics, free from the messy complexities of denser, more urban environments. Not surprisingly, the idealized geometries of these developments frequently evoke the fortified ideal cities of the Renaissance – now protected not by thick walls, but by a (seemingly) benevolent ring of golf courses.

In the Sun City retirement community (a half hour drive from Phoenix), the second most preferred form of transportation is the golf cart and the average resident is 73 years old. Invented by Del Webb, a pivotal figure in the construction and development of huge swatches of commercial and residential properties throughout the American West, Sun City is not just a place, but a concept and a way of life. In the late 1950's the Del Webb Corporation purchased nearly 3600 hectares of the Sonoran Desert to build the "ideal retirement community," where deed restrictions require that all households have at least one resident over the age of 55. (This age-based zoning restriction limits the stay of all individuals under the age of 19 to 30 days a year – though exceptions may be made in the case of sudden death or other family crisis.)

Sun City and its sister city, Sun City West, take on the form of several residential neighborhoods that radiate from a series of central "recreational nuclei" which house the city's seven recreation centers. These residential circles are bounded in turn by a ring of golf courses. Both cities remain unincorporated and do not qualify for government services, which have been assumed by a volunteer force of groups (such as the "Sheriff Posse" and PRIDE) that have helped to establish community's reputation as a "City of Volunteers." (The slogan was coined in the early nineties to counter the perception that residents were snobs "who didn't like children.")

The popularity of Sun City is undeniable. Although the retirement community concept was not new in 1960, the scale of Sun City was unimaginable during that era. All homes were sold within twelve months of opening day on New Year's Day 1960. Since this initial offering, several subsequent Sun City franchises have been constructed in California, Nevada, Florida, South Carolina, and Illinois. Today, each of these Del Webb "active adult" communities have populations in excess of twenty thousand residents. Although the average age of the residents continues to rise (leading to revenue loss as fewer and fewer residents are able to participate in recreational activities), the community remains vehemently opposed to any revisions to the age ordinance, fearing changes in the established character of the Sun City retirement lifestyle.

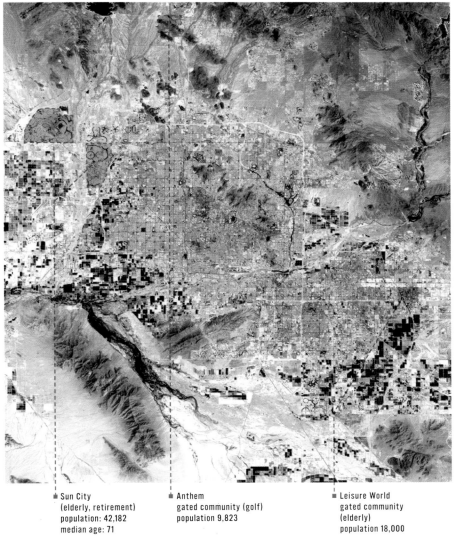

Sun City
(elderly, retirement)
population: 42,182
median age: 71

Anthem
gated community (golf)
population 9,823

Leisure World
gated community
(elderly)
population 18,000

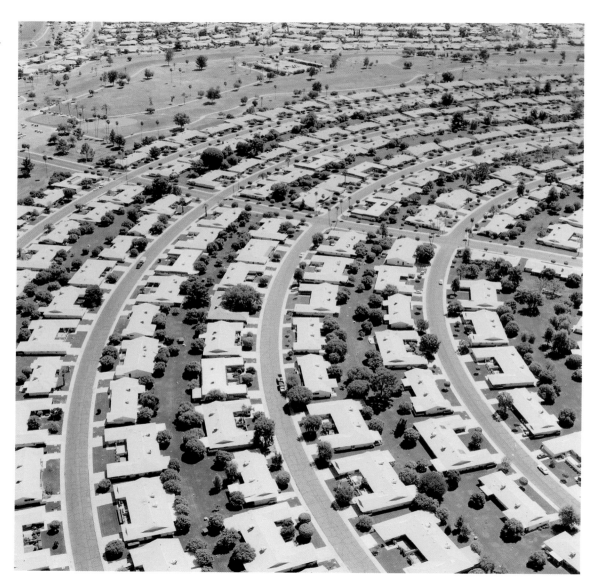

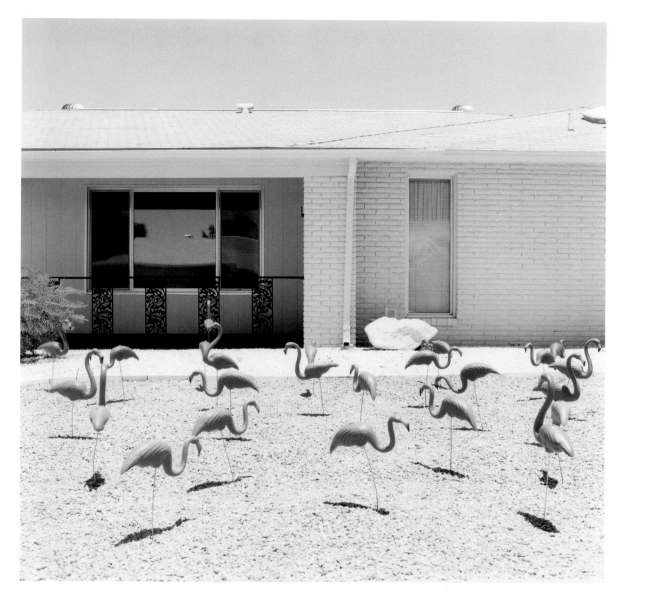

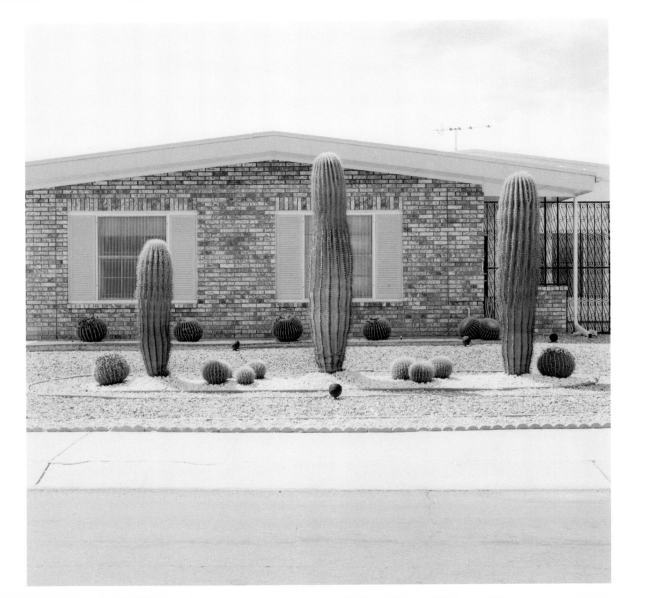

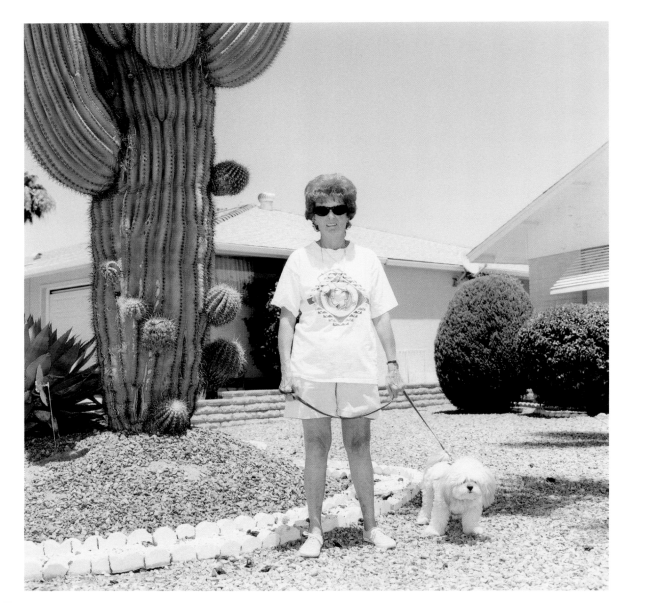

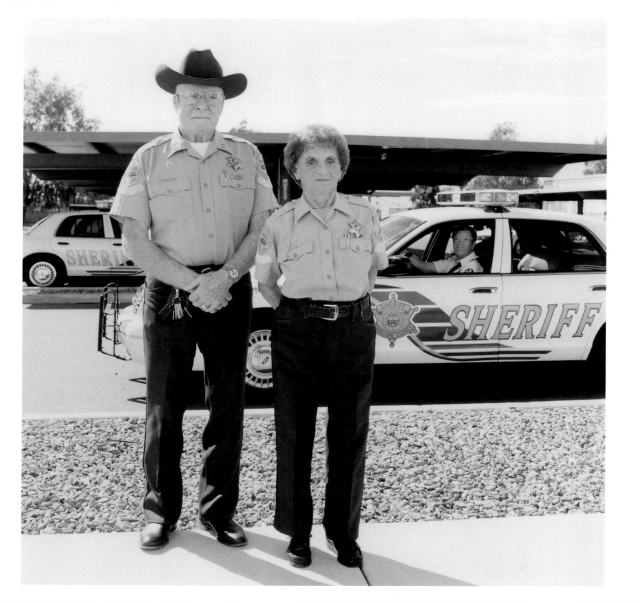

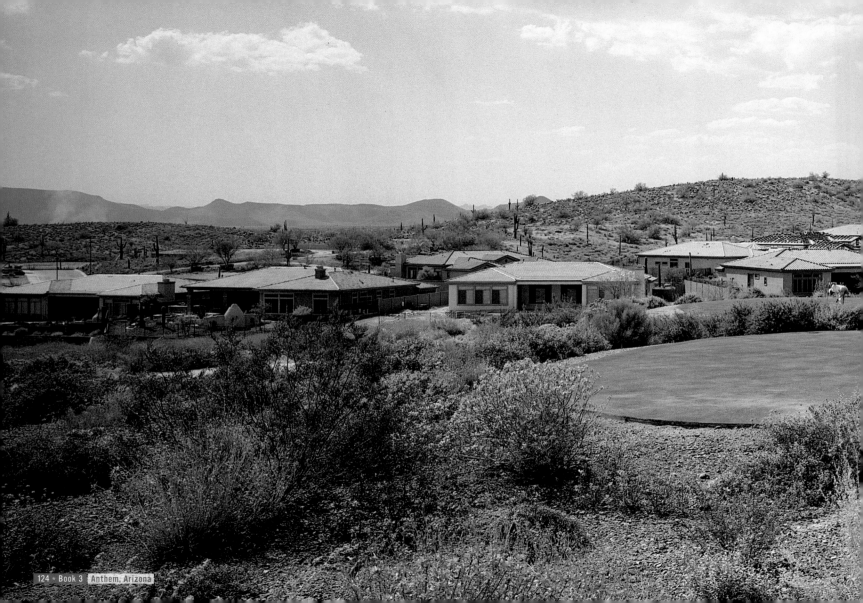

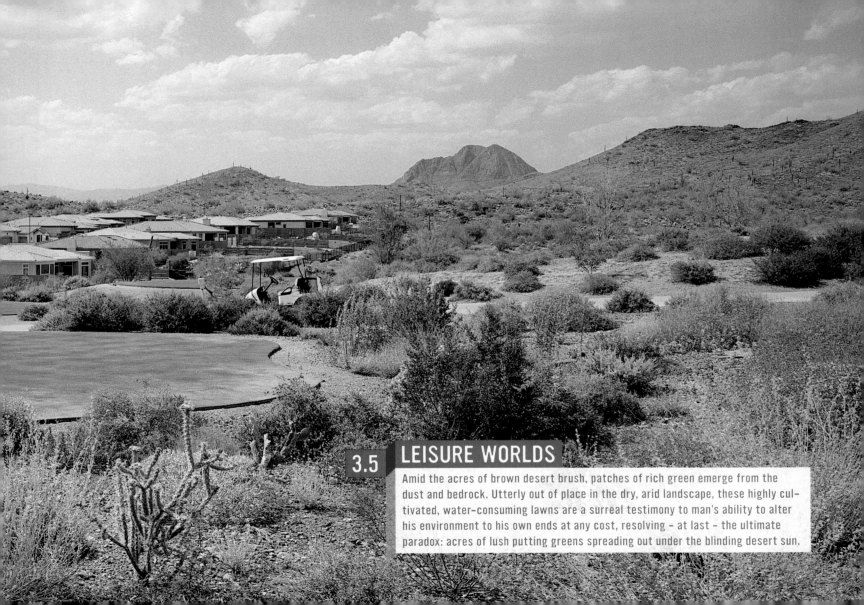

3.5 **LEISURE WORLDS**

Amid the acres of brown desert brush, patches of rich green emerge from the dust and bedrock. Utterly out of place in the dry, arid landscape, these highly cultivated, water-consuming lawns are a surreal testimony to man's ability to alter his environment to his own ends at any cost, resolving - at last - the ultimate paradox: acres of lush putting greens spreading out under the blinding desert sun.

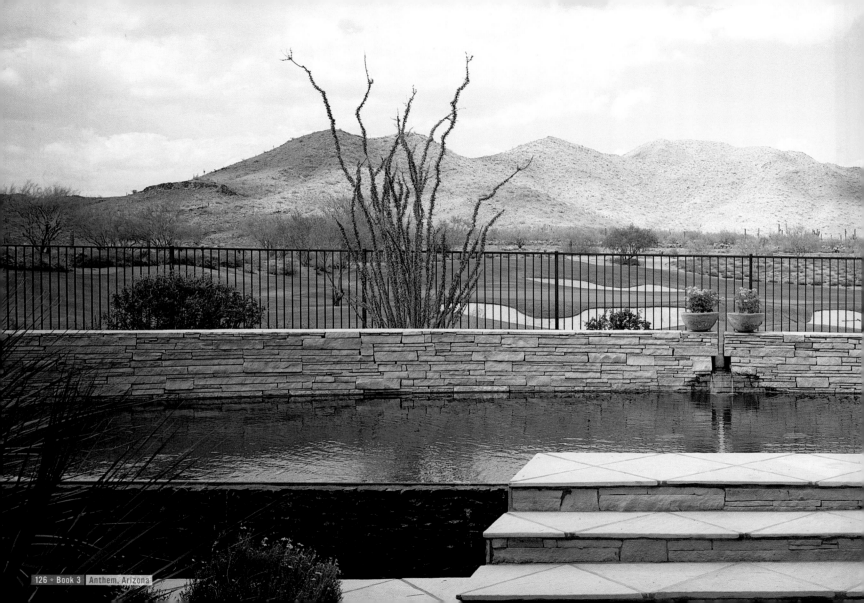

Also developed by the Del Webb Company, the Anthem group of residential communities consists of Anthem Country Club (high-end, gated), Anthem Sun City (retirement), and Anthem Parkside (family housing). Offering more than housing, these communities provide residents with "master planned lifestyles." Like its older sibling, golf courses are an essential element in the nationwide marketing campaign of the contemporary Sun City brand. (The Anthem visitor center features a huge golf ball and tee sculpture.) The lure of this "fairway lifestyle" cannot be underestimated. According to one developer: "We put in all this turf to sell houses," even though the majority of residents may not even set foot on the course. In this section of Nevada, there are more than 60 lush, green golf courses, constituting more than 2500 hectares of turf that need constant watering to maintain their shimmer. The lack of rainfall has not stopped golf communities from developing what local newspapers call the "most impressive collection of waterfalls and water features" in the country. In Anthem, like much of the southwest, the majority of all fresh water is piped in from Lake Mead in Nevada. Recently the reservoir has suffered through tremendous drought conditions in which water levels have dropped to 50% of their full capacity. The majority of local golf courses are allotted 1 million gallons of water a month, and during the drought many exceeded this ration regularly, incurring repeated fines and penalties for their violations. (In Summerlin, a rich golf suburb, dozens of acres of its "grass guzzling" turf were removed to avoid water fines.)

Golf courses generate enormous revenue for property development companies, and not even primarily through greens fees, though these may run up to 250 dollars per round on many popular courses. Despite (or perhaps because of) its extravagance, in the past decade this "desert golf" model has been exported to Dubai, Turkey, Egypt, and Spain.

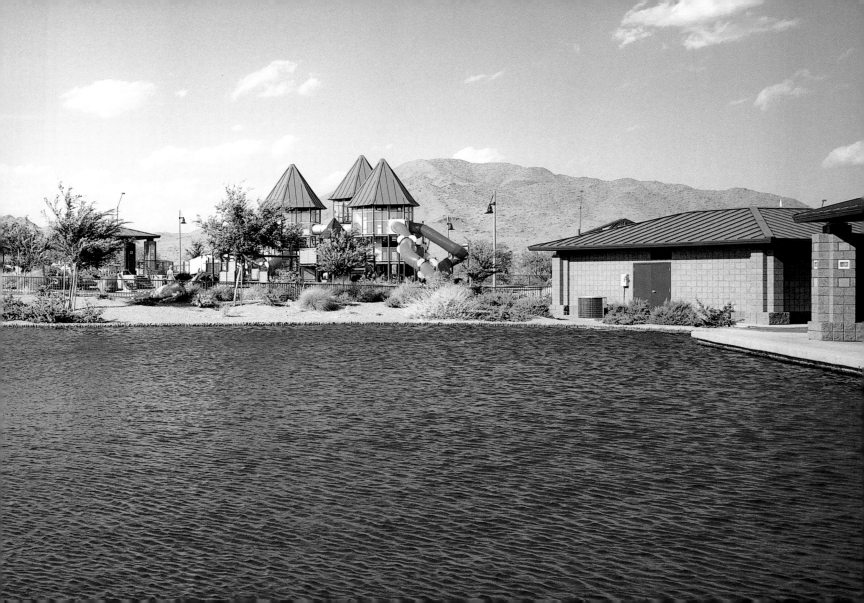

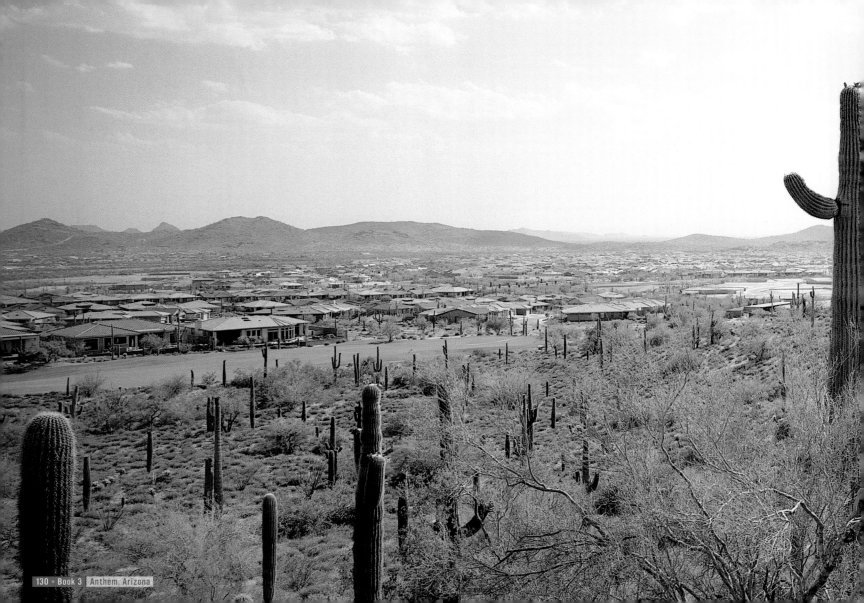

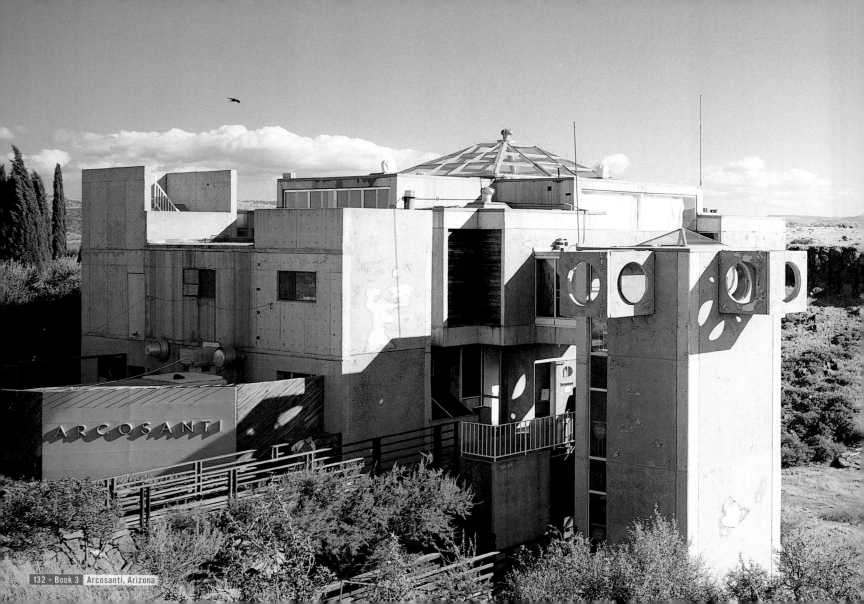

ARCOSANTI

http://test.arcosanti.org/

--

In 1970, the Cosanti Foundation began build-
ing Arcosanti, an experimental town in the high
desert of Arizona, 70 miles north of metropolitan
Phoenix. When complete, Arcosanti will house
5000 people, demonstrating ways to improve
urban conditions and lessen our destructive
impact on the earth. Its large, compact struc-
tures and large-scale solar greenhouses will
occupy only 25 acres of a 4060 acre land pre-
serve, keeping the natural countryside in close
proximity to urban dwellers.

Arcosanti is designed according to the concept
of arcology (architecture + ecology), developed
by Italian architect Paolo Soleri. In an arcology,
the built and the living interact as organs would
in a highly evolved being. This means many sys-
tems work together, with efficient circulation
of people and resources, multi-use buildings, and
solar orientation for lighting, heating and cooling.
In this complex, creative environment, apart-
ments, businesses, production, technology, open
space, studios, and educational and cultural
events are all accessible, while privacy is para-
mount in the overall design. Greenhouses provide
gardening space for public and private use,
and act as solar collectors for winter heat.

At the present stage of construction, Arcosanti
consists of various mixed-use buildings and
public spaces constructed by 5000 past Work-
shop participants.

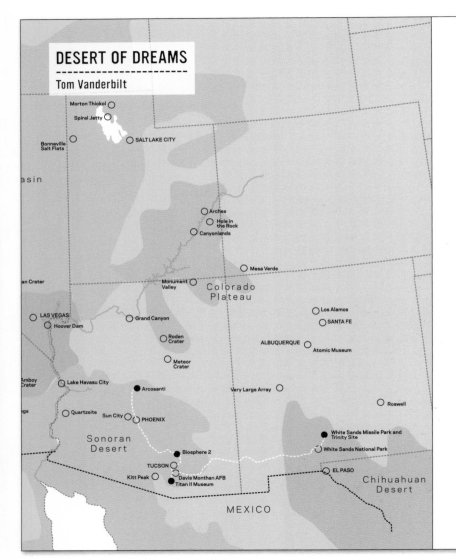

DESERT OF DREAMS

Tom Vanderbilt

Morton Thiokol
Spiral Jetty
Bonneville Salt Flats
SALT LAKE CITY
asin
Arches
Hole in the Rock
Canyonlands
an Crater
Mesa Verde
Monument Valley
Colorado Plateau
LAS VEGAS
Hoover Dam
Grand Canyon
Los Alamos
SANTA FE
Roden Crater
ALBUQUERQUE
Atomic Museum
Meteor Crater
Amboy Crater
Lake Havasu City
Very Large Array
Arcosanti
Roswell
gs
Quartzsite
Sun City
PHOENIX
Sonoran Desert
Biosphere 2
White Sands Missile Park and Trinity Site
White Sands National Park
TUCSON
Kitt Peak
Davis Monthan AFB
Titan II Museum
EL PASO
Chihuahuan Desert
MEXICO

The American desert, land of lost civilizations, wayward prophets, and air-conditioned fantasy, has long been the country's last New Frontier, where dreams might be played out with a minimum of interference—if only, as in the scene in Joan Didion's *Play It as It Lays*, we can keep sweeping the drifting sand back to the perimeter of the yard. It is a vast tabula rasa, where one's mark can be seen for miles—whether it be the earthworks of endowed artists, the ancient trails of primeval visitors, or the pockmarked craters of an aerial bombing range.

In this regard, the desert was the perfect home for the Cold War, not simply for its sheer size and emptiness, but because the desert, in America, has come to signify the future. The Cold War was at heart a conflict projected toward the future: the race to see who would first reach space, whose Air Force would first reach 10,000 bombers, who would explode the first 25 megaton warhead.

Despite its overwhelming aura of fatalism and apocalypse, it also concealed a perverse undercurrent of optimism, a belief that the science and technology that was being funded by the so-called "imaginary war" would someday mean a better life for all—if it did not kill us first. It is no surprise that the place where people most often go to reinvent themselves in a country of reinvention is the desert city of Las Vegas. It is, after all, a city that has witnessed many futures—the Mormons, the Mafia, the Manhattan Project—and would not exist at the scale it does without the massive technological life-support systems upon which it

rests its confidence in unimpeded future growth. The city exists as a collective delusion that it is not a desert, and such an illusory environment is fertile ground for those seeking to nurture their own illusions.

The desert has attracted all manner of dreamers, from millenarian cultists to visionary artists to the advanced weapons scientists of the United States Air Force. They have all made their mark, tested something or another on America's proving ground. Like bleached bones or bullet-ridden "No Trespassing" signs, these dreams lie in the desert sand, faded and chipped but intact, legible. Several months ago, I traveled to the deserts of Arizona and New Mexico in search of these relics of the future.

There have been few dreams as outsized as those of Paolo Soleri, the enigmatic Italian-born architect and onetime disciple of Frank Lloyd Wright. Lured to the desert in the 1940s to toil at Wright's Taliesin West, Soleri soon estranged himself from the master and began developing plans for model cities based on a theory called "Arcology" (a somewhat fluid and elusive notion, like the concepts of fellow traveler Marshall McLuhan). Soleri's plans for towering cities that would house millions of people, sketched out madly on endlessly spiraling sheets of butcher's paper, became a *cause célèbre* in the art and planning worlds. There was little Soleri was not willing to imagine, as captured in this New York Times description of his 1969 Corcoran show: "Lucite models of polyhedral cybernetic cities scaled higher than two Empire State Buildings; intricate representations of structures resembling jet engines, only 2,000 times their size, and accommodating as many people as San Francisco; plaster casts of graceful, sculptured bridge spans; plans for floating cities, space cities, cities within bridges, megastructures so huge that their inhabitants would be able to build houses within their frameworks."

In retrospect, the year 1970 hardly seems a propitious one for building a hyper-urbanized megalopolis. America's cities were seething with crime and social unrest, suburban outmigration was in full blossom, and LBJ's "Model Cities" program—which rebuilt blighted urban areas—had been abolished by Nixon the year before, its resources channeled into the Vietnam War. Undaunted, Soleri broke ground on Arcosanti on a basaltic mesa overlooking the Agua Fria river, some 60 miles from Phoenix. The Times described it as "less an apartment building than a 2,500-inhabitant megastructure with a volume roughly equivalent to that of St. Peter's in Rome...an alien body on the land, it will be an almost self-contained space colony, and its chief purpose will be to test whether man can build environments that have only a minimal effect on the ecology of his planet." Newsweek, commenting in 1976 that "a magnificent, inspiring and domed city is rising out of the Arizona desert," concluded that "as urban architecture, Arcosanti is probably the most important experiment undertaken in our lifetime."

Today, Arcosanti houses roughly 100 inhabitants, and only an estimated 4 percent of the original plan has been built. In a cruel irony, the city will likely be lost in the malarial

spread of urban sprawl from nearby Phoenix before it is finished. Another epitaph for Soleri's dream appears as I exit I-17 and vhead toward Arcosanti, past a cluster of gas stations. As the road turns to gravel, I see a sign for "Arcosanti: An Experimental Community." To the right, however, I see another form of experimental living: a group of "manufactured housing" units for sale. The trailer is the desert's most ubiquitous living form, its prefab mobility attractive to those likely to pull up stakes when fortune or water runs dry; the trailer succeeds where only a madman would install a permanent house. Where Soleri's utopia envisions communal living in densely clustered, rationally planned superstructures, the trailer, for all its lack of architectural merit, more faithfully evokes the sense of margin-dwelling and mobility by which Americans have sought their fortune in the desert. Arcosanti surges into view only after you drive down a rutted and twisting road (a car company once offered to pave it in exchange for sponsorship; the offer was turned down), and suddenly the view is filled with a kaleidoscope of soaring blocks of poured concrete, earth-colored apses, circular windows, and metal sculptures—as well as looming cranes and other detritus of construction. The scene startles for its sheer visual novelty, but then one's mind begins to play back all the old images of dream architecture and future civilizations. Suddenly, Arcosanti, with its vaults and creeping vegetation and amphitheater-like steps descending in a semicircle around one apse, seems almost a ruin, like something derived from the iconography of science fiction, specifically that variant of science fiction concerned with dystopic visions of the future. A dream civilization arising out of the imagined ashes of a nuclear catastrophe, Arcosanti could be the city in Planet of the Apes, or the refuge on the hill in The Omega Man, or the self-contained dome-world of Logan's Run.

For decades, Soleri's workforce has been idealistic youth, an impression reinforced on this visit. From one apse comes the honk of an avant-garde saxophone. "They're practicing for Burning Man," a guide tells me. Burning Man, that Archigram-like "Instant City" on the desert at Black Rock, is actually a useful referent for evaluating Soleri's utopia. Arcosanti has a very small full-time population; the bulk of its residents carry out short-term internships. With its perpetually recharging constituency of like-minded people, living and working under the eye of the benevolent dictator, it works quite well. Like Burning Man, though, it is a temporary fantasyland, a respite from the mainstream environment; one wonders what would happen if Arcosanti were ever to incorporate a large and varied population or any of the other elements of a real city.

With its ecologically minded architecture and anticonsumerist rhetoric (even if it survives by selling its iconic bells and ceramics), Arcosanti hardly resembles a Cold War landscape, but Soleri's grandiose visions, with their redemptive faith in technology, can't be considered in isolation from the time in which they were spawned. As George Collins writes in his book Visionary Drawings of Planning and Architecture, "Following World War II, the visionary revived, ostensibly simulated by reconstruction programs and the desire to invent

structures that would keep people safe from atomic attack, leading in the latter instance to radical decentralization plans and even underground living schemes."

From Kiyonori Kikutake's underwater Marine City to Hans Hollein's Airplane Carrier City—which proposed mounting the U.S.S. Enterprise on a hillside and turning it into a series of residences—the Cold War's twin axes of technological hope and doom prompted visionary architects to respond with plans for cities that would use technology to survive on a planet—"Spaceship Earth," as the suggestive phrase went—that was itself no longer habitable.

Ironically, many of the schemes were influenced by the Cold War's architecture itself (e.g., Archigram cited NASA's Cape Canaveral as an influence, while Buckminster Fuller's domes and hyperboloid housing towers resembled radomes and nuclear reactors, respectively). Like Fuller, Soleri was a technological optimist, with early plans calling for "Cosmodomes" that featured self-contained environments and artificial suns; his theories bristled with unintended Cold War phraseology like "complex systems" or "miniaturization," as in cities that would miniaturize their inhabitants. Arcosanti was a survivalist project, a shelter from a society that would kill itself in one great bomb flash or in the slow strangle of resource-consuming sprawl.

Where most visionary architects' projects existed only in theory ("The Radiant City is on paper," Le Corbusier had written. "When a technical work is drawn up [in] figures and proofs, it exists."), Soleri had found his drawing board in the desert. The metaphorical spaceship that Soleri proposed took literal form in Biosphere 2, which lies some three hours away, north of Tucson. What began as a fringe idea (i.e., Martian colonization) in the cultist confines of Synergia Ranch, a 1960s commune in New Mexico, was famously transformed with an infusion of oil scion Ed Bass' money into the extraterrestrial habitation simulation complex that was a media spectacle in the 1980s before the project collapsed due to problems ranging from the well-being of the bionauts to the integrity of the scientific research being conducted. Now billed as a "wellness center" and still sporting its Bucky Fuller geodesic dome, the Santa Fe-based Synergia Ranch survives, albeit under a different guise. That some of its more outlandish original ideas should have been blown up to Biospherian proportions is a metaphor in itself for the kinds of research that found funding during the Cold War.

Appropriately, the Biosphere resembles some kind of alien landing craft, a massively hulled vessel of glass and concrete surrounded by an array of attendant domes and service buildings. The site is now managed by Columbia University, which employs it to quietly conduct research on global warming and other respectable topics. With a handful of other visitors, I register for an "Under the Glass" tour, which means that we don hard hats and pass through the airlock to view the former living and working quarters of the biospherians. While scientists still scuttle around the various passageways, it is clear, standing in one of the now-deflated dome-covered "lungs" that once served as the internal air source, that the originally

envisioned Biosphere is dead, reincarnated as a rather extravagant greenhouse. The interior is no longer self-sufficient, and the decontamination procedures that occur at the airlock are intended to prevent bringing germs outside—not the other way around. As we sit on a concrete ledge watching the water of the "Ocean Biome" lap against the manufactured shore, the air warm and dank, we see hundreds of ants working their way along the concrete floors and walls. The proverbial cockroaches after a nuclear war, the ants are a symbol of the problems that plagued Biosphere: no one seems to know how they arrived, but once they began to proliferate no one knew exactly how to get rid of them, or the consequences to the ecosystem if they did.

The Biosphere was designed by architect Philip Hawes, who, like Soleri, had made a pilgrimage to Taliesin West. Hawes cited Egyptian and Mayan influences and, like Soleri, was concerned with creating environmentally sensitive architecture. But in its lavish funding, scientific trappings, and belief that humans could replicate their environment through technology, the Biosphere cannot be detached from Cold War thought. The airlocks and decontamination chambers, as well as the self-contained air and energy systems, are of a piece with the headquarters of the North American Aerospace Defense Command, that city within a mountain in Colorado Springs whose 10-ton blast doors and blast intake valves will, upon a nuclear explosion, "button up," ensuring its residents' safety for at least 30 days. The notion of extraterrestrial colonization that Biosphere posits was given its first

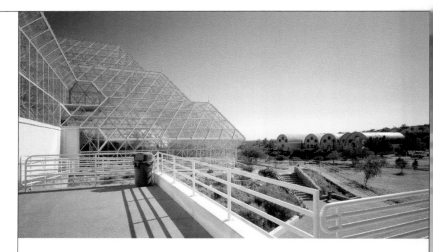

major impetus by the military, with early Air Force studies noting that a "lunar base possesses strategic value . . . by providing a site where future military deterrent forces could be located."

I find deterrent forces of a more earthbound variety an hour south of Tucson, at the former Air Force launch complex 571-7, once operated by the Strategic Air Command. It is the only place in the country where a tourist can view a fully preserved ICBM silo, once the home of a 33,000-pound Titan II missile (the largest the U.S. ever built) with a range of 9000 miles and able to carry a nine-megaton warhead. With its coterie of polite elderly women volunteers, the site might easily be mistaken for a provincial historical society museum

(Dr. Strangelove slept here!), were it not entirely underground. It is the last tour of the day, and one lone man and I accompany our guide, a lanky, long-haired "missile nut" (his phrase), down a hatch. A nearby sign warns of rattlesnakes.

With its echoing metal tunnels, banks of gray metal computers, closetfulls of white rocket-fuel-handler suits, and submarine-like vault doors, the Titan site is a steely mausoleum of America's nuclear past, as well as a fantastic vision of an alternate future in which not only defense installations are located underground, but factories and housing as well. The thermonuclear strategist Herman Kahn proposed a kind of evacuation nation, a permanent civil defense footing in which it was "perfectly conceivable . . . that the U.S. might have to evacuate two or three times every decade."

Yet, in spite of its ominous atmosphere and connotation, the Titan is arguably inseparable from the technological optimism that characterizes utopian projects like Arcosanti. If Soleri's New Age space city in the desert is inspired in part by the ideal city schemes of Le Corbusier, so too is the Titan an expression of Le Corbusier's modernism, the factories and power stations he so respected. The Titan's subterranean Launch Control Centers are domes, a form favored by Buckminster Fuller that saw use both in Fuller's ultramodern "Dymaxion" housing and in blast shelters by the U.S. Army Corps of Engineers, who learned at places like the Aberdeen Proving Grounds that the dome was the form most structurally resistant to blast effects. There is nothing superfluous to the Titan site: the "hard space" only covers those functions essential to launching the missile (the site itself exists simply to launch the missile once); everything outside the 6000-pound blast doors one reaches via a series of catwalks and staircases is "soft space." If forts were once constructed to house armaments, there is no distinguishing, here, between the weapon and the system constructed to house it: the architecture is the gun, the missile the bullet.

Sitting in one of the jet-fighter chairs once reserved for the flight-suited Launch Control Officers, listening to the klaxon sound, watching the warning lights flash, and staring ahead, into the imaginary airspace charted on the radar screens, the future as once imagined looks terrifying to me, its grandiose geopolitical rhetoric lost in the cold array of the flickering console, the rotary-dial phones, and the safe that once contained the Emergency War Orders. If Arcosanti and Biosphere 2 represent different forms of folly, varying visions of a better world, the Titan may be the maddest scheme of them all: a series of Underground Cities that actually got built, in places where no one was likely to pay much attention.

To find the single largest collection of relics of futures past, I drove east, to the White Sands Missile Range, an arid territory in New Mexico's Tularosa Basin so large it could swallow up Delaware and Rhode Island. For more than half a century, the secret landscapes of White Sands have witnessed the testing of prototype weaponry, ranging from the V-2 rocket to the atomic bomb to the Boeing 747-mounted airborne laser.

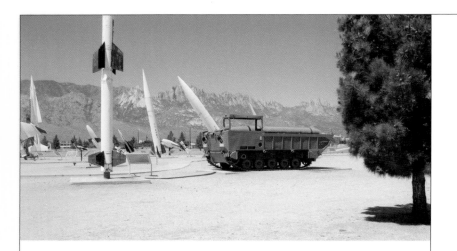

I rattle across its back roads, sending the occasional startled Oryx—a Kalahari antelope introduced decades ago by the state's wildlife agency—bounding out of the mesquite brush. Squat, dun-colored bunkers and shiny radar towers shimmer briefly on the horizon, only to vanish in a mirage-like haze, as if jammed by the radar of the sun. Markers announce cryptic fields of activity: "Zurf Site," or "Phenomenology Test Bed."

White Sands bills itself as a "multi-service test range," which these days means the grounds are open to anything from automakers testing car paints to a solar furnace that can focus a 5,000-degree beam on objects. Its tenants include everyone from the U.S. Army Research Laboratory's

Information and Electronic Protection Division to NASA to the Directorate for Applied Technology, Test and Simulation, which boasts "the most complete assembly of nuclear weapons environment simulators in the Department of Defense."

Another tenant, the Army Research Lab's Battlefield Environment Division, has the mission of "owning the weather," which includes the Biospherian task of re-creating various global environments to test weapons systems. As public affairs officer Jim Eccles and I drive past one of these "climatic chambers," he notes, "if we want it to be like Alaska in the middle of winter we can put a shroud over the launcher and cool it down to 20 below zero, or we can heat the item to re-create Middle East conditions—about the only thing we can't re-create is snow."

For every active facility, however, there seem to be three abandoned buildings. We pass a peaked concrete blockhouse, a foreboding Inca temple with the logo "Army" stenciled on its side, which sits opposite a rocket gantry several hundred yards in the distance. "Launch Complex 33" is its formal name; in September 1945, the humble building had the distinction of ushering in America's rocket age. Fogged window slits face the gantry. One story has Werner von Braun and a group of rocket scientists scrambling out of the bunker following a V-2 launch. "So they go out the door in the backside and look up at this big empty sky," Eccles says. "It only goes up four miles, [then] they terminate the flight because it's erratic. So it starts back down and looks as if it's headed right toward them. They're all trying

to get back into the blockhouse, while other people are still trying to get in or out." The rocket crashed a mile away.

White Sands was a place where the future itself was tested, where scientists and soldiers sent machine and man up against the barriers of nature, confident that engineering would win the day. Here, "bunker busters" were tested for their effectiveness at penetrating enemy fortifications; here, Col. John Stapp—the "Fastest Man Alive"—rode the rocket sled "Sonic Wind" to 632 miles per hour and then was stopped in 1.6 seconds as he experienced 42gs of pressure. (Stapp survived this pressure—more than 40 times his body weight—intact, with some bruising and temporary eye damage, and in another case of Cold War technology transfer the research was used to help develop car-seat restraints.) White Sands was the imaginary battleground of the American Cold War psyche, with exotic weapons fighting unfought wars. Everywhere there are ruins and relics of simulations and tests. On one playa rests what Eccles calls the "only landlocked ship in the U.S. navy," a "desert ship" brought here to practice naval missile launching; in another area is the "Large Blast Thermal Simulator," which as Eccles notes is the "world's largest shock tube." By transforming liquid nitrogen into a gas, the tube is able to create simulated "blast waves" of up to 1250 psi. "You can have it flow down the tunnel of the shock tube and strike the item so you get a shock wave similar to the blast of a nuclear explosion," says Eccles. Built in the 1990s, the shock tube is now vacant. "There's not much demand for that anymore," he notes, with dry regret. The final stop, appropriately, is the place where it all began: Ground Zero. A basalt obelisk marks the precise spot, while a nearby wooden structure covers what is one of the last intact sheets of trinitite, the glassy material that was formed on the desert floor in the heat of the bomb's explosion. "A lot of people selling Trinitite on Ebay will advertise it as not radioactive," Eccles offers. "Real trinitite will emit radiation. It's not hazardous—the only way it would pose any danger is if it were ground up and eaten."

Archaeologists of futures past, we've arrived at a nuclear tomorrow entombed beneath the desert floor. I am reminded of J. G. Ballard's story "The Terminal Beach," about a man marooned on a Bikini-like atomic test island. "The series of weapons tests had fused the sand in layers, and the pseudo-geological strata condensed the brief epochs, microseconds in duration, of thermonuclear time. Typically, the island inverted the geologist's maxim, 'The key to the past lies in the present.' Here, the key to the present lay in the future. This island was a fossil of time future, its bunkers and blockhouses illustrating the principle that the fossil record of life was one of armor and the exoskeleton." At White Sands and the other fossil tomorrows adrift in the American desert, we see portents of how the future was going to be. Whether dystopic or Edenic, these visions summoned America's ultimate faith in technology, as well as a more primitive desire to bring human meaning to a natural landscape.

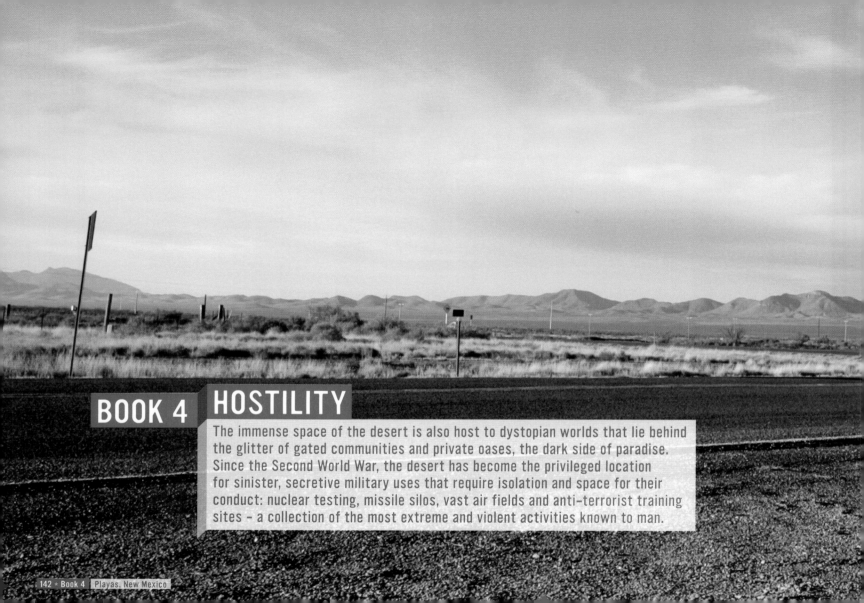

BOOK 4 | HOSTILITY

The immense space of the desert is also host to dystopian worlds that lie behind the glitter of gated communities and private oases, the dark side of paradise. Since the Second World War, the desert has become the privileged location for sinister, secretive military uses that require isolation and space for their conduct: nuclear testing, missile silos, vast air fields and anti-terrorist training sites - a collection of the most extreme and violent activities known to man.

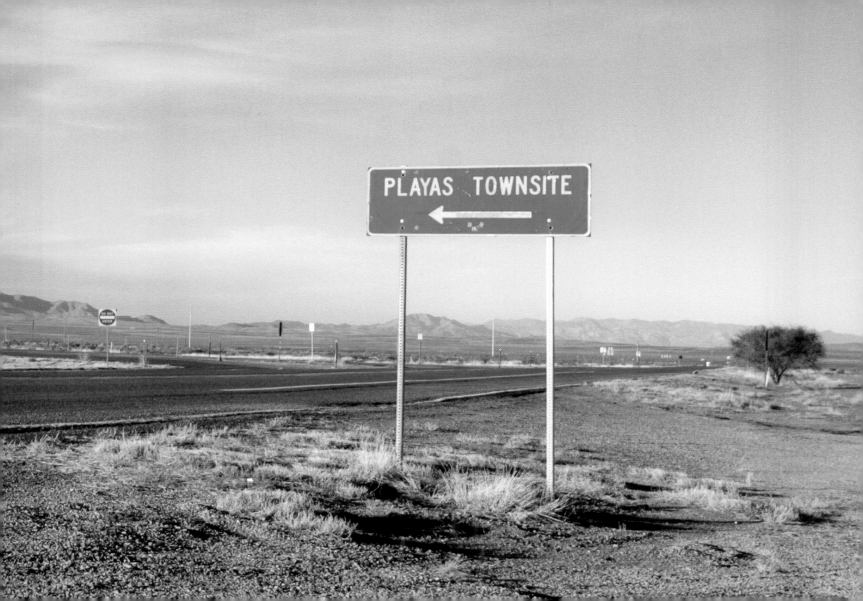

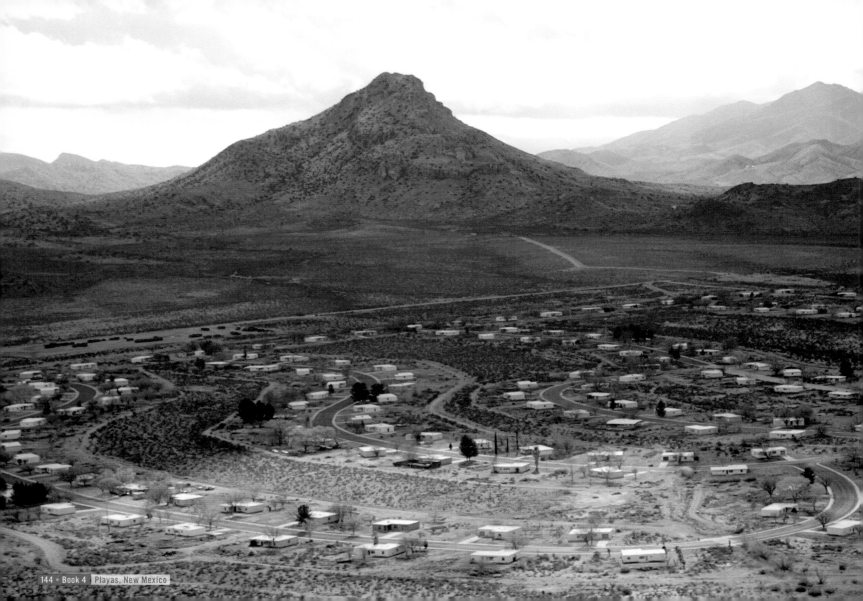

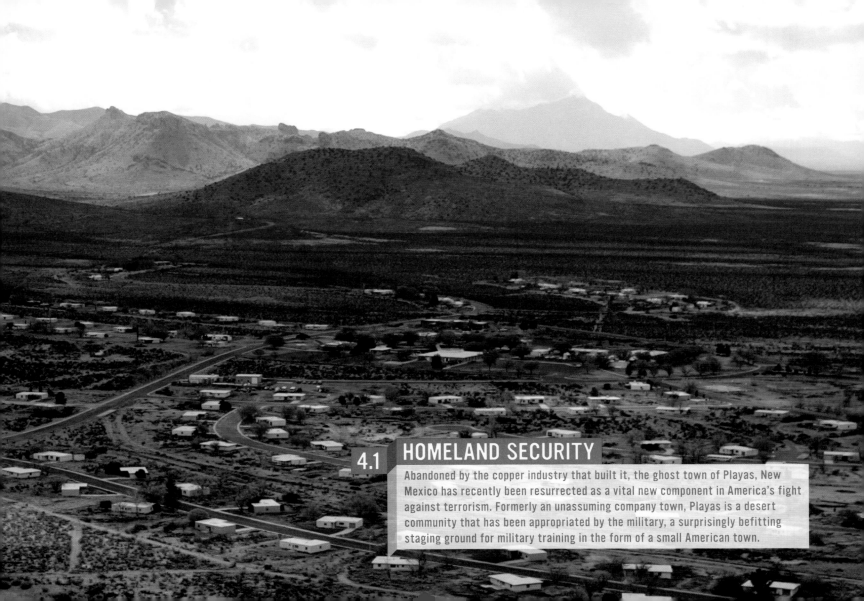

4.1 HOMELAND SECURITY

Abandoned by the copper industry that built it, the ghost town of Playas, New Mexico has recently been resurrected as a vital new component in America's fight against terrorism. Formerly an unassuming company town, Playas is a desert community that has been appropriated by the military, a surprisingly befitting staging ground for military training in the form of a small American town.

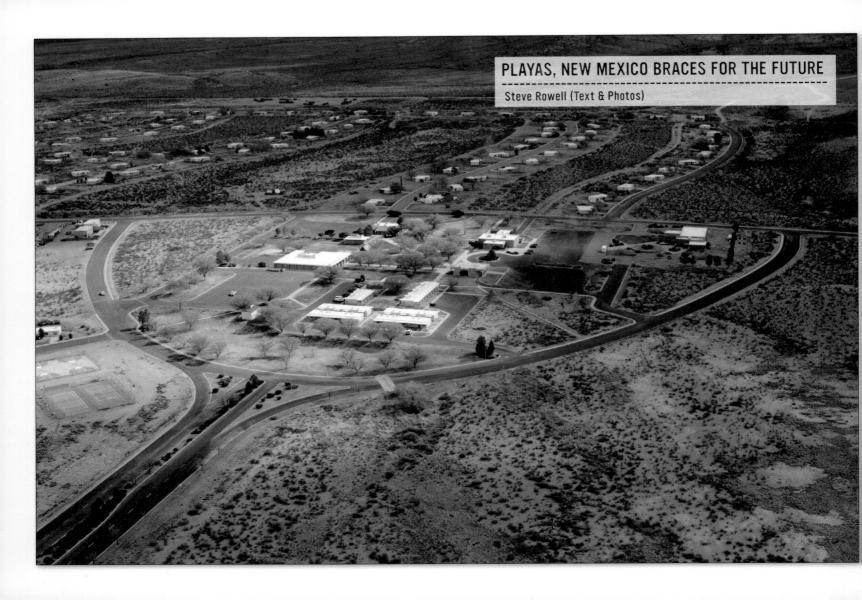

PLAYAS, NEW MEXICO BRACES FOR THE FUTURE

Steve Rowell (Text & Photos)

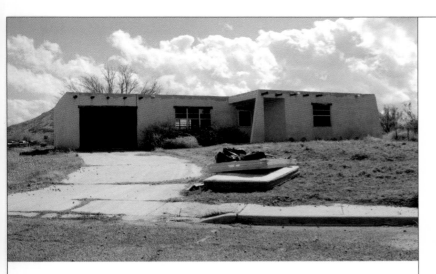

"Imagine the possibilities... seize the opportunity," reads the brochure showing what appears to be a suburb located somewhere in the American Southwest. Amenities include a swimming pool, baseball fields, a skeet range, even a rodeo arena. Closer inspection reveals that the promoted real estate is in an early state of ruin. Snapshots show dilapidated homes with dead gardens and crumbling driveways. This entire town, it seems, is available to interested clients. It is a place that has a brief history, but one that has allowed it to become repurposed in a unique way that reveals more than a few possible futures for America.

Playas, a small town that sits near a dry lake bed of the same name in the "bootheel" of southwest New Mexico, is the subject of the brochure. It is equidistant to the borders of Texas to the east, Arizona to the west, Mexico to the south, and is almost closed off from the rest of the nation to the north by a winding continental divide. These political, cultural, and geophysical lines situate it in a multitude of dead-ends. The suburban design is unusual to small desert towns. The serpentine streets, sidewalks, and bowling alley are more common to communities adjacent to cities populous enough to require such infrastructure. But, the nearest of these are over 100 miles away, in the bordering states of Texas and Arizona. Instead, open desert surrounds Playas.

Its outline clearly defined by the empty backyards and cul-de-sacs; a visible border, but one without gates or fences and exposed and vulnerable. The indigenous animals and plants, highly adaptable and opportunistic, have begun gradually moving in, taking shelter in this deserted town.

But there are people here. Sometimes there are even guests. Families crossing illegally from Mexico take temporary refuge from the harsh and sometimes lethal Chihuahuan Desert.

147

In addition to the lone patrol car, a few Blackhawk helicopters crouch on disused baseball diamonds. Uniformed figures with automatic weapons and body armor are dropped from the helicopters to stalk the empty streets, looking for phantom threats in mock-adobe homes. These are soldiers training for urban warfare in an abandoned mining town. If, in the course of an exercise, one of them were to glance through a broken kitchen window, they might see the peaks of the Animas mountain range. Translated as "spirit" or "lost souls" the Animas range and valley beyond are rumored to have been named by doomed conquistadors in the 1750s looking, in vain, for gold.

Differing from other desert towns by more than its formal plan and unusual set of amenities, Playas was built in 1972 on this remote site to serve as company town to the copper smelter that rises from the valley horizon a few miles south. The smelter operated from 1970 until the decline in the copper industry made it a liability. In 1999, its owner, Phelps Dodge, made the decision to shut down operations. A few families have been retained as caretakers of the town, but most left to find work where they could. The dismantling process, now in its seventh year, provides a handful of jobs for a dwindling population. The future of Playas was bleak, and it seemed destined to become another ghost town, succumbing to weather, souvenir hunters, and vandalism. However, with the advent of the the war of terror and the Department of Homeland Security (DHS), a new opportunity has presented itself. In 2003, while searching for ways to bolster the economy of New Mexico, Senator Pete Domenici announced plans by New Mexico Tech to convert the entire town into an anti-terrorism training facility: "We all recognize that 'real world' training for first responders and anti-terrorist organizations within our government will be of vital importance to accomplishing our mission. Because all of the necessary infrastructure is in place, this town could be used for training personnel charged with protecting our homeland. I suggest that Homeland Security consider purchasing this town..."[1] During the inaugural event in December 2004 he went on to credit Bin Laden for the very existence of this new opportunity: "People give Bin Laden a lot of credit for a lot of things. But I'm quite sure that he never thought we would be buying Playas, NM to prepare for the kinds of things he might want to do to America and other parts of the world. So in a sense, [since] he chose to do that, we're very grateful that we get the benefit of setting up this facility here. I don't want anybody to think I'm thanking Bin Laden, but in a sense, it's our good fortune."

Federal funds were allocated and Playas was sold for $4 million to New Mexico Tech, specifically its research division - the Socorro, NM based Energetic Materials Research and Testing Center (EMRTC). Energetic materials means explosives: car bombs, briefcase bombs, letter bombs, even suicide bomber chest bombs. EMRTC owns mines, labs, and manufacturing facilities for the custom creation of these explosives. Also on site are lots full of scrap vehicles, plywood mannequins, and mock structures for the testing of these explosives. The goal of most situations in first responder training is to simulate only a vague degree of realism with priority given to trainee safety. The inevitable wear and sometimes repeated destruction of the facilities as a result of the training requires that simulated architecture designers and engineers

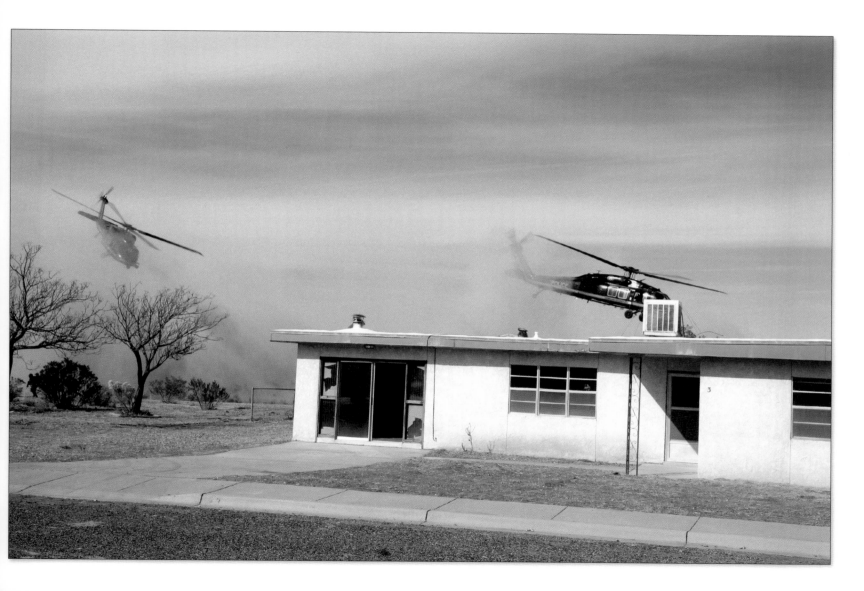

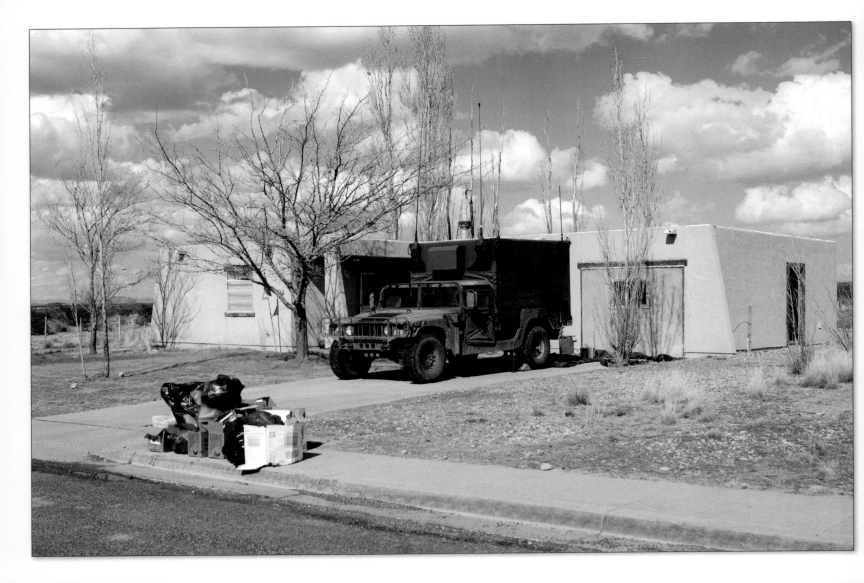

rely on crude, strictly functional buildings, such as shipping containers and simple cinderblock structures. In contrast, Playas offers a ready-made world featuring 260 homes with backyard grills, shag carpet, and converted garages - the stuff of dreams for planners of simulated urban (or suburban) warfare training. The parks, grocery store, and even its airfield, designed originally for mining executives, are being modified as sets for first responder and hostage negotiation, urban warfare and weapons of mass destruction exercises (including simulated nuclear, chemical and biological attacks), as well as terrorism related border security programs. When the facility opened in December 2004 (by ribbon detonation, not cutting)[2] NMT officials, State Department VIPs, and members of the press were treated to a simulation involving one of the homes, a pair of helicopters, a dozen armed "students," a bus full of "victims," and a "suicide bomber." Bleachers were erected for the show, and after the dust cleared, the troops surrounded the home, smashed in windows and deployed a bomb-sniffing robot to clear the area. Simultaneously, a mock chemical bomb exploded in the nearby bus. As quickly as they started, the operations ended and after a few minutes of local news reportage, the street was empty once again.

Residents of Playas have been given new jobs role-playing as victims in this new type of company town. Landlord/tenant relations seemed amiable at first.[3] Some previous residents even returned to their previous quarters; about 30 of the 260 homes are now inhabited. Most, however, make the daily commute from Lordsburg (50 miles away) and Deming (70 miles) to work here. Recent security enforcements have dampened the initial excitement of new employment, and some residents have complained

of living or working in an occupied town where a form of martial law is in effect.

The future of Playas involves a series of infrastructure upgrades; command and control rooms are to be built and outfitted with live video monitoring systems to allow for more detailed scenario planning and review; homes are to be modified with breakaway doors and safety glass. The facility has been successful in attracting clients such as the U.S. Army and numerous city police and SWAT forces. With a combination of luck and resolve, Playas may actually succeed as a hybrid enterprise, both federal and commercial, giving NMT/EMRTC

151

a solid research site and giving the state of New Mexico a much needed revenue stream, and perhaps will also serve as a prototype for this new type of land reuse.

Playas is an icon for future development here and the timing could not be better; recent national attention provide New Mexicans with a new sense of wonder and hope for their state, the third poorest in the Union. In the summer of 2005, it was discovered that the Hollywood-based Church of Scientology had begun building a bunker to house its founder's writings not far from Las Vegas, NM, a town that has served as a location for such thematically diverse films as Easy Rider, Convoy, and Red Dawn. On a remote plateau, L. Ron Hubbard's visionary texts will be immortalized on steel plaques and entombed for the indefinite future. To reduce the chance of their treasure being lost, Scientologists have carved a large earthwork in the form of two overlapping circles out of the sagebrush on a scale large enough to be visible from outer space so that future travelers, apparently returning to Earth by spaceship, can find it.[4] Perhaps as a coincidence, America's first tourism spaceport is to be built near the White Sands Missile Range and adjacent to modern day Truth or Consequences, NM, with planned civilian passenger launches to begin in 2009.[5] Who knows the future fate of little Truth or Consequences. If anything, its name is likely to change, just as it has from Las Palomas to Palomas Springs to Hot Springs to its current name, given in 1950 as a promotional gimmick by a TV game show. Indeed, imagine the possibilities.

The vernacular of New Mexico is fairly consistent with much of the SouthWest: truck stop, ranch, Native American reservation, RV park, and ski resort. In contrast, Playas is an anomaly. It exists as a logical result of its isolation away from cities but is at odds with the desert on both functional and design levels. It is untethered from civic rules, yet represents an organized front in the war against terror. It is bracketed by ruins of ancient civilizations and the ghosts of the Cold War, the coded messages of petroglyphs in cliff dwellings, and decaying isotopes buried beneath the site of the world's first atomic bomb. This place embodies America's past and its future - a dystopic playground on the fringe of America, available as host to innumerable simulated disasters. Homes here are now kept empty as monuments to their own desolation. As a byproduct of industrial processes, political will, and economic pressures; out of convenience, fear, and desperation; Playas, now reanimated, convulses in an undead state.

NOTES

1. "Domenici Urges Sec. Ridge to Turn Playas, N.M. into "Real World" Training Facility for Homeland Security", Press release from the Office of Senator Pete V. Domenici, Tuesday, March 11, 2003. **2.** When the author visited the site for the inauguration event, Senator Domenici, along with two other politicians, threw switches to detonate the ribbon instead of cutting it. See NMT's online article for details about the day, http://info-host.nmt.edu/mainpage/news/2004/2dec01.html. **3.** "[Residents] say that their new landlords have tried hard to minimize disruptions to their lives - for instance, building a special half-mile road for [a resident] so his commute to his job at the cattle ranch on the other side of town would not take him through training exercises in the center of town. And, as landlord, New Mexico Tech continues to make available a bank window, convenience store and diner. It also threw the residents a Christmas dinner and gave each family a bottle of champagne for New Year's." Ariana Eunjung Cha "New Mexico Plays Home To Terror Town, U.S.A. Simulated Attacks Prepare for Worst." *The Washington Post* 8 May 2005. **4.** Richard Leiby "A Place in the Desert for New Mexico's Most Exclusive Circles." *The Washington Post* 27 Nov. 2005. 5. Laura Meckler "New Mexico Plans First 'Spaceport' For Space Travel." *The Wall Street Journal* 9 Dec. 2005.

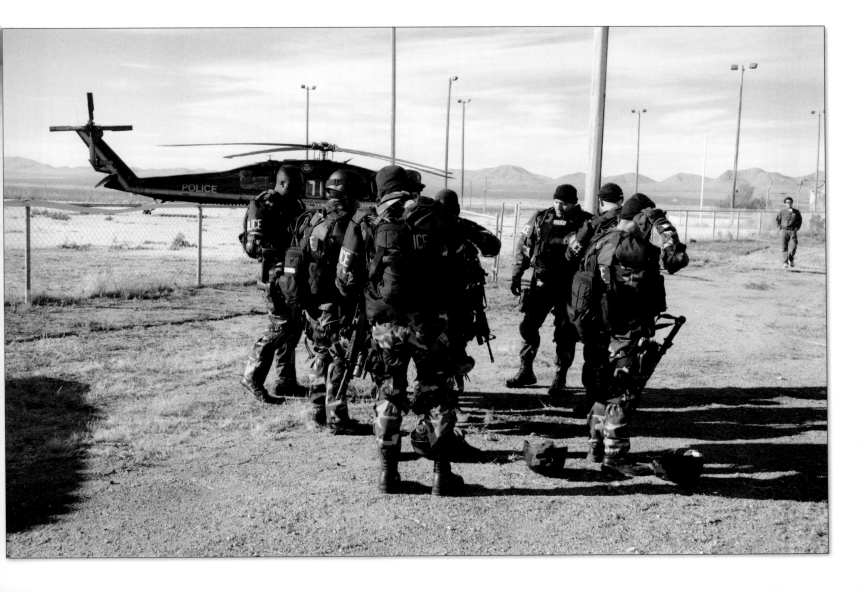

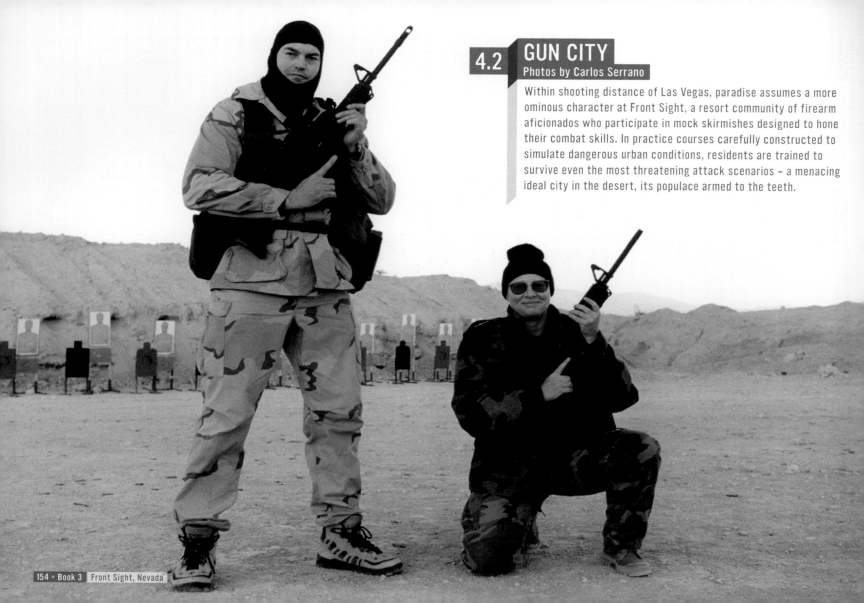

4.2 GUN CITY
Photos by Carlos Serrano

Within shooting distance of Las Vegas, paradise assumes a more ominous character at Front Sight, a resort community of firearm aficionados who participate in mock skirmishes designed to hone their combat skills. In practice courses carefully constructed to simulate dangerous urban conditions, residents are trained to survive even the most threatening attack scenarios – a menacing ideal city in the desert, its populace armed to the teeth.

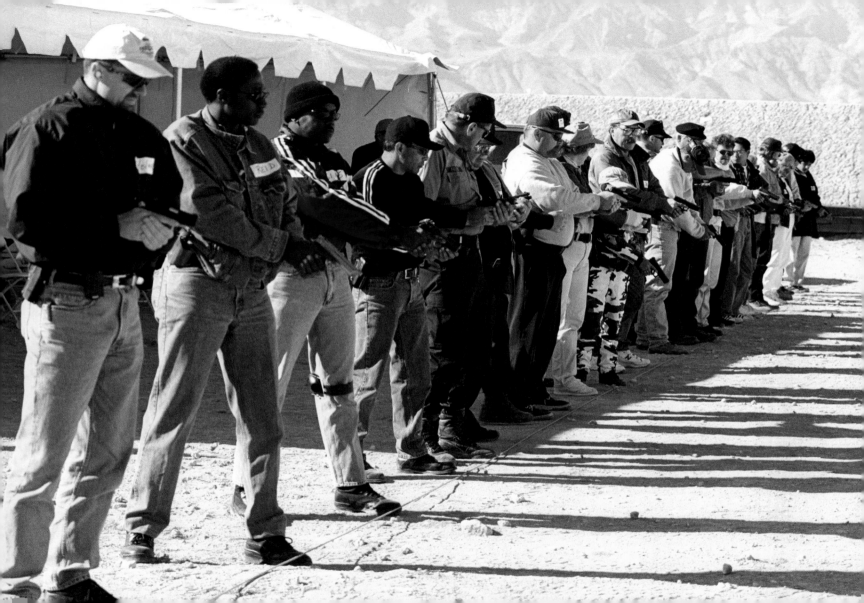

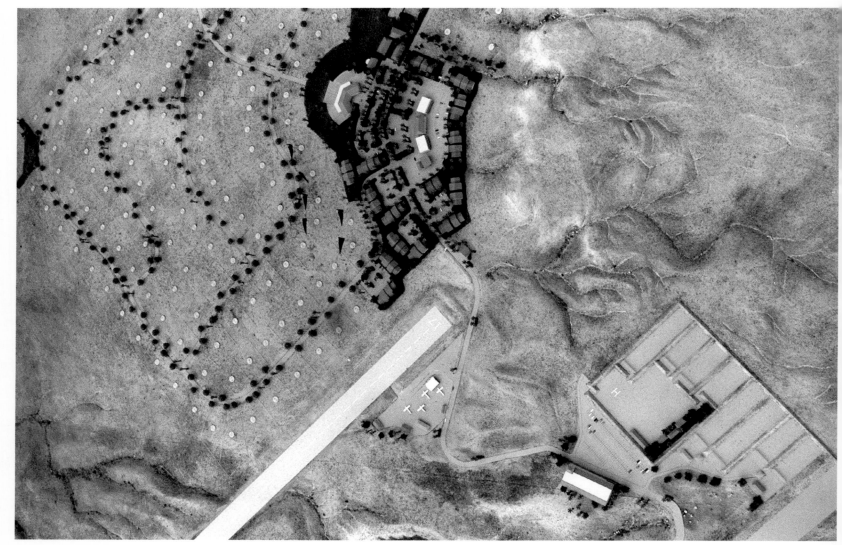

Fifty miles outside of Las Vegas, a high-security perimeter fence surrounds the beginnings of a 550-acre, gated community dedicated entirely to the Second Amendment. In Front Sight, Nevada, construction has already begun on a 25 million development that, in addition to the standard array of private homes and condominiums, will also include a dozen shooting ranges, a SWAT practice course, several video simulators, an armory, a repelling wall, gunsmithing facility, and a "tunnel of terror," which unlike its Coney Island counterpart is designed to expose residents to "a unique and extremely challenging tactical environment."
In this enclave, temporary residents will learn how to develop a "combat mindset," one that prepares any individual to survive an unexpected armed encounter. The founder of the Front Sight Firearms Training Institute, Dr. Ignatius Piazza - an ex-chiropractor turned "four weapons combat master" - aims to create the safest community in the world. Front Sight residents may participate in training courses ranging from "Uzi submachine gun" to "empty hand defense" to "select M16 and Glock pistol precision." Targeting an affluent clientele, Piazza insists that Front Sight is not a fringe community of violent individuals, but is instead a desert haven free of the stricter gun control laws found in other states. According to Piazza, his community will be the safest in America - a hamlet where gun savvy teachers (who will be armed, in a planned private school) and combat educated residents will ensure the safety of the entire populace.

Dr. Ignatius Piazza, founder of the Front Sight Resort

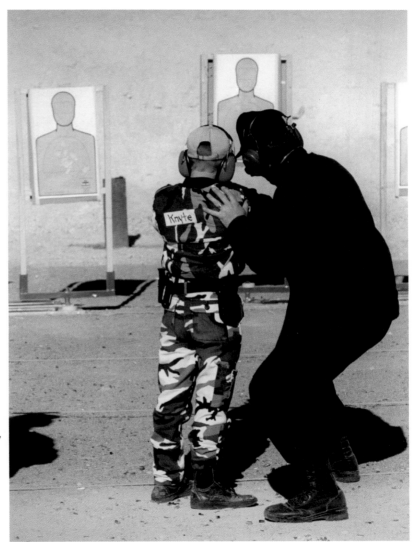

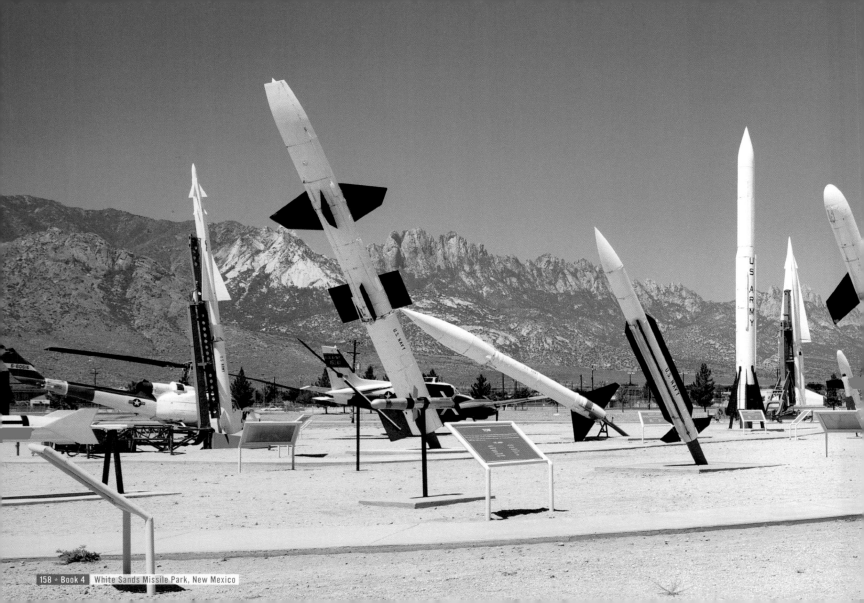

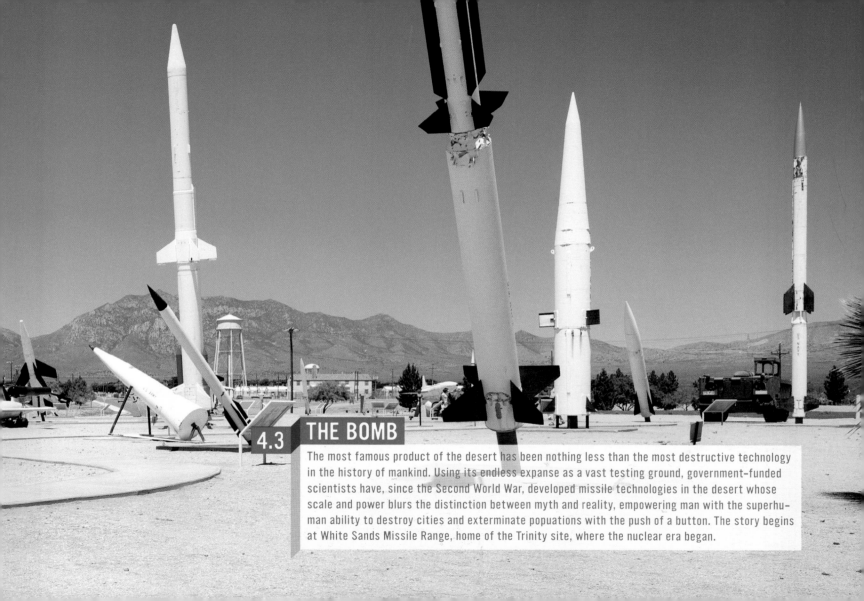

4.3 THE BOMB

The most famous product of the desert has been nothing less than the most destructive technology in the history of mankind. Using its endless expanse as a vast testing ground, government-funded scientists have, since the Second World War, developed missile technologies in the desert whose scale and power blurs the distinction between myth and reality, empowering man with the superhuman ability to destroy cities and exterminate popuations with the push of a button. The story begins at White Sands Missile Range, home of the Trinity site, where the nuclear era began.

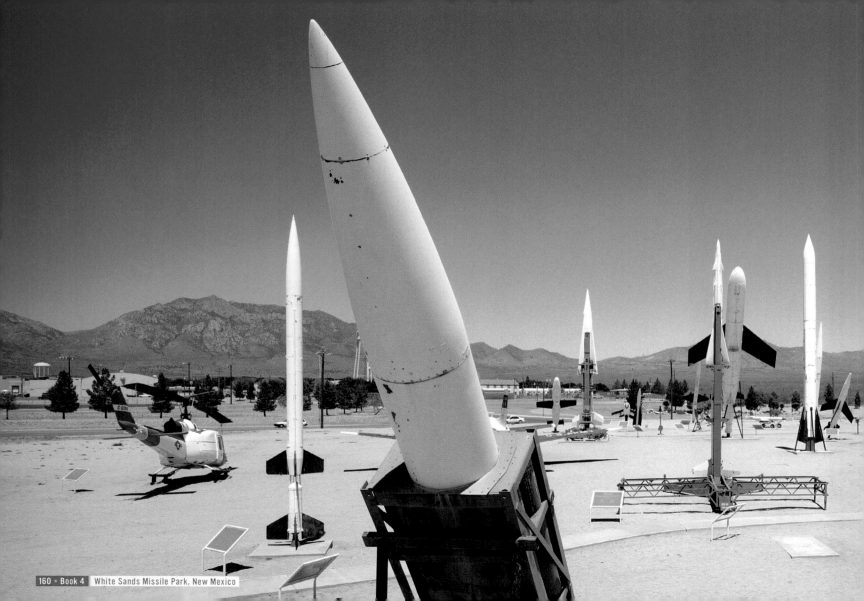

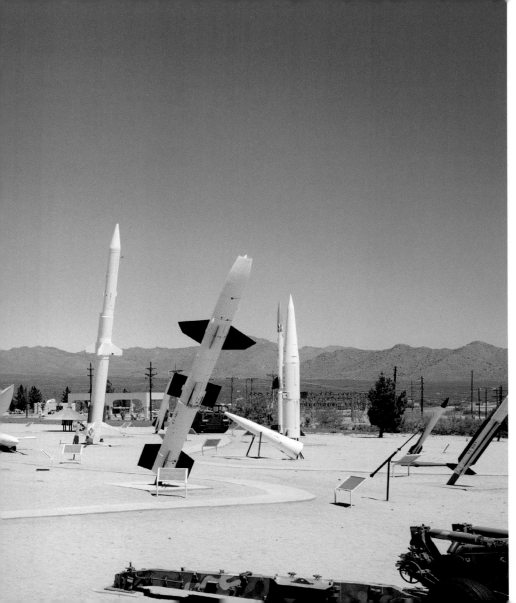

Today, the White Sands Missile Range (WSMR) is the largest military installation in the country, occupying 3200 square miles of the northern sector of the Chihuahua desert. WSMR (known locally as "wizzmer") has provided the military with ideal conditions for the year-round testing of all types of missile technology. Larger than the state of Rhode Island, WSMR has continuous sunshine, clear weather, and hundreds of miles of uninhabited terrain, all within convenient driving distance of Las Cruces, New Mexico and El Paso, Texas. Founded as a test site for German V-2 missiles collected by US armed forces at the close of World War II, WSMR currently serves most defense related federal agencies, as well as private clients, with a workforce of 6000 individuals. To date, WSMR has been the site of 45,000 missile firings. In addition to missile testing, WSMR conducts laser weapons testing, thermal radiation testing, and serves as a practice landing strip for the Space Shuttle. Named after the bleached gypsum dunes of White Sands National Park next door (see page 2), WSMR has an on-site museum and missile park, where visitors can learn all about the various types of missiles tested at the range, as well as pose next to replicas of the nuclear devices developed during the Manhattan Project.

TARTAR

During the 60s this was the smallest Navy surface-to-air missile and was placed on destroyer-type ships and as a secondary battery on larger ships. Testing of this supersonic missile took place at the U.S.S. Desert Ship located at Launch Complex 35 at White Sands. U.S. Navy

Length: 15 feet
Diameter: 12 inches
Weight: 1,200 pounds
Propellant: Solid
Range: 10 miles
Ceiling: 5 miles
First Fired: 1966 (This was first fired at White Sands Missile Range. It was fired extensively for several years at other installations)

TALOS

This missile could carry a nuclear or conventional warhead and could be used for air defense and against ships and shore-bombardment targets. Thirteen years of research and development went into the Talos. A prototype missile ship called the Desert Ship was built at White Sands for testing the missile's performance. It used a solid-fuel rocket motor as a booster and then a ramjet engine as a sustainer. U. S. Navy

Length: 30 feet
Diameter: 30 inches
Weight: 7,000 pounds including booster
Propellant: Missile - Liquid, Booster - Solid
Ceiling: 50,000 feet
Range: 50 miles
Velocity: Mach 2
First Fired: 1951

HIBEX

This was an experimental program to develop high acceleration booster technology. The name is an acronym for High Boost Experiment. The program purpose was to develop a motor for the Sprint missile which was to be an anti-ballistic missile interceptor. First tested at White Sands in 1965 the vehicle was fired from both above ground and underground cells.

PERSHING I

This two-stage ballistic missile was highly mobile, had a selective range capability and replaced the Redstone missile as the Army's "Sunday Punch." Testing of this nuclear capable missile at White Sands involved off range firings from Fort Wingate, N.M. and several locations in southern Utah like Green River. U.S. Army

Length: 35 feet
Diameter: 40 inches
Weight: 10,000 pounds
Propellant: Solid
Range: 100 - 400 miles
First Fired: 1963

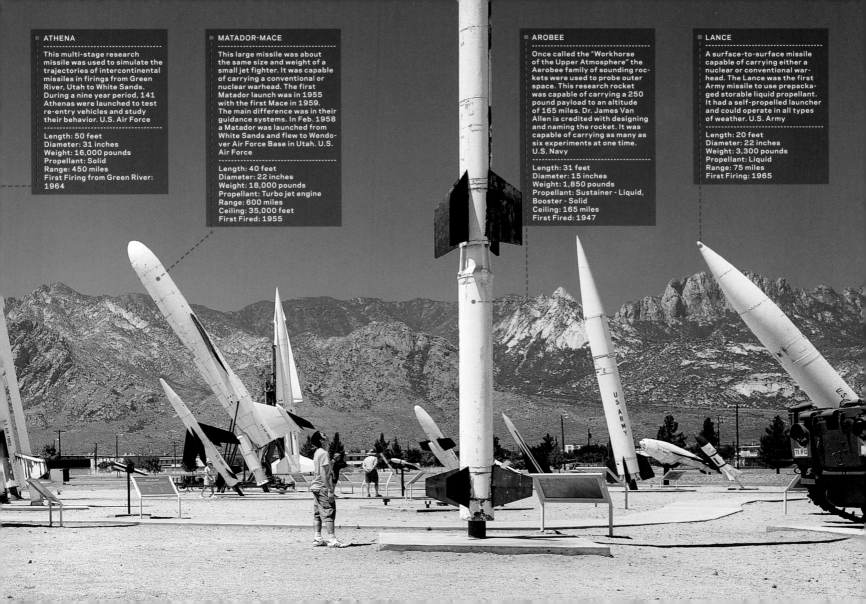

ATHENA

This multi-stage research missile was used to simulate the trajectories of intercontinental missiles in firings from Green River, Utah to White Sands. During a nine year period, 141 Athenas were launched to test re-entry vehicles and study their behavior. U.S. Air Force

Length: 50 feet
Diameter: 31 inches
Weight: 16,000 pounds
Propellant: Solid
Range: 450 miles
First Firing from Green River: 1964

MATADOR-MACE

This large missile was about the same size and weight of a small jet fighter. It was capable of carrying a conventional or nuclear warhead. The first Matador launch was in 1955 with the first Mace in 1959. The main difference was in their guidance systems. In Feb. 1958 a Matador was launched from White Sands and flew to Wendover Air Force Base in Utah. U.S. Air Force

Length: 40 feet
Diameter: 22 inches
Weight: 18,000 pounds
Propellant: Turbo jet engine
Range: 600 miles
Ceiling: 35,000 feet
First Fired: 1955

AROBEE

Once called the "Workhorse of the Upper Atmosphere" the Aerobee family of sounding rockets were used to probe outer space. This research rocket was capable of carrying a 250 pound payload to an altitude of 165 miles. Dr. James Van Allen is credited with designing and naming the rocket. It was capable of carrying as many as six experiments at one time. U.S. Navy

Length: 31 feet
Diameter: 15 inches
Weight: 1,850 pounds
Propellant: Sustainer - Liquid, Booster - Solid
Ceiling: 165 miles
First Fired: 1947

LANCE

A surface-to-surface missile capable of carrying either a nuclear or conventional warhead. The Lance was the first Army missile to use prepackaged storable liquid propellant. It had a self-propelled launcher and could operate in all types of weather. U.S. Army

Length: 20 feet
Diameter: 22 inches
Weight: 3,300 pounds
Propellant: Liquid
Range: 75 miles
First Firing: 1965

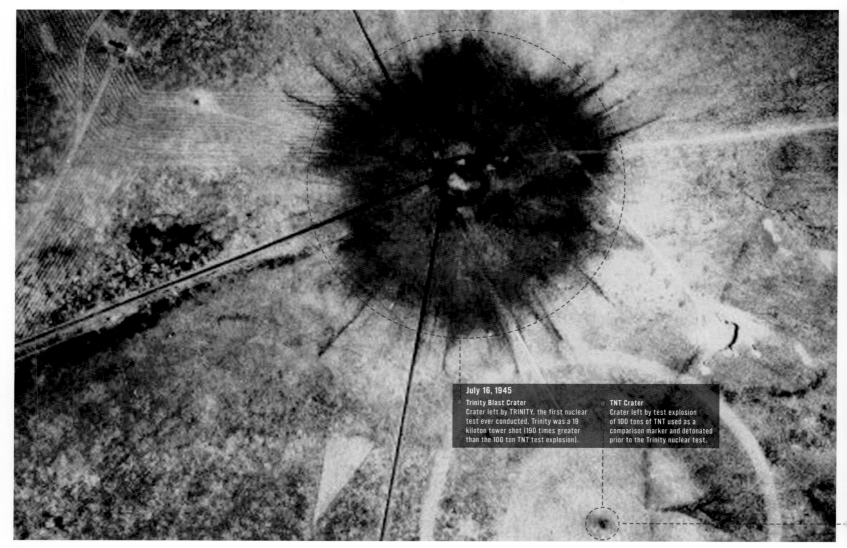

July 16, 1945

Trinity Blast Crater
Crater left by TRINITY, the first nuclear test ever conducted. Trinity was a 19 kiloton tower shot (190 times greater than the 100 ton TNT test explosion).

TNT Crater
Crater left by test explosion of 100 tons of TNT used as a comparison marker and detonated prior to the Trinity nuclear test.

TRINITY SITE

On July 16, 1945, a mere seven days after its establishment as the White Sands Proving Ground, the area later known as White Sands Missile Range (WSMR) became the site of Project Trinity, the world's first successfully detonated atomic bomb. The 19-kiloton bomb (codenamed "Gadget") had an orange-sized plutonium core that produced an explosion four times hotter than the interior of the sun, with a resultant force 190 times greater than the earlier 100-ton TNT test used to calibrate data instruments. Though nearby residents were alarmed by the explosion (which shattered windows 160 miles away), they were not informed of the true character of the event until several months later, after the bombings of Hiroshima and Nagasaki. The first and only nuclear device to be tested at White Sands, this rather spectacular inauguration in the "Jornado del Muerto" section of the desert melted thousands of acres of sand, creating a shallow crater of greenish glass that was named "trinitite." Fragments of trinitite are still scattered at the site, which has become a popular destination for "atomic tourists," who are strictly prohibited from removing shards of the slightly radioactive glass as souvenirs.

Declared a National Historic Landmark in 1975, the Trinity site holds an "open house" twice yearly: "ground zero," the site of the explosion, is marked by a small monument made of black volcanic rock. For the site's 60th anniversary in 2005, 3500 visitors (including local and international media, tourists, peace demonstrators, and 19 dogs) attended the July 16th opening.

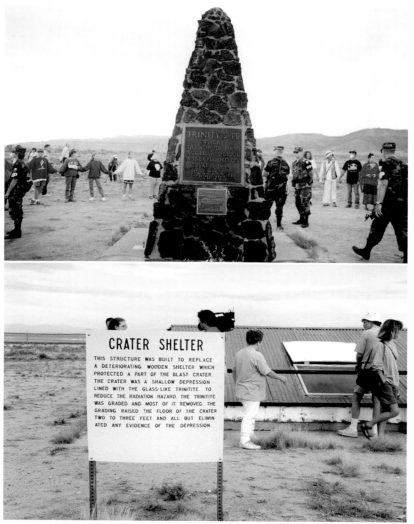

Trinity Site, 2004

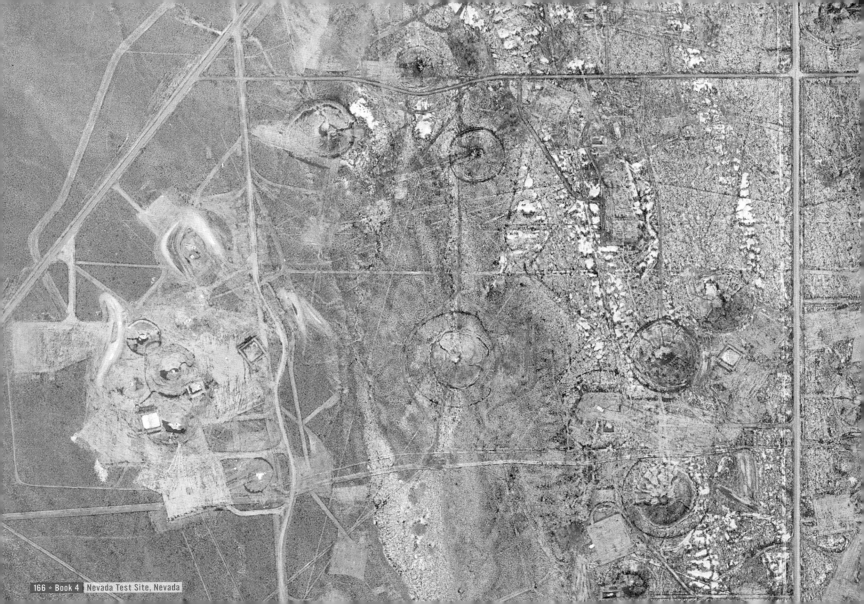

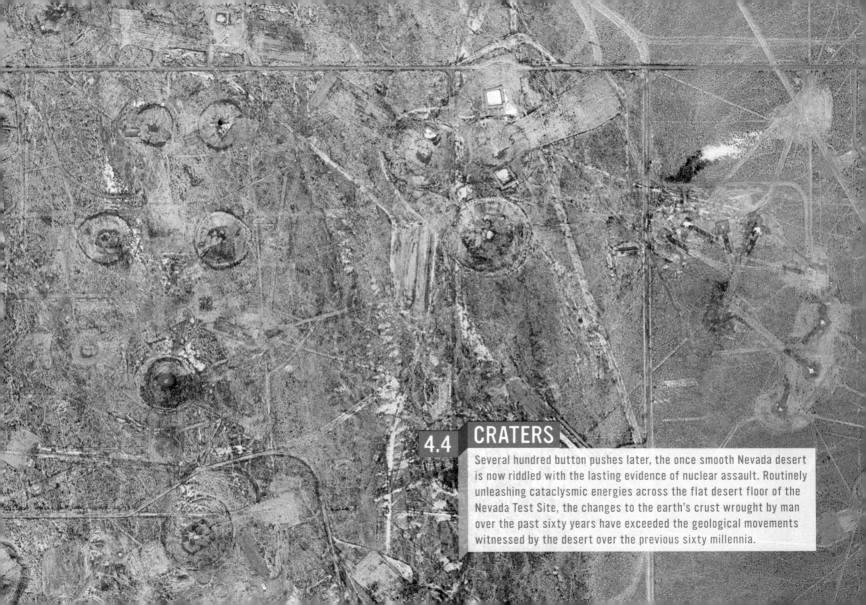

4.4 CRATERS

Several hundred button pushes later, the once smooth Nevada desert is now riddled with the lasting evidence of nuclear assault. Routinely unleashing cataclysmic energies across the flat desert floor of the Nevada Test Site, the changes to the earth's crust wrought by man over the past sixty years have exceeded the geological movements witnessed by the desert over the previous sixty millennia.

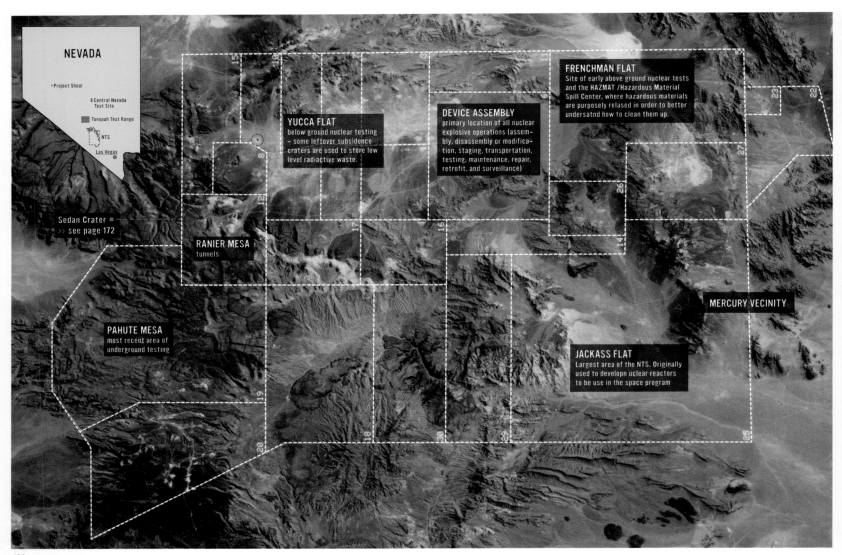

NEVADA

+ Project Shoal

‖ Central Nevada
Test Site

▢ Tonopah Test Range

▢ NTS

Las Vegas

Sedan Crater ▪
>> see page 172

YUCCA FLAT
below ground nuclear testing
– some leftover subsidence
craters are used to store low
level radiactive waste.

DEVICE ASSEMBLY
primary location of all nuclear
explosive operations (assem-
bly, disassembly or modifica-
tion, staging, transportation,
testing, maintenance, repair,
retrofit, and surveillance)

FRENCHMAN FLAT
Site of early above ground nuclear tests
and the HAZMAT /Hazardous Material
Spill Center, where hazardous materials
are purposely relased in order to better
undersatnd how to clean them up.

RANIER MESA
tunnels

PAHUTE MESA
most recent area of
underground testing

JACKASS FLAT
Largest area of the NTS. Originally
used to developn uclear reactors
to be use in the space program

MERCURY VECINITY

Area 1 (70 km²)
U1a underground facility of quarter-mile long tunnels still used for sub-critical experiments and other tests about aging nuclear materials.
Area 1 Industrial Complex: used for drilling maintenance and storage area.

Area 2 (52 km²) – 7 atmospheric and 137 underground nuclear tests. Currently all installations are being relocated to Area 6

Area 3 (82 km²) – 17 above ground and 251 underground nuclear tests. Contaminated (radioactive) waste has been buried in several of the post-detonation craters located in this area of Yucca Flats.

Area 4 (41 km²) – 5 atmospheric and 35 underground nuclear tests. Location of Big Explosives Experimental Facility (BEEF), two underground bunkers used for high-yield explosive experiments.

Area 5 (246 km²) – 14 atmospheric and 5 underground nuclear tests.
Facilities include: Radioactive Waste Management Site (low-level waste disposal), Hazardous Waste Storage Unit (dangerous but non-radioactive materials), and Spill Test Facility (use for measuring the effects of hazard waste release into the environment).

Area 6 (212 km²) – 1 atmospheric 5 underground nuclear tests.
Control Point Complex: command center for Pahute Mesa, Yucca and Frenchman Flats
Device Assembly Facility: site of all assembly, maintenance, and modification of nuclear devices tested at the NTS.

Area 7 (52km²) – 26 atmospheric, 62 underground tests

Area 8 (34km²) – 3 atmospheric, 10 underground tests

Area 9 (52km²) – 17 atmospheric, 100 underground tests. Class II landfill (non-hazardous waste)

Area 10 (52 km²) – 1 nuclear rocket test, 57 non atmospheric tests (shallow crater and underground)

Area 11 (nickname Plutonium Valley) (67km²) – 4 plutonium dispersal tests - testing effects of widespread plutonium release, 5 underground nuclear tests

Area 12 (104km²) – 61 underground test, no atmospheric tests. Site of high explosives research and testing

Area 13 – Not officially part of NTS roster - no DOE activities planned for this area.

Area 14 (67km²) – Reserved Zone Area, no testing

Area 15 (96km²) – no atmospheric, 3 underground nuclear tests.
Closed: EPA Farm Complex, a diary farm used to test the effects of radionucleotides in the food chain.

Area 16 (73 km²) – no atmospheric, 6 underground nuclear tests, currently used for high-explosives and conventional explosives and munitions research.

Area 17 (80km²) – Buffer between testing areas.

Area 18 (231 km²) – Inactive Pahute airstrip used for supply delivery, 4 above ground and 1 underground nuclear test.

Area 19 (388km²) – 35 underground, high-yield tests

Area 20 (259 km²) – Schooner Crater, 46 underground nuclear tests, 3 in the megaton+ range.

Area 21 – Does not exist

Area 22 (83 km²) – Main entrance area into the NTS and site of the now dismantled Camp Desert Rock, which housed troops who participated in military exercises prior to 1958.

Area 23 (13km²) – Location of Camp Mercury, main administrative and support center of the NTS.

Area 24 – No official Area 24; Las Vegas and vicinity sometimes jokingly referred to as "Area 24."

Area 25 (578 km²) – Entrance gate, site of nuclear reactor testing and development and now inactive "Nuclear Rocket Development Station." Currently use for experimentation of nuclear waste management techniques, infared satellite technology, ecology and radiation effects, and military training exercises.

Area 26 (57km²) – Site of Project Pluto, used to test nuclear-powered ramjet engines

Area 27 (130km²) – Location of critical assembly facilities

Area 28 – Absorbed into Area 25 and 27

Area 29 (161 km²) – Communications facilities.

Area 30 (150km²) – Site of 1 nuclear testing program, Project Buggy, part of the Plowshare program.

NEVADA TEST SITE
--

Signed into existence by President Truman, the Nevada Proving Ground (later renamed the Nevada Test Site, or NTS) was established on January 11, 1951. Two weeks later, all US nuclear testing was moved here from the South Pacific; the commencement of Operation Ranger would initiate forty years of nearly continuous nuclear testing in the state of Nevada.

During these next four decades, the NTS withstood 928 nuclear tests of all shapes and sizes, completing as many as 40 successful tests a year. Initially, all testing was conducted above-ground on the Frenchman Flat area of the NTS: nuclear devices were dropped by B-52 bombers, installed in towers (some taller than the Empire State building), or suspended from hot air balloons to mimic air-drop conditions. Apart from the collection of raw data, many tests were designed to monitor the blast effects suffered by American troops squatting in foxholes as little as 2500 yards from ground zero, or to gauge the destruction of fully furnished subdivisions ("doom towns") populated by department store mannequins.

Of the seven nuclear nations, the United States has conducted half of the total number of worldwide atomic tests. The large majority of these tests (for defense and peaceful objectives) occurred at the NTS, which at 1375 square miles occupies a territory greater than that of several states. Currently the NTS is controlled by the US Department of Defense and sits adjacent to vast tracts of unsettled land controlled by the US Bureau of Land Management. These areas represent a total of 5470 square miles (14 000 km²) of land held outside the public domain.

After above-ground testing was prohibited in 1962 by the Limited Test Ban Treaty between the United States and Soviet Union, the Atomic Energy Commission (AEC) moved all testing thousands of feet underground to emplacement tunnels bored into the desert mesa. The once even landscape of Yucca Flat and Pahute Mesa, the principal nuclear blast zones of the NTS, is now blistered with subsidence craters, markers of where the earth has caved in after an underground nuclear blast; much of the site's 400-mile road network has been transformed into stretches of undulating track, the roadway warped by shockwaves from hundreds of seismic-scaled explosions.

YUCCA FLATS

Testing at the NTS began at Frenchman Flat, in the southern portion the site. As the magnitude of testing increased, detonations were moved underground to reduce the danger of nuclear fallout and visual spectacles. A consequence of this switch was the dramatic rise in the intensity of seismic shocks, which alarmed nearby residents of Las Vegas. To lessen this effect, the DOE relocated their tests northward, to three primary areas: Yucca Flat, Pahute Mesa, and Rainier Mesa. Of these three areas, Yucca Flats has hosted the largest majority of explosions, 658 tests in 719 different locations. With a non-test population of 100 personnel, the Mercury base camp, located at the edge of Yucca Flats, has swelled to nearly fifty times that during more important events. Though it has few permanent buildings (the majority of structures are military-issue tents) and a hugely fluctuating population, Mercury does include a permanent air-strip, security guard post, and post office.

ANNALS OF BOMBING 1

"Dog" (Operation Buster-Jangle), November 1951
The first test to include human subjects. Part of Operation Buster-Jangle, scientists hoped to gather information on the effects of heat and flash blindness, the physical impact of 180-mph dust-filled winds, and the potency of the "hot" (radioactive) fallout that follows a nuclear explosion.

Thousands of troops watched the explosion at a distance of only 6 miles and were sent into to ground zero immediately afterwards, supposedly to inspect the remains of the 21-kiloton detonation. The unstated objectives were to monitor the psychological reactions of troops in a post-nuclear setting and test their ability to remain combat effective under extreme conditions.

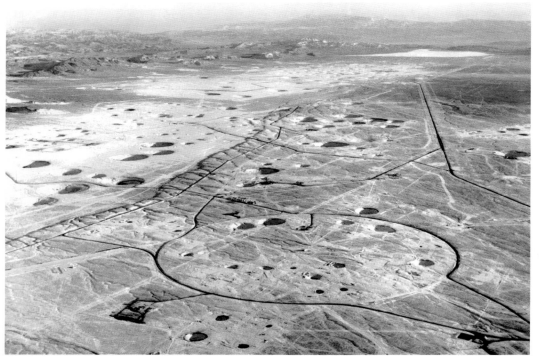

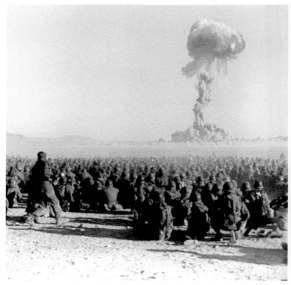

ANNALS OF BOMBING 2

"Apple" (Teapot test series), 1955 Designed to test the effects of a nuclear attack on a typical American residential neighborhood (part of the "Teapot" test series), scientists constructed an entire "survival town," an abridged version of Anytown, USA complete with office buildings, a radio station, mini-trailer park, and electrical and communications infrastructures including power lines, a substation, and a natural gas facility. Several different types of wood-frame houses were also built and fully furnished, with their "residents" (mannequins from JC Penney) seated for dinner at fully-set tables, cars parked in their driveways and individual fallout shelters at the ready (but never used). Experiments such as Apple II and the earlier Annie Shot, which involved troop maneuvers, not only measured the destructive capabilities of the bomb, but also tested protective capabilities. These tests recorded the effectiveness of government-issue clothing, bomb shelters, and ground force vehicles to withstand an enemy-initiated nuclear attack. Apple II was the second televised nuclear test. The mock-town was approximately two miles from ground zero and the blast left only two homes standing. (According to a military-produced film of the era, such experimentation could provide additional insight into "how we can increase the radius of destruction from concrete fragments thrown out by an atomic explosion.")

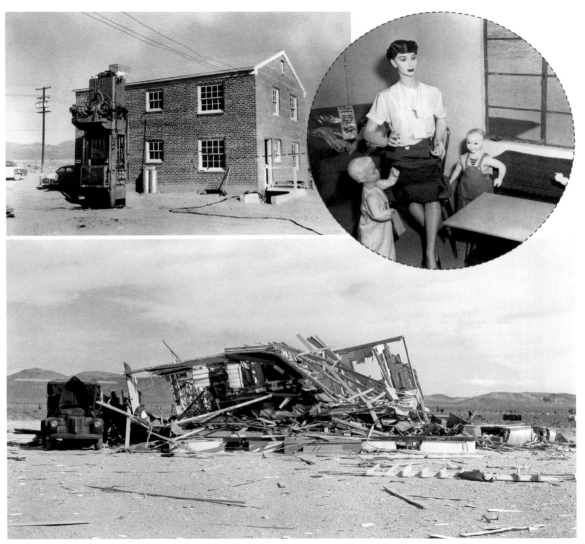

SEDAN CRATER

Of the 1035 subsidence craters peppering the NTS, none is more impressive than Sedan Crater. Code named Shot Storax, this 104-kiloton, underground explosion dislodged 12 million tons of earth, vaporized all surrounding bedrock, and ejected a 12,000 foot column of radioactive steam and dust into the atmosphere. As the blast cavity cooled, the decrease of interior pressure led to a structural collapse that resulted in a crater 320' deep with a diameter of 1280'. Storax Sedan was one of several dozen "Plowshare" tests conducted by the Atomic Energy Commission to investigate "peaceful" uses for atomic explosives that involved the shifting and moving of earth on a gargantuan scale. Peaceful Nuclear Explosions, or PNE's, would help excavation of mining operations, widen the Panama Canal, create enormous underground pathways for the harvest of natural gas, or blast mountains for irrigation and highway projects. Eventually all PNE testing was abandoned, as fine-tuning proved elusive and the consequential radioactive contamination rendered all projects too dangerous for practical applications.

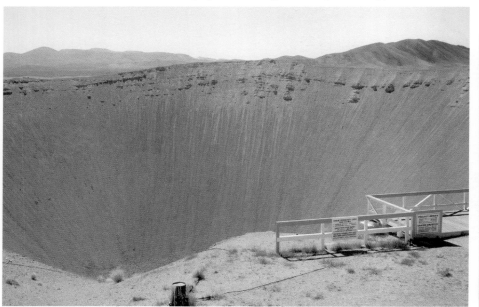

CENTRAL NEVADA TEST SITE

Designated as a supplementary proving ground for nuclear trials deemed too dangerous for the NTS, only one nuclear device was ever detonated at the Central Nevada Test Site (CNTS). Originally planned to be the first of a series of nuclear explosions, Project Faultless was a 1-megaton, calibration test intended to investigate the area's suitability, along with the scientific objective of gathering data on the different characteristics of nuclear versus natural, earthquake induced seismic signals. Unleashed in January of 1968 at a depth of 3200 feet and hoisting the ground surface nearly fifteen feet, the blast confirmed that the geologic character of the CNTS would not support large scale testing: contrary to its name, Faultless resulted in the creation of several mile-long faultlines, and an average vertical subsidence of nine feet over several square miles. All ensuing multi-megaton testing would be conducted in the exceedingly more remote Amchitka test site in Alaska.

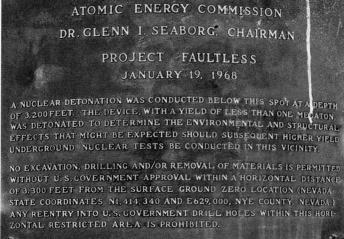

UNITED STATES
ATOMIC ENERGY COMMISSION
DR. GLENN I. SEABORG, CHAIRMAN

PROJECT FAULTLESS
JANUARY 19, 1968

A NUCLEAR DETONATION WAS CONDUCTED BELOW THIS SPOT AT A DEPTH OF 3,200 FEET. THE DEVICE, WITH A YIELD OF LESS THAN ONE MEGATON, WAS DETONATED TO DETERMINE THE ENVIRONMENTAL AND STRUCTURAL EFFECTS THAT MIGHT BE EXPECTED SHOULD SUBSEQUENT HIGHER YIELD UNDERGROUND NUCLEAR TESTS BE CONDUCTED IN THIS VICINITY.

NO EXCAVATION, DRILLING AND/OR REMOVAL OF MATERIALS IS PERMITTED WITHOUT U.S. GOVERNMENT APPROVAL WITHIN A HORIZONTAL DISTANCE OF 3,300 FEET FROM THE SURFACE GROUND ZERO LOCATION (NEVADA STATE COORDINATES N1,414,340 AND E629,000, NYE COUNTY, NEVADA). ANY REENTRY INTO U.S. GOVERNMENT DRILL HOLES WITHIN THIS HORIZONTAL RESTRICTED AREA IS PROHIBITED.

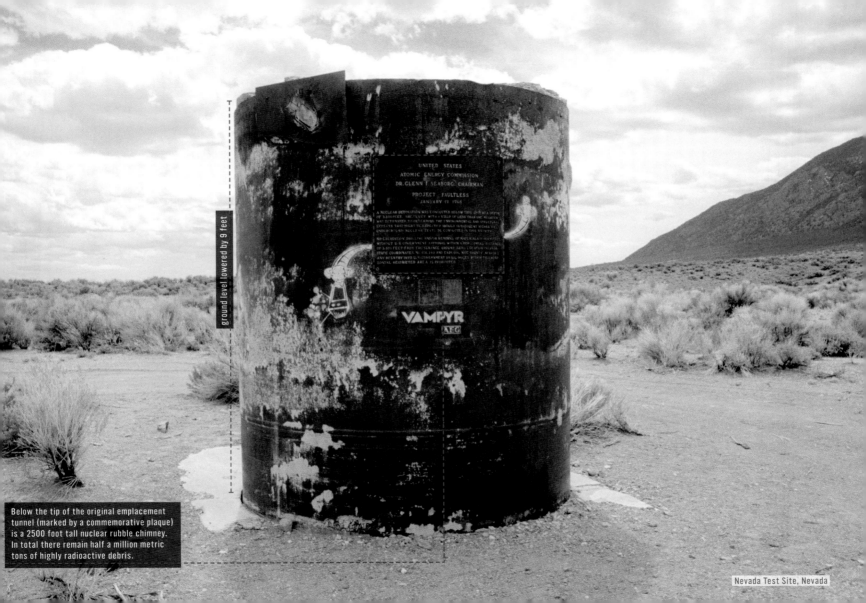

ground level lowered by 9 feet

UNITED STATES
ATOMIC ENERGY COMMISSION
DR. GLENN T. SEABORG, CHAIRMAN

PROJECT FAULTLESS
JANUARY 19, 1968

VAMPYR
AEG

Below the tip of the original emplacement
tunnel (marked by a commemorative plaque)
is a 2500 foot tall nuclear rubble chimney.
In total there remain half a million metric
tons of highly radioactive debris.

Nevada Test Site, Nevada

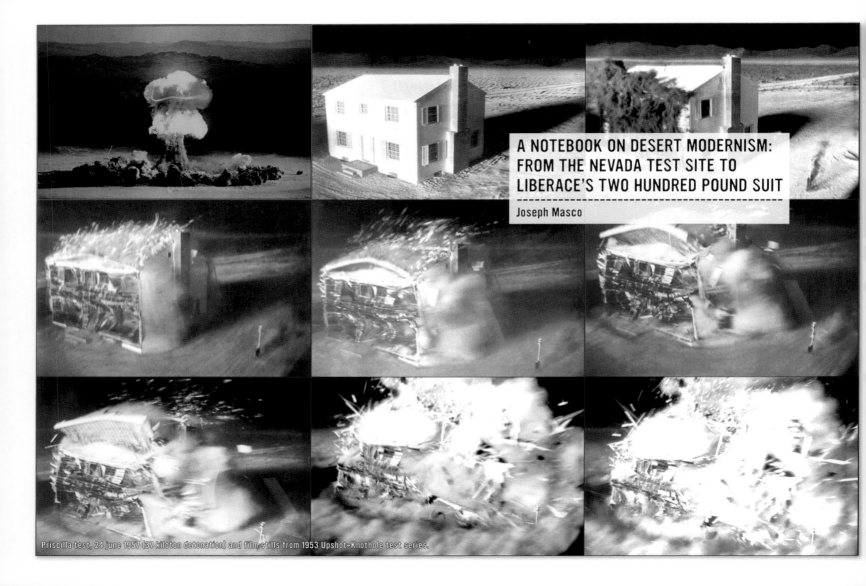

A NOTEBOOK ON DESERT MODERNISM: FROM THE NEVADA TEST SITE TO LIBERACE'S TWO HUNDRED POUND SUIT

Joseph Masco

Priscilla test, 24 june 1957 (37 kiloton detonation) and film stills from 1953 Upshot-Knothole test series.

The modern American desert is a place where curious things seem possible. It exists as (post)modernist frontier and as sacrifice zone, simultaneously a fantasy playground where individuals move to reinvent themselves on their own terms, and a technoscientific wasteland where many of the most dangerous projects of an industrial, militarized society are located. In the 20th century, the desert southwest has become a space of modernist excitement, where the challenge of an expansive wildness has been met by monumental efforts to dislocate its indigenous inhabitants, to redirect its rivers, to populate its interior with cities and roads, and to fill its air space with jet and missile contrails. Part neon oasis, the modern desert now dazzles with a phantasmagoria of electric lights, presenting monuments of distraction which offer up the wonder of the built for intimate comparison with that of the natural.

For those caught under the spell of American desert modernism, the desert can still take on the appearance of a pristine possibility, captivating American imaginations by offering citizens the hope of leaving behind the past in favor of an endlessly renewable frontier, forever open to new possibilities. This ability to reinscribe the desert West requires constant imaginative work, as the pursuit of utopian potential relies on a continual emptying out of the dystopian projects of the nuclear security state. This capacity to invest in monumental projects through practices of cognitive erasure, or "desert modernism," is a conceptual enterprise that perennially reinvents the desert as dreamspace for a spectacular idea of progress.

This migration away from self and nation is now doubly fraught, as refugees to the interior run head long into an equally imaginative military-industrial economy that constructs the desert as a hyper-regulated, national sacrifice zone, a "proving ground" for the super-secret, the deadly, and the toxic. In the slippages between the form and content of American desert modernism we can see how a careful crafting of appearances has been mobilized to endow everyday life with an epic quality. In the desert West, both citizens and officials have come to rely on tactical amnesias and temporal sutures to enable a precarious—if addictive—cosmology of progress, one fueled by high-octane combinations of risk, secrecy, utopian expectation and paranoid anxiety in everyday life.

The American desert is today a national-cultural arena in which the high modernism of the Cold War—sustained by a powerful belief in an unlimited possibility for self re-invention and an unending technological progress—circles back to confront itself in the everyday lives of nuclear weapon designers, tunnel engineers, conspiracy theorists, and sequined entertainers. As survivors of that expressive national performance known as the Cold War, which offered the delirious rush of participating in a universe-making or universe-breaking cosmology, desert dwellers are left to negotiate the accumulating residues of desert modernism, even as they mobilize to reinvent the future. The contradictions of a disable master narrative of progress now saturate everyday life with unruly new forms of imaginative agency, simultaneously exhilarating, excessive, apocalyptic—American.

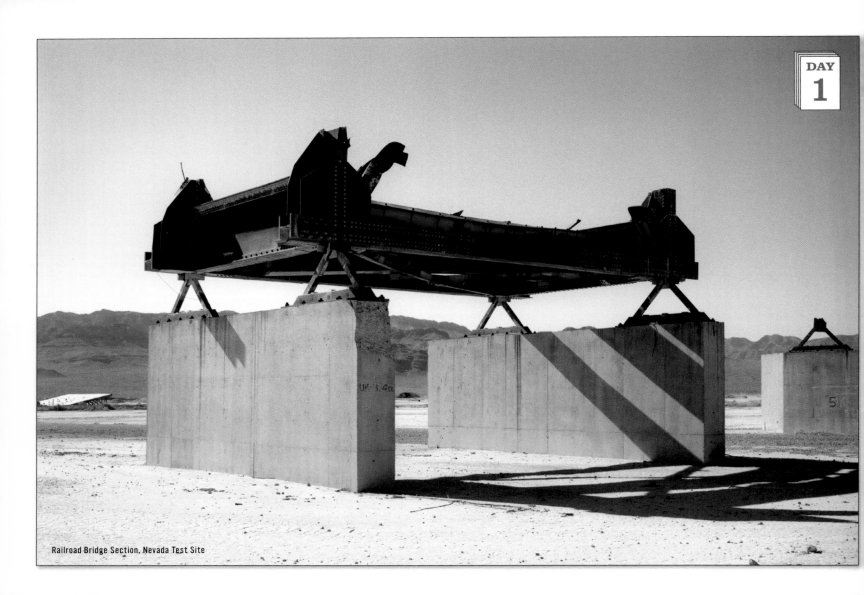

Railroad Bridge Section, Nevada Test Site

ON MYTHIC MASCULINITY:
THE NEVADA TEST SITE

Our guide is utterly charming.[1] A 35-year career at the Nevada Test Site (NTS) building detonating mechanisms for nuclear weapons has obviously been good to him. He carries himself today with the cool assurance of someone who has performed well at the center of an important national project, a Cold Warrior in the truest sense of the term. Even after the demise of the Soviet Union and while in retirement, he upholds the mission of the test site, educating the public about "what really went on," articulating the continued need for weapons of mass destruction, and reiterating the critical role the NTS plays in managing a global order of proliferating danger and constant threat. Physically strong, crystal clear in thought, and with a great sense of cowboy humor, our guide's manner is, in and of itself, a political counter to many of the popular images of weapons scientists, the NTS, and the nuclear security state. This is no Dr. Strangelove but more a very favorite story-telling relative.

Driving us through the NTS, he relates stories of Cold War excitement, pointing out project details: "that's Sedan Crater (Second biggest crater in the U.S.—part of the nonmilitary use of nuclear explosives program—astronauts trained there before going to the moon); that's the Chemical Spill Test Facility (the only place in the country where you can create a major toxic accident to study how to clean it up); that's the new Device Assembly Facility (it's got miles of underground tunnels—we can't go there)." He presents a seamless history of work at the test site, mediated by an understated, if undeniable, patriotism. I asked him when, in his experience, was the best moment to be working on nuclear weapons at the test site. "From 1962 to 1988," he replies without hesitation. This is the period from the implementation of the above ground nuclear test ban to the near collapse of the nuclear narrative in 1988, when revelations about the scope of environmental damage at places like Hanford, WA, Rocky Flats, CO, and Fernald, OH, brought heightened public suspicion and new regulatory restraints on work at the test site. During this 26-year period, the only pause he mentions in a narrative of pure techno-national progress was for President John F. Kennedy. "He was assassinated on a test day" he tells us, "we postponed the 'shot' for 24 hours in his memory, but then got back to work."

For our guide, working at the test site provided access to the very best minds in the world, the weapons scientists at the national laboratories (Los Alamos, Livermore, and Sandia), but it also demanded a constant negotiation of the military mindset. He confides that he had to put an Army Colonel or two in his place who didn't understand the technoscientific logistics of the test site. During one such confrontation, he simply pulled the detonating mechanism out of the nuclear device, placed it in the trunk of his car, and drove away—putting the whole multi-million dollar test on hold until *he* felt confident in its success. In the realm of Cold War masculinity the buck stops here. But it was also obviously so much fun. Our guide populates his stories with tales of adventure, of midnight helicopter rides across the desert test site, hints at secrets he's not allowed

to share, and reiterates the pleasures of commanding earth-shaking technoscience. "I could wreck 20,000 marriages," he proclaims, the isolation and excitement of nuclear science at the NTS creating a culture of hard work, drink, and (inter-marital) play. His commentary constantly registers the pleasure of the Cold War, the satisfaction of having a significant job, all the resources the nation-state could muster to support it, and a race with a real enemy to give military science meaning in everyday life.

Much of our tour focuses on remnants of the "weapons effects tests" from the 1950s, consisting of tanks, bridges, and buildings that were placed near a nuclear blast to see what would happen to them. The torn wreckage that remains documents a particular moment in the Cold War, when in order to understand how to fight a nuclear war with the Soviets, U.S. military officials actually waged one at the NTS. We look at twisted steel girders, whose original shape has been lost to the bomb and the shifting sands of the desert, and learn about kilo-tonnage and blast effects. But our guide continually emphasizes moments of survival over all. Ignoring that which was vaporized by the nuclear blast, he shows us a safe, which was filled with money, and used in a 1957 nuclear effects test called Priscilla. The building was completely destroyed by the 37-kiloton explosion, but the safe and the money inside it, he notes with clear satisfaction, came through just fine. (This was an important discovery in the early days of the Cold War: the monetary system might just survive a nuclear exchange after all.)

Next we visit the nuclear waste storage site at the NTS, which consists of an enormous trench filled with neatly stacked wooden boxes and metal drums filled with radioactive refuse. In the accompanying office building, we immediately encounter a poster board presentation detailing how site workers mobilized to relocate a family of foxes that were living inside the nuclear waste dump. Thus, while asking questions about radioactive waste and pondering the 100,000-year threat posed by some nuclear materials at the NTS, we are presented with images of baby foxes and overtly documented signs of worker environmentalism. When we ask about radiation contamination, our guide steps in to say that he has walked "every inch of this site" and suffered "no ill effects." Here his own vitality is used as political commentary: 35-years at the test site without a cancer. Yes, there is some contamination at the test site, he acknowledges, but it is readily contained by the desert and poses no risk to the public. He soon counters the reference to radioactive contamination with a story about a rattlesnake that attacked him one day while he was wandering the test site. It bit into his cowboy boot and wouldn't let go. He fought back and then had the boots—snake included—bronzed. Dangers at the test site, in his presentation, are natural or international but not radioactive or technoscientific—*that's* well under control.

Our final stop on the tour is the Apple II site, where the U.S. military built a "typical" American suburb in 1955 for the sole purpose of detonating a nuclear bomb on it. A fire station,

a school, a radio station, a library, as well as a dozen homes were built, and furnished with everyday items (televisions, refrigerators, furniture, carpets, and linens). They were then stocked with food, populated with white skinned mannequins and neatly incinerated. Today, two remnants of the test remain: a brick ruin and what looks like an abandoned wooden house. Our guide describes the latter as "a real fixer-upper," but soon suggests that it wouldn't take much work to bring the house back to life after all. This is a curious place; the only real sign that something dramatic happened here is that the brick chimney is significantly cracked and wildly off center, suggesting a powerful blast but only hinting at the force of the 29-kiloton bomb that was detonated one mile away; it vaporized the rest of "survival town." After the explosion, scientists held a feast in which they ate the food that survived the test, again as our guide informs us, "suffering no ill effects." The food had been flown into the NTS by special military charter from Chicago and had been neatly laid out on kitchen tables before the test. In the serious play of the test site, this was a kind of reverse last supper, where any signs of life after the nuclear explosion were celebrated as an absolute victory.

I ask our guide if the U.S. could survive a nuclear war. "Oh, yes I believe we could," he replies confidently, but at another moment he seems unsure, stating that a nuclear war would be, of course, an "act of insanity—the end of everything." This is the only ambiguity in a nearly perfect performance, a slight slippage about what the end would look like.

The seamlessness of his narrative, in fact, is a register of his Cold War discipline: he neither confirms nor denies anything that makes work at the NTS suspect. To that end, he focuses on certain historical events in our tour, while scrupulously avoiding others. His history of the test site, for example, is largely restricted to the era of above ground nuclear testing (1951–1962), after which testing—and most of the *visual* consequences of nuclear explosions—went underground. This was, however, also the era of the most extreme environmental damage, when studies of nuclear blast effects included experiments not only on banks, tanks, houses, and airplanes, but also on soldiers (ordered to march into fallout clouds) and on civilians (hit by the fallout from this era of nuclear testing). We know now that most of the continental U.S. was covered with radioactive fallout from above ground testing at the NTS, contributing significantly to national thyroid cancer rates. But when I ask about fallout he simply states, "that was before my time" and moves on in his narrative.

But isn't this simply desert modernism in its purest form, a profound belief in the possibility of an unending, and conceptually clean progress, but one only made possible by tactical amnesias and sublimated technophilia? The Cold War nuclear complex required a constant surveillance and regulating of discourse to retain its narrative purity. For just as the desert constantly threatens to overrun the activities of the test site, introducing weeds and blowing sand where shiny metal should be, the cosmology of the Cold Warrior required a constant

self-monitoring, a patrolling of the cognitive field, to prevent multiplicity or ambiguity from taking root. As we leave the NTS, I ask our guide about the future of nuclear weapons after the Cold War. He states unequivocally that the U.S. will need to return to nuclear testing, that a world without an active NTS producing new and improved nuclear weapons is a more dangerous and uncertain world. "The Soviets" he states, then correcting himself with private half-smile that we hadn't seen previously, "I mean Russians" are still unpredictable and dangerous.

Our guide reiterates that developing nuclear weapons is a means of protecting the "free world," a means of producing stability and security in everyday life. However, his narrative does not acknowledge the local consequences of nuclear testing or assess the legacy of nuclear waste produced by that mission—in a perceived fight to the death one doesn't have time to think about such things. Historical displacement and tactical erasure have enabled a strategic re-narration of America's nuclear powered national security in his presentation. Thus, the signs of nuclear nationalism revealed to us in our tour, are not drawn from the current nuclear complex, which is busily re-inventing itself and prospering in a post-Cold War world, but are instead a displaced and carefully edited reiteration of 1950s nuclear culture. By the end of our visit to the NTS, it's difficult not to conclude that nuclear weapons, despite our guide's proclama-tions about the future, are now located in the past, part of an abandoned project likely to be completely reclaimed by the desert sands. We've seen no real evidence that nuclear weapons remain the foundation of U.S. national security or a multi-billion-dollar a year operation in the U.S., with budgets exceeding height of the Cold War levels in 1997. The vast desert landscape of the test site, combined with the aged quality of the buildings we visit, and the lack of any substantive sign of ongoing nuclear science, reduce the scale of the nuclear project at the NTS, and seemingly, its claim on the future.

In the end, this may be a public relations tactic (a strategy to reduce public concern about activities at the test site during a time of institutional change), but it might also be one structural effect of desert modernism. For it might well be that those inhabiting the center of this kind of techno-national project cannot assess their own history, or terms for being, nor recognize their own historical excess. For that we might have to look more closely at the borders, look to neighboring communities that live with the effects of nuclear nationalism but are excluded from the internal logics of the national security state. In other words, we might have to turn to those who reflect back the mission of the NTS but who do so from radically different perspectives, revealing nuclear weapons science at the NTS to be productive of far more than a particular form of international relations.

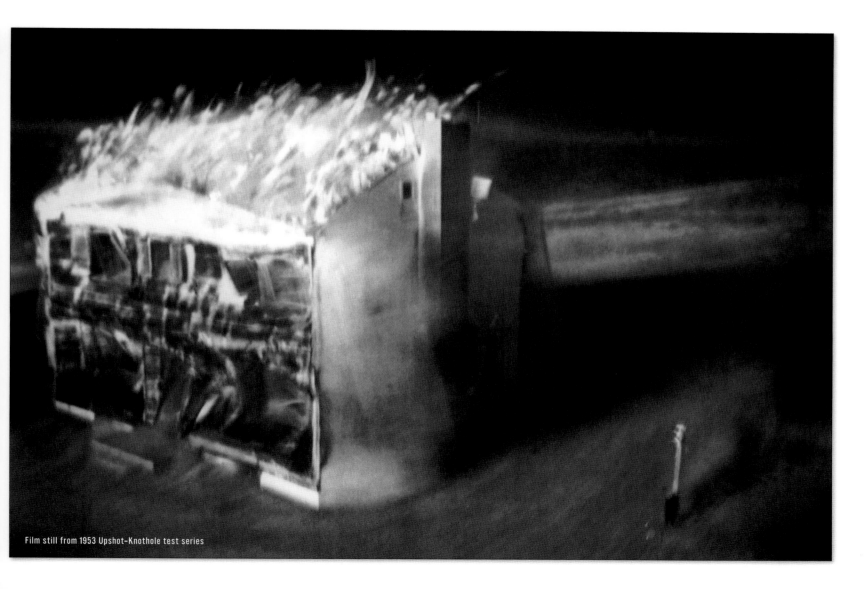

Film still from 1953 Upshot-Knothole test series

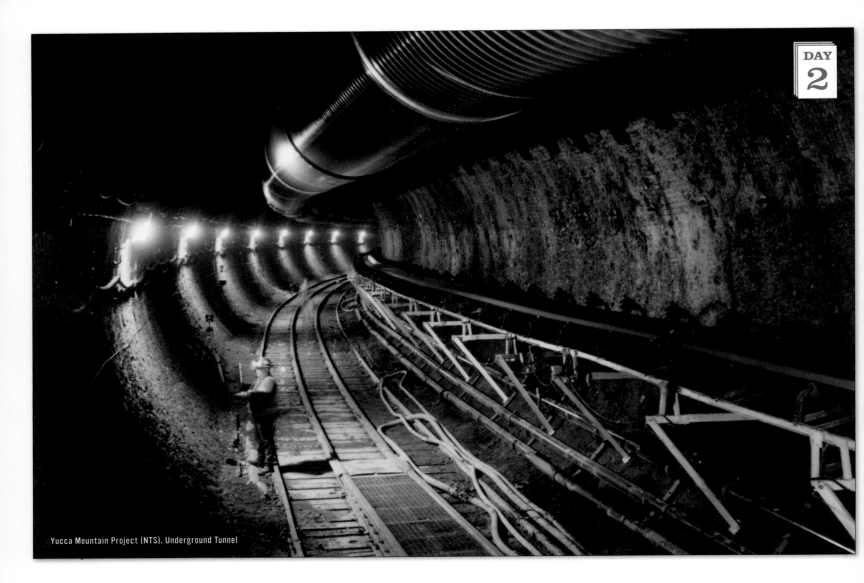

DAY
2

Yucca Mountain Project (NTS), Underground Tunnel

ON THE POETICS OF ROCK BOLTS
THE YUCCA MOUNTAIN PROJECT

On the western periphery of the Nevada Test Site, overlooking the desert proving grounds where nuclear devices were detonated throughout the Cold War, is Yucca Mountain, which is currently in preparation to become the principal nuclear waste storage site in the United States.[2] If the narrative of weapons scientists at the NTS presents desert modernism in its positive form (that is, still invested in a conceptually pure narrative of progress), then the Yucca Mountain Project represents its flip-side, an arena where the dream space of absolute technical mastery and control of nature slips out of joint, revealing other processes also to be at work. For in this mountain, a spiritual center for the displaced indigenous cultures of the desert Southwest, the industrial waste of a nuclear powered state proves to be uncontainable, exceeding the power of the nation-state that produced it to predict its future effects. From a distant coast, the Department of Energy has ruled that any permanent nuclear waste depository in the U.S. must have an operative plan that would make it safe for 10,000 years. Such a plan is unprecedented in human history, though still accounting for only a fraction of the life span of the most dangerous nuclear materials, which will remain radioactive for hundreds of thousands of years. Nevertheless—*a 10,000-year safety plan*—consider the astonishing confidence this regulation reveals, as well as the certainty it registers about the future and the eternal reliability of the nation-state.

We arrive at Yucca Mountain from Las Vegas at mid-morning, just in time for a safety lecture before plunging into the thirty-foot diameter cave that U-turns in a great arch through the center of the mountain. We don red hard-hats, put on huge fluorescent orange earplugs, eye protection, and strap an emergency-breathing filter around our waists. We have been told to wear long sleeve shirts and good shoes, and are now briefed on emergency procedures. We are told that in case of a fire we should use our breathing filters even though they might scorch our lungs. Weighted down with our awkward new gear, we move slowly pass the work trucks, and walk single file along the railway tracks into the darkness of the tunnel. Deafening machine noise mixed with the long shadows produced by artificial light and the smell of stale earth greet us. We walk about 75 yards into the mountain and move into a large chamber off the main tunnel.

Here, we meet the tunnel engineer, a middle-aged man who wears his protective gear with practiced ease, and learn about the technical aspects of the Yucca Mountain Project. He explains to us how the waste is to be shipped to the site in barrels, where and how it will be stacked within the mountain, as well as contingencies for retrieving specific barrels once

stored. Our tunnel engineer is nervous talking with us, the intense politics around the Yucca Mountain Project having undoubtedly brought many confrontations to his workplace.

He immediately has my sympathy, for he is not a public relations expert or a nuclear policy maker; he builds things, tunnels to be precise. Shouting over the machine noise echoing through the mile-long project, he seems to be most comfortable providing technical information about the tunnel itself which he does in great detail. Eventually, our attention moves to the chamber walls and ceiling, which are covered with countless metal spikes, secured by netting. It looks as though project engineers feared that the entire surface of the cave might crumble and sought to shore it up with hundreds of metal spikes each set about a foot apart. A strange place for a public conversation about nuclear safely, the overwrought performance of the cave begs immediate questions about the nature of its technology as well as its long-term stability.

The engineer, who has seemed tentative up to this point in our conversation, lights up with a newfound enthusiasm to our questions. "Well you see, there are two kinds of rock: good rock and bad rock. This is bad rock." We learn that "bad" rock is that which crumbles and needs mechanical reinforcement, while "good" rock is internally stable and reliable from an engineering point of view. Yucca Mountain, he tells us,

has both good and bad rock, and the tunnel has been engineered through use of rock bolts to compensate for both. "There are three different kinds of rock bolts," the tunnel engineer offers, and then, in a moment of technoscientific reverie, proceeds to introduce us to the engineering cosmology of the rock bolt. In the next few minutes, we learn that rock bolts differ by length, by thickness, by head type and by means of insertion. Some can be removed, some can't. Some are stronger than others and are used on certain kinds of rock, but not on others. We learn that rock bolts are a very important technology and that this tunnel is largely dependent upon them. With alarming ease, in fact, all the debates about the scientific viability of Yucca Mountain as a nuclear waste site, the 20-plus years of acrimonious technical and political debate, the hundreds of thousands of pages of technical reports that argue with specificity the potential risks and advantages of the site, the entire 10,000 year modernist plan for ensuring safety at the site, are reduced to the (conceptual and engineering) power of the rock bolt. Rock bolts, a brilliantly simple technology, present desert modernism in its primordial form, for they seem to offer the possibility of holding Yucca Mountain together, of disciplining the earth itself through the millennia.

I ask the tunnel engineer if the 10,000-year safety plan required by federal law for the Yucca Mountain Project has

affected his engineering in any way, if it has made this tunnel different or more difficult than other tunnels he has built. "No, it hasn't," he replies testily. Startled by his answer, I continue: "Do you ever feel like you are building something for the ages here, like the pyramids in Egypt, because it will last for thousands of years?" "I don't like to think about those kinds of things" he replies. Then, looking me directly in the eyes, he says, "I'll guarantee this tunnel for 100 years. After that I hope they'll have someplace else to put this stuff." *After that I hope they'll have someplace else to put this stuff.* It soon becomes clear that the tunnel engineers do not believe the 10,000-year plan is attainable. In fact, they readily dismiss the 10,000-year program as a product of a political, not a technoscientific, process. We also learn from our guide that Yucca Mountain is on top of several major fault lines and that the underground water supply for much of the southwest runs underneath the project. Neither our guide nor our tunnel engineer will say that Yucca Mountain is a good place to permanently store nuclear waste; they just say it will happen and that much of the reason for it is politics: there is simply nowhere else to put the nation's radioactive garbage. As the zeros drop off the 10,000-year master plan, the Yucca Mountain Project assumes for many of us the appearance of a national hoax, and its desert modernism once seemingly perfected fractures unredeemably.

We leave Yucca Mountain knowing that the 10,000-year safety plan maintains a very public secret. The narrative of absolute technical mastery and control of nature, propagated by work on nuclear weapons at the NTS and now necessary to legitimate the power of the state to deal with its nuclear waste, is revealed to be a political tactic at Yucca Mountain and not a technoscientific reality. The excesses of nuclear nationalism, the tons of nuclear waste located all around the country, thus remain unpredictable despite the rhetorical effort by the state to contain them within a 10,000-year institutional plan. What will happen a thousand years from now at Yucca Mountain, and who will be around to watch over the radioactive waste of the 20th century? Can we imagine a nation-state that lasts 1,000 years, let alone 10,000?

Leaving the Iron Age technology of the rock bolt to grapple with the unpredictable products of the Nuclear Age, the future is being re-invented at Yucca Mountain. The nuclear apocalypticism of the Cold War, the fear of a sudden fiery end that propelled nuclear weapons science and the creation of deterrence theory, assumed that the nation was going to end abruptly with a nuclear flash, requiring radical action in the here and now. The Yucca Mountain Project, however, now assumes an eternal nation-state, one that will diligently uphold 20th-century laws, and watch over 20th-century nuclear waste, across the millennia.

Thus, the nuclear waste storage project at Yucca Mountain is where the desert modernism of the NTS formally confronts its own apocalyptic excess, and in an effort to control that excess, is expanded—exponentially—to the point of self-contradiction and failure. The same modernist logic that made the nuclear complex blind to its own waste in the first place, to nuclear contamination in all its forms, continues to inform the Yucca Mountain Project, which is now attempting a massive compensation for the unprecedented physical effects of the Cold War nuclear complex by maintaining the fiction of a 10,000-year operative plan.

But in the American desert, reality is not only mandated by modernist planning and official discourse, but also by wild processes. Over the millennia Yucca Mountain is an object in motion, a living being, subject to tectonic shifts, erosion, and unseen planetary forces. In the Yucca Mountain Project we see desert modernism transformed into a new kind of mystic vision, an arena in which human control is assumed to be eternal, even as our tunnel engineer articulates the tenuous power of the rock bolt, as emblem, exemplar, and limit of modernity. The poetic call of the rock bolt may be the conceptual limit of Yucca Mountain, but the logic that supports it—the search for a master narrative that denies the uncontainability of the future—proliferates in modern American life, and like the unpredictable course of nuclear materials, radiates, catching individuals outside the center in its mutating glow.

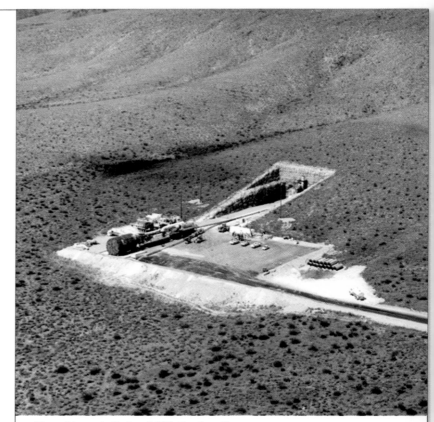

Yucca Mountain Project (NTS), Southern Entrance

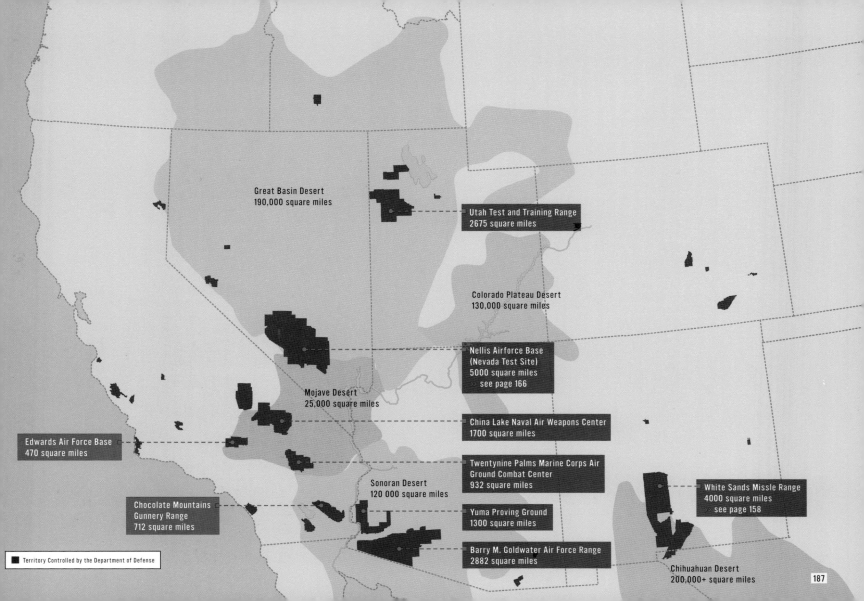

Great Basin Desert
190,000 square miles

Utah Test and Training Range
2675 square miles

Colorado Plateau Desert
130,000 square miles

Nellis Airforce Base
(Nevada Test Site)
5000 square miles
see page 166

Mojave Desert
25,000 square miles

China Lake Naval Air Weapons Center
1700 square miles

Edwards Air Force Base
470 square miles

Twentynine Palms Marine Corps Air
Ground Combat Center
932 square miles

White Sands Missle Range
4000 square miles
see page 158

Sonoran Desert
120 000 square miles

Chocolate Mountains
Gunnery Range
712 square miles

Yuma Proving Ground
1300 square miles

Barry M. Goldwater Air Force Range
2882 square miles

Chihuahuan Desert
200,000+ square miles

Territory Controlled by the Department of Defense

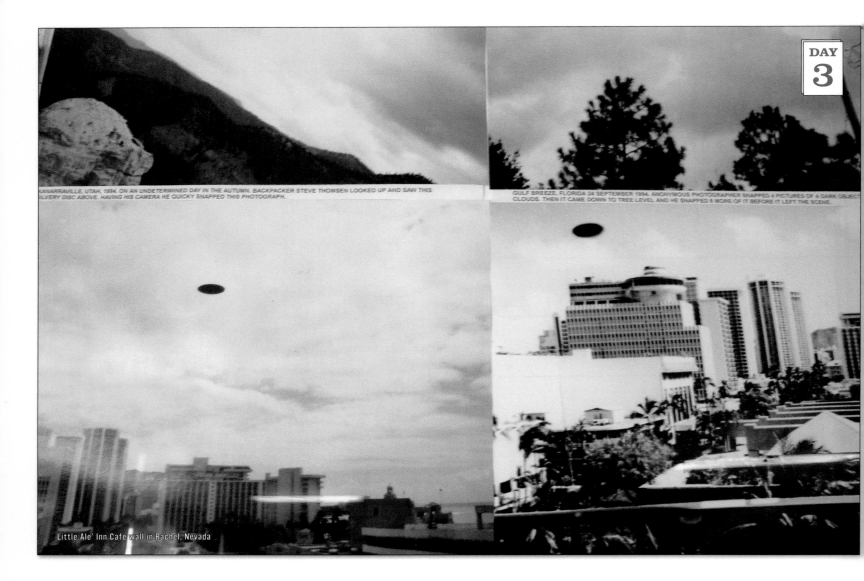

KANARRAVILLE, UTAH, 1994. ON AN UNDETERMINED DAY IN THE AUTUMN. BACKPACKER STEVE THOMSEN LOOKED UP AND SAW THIS SILVERY DISC ABOVE. HAVING HIS CAMERA HE QUICKY SNAPPED THIS PHOTOGRAPH.

GULF BREEZE, FLORIDA 24 SEPTEMBER 1994. ANONYMOUS PHOTOGRAPHER SNAPPED 4 PICTURES OF A DARK OBJECT CLOUDS. THEN IT CAME DOWN TO TREE LEVEL AND HE SNAPPED 5 MORE OF IT BEFORE IT LEFT THE SCENE.

Little Ale' Inn Cafe wall in Rachel, Nevada

PARANOID SURVEILLANCE:
RACHEL

If nuclearism at the Nevada Test Site represents the center of a certain kind of modernist planning, of big science protected and enabled by government secrecy, what is it like to live on the outside, to be surrounded by nuclear nationalism but to be denied access to its internal logics or lines of power?[3] One need drive only 90 minutes north of Las Vegas to find just such an outpost on the frontier of desert modernism. In the little town of Rachel, which consists of a dozen or so mobile homes parked on the side of a two-lane desert highway, one encounters an important cultural side effect of Cold War military technoscience. Apparently surrounded by wilderness, the desert calm of Rachel – population 100 – is broken primarily by the military aircraft that fly overhead from Nellis Air Force base, the Nevada Test Site, and the mysterious Area 51, also known as Dreamland, where Stealth Fighter technology was covertly invented, some locals say, by a process of reverse engineering crashed UFOs. On the outer periphery of military-industrial airspace, Rachel is a center for conspiracy theorists and UFO believers, a point of pilgrimage for those caught up in another aspect of American desert modernism. In Rachel an important cultural legacy of the Cold War intermingling of secrecy, security, and science at the NTS becomes visible. Indeed, we can see in Rachel how a century of revolutionary technological progress has combined with a half century of intense government secrecy to permeate everyday life, encouraging those on the periphery to assume the existence of a secret master narrative that controls everything, one that is busy regulating and re-inventing the terms of existence from a hidden center of power.

We go into the Little Ale'Inn Cafe, where you can buy conspiracy theory and a hamburger. The walls are covered with hundreds of photographs of fuzzy disk-shaped things that might be space ships, and talk here frequently turns to tracking the signs of cover up, of misinformation, of why "they" are here and "what's going on." Here you can discuss government black budgets, and black helicopters: are they disguised UFOs or part of a covert military project? You can explore the latest theories on cattle mutilations in the desert West or on human abductions, covert genetic experimentation, and the coming New World Orders. Who is secretly behind the United Nations, the International Monetary Fund, and the Trilateral Commission, and when will they reveal their true purpose? Was the Cold War really a battle with the Soviets or merely a way for both countries to secretly arm themselves against an invading extraterrestrial source? Is the current fascination with UFOs a giant misinformation campaign to hide *The Truth* or is the government slowly preparing us for news that *They* have been here for a long, long time? Whose soldiers are training under the cover of the desert night and using that vast underground network of tunnels connecting U.S. military sites to stay hidden during the daytime? Why did JFK need

to be silenced, and which government entity invented AIDS? And above all—what's coming next?

While we eat lunch in the cafe and discuss the strange desert context of life in Rachel (a curious mix of pure Americana and paranoid utopia), a conspiracy theorist takes center stage, literally. He begins singing country western songs over a microphone while playing an electric organ. One of the two waitresses joins him for a song. They are having a good time, and the public space has been made intimate by their performance. Between tunes, he introduces himself and spins a conspiracy.

I recognize him, having seen one of his self-financed videos on UFOs. On tape he argues that all UFO sightings are masterminded by an "international cabal" of men who are planning to take over the world. UFOs, he believes, are human-made, a ruse to distract people from the real conspiracy, from the men who are positioning themselves to take control of everyday life and implement a "new world order." He warns that sometime in the late-1990s a "major UFO incident" will be staged at Area 51, a carefully planned media distraction to enable the global take over. Today, he has some new information he wants to share, identifying perhaps the first salvo in this upcoming campaign of public misdirection and conspiracy. He holds up an 11-by-14 inch color photograph, an aerial image of a parking lot, which is surrounded by trees, and populated with several olive-green U.S. army vehicles and one discordant bright yellow Ryder

moving van. "This photograph was taken in April of 1995 at a military base near Oklahoma City a few days before the Oklahoma City bombing." Then he holds up another photograph of the same parking lot, same visual perspective, same olive-greed army jeeps but no Ryder Moving Van. "This photograph was taken a few days after the Oklahoma City bombing. Now, I think this is very interesting. Now what is a Ryder moving van doing in a military parking lot? I'm not saying the government was directly involved in the bombing of the Oklahoma federal building, but I think this is very interesting. Before the bombing of the Murrah Federal building there is a Ryder van on the military base, and after, it is gone. I think this is very significant..." Having set the conspiratorial narrative in motion, he returns to his music, leaving his audience to contemplate what it would mean to their everyday lives if a secret organization with access to U.S. Army facilities had bombed a U.S. federal building and implicated a white supremacy group for the crime as part of a calculated plan to take over the world.

Conspiracy theorists are one of the unexpected side effects of the desert modernism pursued at the NTS and Area 51. Excluded from the internal logics of state power, but well aware of the effects of these military sites—nuclear fallout, a militarized space, lights in the night sky—conspiracy theorists mobilize to fill in the gaps in their knowledge. The conspiracy theorist patrols everyday life for the signs of a hidden master narrative, a master narrative that he

endlessly constructs out of the strange details of modern life, attempting to make visible that which is hidden, making rational the national cultural excesses within desert modernism. The very lack of proof becomes evidence of conspiracy as the personal observations of a vast cross-section of America sees that which the government denies. The people of Rachel, for example, live only a few miles from Area 51, a military base that everyone knows about. Some residents have even worked at the base and trace their current health problems to toxic exposures on the job. For years, one of the best, and most readily available, photographs of Area 51 was made by a Cold war era Soviet surveillance satellite. Yet despite the worker histories and the toxic lawsuits, the Soviet photographs and a significant presence in American popular culture (as for example, in the film *Independence Day*), the U.S. Air Force will only acknowledge an "operational presence" in the Groom Lake area.[4] Officially, Area 51 does not exist.

For citizens in Rachel, the engine of modernity has become a giant conspiracy, requiring those who want to "live free" in the desert West to track the signs of military-industrial life that impinge upon everyday life, and search for the truth behind the cover-up and misinformation. It should not be surprising that places like Rachel exist. A half-century of government policy to "neither confirm nor deny" questions about nuclear nationalism has forced the question of "security" to remain open and unanswered. An ironic effect, the effort to control technical information about military science in a world of competing nation-states, has produced a proliferating discursive field where citizens who confront the effects of nuclear nationalism are left to rely on their own imagination for information. The reality of black budgets and apocalyptic technologies, the possibilities of a 10,000 year safety plan and its obvious propaganda, the history of nuclear fallout and covert human plutonium experiments on U.S. citizens, and always the wild new technologies that arrive unannounced (especially during war time), all of these realities have demonstrated that government planning can indeed take the shape of conspiracy. The problem in Rachel is how to negotiate that knowledge, how to resolve the effects on everyday life of living side-by-side with covert and dangerous government projects, how to make sense of it all with only the peripheral effects and those strange lights in the sky as muse. In this way, the citizens of Rachel present merely the displaced mirror-image of nuclear nationalism, for the logics informing work at the NTS, Yucca Mountain, Area 51 and life in Rachel all assume that the world is ultimately knowable, that there are no coincidences in modernity, and that careful observation of the details of everyday life can reveal the hidden master-narrative of existence. This fixation on the scripting of appearances in the desert West, however, now exceeds the logics of the national security state, evolving into an resilient new kind of American expressive culture —apocalyptic, narcissistic, sensational.

"Too much of a good thing is wonderful."
Liberace

Liberace Live

DELIRIOUS EXCESS:
LAS VEGAS

One of the most remarkable attributes of the Nevada Test Site is its location. Founded on the need for concealment (of military technoscience and environmental ruin) it is nonetheless bordered by the one city in the world most famous for its embrace of extravagant public display. Contrary to the NTS, where every act is supposedly regulated by a national security state, and where the foremost experience of place involves fences, gates, and guards, Las Vegas is known as the town where quite literally "anything goes" (gambling, prostitution, the Mafia), a place where there are few barriers to the imagination and the nation-state is somehow conceptually absent. If there is a seam in the structure of desert modernity that links the introverted world of the NTS and the extroverted world of Las Vegas, it should be visible in any number of sites, but perhaps most powerfully in the cultural exemplars of Las Vegas itself. We enter just such a site on day four of our tour through the afterimages of American Cold War culture, the Liberace Museum, which is located in a shopping complex just off Tropicana Avenue. Inside this museum/shrine, one can move through room after room filled with the material traces of a Cold War life uniquely devoted to visual excess. Near the end of our visit, our senses increasingly dulled and bored with ostentatious display, we are nevertheless stopped dead in our tracks, caught in the shimmering reflection of a room filled with an entirely new form of desert modernism.

Dazzled by the sheer visual power of tens of millions of glimmering sequins, we stare at Liberace's fantastic suits, and are forced to contemplate how Liberace, and the broader Las Vegas culture of excess he embodies, participates in the desert modernism of the Cold War.

As one of the most popular attractions in Las Vegas, the Liberace Museum, which houses the entertainer's famous costumes, his jewel-encrusted pianos and candelabras, his custom built cars, and other mementos from a career that resides within the temporal limits of the Cold War, provides a unique window into American Cold War culture. Indeed, Liberace, Las Vegas, and the Nevada Test Site (NTS) were structurally linked right from the very beginning. The NTS opened in 1951, about the time Liberace first played Las Vegas, and by the mid-1950s the two biggest shows in Nevada were the nuclear explosions at the test site and Liberace, who by then was making $50,000 a week at the brand new Riviera casino performing in a black tuxedo jacket studded with 1,328,000 shimmering sequins. We can begin to see here how the serious politics of concealment at the NTS and the seemingly frivolous politics of display in Las Vegas are mutually reinforcing, sharing in a common modernity. Indeed, a favorite pastime of that era was to take a cocktail to the top of a Las Vegas casino in the early morning hours, and from that vantage point search the northern horizon for a flash of light or the shape of a mushroom cloud emanating from the test site, and thereby offer a toast

193

to America's ascendancy to superpower status. Could it possibly be that Liberace, whose career is a both a Cold War and a Las Vegas artifact, never partook in that premier spectacle of the nuclear age?

Whereas the public/secret world of the desert nuclear complex, as we have seen, denies its own excess, the public/private world Liberace created so successfully for himself delights in presenting a delirious excess. Linked with that other icon of Cold War masculinity, JFK, Liberace's fame was, in part, drawn not only from a public fascination with his sexuality, but also from the explicit constructedness of his public persona, which constantly offered audiences the chance to participate in the act of its construction. Living at a moment when to be gay was to occupy the structural position of the communist in the U.S. (and therefore to be subject to all the assaults of the McCarthy Era), Liberace successfully sued newspapers that questioned his heterosexuality in print, even as he lived with male partners. [And we might note here, that is was only in 1993 that U.S. security clearance guidelines for those working within the nuclear complex were revised to take homosexuality off the list of things that make a potential employee, by definition, a national security risk.] Liberace's over-the-top stage performances and fantastic costumes, however, constantly registered his acute awareness of the normalizing structures in Cold War life, and his charm was, in part, how explicit his scripting of appearance was, enabling audience after audience to enjoy his overt class transgressions and mimetic gender play without feeling in any way challenged by them.

In the realm of Cold War masculinity, Liberace's life reveals something important, both inverting an imagined white, heterosexual norm, and through expressive cultural performance, becoming a site of release, where the excesses of Cold War identity politics were put on stage and manipulated for pleasure. As an intensely private person, who paradoxically made a living displaying himself as spectacle, Liberace rejected the Cold War logics of white, middle class masculinity that emphasized self sacrifice and capitalist production above all. This is evident both in his stage persona and in the nature of his musical performance. Liberace co-mingled musical genres, high classical and contemporary popular music, in his stage show, cutting and pasting musical types as a gag. Mixing works by Listz, Chopin and Debussy with the "Beer Barrel Polka" and "Cement Mixer (Put-ti Put-it)" Liberace played with the division between classical and popular music, and showed a keen attention to the power of transgressing, and marking the artificiality, of such boundaries. In his early performances, one of Liberace's famous acts was to play duets with recordings of famous classical pianists on stage. His perfect bodily synchronization with the virtuoso recordings of Vladamir Horowitz, Arthur Rubinstein, and other classical artists, demonstrated for all his musical technique, but also his ability to mimic official culture, thus drawing attention to the constructed

discourse of high classical art. His fantastic financial success, and his unrelenting public display of wealth, cut against serious logics of Cold War consumption and suggested that money could be fun. Not tied to "serious" art production, mocking notions of class standing, rejecting the need to produce a traditional "nuclear" family (the most prominent woman in his life remained his mother who was ritually evoked in every performance), while ridiculing Cold War notions of utilitarian consumption through his baroque life style, Liberace offered relief from the seriousness of the Cold War nuclear standoff, while nonetheless sharing in its (desert) modernity.

So, one need not be a conspiracy theorist to wonder today at the vast global intrigue that must have been in place to bring down two exemplars of Cold War masculinity on that same November night in 1963. As news of John F. Kennedy's assassination swept the nation, Liberace promised to put special energy into that evening's performance to console his audience. However, his own life was soon put into jeopardy by his fabulous wardrobe—which, quite simply, tried to kill him. In the midst of that evening's memorial performance and while the nation mourned, Liberace collapsed, having been poisoned by the dry cleaning chemicals used in his costumes. The toxic shock brought on by the chemicals took Liberace into complete kidney failure. Unconscious, and on life support, he was eventually given last rites, and thought lost.

In its pure form, I've suggested, desert modernism is necessarily blind to its own excess. And just as the toxins produced by the nuclear complex are somehow conceptually absent from the narrative of our nuclear weapons scientist at the NTS, so too was Liberace's brush with a toxic death taken by him not as an invitation for critique, requiring at least a moment of reflection, but instead as a new authorization of his act. Liberace claimed afterward that in a vision, a white robed nun had not only healed him, but had actually blessed his love of opulent display. After this near-death experience, his outfits only got more lavish, and he embraced his love of visual excess with no restraint. Indeed, Liberace sought to re-invent himself with each new costume, and was soon fighting a Cold War of his own with entertainers like Elvis Presley and other Las Vegas super-powers for command of the most over-the-top performance. Liberace's love of sequins continued to escalate; and by the 1970s, his sequined outfits had attained truly epic proportions—often weighing over two hundred pounds. Sequins serve no purpose other than to be pretty. But consider their power when sewn together in the hundreds of thousands; they shimmer brilliantly, becoming luminous. To achieve this visual effect, Liberace performed nightly in sequined suits that could, like his poisonous outfits, certainly kill him. The nature of this public display, its perilous tightrope act, was always a meta-commentary on Liberace himself, who was always on the verge of crashing, of turning into a spectacular ruin. In this

light, his Las Vegas career provides an index of American Cold War culture, in which the hyper-production of nuclear weapons (70,000 in all, enough to destroy every city on the planet dozens of times over) also registered a national fascination with excess and display, and involved a precarious dance with death. The shared nature of this desert modernism allowed Liberace's stage performances in Las Vegas and the serious work at the NTS to mirror-image each other, as both provided distractions from the desert landscape (and from each other) through specific forms of techno-social power. It is important to remember that (after Hiroshima and Nagasaki) the U.S. nuclear arsenal was officially designed never to be used; it was intended merely to display American might to the Soviets and thereby to be a tool in foreign relations. Thus, the Cold War nuclear explosions at the NTS were not merely tests, *they were the entire performance*, communicating to the world the U.S. possession of, and commitment to, weapons of mass destruction. From this perspective, the Cold War logics of "containment" that energized the U.S. nuclear economy also produced a powerful scripting of appearance that today can be read as a kind of expressive national cultural performance. To suggest that Liberace shared in the logic of this Cold War display, inverting and revealing its excess, making playful that which was so deadly serious (particularly in the 1950s when he began), and re-inventing Las Vegas in the process, is only to wonder at the danger and discipline required to perform in a life threatening mass of sequins.

Notes:

1 For a remarkable introduction to the Nevada Test Site as an environmental site, see Center for Land Use Interpretation, *The Nevada Test Site: A Guide to America's Nuclear Proving Ground* (Los Angeles: Center for Land Use Interpretation, 1996), as well as Kathleen Stewart, "Bitter Faiths," in *Technoscientific Imaginaries: Conversations, Profiles, and Memoirs*, ed. George Marcus (Chicago: University of Chicago Press, 1994). For a historical analysis of the era of above ground nuclear testing at the test site, see Richard L. Miller, *Under the Cloud: The Decades of Nuclear Testing* (New York: Free Press, 1986), Philip L. Fradkin, *Fallout: An American Nuclear Tragedy* (Tucson: The University of Arizona Press, 1989), and Barton C. Hacker, *Elements of Controversy: The Atomic Energy Commission and Radiation Safety in Nuclear Weapons Testing, 1947–1974* (Berkley: University of California Press, 1994). For studies of communities suffering the most severe health effects from work at the Nevada Test Site, see Carole Gallager, *American Ground Zero: The Secret Nuclear War* (Cambridge: MIT Press, 1993) and Valerie L. Kuletz, *The Tainted Desert: Environmental and Social Ruin in the American West* (New York: Routledge, 1998). For an assessment of Cold War human radiation experiments in the U.S., see Advisory Committee on Human Radiation Experiments, *The Human Radiation Experiments: Final Report of the President's Advisory Committee* (New York: Oxford University Press, 1996). For a 10,000-page, county-by-county dose reconstruction of radioactive fallout from nuclear testing, and its impact on national thyroid cancer rates, see "Estimated Exposures and Thyroid Doses Received by the American People From Iodine-131 in Fallout Following Nevada Atmospheric Nuclear Bomb Tests," Cancer.gov, 1997, The National Cancer Institute, 9 Apr. 2003 <http://i131.nci.nih.gov/>. For a global assessment of the environmental impact of military nuclear technology, see International Physicians for the Prevention of Nuclear War and the Institute for Energy and Environmental Research, *Radioactive Heaven and Earth: The Health and Environmental Effects of Nuclear Weapons Testing In, On, and Above the Earth* (New York: Apex Press, 1991), and see Stephen I. Schwartz, ed., *Atomic Audit: The Costs and Consequences of U.S. Nuclear Weapons Since 1940* (Washington, D.C.: Brookings Institution Press, 1998) for a detailed accounting of the nearly $6 trillion spent on U.S. nuclear weapons in the 20th century.

2 On July 23, 2002, President George W. Bush approved Yucca Mountain as the nation's primary commercial nuclear waste repository. Barring the numerous lawsuits that still have to work their way through the courts, Yucca Mountain will open in 2010. See Kuletz, *The Tainted Desert*, for complex reading of the cross-cultural politics of the Yucca Mountain Project; Michael Taussig, *Defacement: Public Secrecy and the Labor of the Negative* (Stanford: Stanford University Press, 1999), who defines a public secret as "that which is generally known but cannot be spoken"; and for a trenchant analysis of desert monumentalism, see Daniel Rosenberg, "No One Is Buried in Hoover Dam," in *Modernism, Inc.: Body, Memory, Capital*, ed. Jani Scandura and Michael Thurston (New York: New York University Press, 2001).

3 See Susan Lepselter's sublime essay on Rachel, "Why Rachel Isn't Buried at her Grave: Ghosts, UFOs, and a Place in the West," in Daniel Rosenberg and Susan Harding (eds) *Histories of the Future* (Durham: Duke University Press, 2005) as well as David Darlington, *Area 51: The Dreamland Chronicles* (New York: Henry Holt and Company, 1997) on Area 51 beliefs. See Kathleen Stewart and Susan Harding, "Bad Endings: American Apocalypsis," *Annual Review of Anthropology* 28 (1999): 285–310 on American apocalypticism, and Mark Fenster, *Conspiracy Theory: Secrecy and Power in American Culture* (Minneapolis: University of Minnesota Press, 1999) on conspiracy theory in the United States. See Eileen Welsome, *The Plutonium Files: America's Secret Medical Experiments in the Cold War* (New York: Dial Press, 1999) for a discussion of covert human experimentation during the Cold War; Spencer R. Weart, *Nuclear Fear: A History of Images* (Cambridge, Mass.: Harvard University Press, 1988) for a cultural history of nuclear anxiety in the U.S.; and Daniel Patrick Moynihan, *Secrecy: The American Experience* (New Haven, Conn.: Yale University Press, 1998) for an analysis of U.S. secrecy since World War II. See Joseph Masco, "Lie Detectors: On Secrets and Hypersecurity in Los Alamos," *Public Culture* 14, no. 3 (2002): 441–67 for a discussion of post-Cold War secrecy and security concerns within the U.S. nuclear complex.

4 See the Federation of American Scientists study of satellite imagery of Area 51 at: "Area 51-Groom Lake, NV," Federation of American Scientists website, 17 Apr. 2000, 9 Apr. 2003 <http://www.fas.org/irp/overhead/ikonos_040400_overview_02-f.htm>. In September 2001, President George W. Bush renewed a Clinton Administration executive order exempting an "unnamed" Groom Lake Air Force facility from environmental laws. This rule has been justified under national security protocols as a way to keep state secrets, but it also has the effect of suppressing the lawsuits filed by former Area 51 workers over toxic exposures. In other words, the state can now argue that since the base does not formally exist, how could anybody have worked there, let alone been poisoned on the job?

5 Biographical information on Liberace in this section is based on the presentation at the Liberace Museum (Las Vegas), as well as *Liberace: An Autobiography* (New York: G. P. Putnam's Sons, 1973), and Bob Thomas, *Liberace: The True Story* (New York: St. Martin's Press, 1987). For an analysis of gender roles during the height of the Cold War, see Alan Nadel, *Containment Culture: American Narratives, Postmodernism, and the Atomic Age* (Durham: Duke University Press, 1995). For a policy assessment of U.S. security clearances and sexual orientation, see U.S. General Accounting Office, *Security Clearances: Consideration of Sexual Orientation in the Clearance Process* (Washington, D.C., 1995). For more on Las Vegas and the culture of above ground nuclear testing at the NTS, see Constandina A. Titus, *Bombs in the Backyard: Atomic Testing and American Politics* (Reno and Las Vegas: University of Nevada Press, 1986).

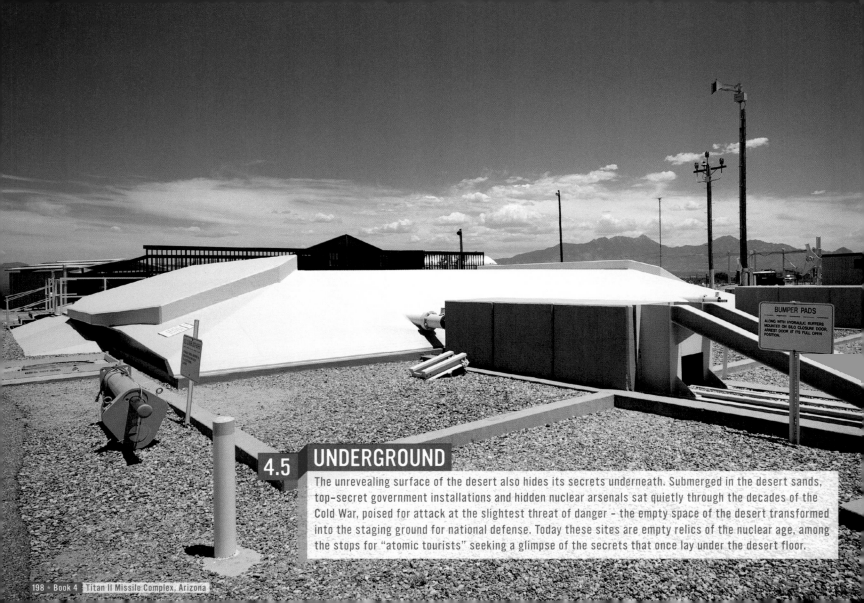

BUMPER PADS
ALONG WITH HYDRAULIC BUFFERS MOUNTED ON SILO CLOSURE DOOR, ARREST DOOR AT ITS FULL OPEN POSITION

4.5 UNDERGROUND

The unrevealing surface of the desert also hides its secrets underneath. Submerged in the desert sands, top-secret government installations and hidden nuclear arsenals sat quietly through the decades of the Cold War, poised for attack at the slightest threat of danger - the empty space of the desert transformed into the staging ground for national defense. Today these sites are empty relics of the nuclear age, among the stops for "atomic tourists" seeking a glimpse of the secrets that once lay under the desert floor.

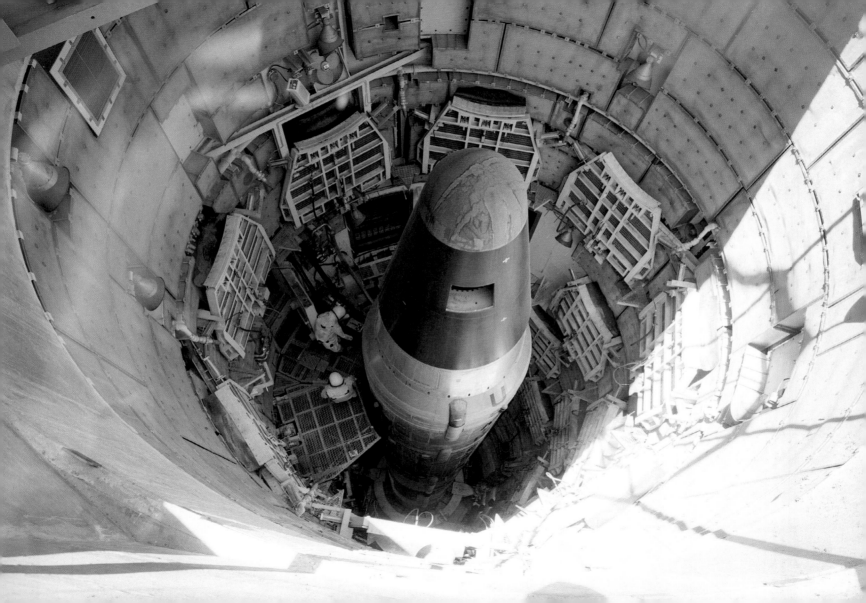

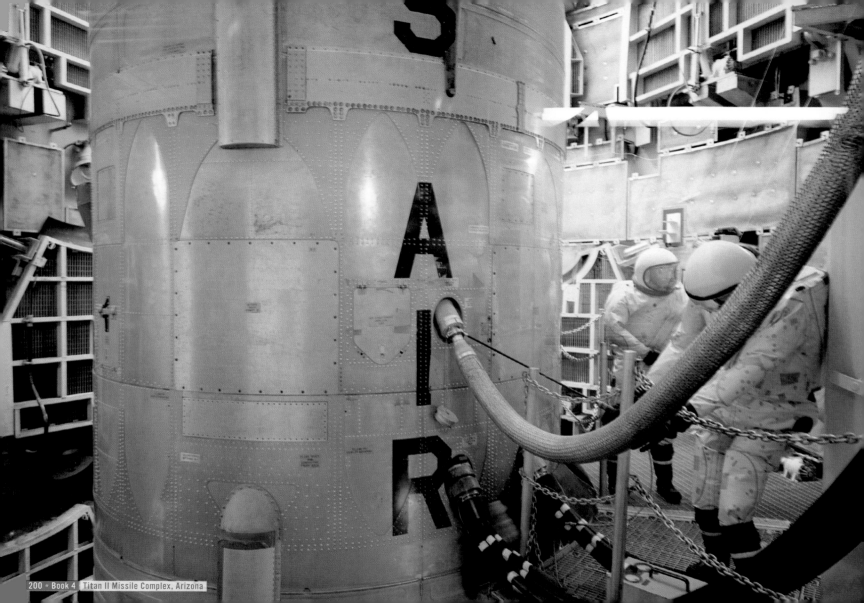

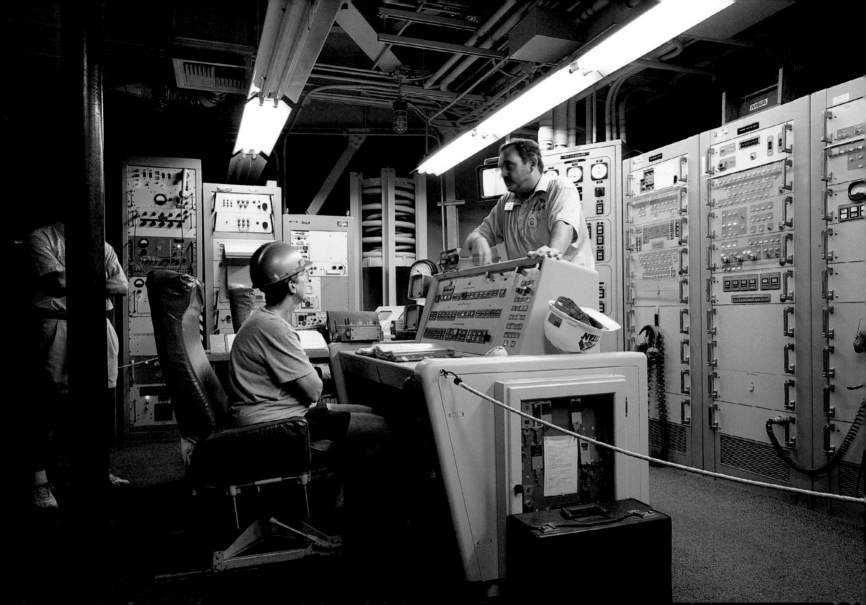

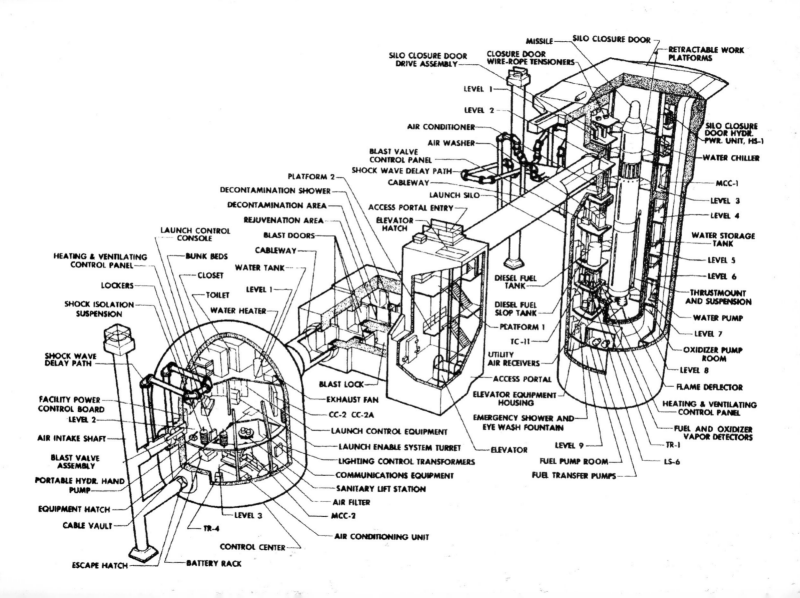

SILO CLOSURE DOOR DRIVE ASSEMBLY
CLOSURE DOOR WIRE-ROPE TENSIONERS
MISSILE
SILO CLOSURE DOOR
RETRACTABLE WORK PLATFORMS
LEVEL 1
LEVEL 2
AIR CONDITIONER
AIR WASHER
BLAST VALVE CONTROL PANEL
SHOCK WAVE DELAY PATH
CABLEWAY
LAUNCH SILO
ACCESS PORTAL ENTRY
ELEVATOR HATCH
SILO CLOSURE DOOR HYDR. PWR. UNIT, HS-1
WATER CHILLER
MCC-1
LEVEL 3
LEVEL 4
WATER STORAGE TANK
LEVEL 5
LEVEL 6
THRUSTMOUNT AND SUSPENSION
WATER PUMP
LEVEL 7
OXIDIZER PUMP ROOM
LEVEL 8
FLAME DEFLECTOR
HEATING & VENTILATING CONTROL PANEL
FUEL AND OXIDIZER VAPOR DETECTORS
TR-1
LS-6

PLATFORM 2
DECONTAMINATION SHOWER
DECONTAMINATION AREA
REJUVENATION AREA
LAUNCH CONTROL CONSOLE
BUNK BEDS
CLOSET
TOILET
WATER HEATER
BLAST DOORS
CABLEWAY
WATER TANK
LEVEL 1

HEATING & VENTILATING CONTROL PANEL
LOCKERS
SHOCK ISOLATION SUSPENSION
SHOCK WAVE DELAY PATH
FACILITY POWER CONTROL BOARD
LEVEL 2
AIR INTAKE SHAFT
BLAST VALVE ASSEMBLY
PORTABLE HYDR. HAND PUMP
EQUIPMENT HATCH
CABLE VAULT
ESCAPE HATCH
BATTERY RACK
LEVEL 3
TR-4
CONTROL CENTER
AIR CONDITIONING UNIT
MCC-2
AIR FILTER
SANITARY LIFT STATION
COMMUNICATIONS EQUIPMENT
LIGHTING CONTROL TRANSFORMERS
LAUNCH ENABLE SYSTEM TURRET
LAUNCH CONTROL EQUIPMENT
CC-2 CC-2A
EXHAUST FAN
BLAST LOCK

DIESEL FUEL TANK
DIESEL FUEL SLOP TANK
PLATFORM 1
TC-11
UTILITY AIR RECEIVERS
ACCESS PORTAL
ELEVATOR EQUIPMENT HOUSING
EMERGENCY SHOWER AND EYE WASH FOUNTAIN
ELEVATOR
LEVEL 9
FUEL PUMP ROOM
FUEL TRANSFER PUMPS

202

BURIED

In the midst of the Cold War, the US government began to develop a series of liquid fuelled ballistic missiles to protect the country against the perceived Soviet nuclear threat. Fifty-four Titan II missiles (each with a 9-megaton yield) were located on three different sites, divided between Davis-Monthan Air Force base in Tucson, Little Rock Air Force Base in Arkansas, and McConnell Air Force Base in Kansas. The program reached full alert status in December 1963 and was maintained continuously at full "ready mode" until 1979. Designed to destroy military and enemy nuclear complexes, and to a lesser extent major industrial and urban areas, the missiles, with a maximum range of 5500 nautical miles, were aimed at "classified" areas in the Soviet Union and northeastern sections of China, capable of reaching their targets within 35 minutes. Guided by the theory of "Mutually Assured Destruction" (MAD), the main strategy of the Titan II missile program was to gain "Peace through Deterrence," rather than defending against possible attack.

Two years after the signing of the 1979 Strategic Arms Limitation Treaty (SALT), the US Department of Defense began to dismantle the Titan II silos. In 1984, fifty-three of the fifty-four original Titan II sites were destroyed and the rubble left undisturbed for six months as Soviet satellites confirmed the demolition. The single remaining complex (located in Tucson, Arizona) was transformed into a museum to encapsulate the "enormity" of the mission, to commemorate the individuals who died in the testing and maintenance of the missiles, and to reveal the chilling reality of what might have been. The triple complex of control center, blast lock, and missile silo has been completely preserved, currently manned by military mannequins. Through the blast door, at a depth of 35 feet, visitors can touch the 110 foot rocket and experience the thrill of turning the two-key "fail safe" system, which includes a simulated launch sequence and mock annihilation.

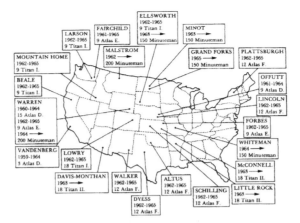

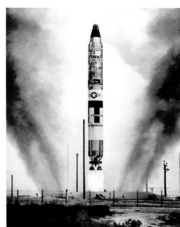

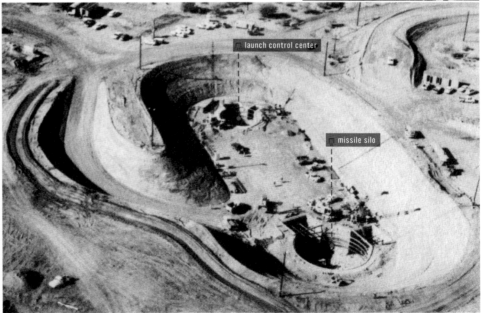

launch control center

missile silo

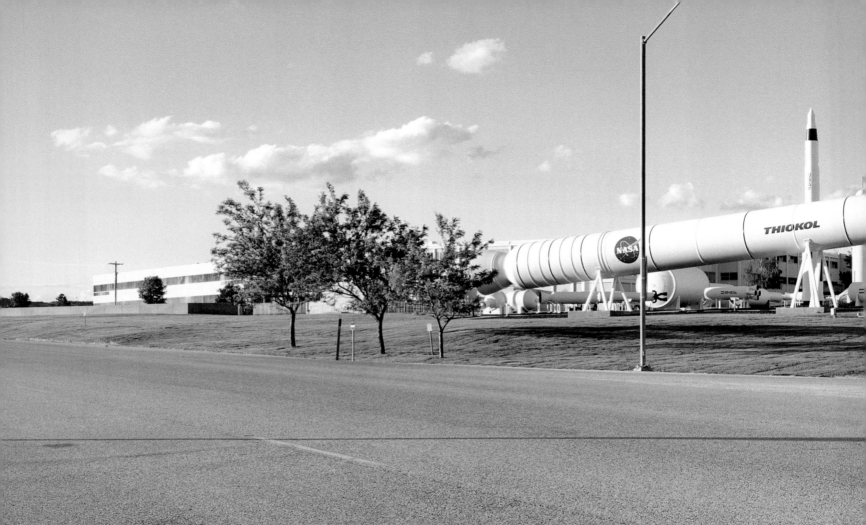

4.6 CHEMISTRY

From missiles to rockets, the desert is a space for the production of advanced technologies. Concealed on a remote site north of the Great Salt Lake (not far from Robert Smithson's Spiral Jetty) lies the manufacturer for the boosters that power the Space Shuttle, another Cold War technology - rocket science born unwittingly of a single botched science experiment that would ignite a billion dollar industry.

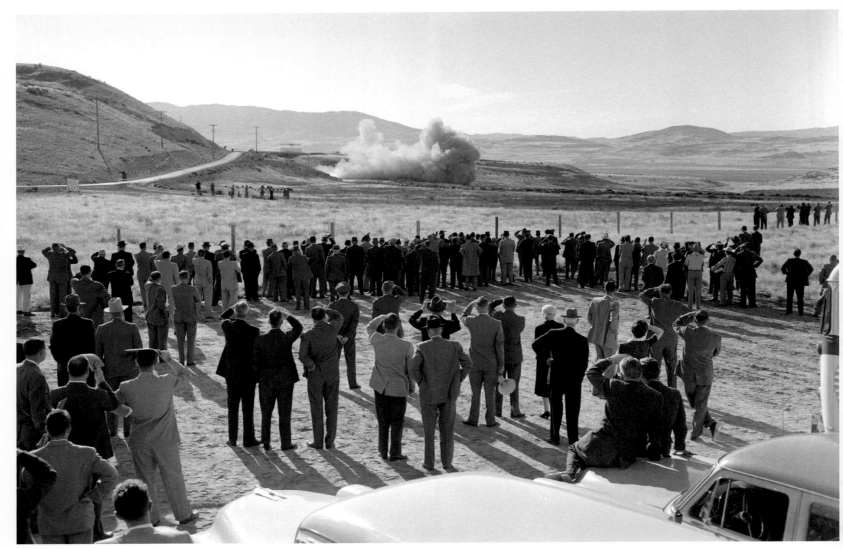

ROCKET SCIENCE

For the past sixty years the Thiokol Corporation (currently ATK Thiokol, Inc.) has been involved in the development and manufacture of motors for the Mercury and Gemini manned space programs, Apollo lunar missions, and the submarine-launched missiles of the Trident I and II programs. Today synonymous with the space exploration industry, Thiokol gained infamy when one of their products, an ill-fated solid-fuel rocket booster, was implicated in the 1986 explosion of the space shuttle Challenger. Less known is that the booster in question owed its existence to an accidental discovery by a little known physician moonlighting as a chemist, on April Fool's Day 1926. Dr. Joseph 'Doc' C. Patrick ran a small independent laboratory in Kansas City, Missouri that, among various things, analyzed the cholesterol levels of kosher food and investigated possible uses for the apple residues leftover from the vinegar distillation process. While exploring uses for ethylene (a by-product of petroleum refinement), a botched science experiment yielded the first synthetic rubber. In a somewhat unlikely chain of events, Doc Patrick sold the rights to his polymer, joined forces with an entrepreneur to repurchase those rights, then formed a company named Thiokol, an invented word describing the combination of the Greek words for sulfur and glue (respectively (Θειο) "theio" and (κολλα) "kolla"), which had been the basis of his discovery, and began marketing his new product. Patrick's company suffered and survived the Great Depression and eventually entered the WWII war effort, supplying durable sealants for fuel tanks and gun turrets.

This comfortable existence - sealing seams of all kinds - changed when scientists at NASA's Jet Propulsion Laboratory (JPL) discovered that Thiokol's polymers made an ideal solid rocket fuel binder. After learning of JPL's research, Thiokol brokered a commission with the US Army to develop the Thunderbird solid propellant rocket and to conduct ongoing research in the field of aerospace technology. In 1956, the Thiokol Corporation acquired what is now their headquarters in Brigham City, Utah. Chosen on the basis of size and price, executives purchased 10% (11 000 acres) of a cattle ranch for $2.95 per acre, and shortly thereafter began production of first-stage rockets for the Air Force's Minuteman Intercontinental Ballistic Missile (ICBM).

In 1982, Thiokol merged with the Morton Salt Company ("When it rains it pours!"), becoming Morton Thiokol International until its recent purchase by Alliant Techsystems Incorporated (ATK). ATK Thiokol, Inc. currently controls the major part of the US solid-rocket market, with 4,000 employees worldwide and annual sales of around $840 million. It is also a leading manufacturer of sodium azide gas generators, a propellant that inflates nearly 60% of the world's airbags (including those of the two successful Mars rover landings). Until its recent incorporation into ATK, the Morton Thiokol website proudly proclaimed: "As a matter of fact, we are rocket scientists!"

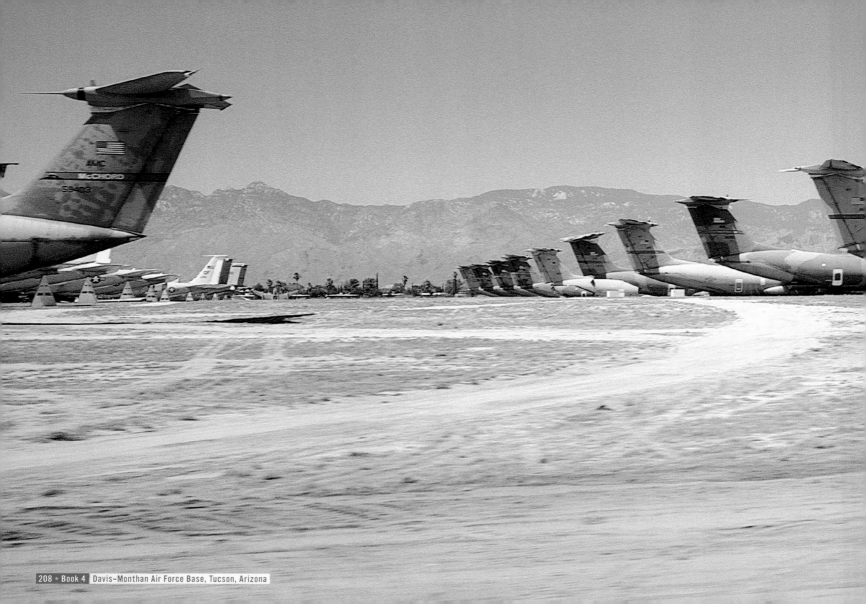

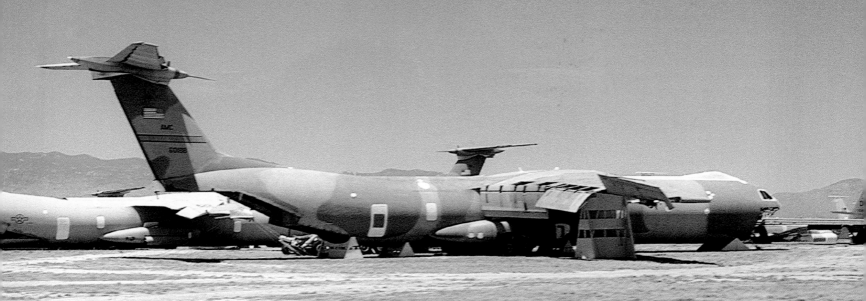

4.7 **GRAVEYARD**

While the pronounced absence of water in the desert is deadly for man, its aridity has made it the ideal place for the extension of non-organic life. Outside of Tucson, Arizona sits the largest airplane storage and regeneration facility in the world, an open-air museum for the relics of the last half-century of military aviation.

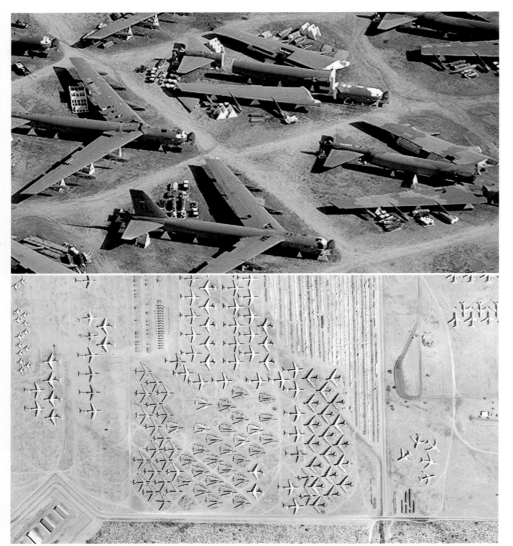

THE BONEYARD

The Davis-Monthan Air Force Base in Tucson, Arizona (founded in 1946) is home to AMARC, the Aerospace Maintenance and Regeneration Center. Often referred to as "the junkyard" or "the boneyard," AMARC is home to thousands of military and civilian vehicles awaiting repair or dismantling; the low humidity and alkaline soil of the desert make it the ideal location for aircraft storage, greatly reducing the incidence of corrosion and other damaging effects of moisture. AMARC is rumored to have the highest concentration of aircraft in the world (many of which will be melted down into ingots and salvaged for spare parts - only a quarter will regain flight status). Obsolete and ex-military planes are destroyed by "The Executioner," a massive 130 ton (180 000 kg) crane. When the Strategic Arms Reduction Treaty (START) was signed in 1991 (outlining the reduction of nuclear delivery vehicles), the Executioner diced through 350 operational B-52 bombers; for the next six months, these dismembered bombers remained in pieces, their decommission verified by Soviet satellite reconnaissance.

Contrary to AMARC's fame as the "airplane graveyard," not all aircraft come here to die. Many are rehabilitated and resold to friendly governments or private interests. (In the 1980's, Pakistan purchased twenty-eight F-16 jet fighters from the General Dynamics Corporation; after the country's successful development of nuclear weapons, Congress passed a decree banning all further military sales to Pakistan. The fate of these idle F-16's remains uncertain, and they remain parked at AMARC indefinitely.) The Reclamation Insurance Type (RIT) area is located on the east side of the 2500 acre property and consists of a neat patchwork of aircraft waiting patiently to be used as instructional aircraft, targets, museum exhibits, spare parts, and in some instances, for their return to active military duty in American or allied foreign governments.

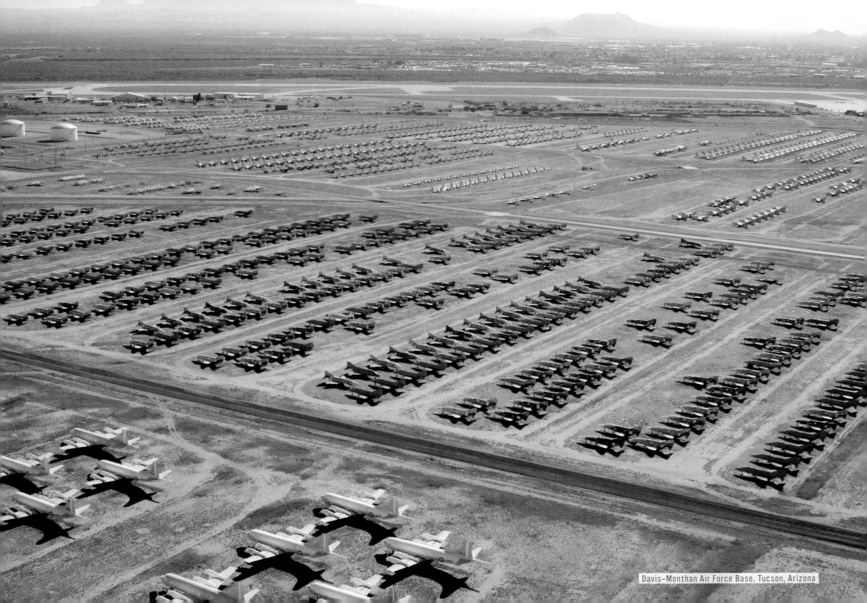

Davis-Monthan Air Force Base, Tucson, Arizona

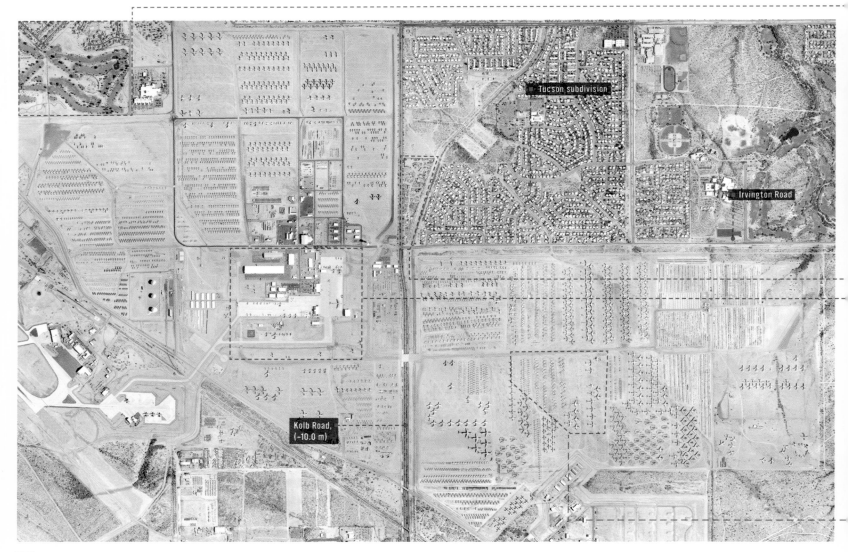

Tucson subdivision

Irvington Road

Kolb Road,
(-10.0 m)

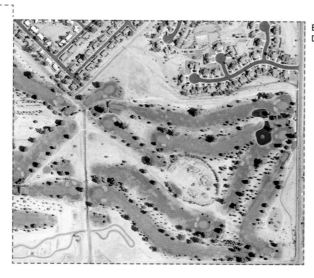

Blanchard golf course,
Davis Monthan AFB

Scrapyard

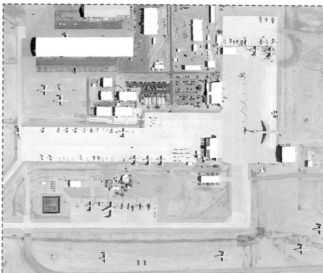

Maintenance
center

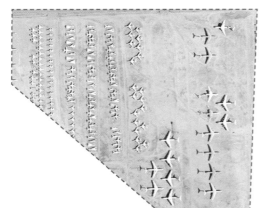

C-141 Starlifters
(chopped)

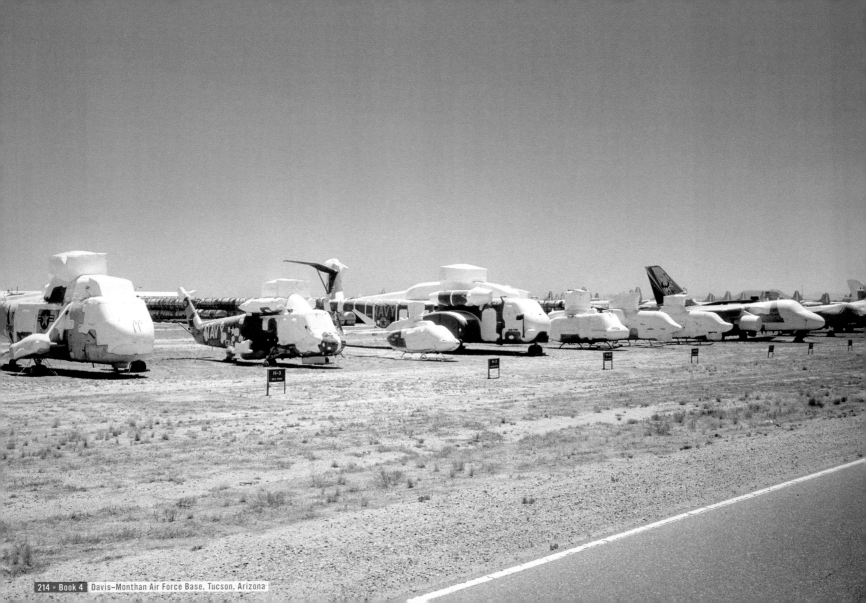

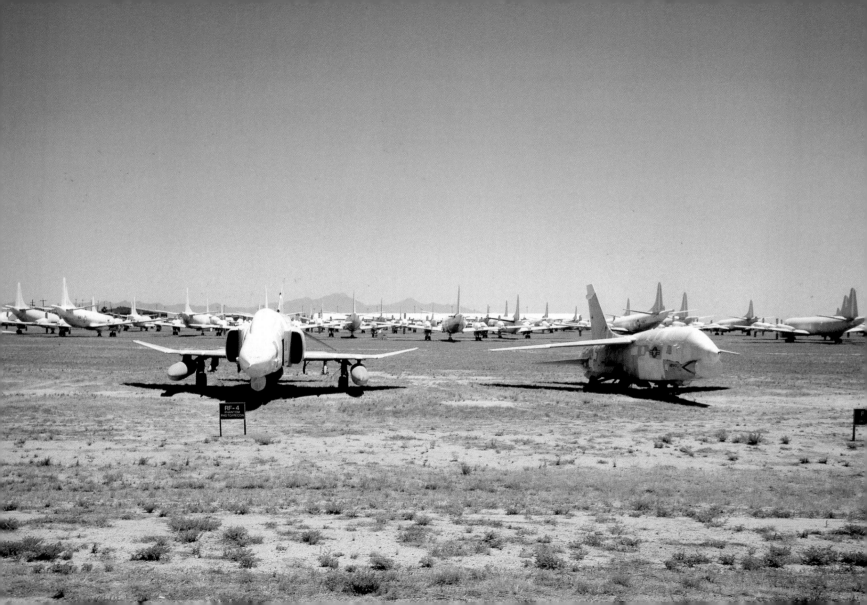

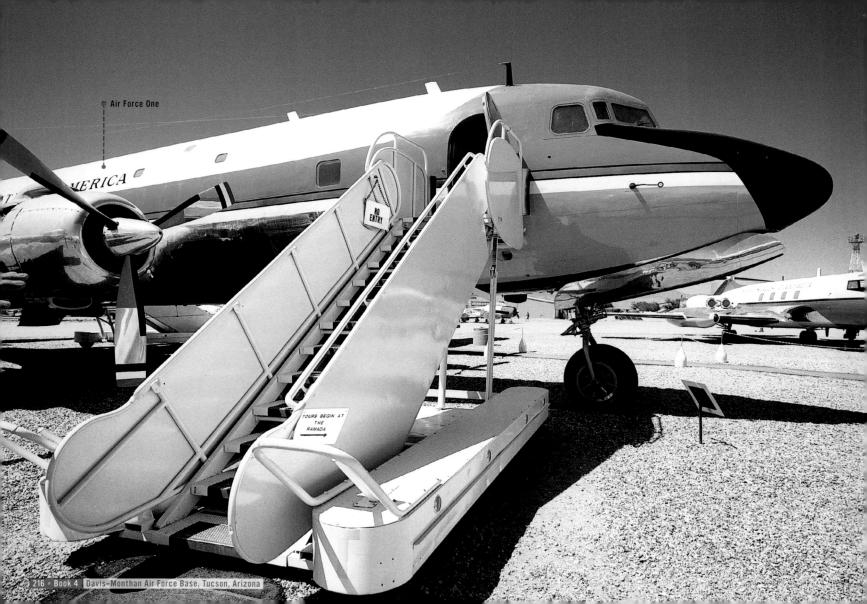

Air Force One

MERICA

NO ENTRY

TOURS BEGIN AT
THE
RAMADA

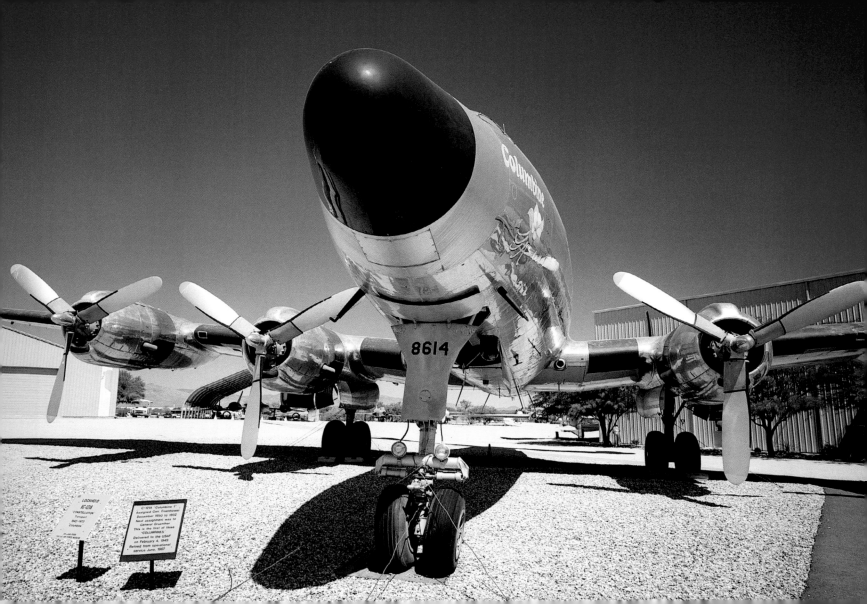

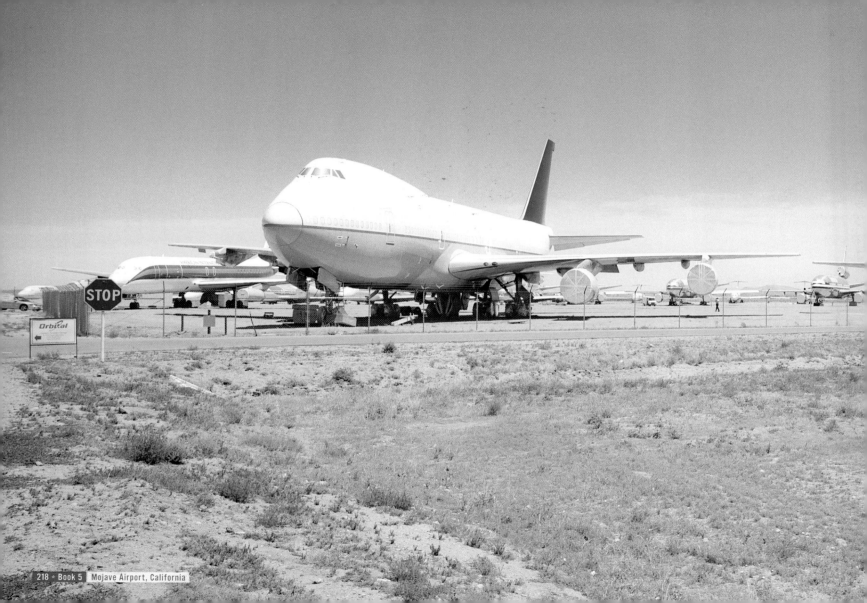

STOP

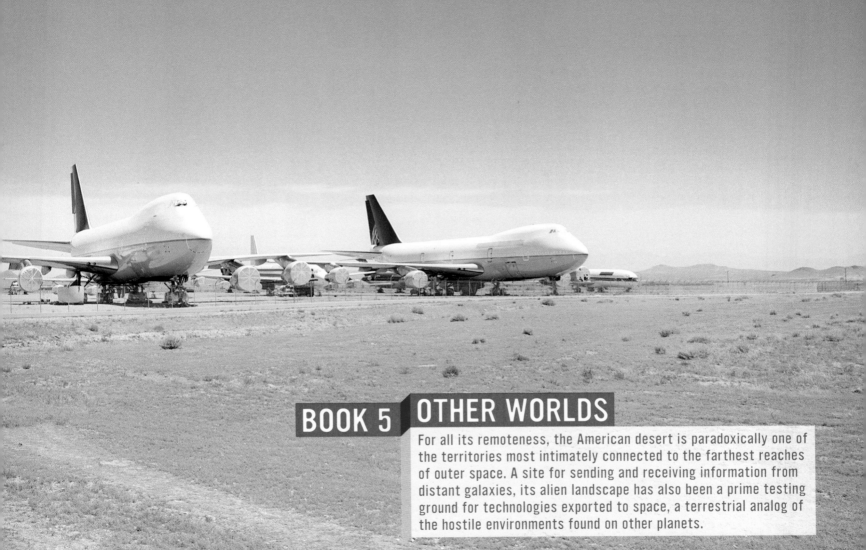

BOOK 5 OTHER WORLDS

For all its remoteness, the American desert is paradoxically one of the territories most intimately connected to the farthest reaches of outer space. A site for sending and receiving information from distant galaxies, its alien landscape has also been a prime testing ground for technologies exported to space, a terrestrial analog of the hostile environments found on other planets.

5.1 SPACE QUEST

With 360 days of sunshine a year, Mojave Airport has become, like Davis-Monthan Air Force Base, one of the larger non-military storage and maintenance facilities in the world; originally a naval air station before its return to civilian service in the 1960s, Mojave Airport has also served as the background for Hollywood productions like Waterworld and Die Hard II, earning it the nickname "Mojavewood." But its newest claim to fame is as the home of the Rutan brothers and their company, Scaled Composites, developers of SpaceShipOne - the first civilian vehicle to reach outer space.

MOJAVE, CALIFORNIA
AND THE FLIGHT OF SPACESHIPONE

Strung along the western edge of the Mojave desert and united by California State Route 14, four towns encompass the most intense concentration of high performance aerospace research in the world.

The southernmost and by far the largest, Palmdale-Lancaster is home to Edwards Air Force Base Plant 42, a secure environment in which legendary names of aviation—Boeing, Northrop Grumman, BAE Systems, and, most storied of all, Lockheed Martin's "Skunk Works"—construct high-technology projects for the military and NASA. Ultra-secret aerospace programs funded by the Defense Department's Black Budget have spawned projects such as the U-2 and SR-71 spy planes, the B-2 stealth bomber, the F-117 stealth ground attack aircraft, and—according to some plane-spotters—the conjectural Aurora hypersonic spy plane at Plant 42.

Further north, Rosamond acts as a gateway to Edwards Air Force Base, an installation virtually synonymous with military test flights. Officially designated as the Air Force Flight Test Center, it is home to both the Air Force Test Pilot School and NASA's Dryden Flight Research Center; the revolutionary X-planes, from Chuck Yeager's sound barrier-breaking X-1 to the X-15 rocket plane, were all tested at Edwards. With the extremely flat dry lake bed of Rogers Lake, the base serves as a backup landing runway for the Space Shuttle, and the Base also houses the most advanced government atmospheric

testing programs in the world. The fascination with aerospace extends beyond the base to the Rosamond Skypark, which features upscale homes with backyard plane hangers and taxiway connections to Rosamond Airport.

Just as Rosamond is the gateway for Edwards, Ridgecrest serves the China Lake Naval Air Weapons Station, the primary airborne weapons testing and training range for the U.S. Navy. Named after another dry lakebed, China Lake is the largest area of land owned by the Navy. The heat-seeking Sidewinder missile, named after a rattlesnake found locally, was developed here.

In contrast to these other three towns, Mojave, population 3,000, has no specific affiliation with the military. Instead, aerospace research here centers on the Mojave Airport, which—following the model of Edwards—has designated itself as the Civilian Aerospace Test Flight Center, becoming, in 2004, the first private spaceport licensed by the Federal Aviation Administration.

Mojave is the product of a century-old quest for speed. Situated at the foot of the Tehachapi Pass, a low point in the mountain ranges dividing the state, Mojave made an ideal depot town for the Southern Pacific Railroad's line between Los Angeles and San Francisco, finished in 1876. Mojave also served as the railhead for freight from nearby extractive industries, most notably borax from mines in Boron to the east. (Mojave's rail connections are still heavily used—long freight trains rumble over the Tehachapi pass at all hours—

and connections through the Union Pacific and Burlington Northern Santa Fe lines allow shipments passing through Mojave to reach virtually the entire country. With the growth of the Ports of Los Angeles and Long Beach and the development of the Alameda Corridor to shuttle container traffic from the ports to points north, Mojave Airport has promoted itself as an Intermodal Freight Center, where cargo from rail-hauled shipping containers can be loaded onto cargo airplanes for more rapid distribution.)

The arrival of the airplane would transform Mojave's future. In 1935, Kern County established a general airfield a half-mile east of the town center, consisting of two dirt runways and minimal services. With the outbreak of World War II, the airfield was turned into the Mojave Marine Corps Auxiliary Air Station to accommodate training pilots for combat in SBD dive-bombers and F4U Corsair fighters. Decommissioned after the Korean War, the field lay abandoned until 1972, when it was opened as a civilian airport.

Today, the dry desert air has made Mojave Airport a prime storage facility for commercial airlines. Cargo and passenger jets are parked here temporarily when the industry faces a downturn, as it did after 9/11. Other airplanes are retired here and scrapped. The easy availability of airplanes of all kinds and the wide-open spaces of the state's largest airport have also made the Mojave Airport an ideal site for films and commercials; over the years, the airport has come to maintain a collection of prop aircraft, as well as two large

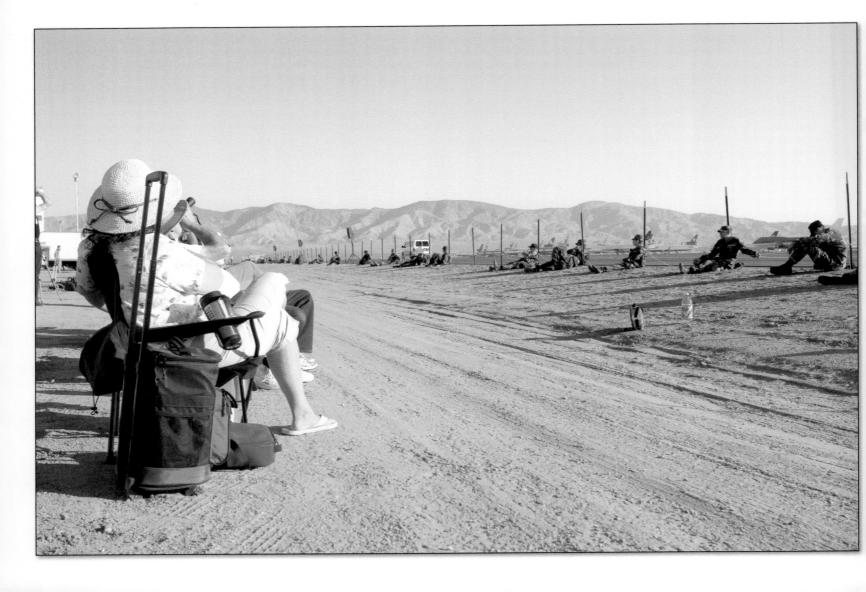

film pads that can be flooded for water scenes. Above all, Mojave's proximity to Los Angeles, the military test flight centers of Plant 42, Edwards Air Force Base, and China Lake, together with its non-congested airspace, long days of sunshine and smooth air, make it an ideal place for civilian flight testing.

Over the last quarter century, Mojave Airport has become identified with Burt Rutan. An experienced pilot, Rutan earned his wings in the Air Force, flying 325 missions (on one occasion being forced to eject from his F-100 fighter after the craft had been hit by enemy fire.) Rutan served as Flight Test Project Engineer at Edwards Air Force Base from 1965 to 1972, and, from 1972 to 1974, worked as director of flight testing at aviation rebel Jim Bede's kit plane company, Bede Aircraft, in Newton, Kansas. As an engineering student, Rutan had designed his own unorthodox airplane, the VariViggen, a backwards-looking craft called a canard with its tailplane in the front and propeller in the rear, and had always dreamed of realizing his vision.

In 1974, he returned to the Mojave Airport and founded the Rutan Aircraft Factory to refine the VariViggen for production. The plane would eventually become the VariEze, the most popular craft produced by the Factory. Like Bede Aircraft, however, the Rutan Aircraft Factory specialized not in building planes but in selling plans that individuals could use to build planes themselves. After some success, Rutan turned his attention to prototyping experimental aircraft designs for commercial industry. His use of composites instead of metal and his expertise in realizing these aircraft as scaled models led him to found Scaled Composites, Inc. in 1982. Since then, the firm has produced a remarkable number of experimental aircraft designs, many of them canards. Scaled Composites' most notable early achievement was the 1986 flight of Voyager, a plane with engines in both front and rear that was the first aircraft to circumnavigate the earth nonstop. (In his essay, "Polar Inertia," Paul Virilio would conclude that in doing so, Voyager "erased the difference in nature between the low-orbit satellite, and the circum-terrestrial airplane.")

A decade later, Scaled Composites began its involvement with spaceflight, serving as the contractor for the graphite composite aeroshell of the McDonnell Douglas DC-X or "Delta Clipper." A one-third-scale reusable Single Stage to Orbit (SSTO) launch vehicle, the Delta Clipper was intended as a precursor for a full-size orbital ship capable of replacing the Space Shuttle as the country's primary manned spacecraft. Conceived by science fiction writer Jerry Pournelle and built under the Strategic Defense Initiative Organization, the DC-X was to both launch and land vertically, with the nose up, using retro rockets to control the descent. Unlike the Space Shuttle with its team of thousands of support staff, this highly automated craft would require only one person for ground support and two for flight operations. And while the Space Shuttle can only be launched in Cape Canaveral, the DC-X could be launched virtually anywhere.

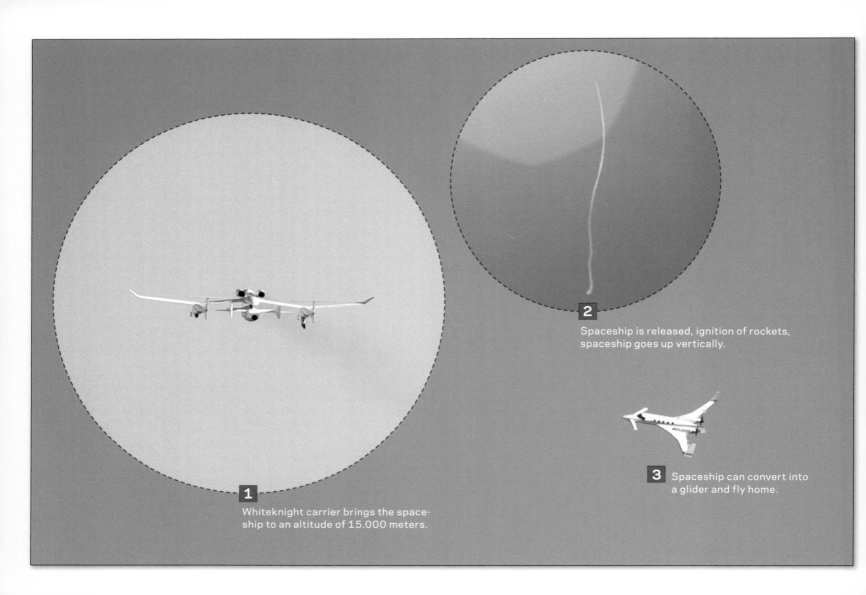

1
Whiteknight carrier brings the space-
ship to an altitude of 15.000 meters.

2
Spaceship is released, ignition of rockets,
spaceship goes up vertically.

3 Spaceship can convert into
a glider and fly home.

With Apollo astronaut Pete Conrad at the ground-based controls for some flights, DC-X flew a series of flight tests successfully. After NASA took over the rocket in 1996 and re-configured it as the DC-XA, the craft set a record with a twenty-six hour turnaround between consecutive launches. On the fourth flight under NASA, however, one of the DC-XA's legs failed to deploy, the craft fell over upon landing and was destroyed in a fire. (Many aerospace buffs, always suspicious of big government, believed DC-XA's destruction to be intentional, the result of NASA's fears of losing its space monopoly.)

Rutan himself has criticized NASA for its inability to make spaceflight affordable, and suggests that his decision to get involved in spaceflight came out of the realization that if he didn't, he would have no hope of ever going into outer space. In the late 1990s, Rutan took part in an attempt to develop the first manned civilian spacecraft. Based at the Mojave Airport, Gary Hudson's Rotary Rocket, Inc. contracted Scaled Composites to produce a full-scale atmospheric test flight vehicle of the Roton SSTO spacecraft. The Roton would use helicopter blades powered by peroxide-tipped rockets to land instead of wings or parachutes, and featured a revolutionary "aerospike" engine that would serve as a water-cooled heat shield during re-entry. Perhaps overly ambitious and facing both technological hurdles and a downturn in the space industry, Rotary Rocket shut its doors in 2000.

While Rutan was working on the Roton, a welcome challenge emerged. Peter Diamandis, an aerospace engineer and CEO of the Zero Gravity corporation—the only FAA-approved provider of weightless flight to the public—made it his goal to develop the X PRIZE, a cash award of $10 million to encourage aerospace companies to make space travel commercially viable. According to contest rules, the X PRIZE would be given to the first team to launch a piloted spacecraft carrying the equivalent of three people on board to the internationally recognized boundary of space, 100 kilometers above the earth, twice within two weeks. As part of the rules, the X PRIZE stipulated that no more than 10 percent of the non-fuel weight of the spacecraft could be replaced between flights.

Rutan was involved with the X PRIZE from the start, speaking at its public inauguration. Later that evening, he quietly announced his intent to compete for the prize himself. With the support of Microsoft billionaire Paul Allen, Rutan worked in secret for seven years, only revealing Scale Composites's entry for the prize, SpaceShipOne, in 2003. Rutan's craft is modest: 5m long with a wingspan of 5m, and weighing only 3,600kg fully loaded with fuel. In comparison, the Space Shuttle is 37m long with a wingspan of 23.79m and weighs 109,000kg. Indeed, if its wings were shortened by a half meter, SpaceShipOne would fit in the Shuttle's payload bay. Unlike the Space Shuttle, SpaceShipOne is designed to deliver a spectacular view of space, with large porthole windows punctuating the ship's thin shell.

Like the X-1 and X-15 rocket planes, SpaceShipOne is air-launched to save fuel. A jet-powered carrier vehicle named the White Knight carries SpaceShipOne on a leisurely, hour-long trip to an altitude of 15km. After being released from White Knight, SpaceShipOne glides for ten seconds to allow the two craft to separate, and a hybrid rocket burning a mixture of the rubber and nitrous oxide ignites, sending the ship skyward. The pilot experiences G-forces three or four times the gravity of the Earth. A timer cuts off fuel after about eighty seconds, but the plane continues to coast nearly straight upwards toward the stars; as the craft begins to decelerate, a feeling of weightlessness begins. After reaching the top of its trajectory, where the sky is black and the curvature of the Earth is visible, SpaceShipOne begins to descend. To ensure safe atmospheric re-entry, Rutan designed SpaceShipOne's wings to pneumatically tilt forwards into a high-drag "feathered" configuration that would shed speed while keeping the vehicle's belly oriented correctly toward the Earth. As the atmosphere begins to reassert its presence, between 10 and 20km above the ground, the wings return to their normal configuration and the rocket plane turns into a glider to fly home.

After a series of test flights, SpaceShipOne made the first privately funded human spaceflight on June 21, 2004, reaching an altitude of 100.1km and a speed of Mach 2.9 despite an early engine shut-off and the collapse of a non-structural fairing. A subsequent flight on September 29 reached 102.9km and Mach 2.92. Five days later, on October 4, SpaceShipOne flew its final flight, reaching 112km and Mach 3.09, thereby winning the ANSARI X-Prize (renamed in May 2004 after a multi-million dollar donation from entrepreneurs Anousheh and Amir Ansari) and besting the previous record for manned rocket-plane flight, held by the X-15.

Days before the launch of SpaceShipOne on its quest to win the X-PRIZE, Rutan appeared with Virgin Atlantic CEO Richard Branson to announce the formation of Virgin Galactic, a venture to create a suborbital space tourist business using vehicles based on SpaceShipOne. Branson has suggested that the initial cost for the flight will be roughly $210,000, including a week of training. Instead of the mere three-and-a-half minute experience of weightlessness at the apogee of SpaceShipOne's suborbital trajectory, Virgin Galactic intends to deliver seven full minutes.

But even SpaceShipTwo remains only a "Tier One" project for Scaled Composites. Rutan's current goal is "Tier Two" —orbital flight, a far more difficult proposition than a mere suborbital jaunt. The rocket motor for Tier Two will have to be substantially larger—some thirty times more powerful— to attain higher altitudes and an orbital velocity of roughly Mach 25. Life support will be more complicated, and re-entry will be significantly more dangerous. SpaceShipOne is already protected with some ablative thermal protection material, but far more would be necessary to shield the ship against the intense heating of the atmosphere it would encounter

while shedding its orbital velocity. Nor would the "feathered" position employed by SpaceShipOne work: at speeds such as those encountered by the Space Shuttle upon re-entry, wings in a feathered position would be mercilessly torn off.

Approaching Mojave from the south, a large sign today announces that it is the home of SpaceShipOne (until recently, it announced the town as the home of the Voyager.) As you leave, the reverse side of the same sign delivers a message from the Bible, 2 Chronicles 7:14: "If my people humble themselves and pray, I will heal the land."
SpaceShipOne suggests an alternative. If it is hard to imagine the people of this rough desert town humbling themselves and praying enough to heal the land, SpaceShipOne suggests that we depart it instead, leaving the old frontier for a new one, some 100km straight up. For now, at least, this is not a frontier to linger on. Like Everest—and like the desert itself for the early pioneers—the edge of space is a death zone, a space in which man cannot sustain himself, but merely visit for a moment. But unlike Everest, the reason to fly to outer space is not merely "because its there." On the contrary, in response to the demand that we humble ourselves, SpaceShipOne suggests healing through transcendence and abstraction instead. The flight to the edge of space allows its passengers to watch the Earth become pure geometry, total abstraction. Human traces vanish as the vastness of the desert below loses its flatness, becoming spherical, while the sky turns to vanishing black: the face of true infinity.

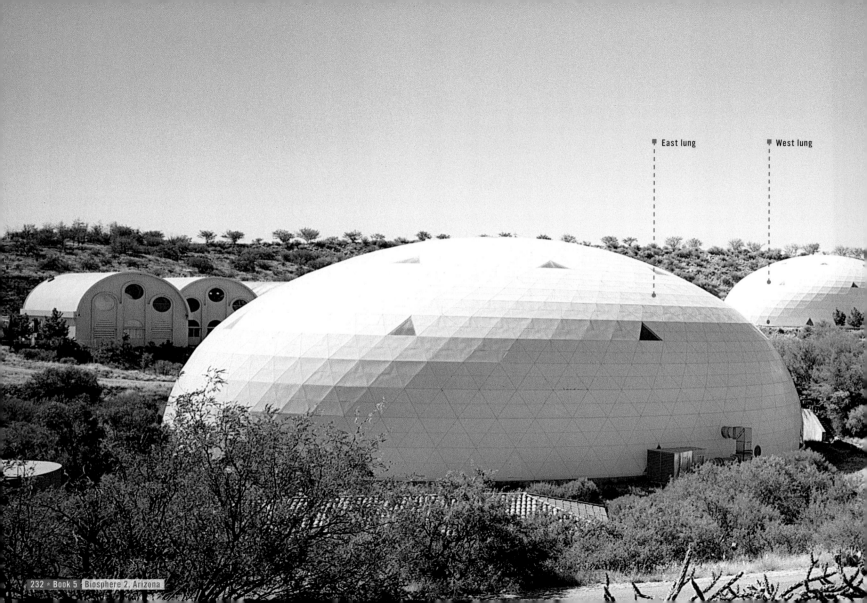

East lung

West lung

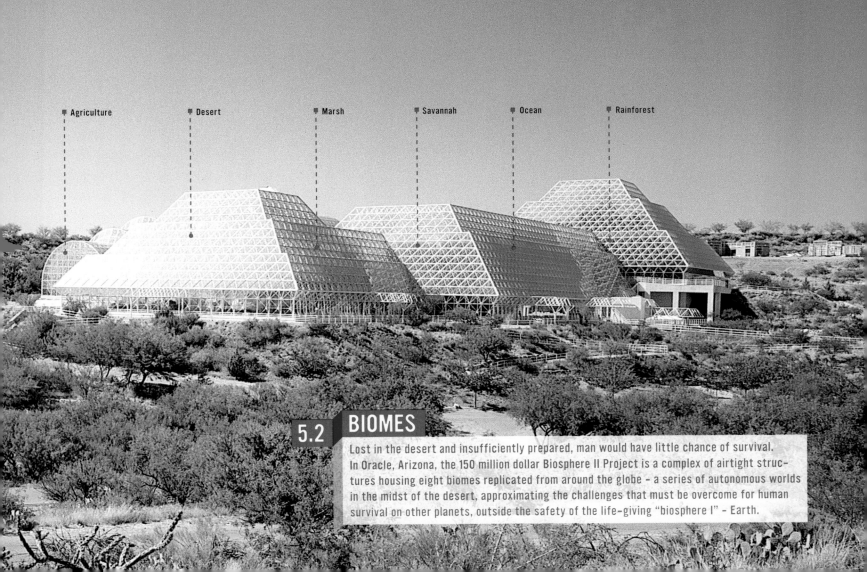

Agriculture Desert Marsh Savannah Ocean Rainforest

5.2 | BIOMES

Lost in the desert and insufficiently prepared, man would have little chance of survival. In Oracle, Arizona, the 150 million dollar Biosphere II Project is a complex of airtight structures housing eight biomes replicated from around the globe – a series of autonomous worlds in the midst of the desert, approximating the challenges that must be overcome for human survival on other planets, outside the safety of the life-giving "biosphere I" – Earth.

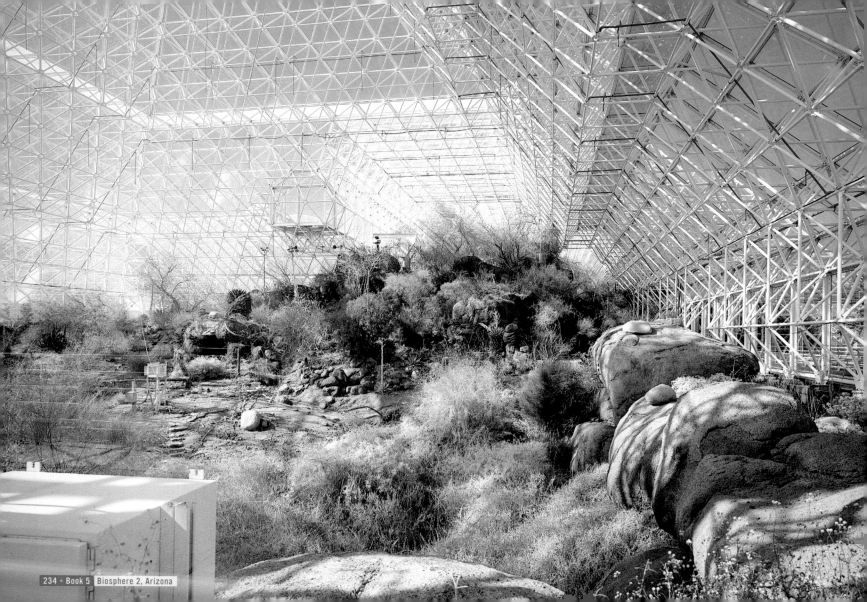

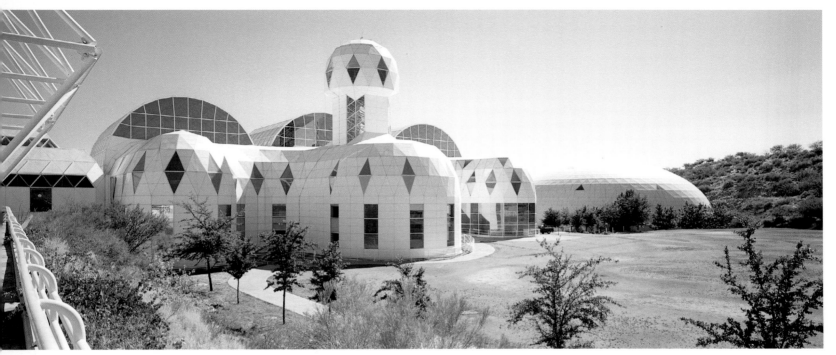

Rising from the Sonoran Desert at the foot of the Santa Catalina mountains, Biosphere 2 is a 72 million cubic-foot sealed glass space frame structure that contains a living replica of the Earth's environment ("Biosphere 1"). Set on 3.15 acres, the 200 million dollar project was built in the late 1980s with the funding of Ed Bass, a Texas oil magnate. The initial concept for Biosphere was
to investigate the conditions necessary for the reproduction of earth-compatible conditions in the event of human colonization of other planets. It contains five of the earth's biomes: ocean, rain forest, desert (that is, an artificial desert within a real desert), savannah, and swamp, with an additional agricultural cultivation area and a micro-habitat.

In 1991, four men and four women ("biospherians") from seven different countries were sealed in the Biosphere for a successful two-year stay. On a subsequent mission, however, a dangerous rise in carbon dioxide levels, infestation of the desert and ocean by ants from the rain forest, and rampant algae blooms in the "South American" coral reef forced the second Biosphere experiment to be prematurely aborted. These failed experiments caused a great deal of derision from the scientific community, which lasted until an agreement was reached between the investors and Columbia University to restore 'real science' to the Biosphere. In 1996 it re-opened as an interactive science center: part tourist attraction, part research center (with a focus, conveniently, on the effects of carbon dioxide and plant development). Recently, a conference center, hotel, gift shop, restaurant, and parking lot have been incorporated into the complex. Biosphere 2 is now one of the largest living laboratories in the world and one of Arizona's most popular tourist spots, attracting more than 180,000 visitors annually.

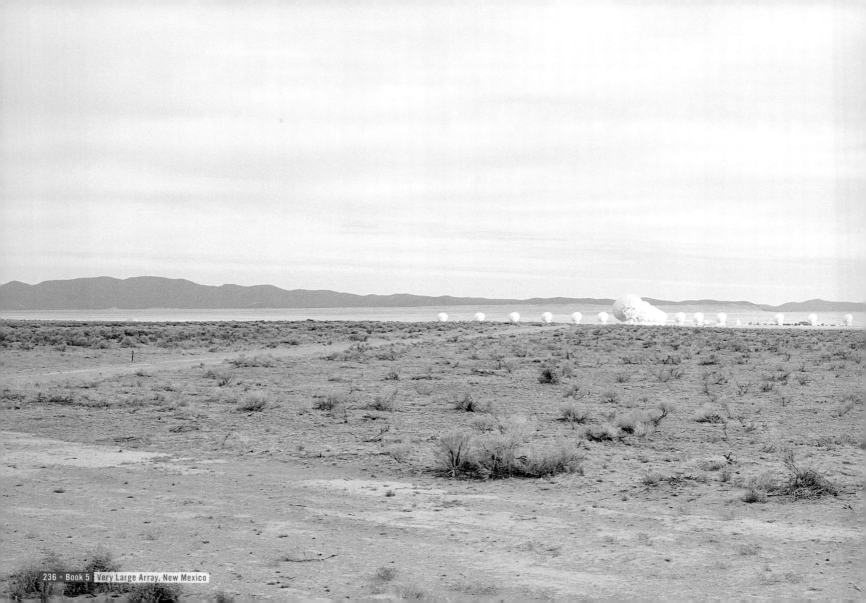

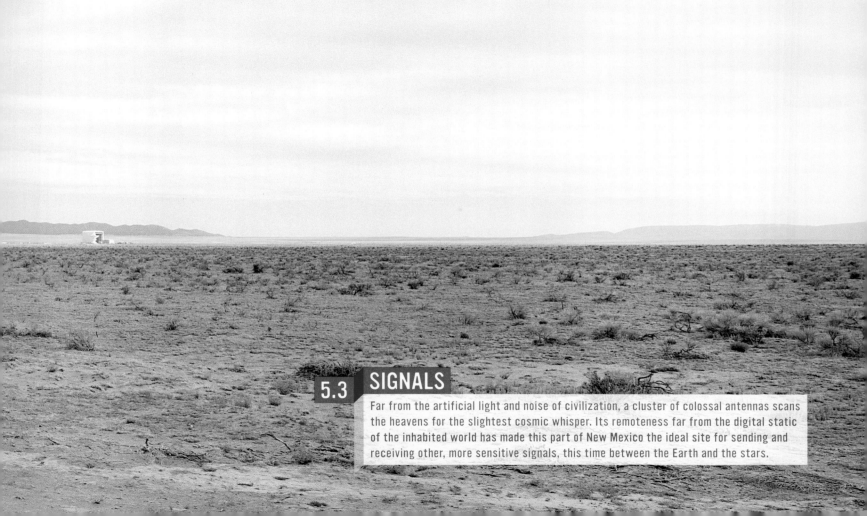

5.3 SIGNALS

Far from the artificial light and noise of civilization, a cluster of colossal antennas scans the heavens for the slightest cosmic whisper. Its remoteness far from the digital static of the inhabited world has made this part of New Mexico the ideal site for sending and receiving other, more sensitive signals, this time between the Earth and the stars.

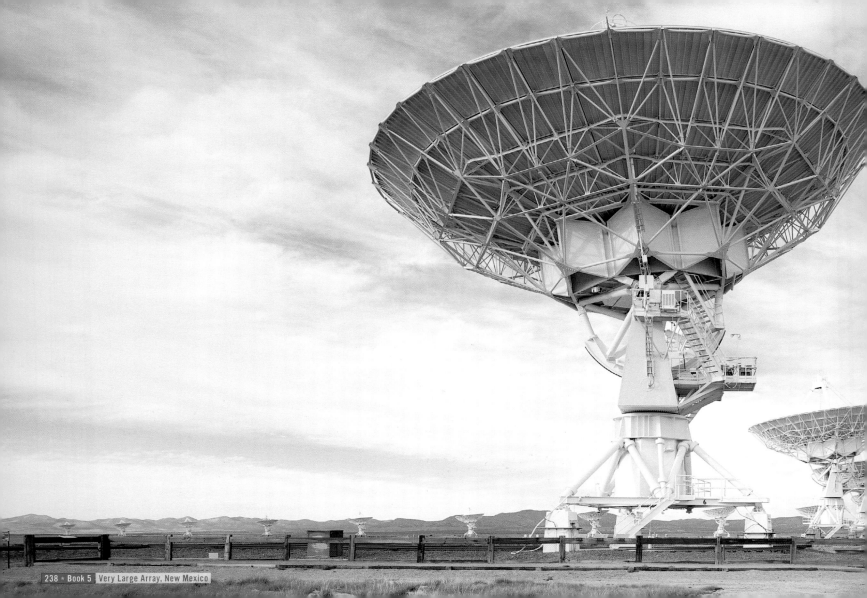

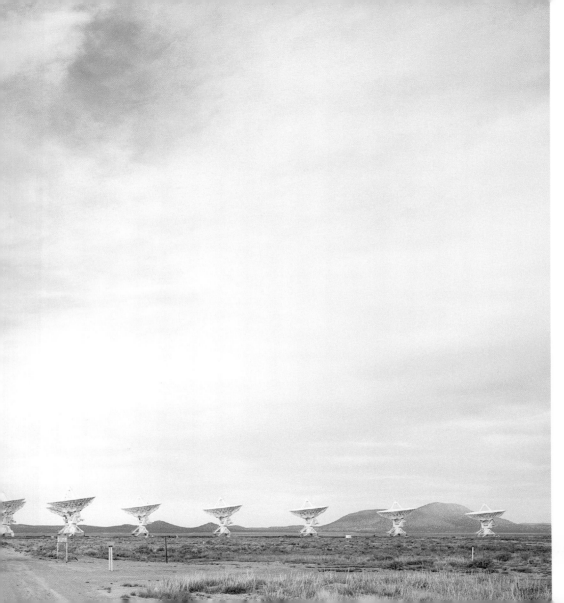

Operated by the National Radio Astronomy Observatory (NRAO), the Very Large Array (VLA) is located on the Saint Agustin plains fifty miles west of Socorro, New Mexico, at an altitude of 2124 meters above sea level. Twenty-seven 25 meter-diameter radio telescopes are set on tracks in a Y-configuration, working in unison to generate an aggregate resolution whose largest equivalent physical dimension reaches up to 36 km in diameter. The VLA is open to scientists from around the world, who complete observation experiments that may last a single minute or take up to several weeks. For projects that do not require full imaging capabilities, the VLA may be divided into sub-arrays, tracking up to five different celestial entities simultaneously. The VLA is scheduled to be incorporated into the Very Long Baseline Array (VLBA), which is currently under construction. The VLBA operates much the same way as the VLA, but at a much larger scale. It will include telescopes located across the United States (from Hawaii to St. Croix) and will be the largest astronomical monitoring device in the world.

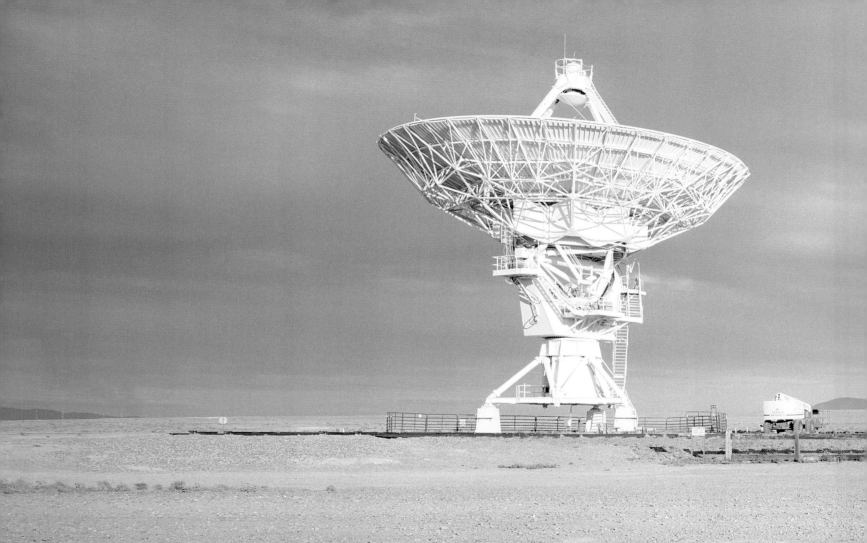

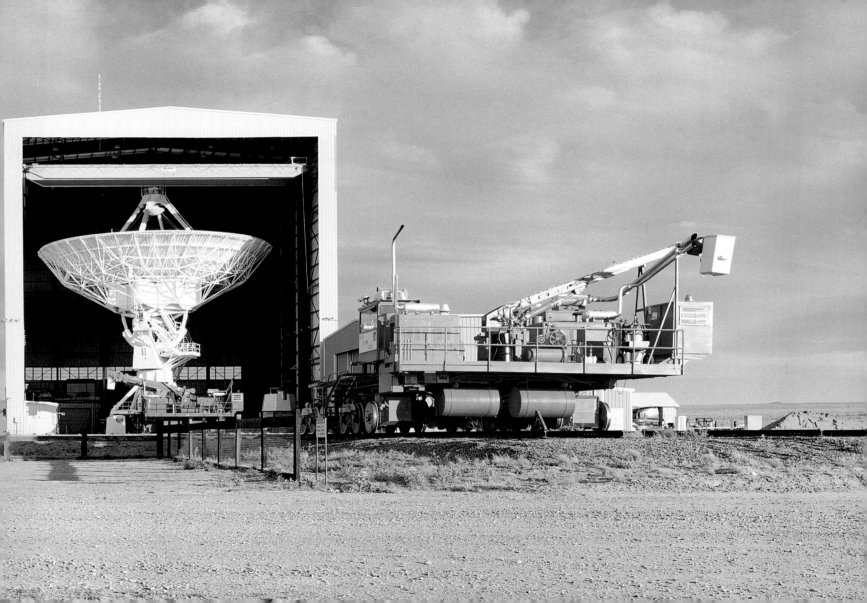

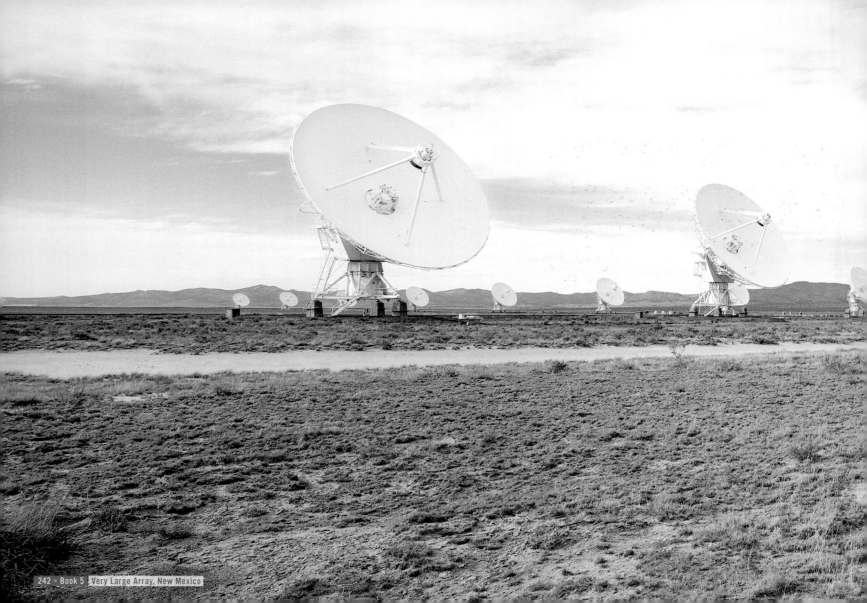

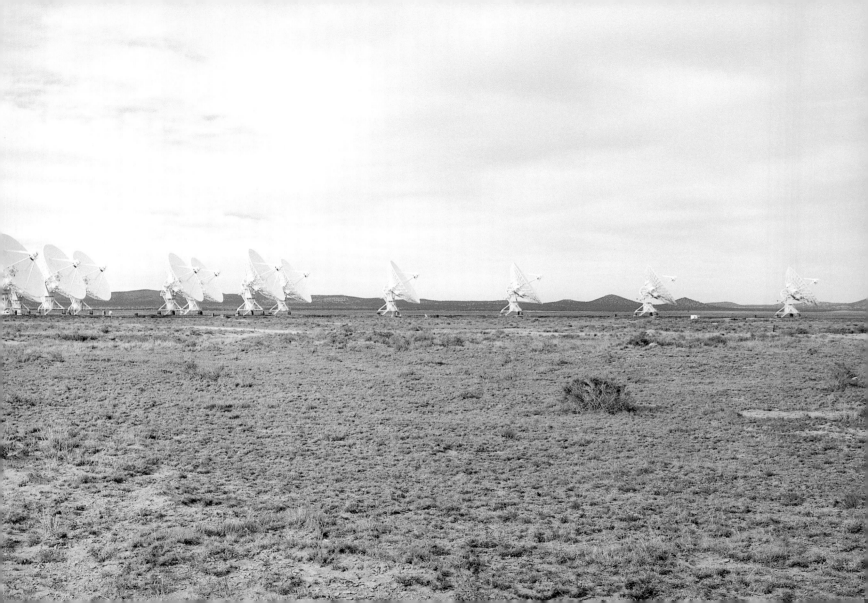

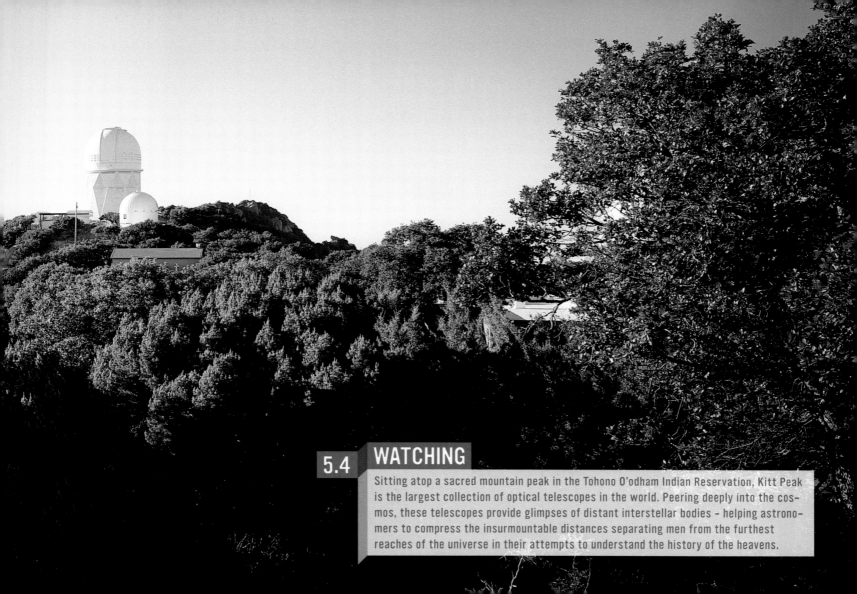

5.4 **WATCHING**

Sitting atop a sacred mountain peak in the Tohono O'odham Indian Reservation, Kitt Peak is the largest collection of optical telescopes in the world. Peering deeply into the cosmos, these telescopes provide glimpses of distant interstellar bodies - helping astronomers to compress the insurmountable distances separating men from the furthest reaches of the universe in their attempts to understand the history of the heavens.

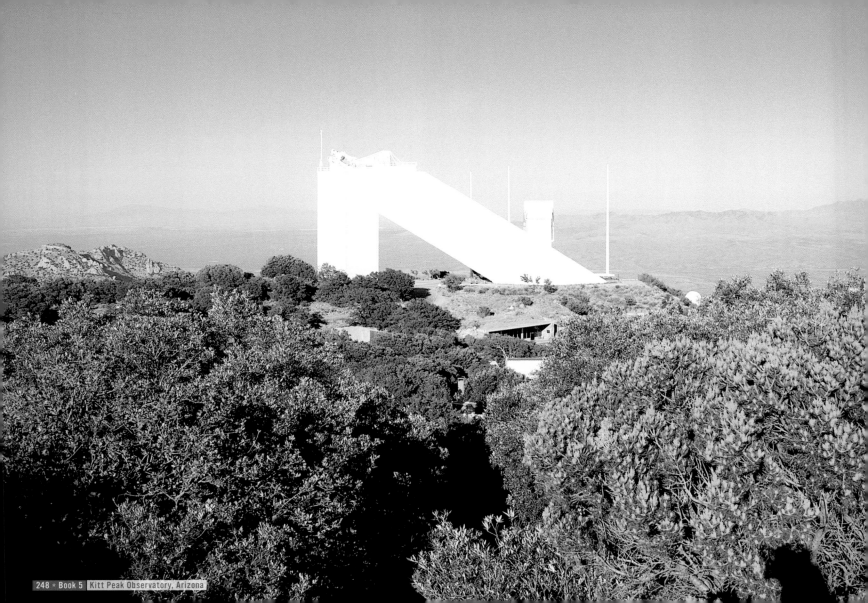

Kitt Peak Observatory
The observatory was established in 1958 as a site for national astronomy, on grounds leased indefinitely from the Tohono O'odham Nation. In 2005, the reservation sued the National Science Foundation to halt the construction of the Very Energetic Radiation Imaging Telescope Array System (VERITAS). The Tohono O'odham Nation asserted that the site of the four-telescope VERITAS complex (used to measure gamma radiation from distant quasars and black holes) would sit directly upon sacred tribal lands.

McMath–Pierce Solar Telescope Facility
Inaugurated at the observatory in 1962, the McMath Pierce solar telescope rises nearly 30 vertical meters and then descends 60 meters underground. Designed by Myron Goldsmith of SOM, the McMath Pierce telescope is the largest such instrument in the world, with an optical path of 150 meters, the whole of which is continually refrigerated to reduce image distortion.

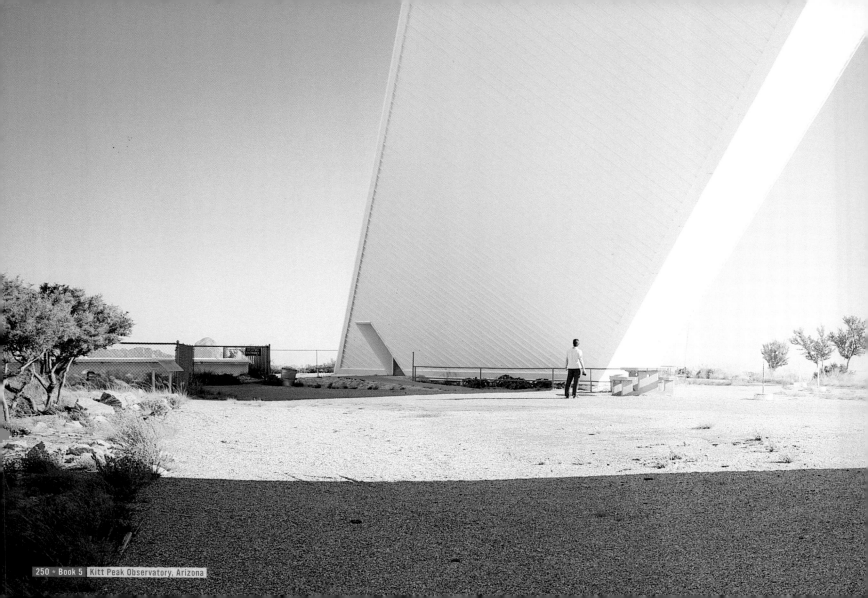

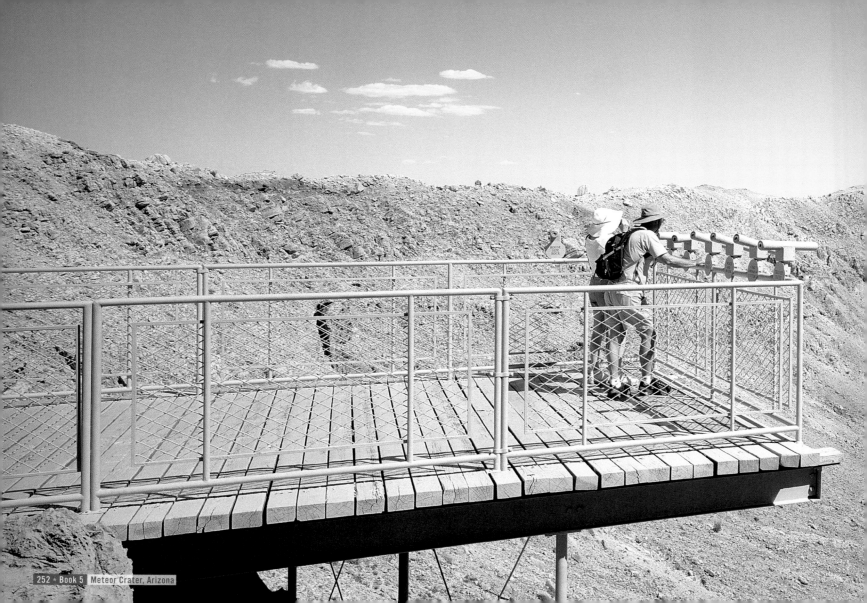

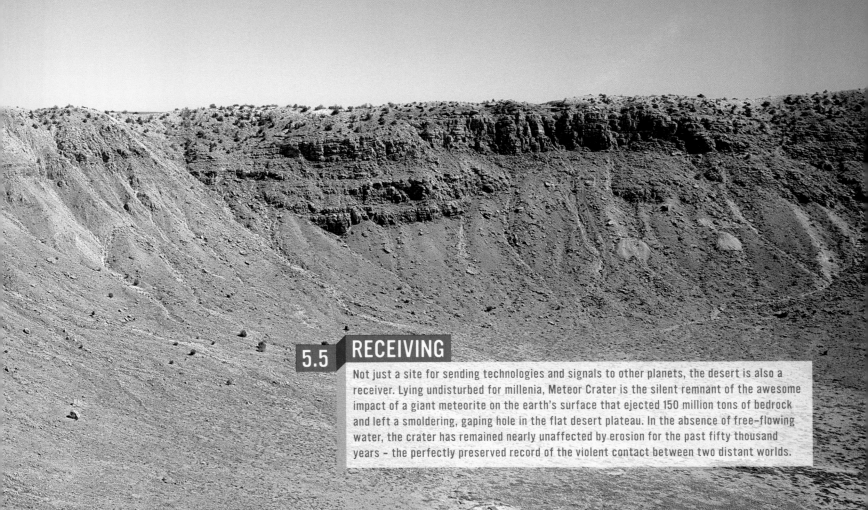

5.5 | ## RECEIVING

Not just a site for sending technologies and signals to other planets, the desert is also a receiver. Lying undisturbed for millenia, Meteor Crater is the silent remnant of the awesome impact of a giant meteorite on the earth's surface that ejected 150 million tons of bedrock and left a smoldering, gaping hole in the flat desert plateau. In the absence of free-flowing water, the crater has remained nearly unaffected by erosion for the past fifty thousand years – the perfectly preserved record of the violent contact between two distant worlds.

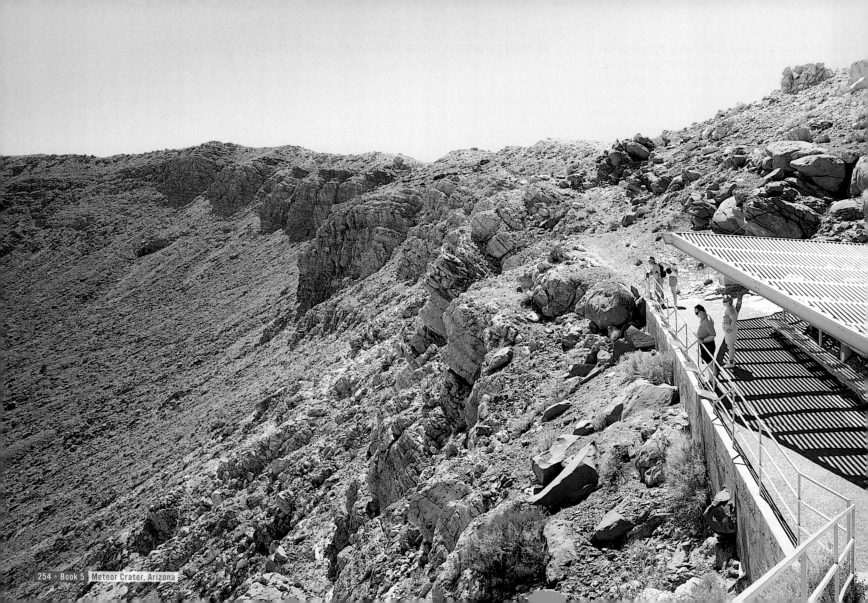

Formed 50,000 years ago, the Barringer Meteor crater remained relatively unpublicized until a scout for General Custer made note of it in 1871. Bearing his name for the next thirty years, the crater was known as Franklin's Hole and thought to be the remains of an extinct volcano. In the early 20th century the hole captured the attention of Daniel Barringer, a Philadelphia mining engineer, who believed the crater's beginnings were celestial in origin. Aware of the heavy iron content in meteors, once Barringer confirmed the telltale presence of magnetic iron oxide along the crater's rim, he immediately formed the Standard Iron Company to locate and harvest what he believed to be the iron-rich remains of the imbedded meteor. Unfortunately for Barringer (and his investors), his estimate of ten million tons of iron was grossly inflated. After repeated and fruitless drillings, investors in Barringer's company contacted Forest Ray Moulton, a well known mathematician and astronomer, whose calculations put the actual mass of the meteor at a mere 3% of Barringer's estimate; moreover, it was likely that the meteor was completely vaporized upon impact. Later, geologist Eugene Shoemaker confirmed these findings with detailed comparisons between the features of Meteor Crater and several impact craters formed by nuclear explosion tests conducted by the Department of Defense.

Today privately owned and administered by Meteor Crater Enterprises, Inc., Meteor Crater has suffered little from erosion and is incredibly well preserved. Visitors can view the 1500 meter wide and 180 meter deep crater from various viewing platforms and learn about the crater's origins in the Interactive Learning Center and theater. The center also offers daily walking tours and provides campers with special parking spaces for RV trailers.

Dr. Eugene Shoemaker's cross section sketch of Meteor Crater

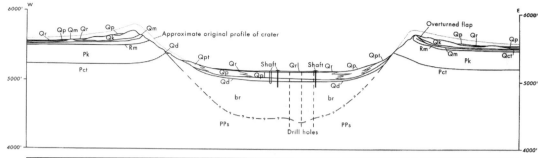

Qr	Recent alluvium	Qd	mixed debris from Coconino, Toroweap, Kaibab and Moenkopi formations; includes lechatelierite and meteoric material	Rm	Moenkopi formation (Triassic)
Qrl	Recent playa beds			Pk	Kaibab limestone (Permian)
Qp	Pleistocene alluvium	Qct	debris from Coconino and Toroweap formations	Pct	Coconino and Toroweap formations (permian)
Qpl	Pleisocene lake beds	Qk	debris vrom Kaibab limestone	PPs	Supai formation (Permian and Pennsylvanian)
Qpt	Pleistocene talus	Qm	debris from Moenkopi i formation		
		br	breccia (includes lechatelierite and meteoritic material)		0 500 1000 1500 2000

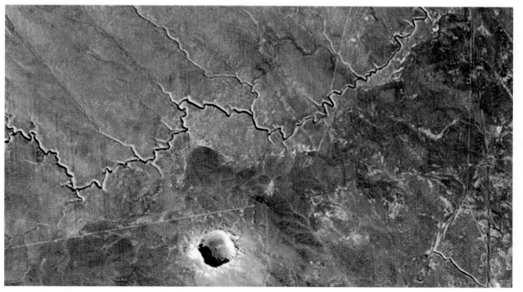

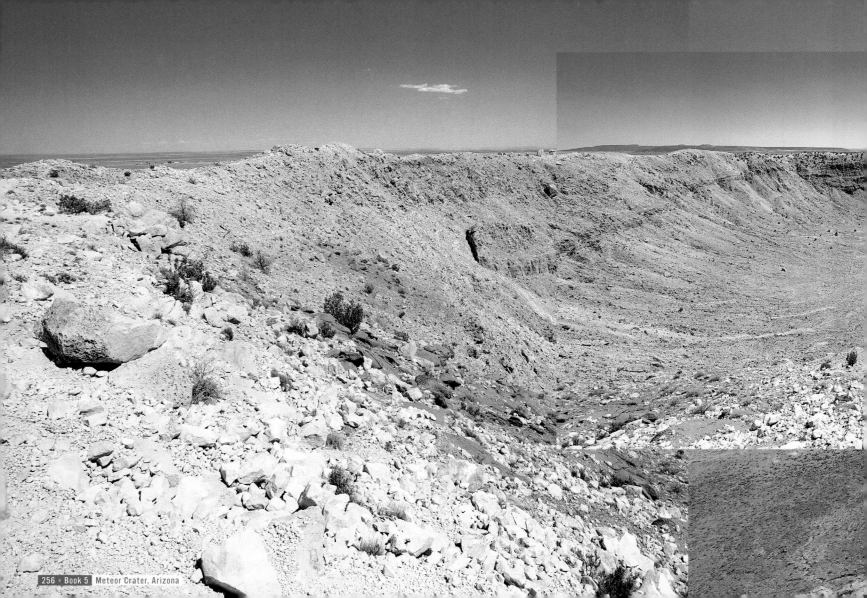

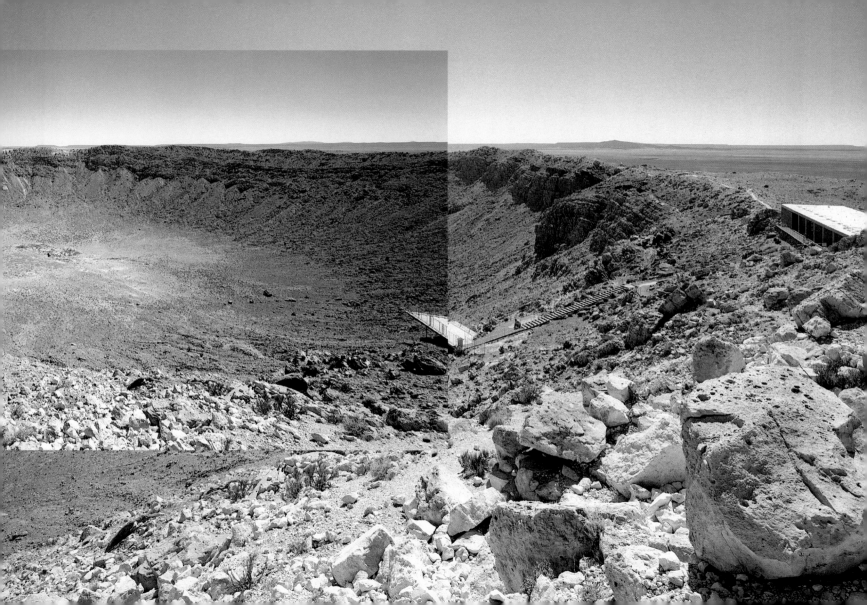

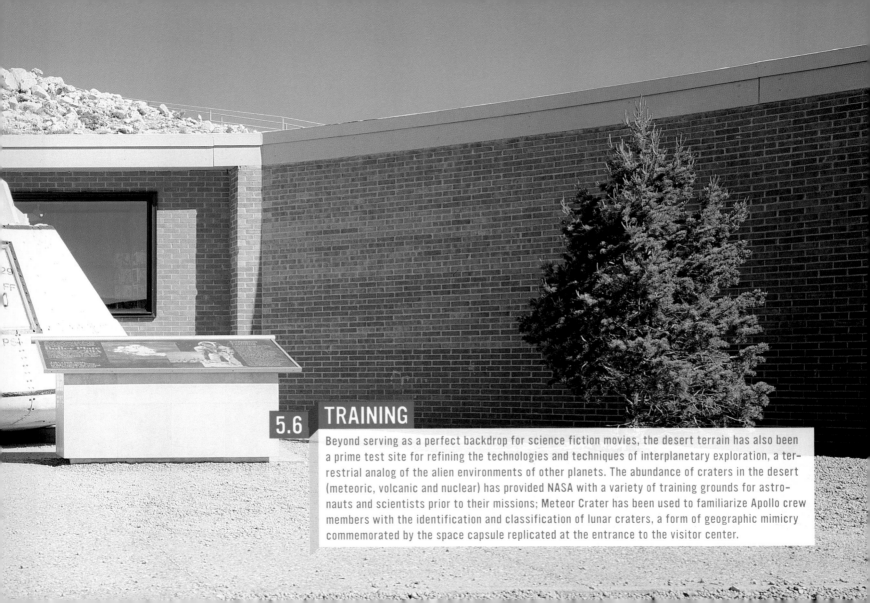

5.6 TRAINING

Beyond serving as a perfect backdrop for science fiction movies, the desert terrain has also been a prime test site for refining the technologies and techniques of interplanetary exploration, a terrestrial analog of the alien environments of other planets. The abundance of craters in the desert (meteoric, volcanic and nuclear) has provided NASA with a variety of training grounds for astronauts and scientists prior to their missions; Meteor Crater has been used to familiarize Apollo crew members with the identification and classification of lunar craters, a form of geographic mimicry commemorated by the space capsule replicated at the entrance to the visitor center.

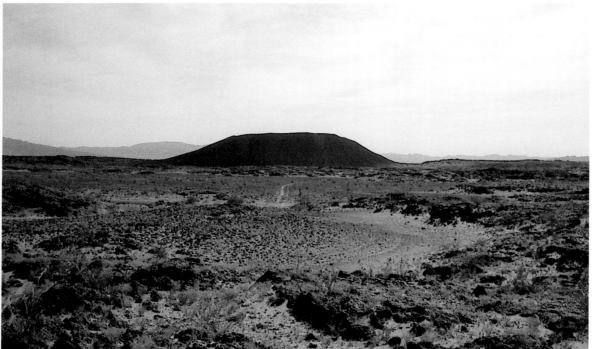

AMBOY CRATER

--

Located in the eastern sector of the California Mojave desert, Amboy Crater is the remnant of an extinct cylinder cone volcano. Less than 6000 years old, the crater and its surrounding lava field contain a wide variety of terrain types located within a very concentrated surface area. These various landscapes have been identified by NASA and the Jet Propulsion Lab (JPL) as an ideal "Mars analog" location for the staging of several past and future rover tests.

1 Apollo astronauts examine the geology around the rim of Schooner Crater (a crater formed by a nuclear blast in the Nevada Test Site), which was thought to be similar to the South Ray crater at Apollo 16's target landing site on the Moon.
2 Apollo 16 astronauts conduct studies near Schooner crater. Crews of Apollo 14 and 17 crews also participated in exercises here, and at other locations on the Nevada Test Site.
3 The size of Schooner crater and the large rocks thrown from it allowed astronauts to appreciate of the problems they would later encounter when observing and sampling the large craters on the Moon.
4 Apollo 16 astronauts ride a Moon Rover in November 1970 near Schooner crater.

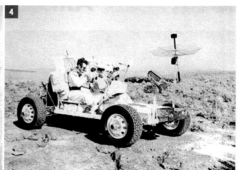

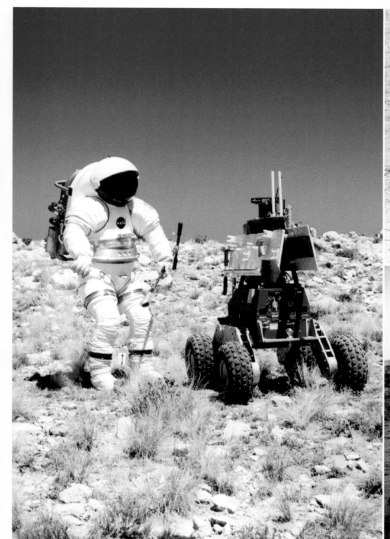
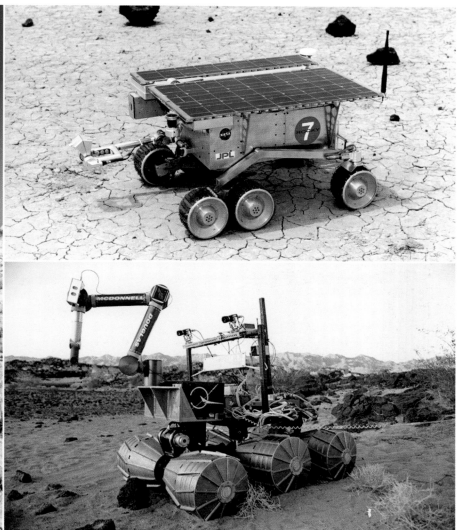

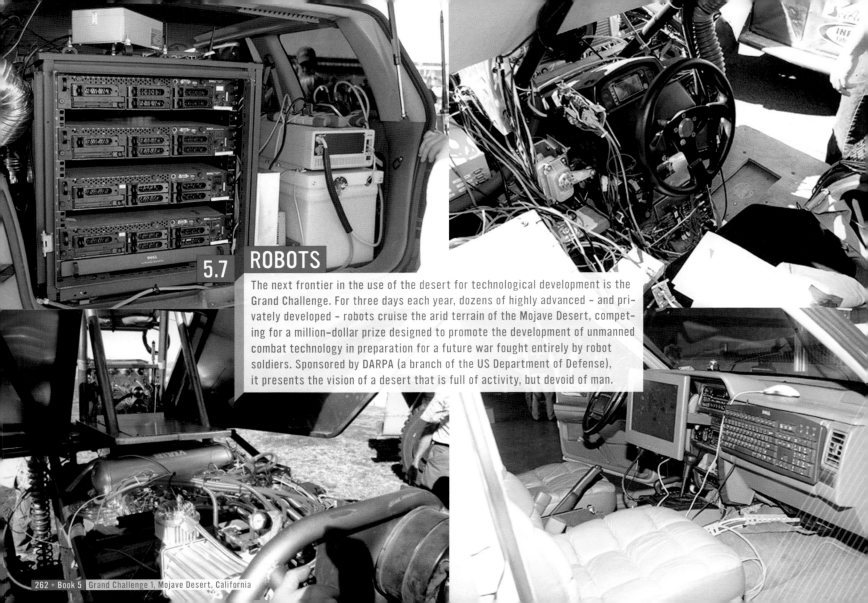

5.7 ROBOTS

The next frontier in the use of the desert for technological development is the Grand Challenge. For three days each year, dozens of highly advanced – and privately developed – robots cruise the arid terrain of the Mojave Desert, competing for a million–dollar prize designed to promote the development of unmanned combat technology in preparation for a future war fought entirely by robot soldiers. Sponsored by DARPA (a branch of the US Department of Defense), it presents the vision of a desert that is full of activity, but devoid of man.

GRAND CHALLENGE I, MARCH 13ᵀᴴ, 2004

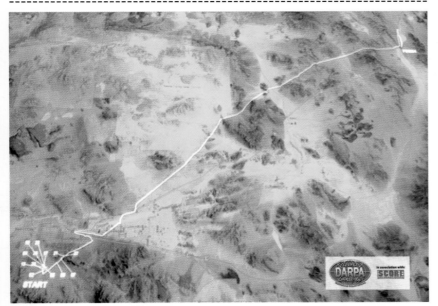

Established by the Defense Advanced Research Project Agency (DARPA) branch of the Department of Defense, the DARPA Grand Challenge hopes to encourage private groups outside of the defense contracting industry to participate in the design and development of robotics technology. The first Grand Challenge, held in the Mojave Desert in 2004, was a direct response to a Congressional mandate aimed at establishing an unmanned military ground force by 2015. To accelerate this process, the Grand Challenge offered participants a cash award of $1 million to the first fully autonomous robotic vehicle able to complete a lengthy desert course in under 10 hours.

All vehicles were required to remain fully autonomous while navigating an unfamiliar course, kept secret until the day of competition. To win, these robots (standard model trucks, cars, small all-terrain vehicles, or fully custom-built vehicles) would have to avoid all en-route obstacles, negotiate prescribed turns, and travel at "combat relevant" speed throughout the length of the course. All human intervention could occur only prior to the start of each individual run and any manual adjustment was strictly prohibited during the course of competition.

Of the fifteen vehicles participating in the first Challenge on March 13, 2004, none were able to claim the million dollar prize. The most successful of these teams (Team Sandstorm from Carnegie Mellon University) covered a mere 3.5% (7 miles) of the 200 mile course before dropping out of competition.

TERRAIN TYPES

PAVED

.overpass .side

UNSURFACED

.railroad .straight .winding

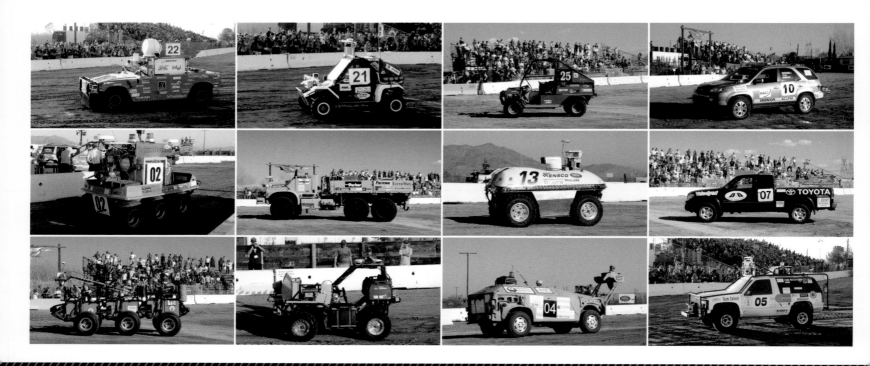

UNDERPASS

TRAILS

.hard

.ridge

.ridge

.rocky

.sandy

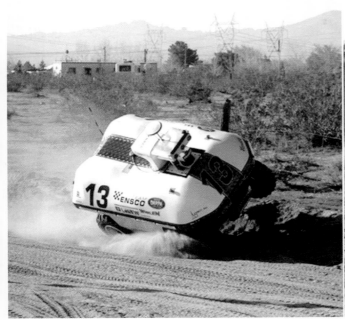

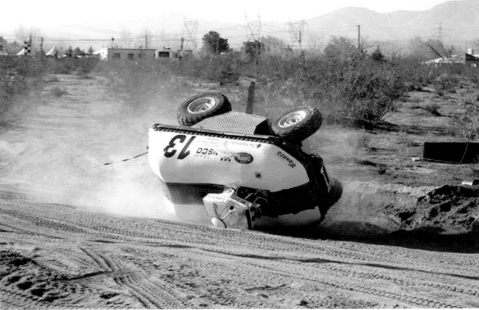

NATURAL OBSTRUCTION

WATER

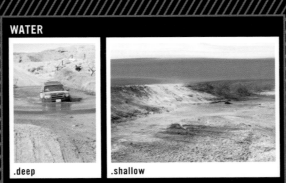

.deep

.shallow

OFFROAD

.brush

.drylake

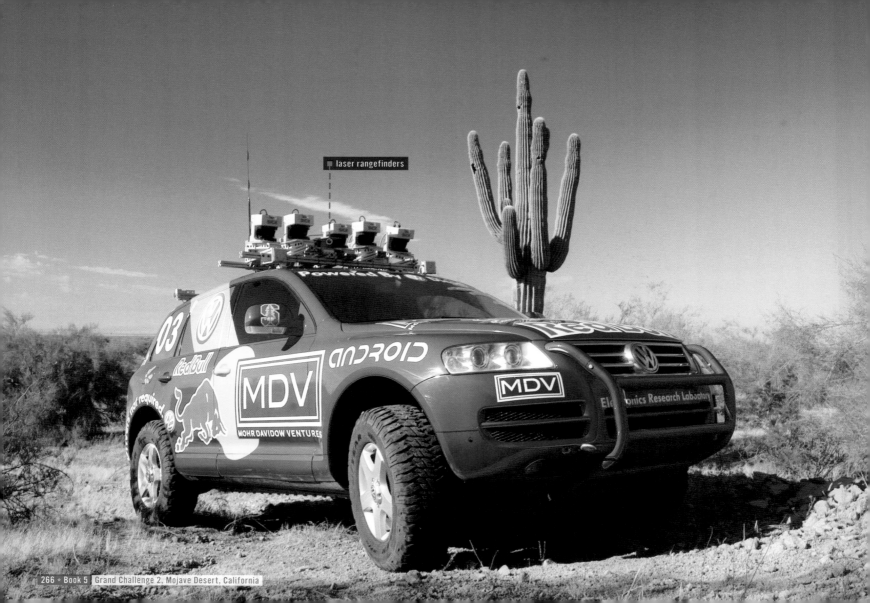

laser rangefinders

GRAND CHALLENGE II, OCTOBER 8ᵀᴴ, 2005

PRIMM, NEVADA. On October 8, 2005, the second installment of the DARPA Grand Challenge (increased to a $2 million prize) announced its first winner: "Stanley," a modified Volkswagen SUV from Stanford University's Racing Team, completed the 132-mile desert course in Primm, Nevada in just under seven hours. Outfitted with a highly sensitive Global Positioning System (accurate to within 20 cm) and entirely autonomous, Stanley collected real-time information as it drove through various types of terrain, processing data with seven onboard computers to instantly calculate optimal and safe navigation routes. Five of the 23 robots contestants completed the course, a vast improvement over the 2004 competition. Though the military already possesses a fleet of unmanned vehicles, these are not robotic and must be guided via remote control. According to Stanford Racing, the technology developed in the Stanley project suggests new civilian applications, like the enhancement of commuter driving safety; moreover, the technology could potentially provide every New Year's Eve reveler with a "designated driver."

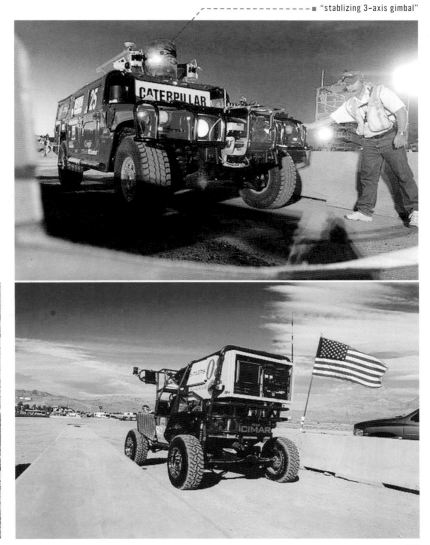

■ "stablizing 3-axis gimbal"

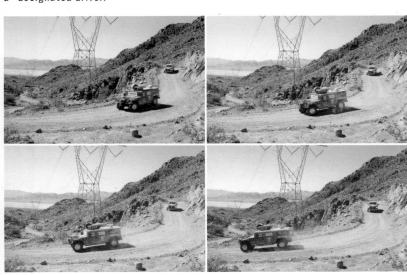

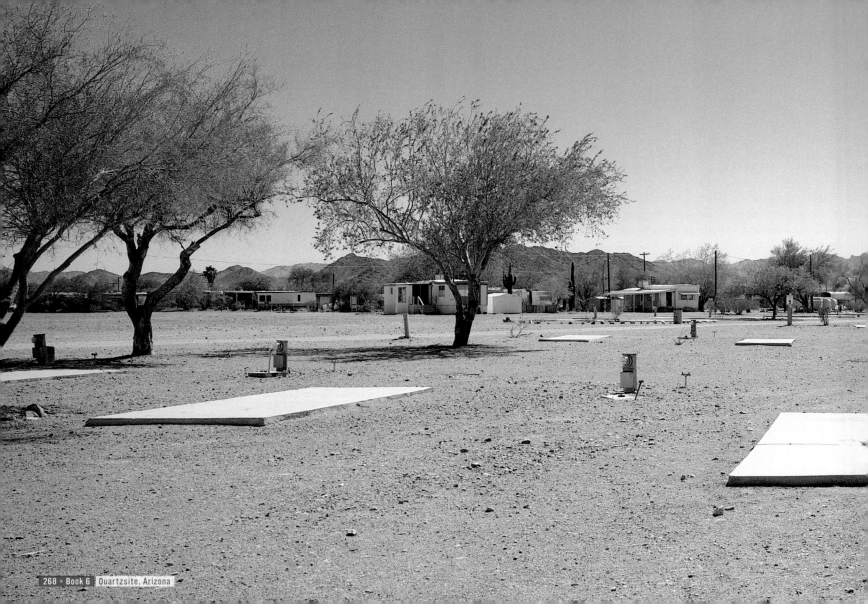

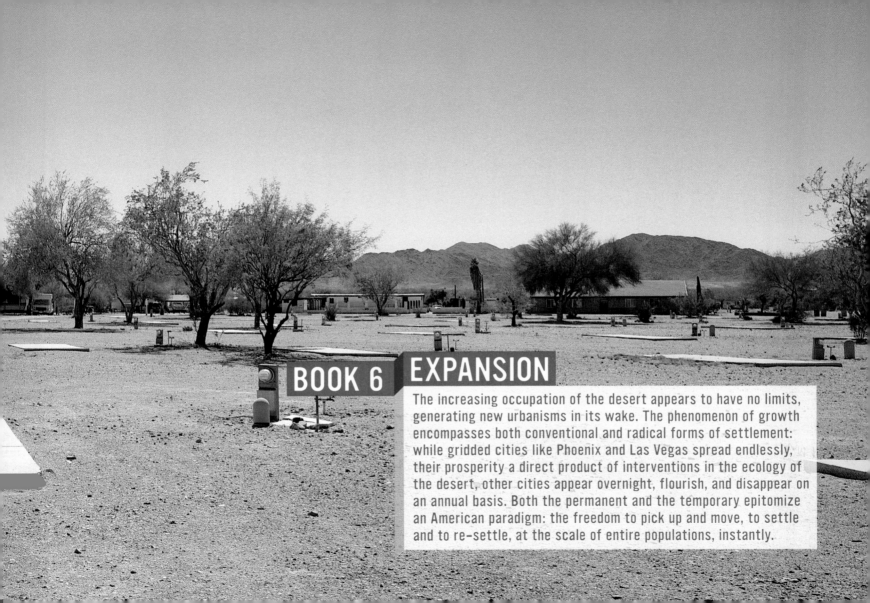

BOOK 6 EXPANSION

The increasing occupation of the desert appears to have no limits, generating new urbanisms in its wake. The phenomenon of growth encompasses both conventional and radical forms of settlement: while gridded cities like Phoenix and Las Vegas spread endlessly, their prosperity a direct product of interventions in the ecology of the desert, other cities appear overnight, flourish, and disappear on an annual basis. Both the permanent and the temporary epitomize an American paradigm: the freedom to pick up and move, to settle and to re-settle, at the scale of entire populations, instantly.

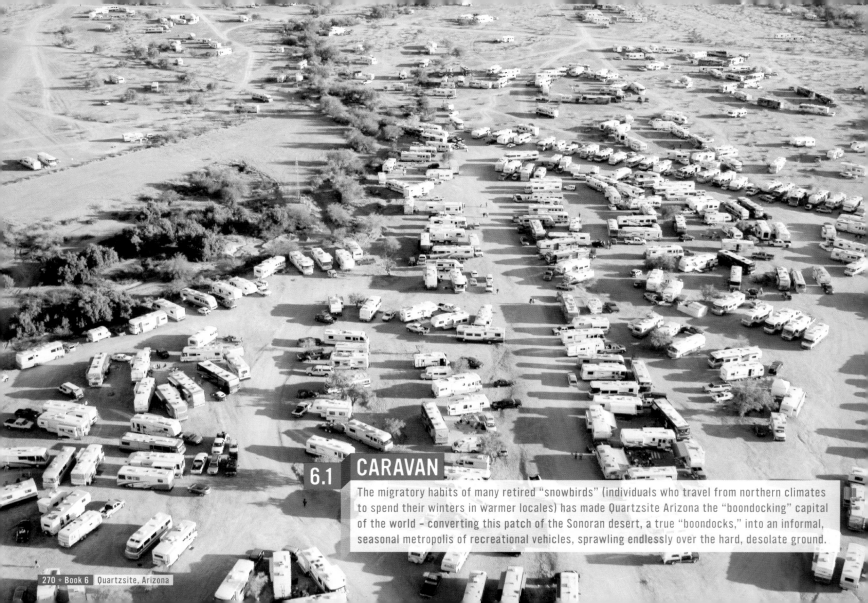

6.1 CARAVAN

The migratory habits of many retired "snowbirds" (individuals who travel from northern climates to spend their winters in warmer locales) has made Quartzsite Arizona the "boondocking" capital of the world – converting this patch of the Sonoran desert, a true "boondocks," into an informal, seasonal metropolis of recreational vehicles, sprawling endlessly over the hard, desolate ground.

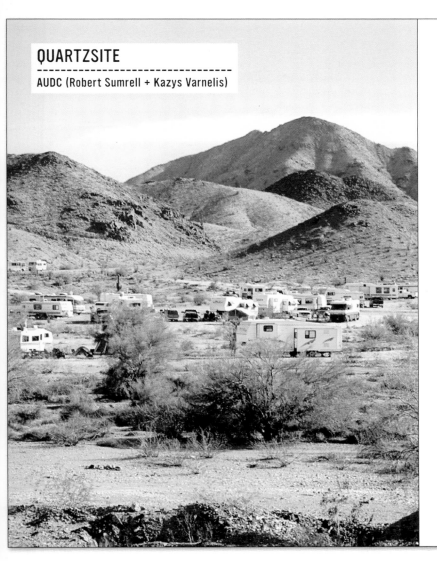

QUARTZSITE

AUDC (Robert Sumrell + Kazys Varnelis)

SWARM INTELLIGENCE

In *Empire*, Michael Hardt and Antonio Negri describe how the withering of the nation-state and the rise of immaterial labor is leading to a new form of imperial sovereignty, a network power so complete and total that it lacks any exterior. In their landmark sequel, *Multitude*, they identify a counterforce arising within *Empire*, a networked swarm that communicates and self-organizes without losing its sense of difference or developing into hierarchical forms of rule. The "multitude," as they call it, lacks any center or readily identifiable organization, but is by no means anarchic, possessing a swarm intelligence much as groups of insects or birds do.

Multitude is the product of a transformation in industrial production from the fixed structures and hierarchies of Fordism to the flexible structures and distributed networks of Post-Fordism. Unlike the mass, which is defined by sameness, the multitude never ceases to lose its inherent difference. Each agent understands itself not as part of the mass, but as an individual cooperating with others through centerless networks.

Hardt and Negri's notion of swarm intelligence is indebted to the new science of emergent systems, which proposes to explain how a large number of independent agents, each subscribing to simple rules, can produce complex structures: the stock market, cells in a body, ant colonies, fractal

271

geometries, cities, beehives, or open-source software communities. As each agent interacts with others, incorporating feedback about its behavior, common goals emerge and higher-level patterns form.

Unlike a grouping of insects or geometric structures, the multitude is composed of individuals that can take advantage of telecommunications systems. No longer tied to others unlike ourselves but in close physical proximity, we can easily establish and maintain ties that cross physical and territorial boundaries, carrying on conversations with isolated individuals both near and far away from us. This does not mean that there is no room for face-to-face interaction. On the contrary, as geographer Ronald F. Abler writes in his seminal article for *Bell Telephone Magazine*, "What Makes Cities Important," "the production, exchange and distribution of information is critical to the function of the modern metropolis… cities are communications systems." Unlike the city of old, however, which served to produce the homogeneous citizen, the contemporary city leads to proliferations of micro-communities interested in increasingly specific activities and often extreme lifestyles—Star Trek fandom, Lacanian psychoanalysis, suspensions, production of machinima epics, modern architecture, No Limit Texas Hold'Em Poker, or bird watching. Dense urban areas offer the possibility for individuals to meet more individuals in similar micro-communities, and for clusters of like-minded people to live together.

EXURBIA

But this is the posturban era. Just as there is no exterior to *Empire*, so too there is also no place that is not touched by the urban condition. If the 1950s and 1960s were the great decades of suburban growth, when inhabitants in both the United States and Europe fled the city for the suburbs, the last decade has been marked by the rapid expansion of the exurban realm. As suburbs have themselves been colonized by coffee shops, alternative music stores and art museums, and the city has been invaded by big box stores and shopping malls, rural ways of life have, at long last, vanished. Agriculture has either become thoroughly industrialized or a boutique industry, with college-educated artisans hand-pressing organic extra virgin olive oil or hand-rubbing Wagyu cattle to create an Arcadia without hunger or toil, a peasant world that never existed. With the rural gone, exurbia is free to recolonize the land, taking a working landscape and making it a landscape of visual consumption.

Exurbia undoes the traditional familial ties of people to the land, replacing them with a new kind of homogeneity based on the urban phenomenon of clustering. For those people so tied to their lifestyles and micro-communities that they identify thoroughly with them, exurbia offers Utopia: neo-hippies, Klansmen, millionaire skiers, back-country snowboarders, organic cattle ranchers, yachters, recluse billionaires, golfers, dirt bikers, woodworkers, amateur gold miners, and elderly nudists can all find exurban communities to suit their lifestyles and live out their fantasies.

If the city is characterized by diversity, exurbia accommodates those individuals seeking lifestyle choices that call for a voluntary homogeneity or for a nature-based infrastructure. Most exurbanites seek to avoid situations in which they would encounter individuals unlike themselves. They maintain a distance from other groups in order to decrease the likelihood of the chance encounters with strangers and dissimilar people that typify urban life. In exurbia, group identity is formed by a collective sameness, rather than by group interaction and communication. To be clear, however, many exurbanites only want to immerse themselves temporarily. Exurbia is the realm of the second home, the time-share, and the bed and breakfast. Nor is exurbia isolated. Exurban areas are networked together like everywhere else, forming virtual clusters of similar areas throughout the world. As exurban areas develop and expand over time, however, their insular nature allows for a new kind of diversity. Radically different neighborhoods develop and coexist in adjacency, creating almost self-contained worlds where interaction is hardly necessary or likely.

In search of an urban form for multitude, then, we turn to exurbia, this newest form of human habitation. For though much has been made of medieval towns and villages as examples of emergence in the urban realm, these are far from our present-day reality. Medieval villagers are far from the multitude. Nor is the urban realm, so tied to historical forms of habitation, likely to produce a radically new type of habitation. Kowloon Walled City in Hong Kong is a recent example of a territory taken over by a swarm, but its hyper-density is the product of one nation (the British) having no authority to rule over a territory owned by another (the Chinese) that did not care to exert its rights. It is still more a product of the old regime of boundaries, interiors, and exteriors than anything applicable to the era of Empire.

THE CAPITAL OF THE MULTITUDE

If there were a capital for the multitude—and by definition there can be no such thing—it would be Quartzsite, Arizona. During the scorching desert summer, Quartzsite is a sleepy town of 3,397 inhabitants, but every year between October and March, a new breed of nomad descends upon the town as hundreds of thousands of campers arrive in their Recreational Vehicles (RVs). These "snowbirds," generally retirees from colder climates, settle in one of the more than seventy RV parks in the area or in the outlying desert administered by the Bureau of Land Management (BLM). The BLM and local law enforcement agencies estimate that a total of 1.5 million people—some recent reports suggest in excess of 2 million—spend time in the Quartzsite area between October and March, a mass migration that temporarily forms one of the fifteen largest cities in the United States. If all of these residents inhabited Quartzsite at once, the result would be a more populous urbanized area than Dallas, San Jose, or San Diego, possibly even bigger than Phoenix or Philadelphia, America's fifth largest city.

Quartzsite is the id for Los Angeles and all generic, horizontal cities of the contemporary era. These sprawling cities, such as Phoenix, Dallas, and Houston are products of mobility, transitory architecture, and relatively little planning. Though architects and planners hate such cities, these communities remain popular with people. But because even the largest class of motor homes is hardly more than 30 square meters in size and motor home can be parked next to motor home, often to access common infrastructure such as water or power, the 94 square kilometers of Quartzsite are remarkably dense. With the majority of Quartzsite's campgrounds within town boundaries, a rough estimate—assuming 1 million inhabitants at its peak—would suggest that Quartzsite has some 10,000 inhabitants per square kilometer, approximately the same density as New York City. Since statistics at Quartzsite are hard to come by, even if we halved that number or even quartered it, Quartzsite would still be far denser than Atlanta with its 1,121 residents per square kilometer.

As the capital of the multitude, Quartzsite reveals how a city can form as an emergent system. Begun as a simple mineral show for desert rock hounds and people passing through the region via highway, it has grown into an instant city and international travel destination that forms every winter with a minimum of pre-planning and instruction. As an emergent system, Quartzsite has a life cycle outside those of its individual members. Quartzsite develops over time, grows, evolves and learns.

Quartzsite's early history would be marked by a series of false starts and brief settlements centered on short-lived stagecoach lines and mines. In 1856, Charles Tyson built a private fort, Fort Tyson, for protection against the Indians at a local watering hole. Tyson's Wells, as the new town came to be known, would become a station for passing stage-coaches. In her book *Vanished Arizona, Recollections of the Army Life by a New England Woman* of 1874, Martha Summerhayes would write of the area that "It reeks of everything unclean, morally and physically."

Although efforts were made at mining the hills in the area, early Quartzsite is best known for its connection to a failed military experiment. In 1855, Secretary of War Jefferson Davis made a proposal to Congress advocating the creation of a Camel Military Corps. Soon after, the army brought seventy-seven camels and a Syrian camel driving expert named Hadji Ali, or "Hi Jolly," to the American Southwest to patrol the desert frontier and supply the dispersed settlements of the area. Although the camels thrived in conditions that would fell any horse, the experiment was not without its problems. The animals did not adapt well to the rocky terrain. They scared other pack animals such as horses and burros. Soldiers found them foul-smelling and bad tempered and complained about camels spitting at them. The Civil War undid the Corps, and in 1863 the camels were sold off at auction. After a time running a camel-borne

freight business, Hi Jolly married a Tucson woman and moved to Tyson's Wells, where he worked as a miner until he died in 1902. In memory of his service, the government of Arizona built a small pyramid topped by a metal camel on his gravesite in the 1930's. Feral camels would be seen roaming the desert until the early 1900s.

For a half century after Hi Jolly's death, the population of Quartzsite remained small, with only about 50 people living in the outpost town on a permanent basis. By the 1950s, however, snowbirds began spending the relatively mild winter months in the area, and by the 1960s the seasonal population could swell to 1,500. Many of these winter travelers returned year-after-year and some settled permanently. As the community slowly grew, businessmen and civic boosters formed the Quartzsite Improvement Association, creating a gem and mineral show to encourage more winter travelers to come.

Contemporary urban theorists speak of the "Bilbao effect," suggesting that works of cutting-edge architecture can drive tourists to cities simply through their remarkable appearance. Quartzsite is like the Bilbao effect, except there is no building. Instead, Quartzsite has grown through word-of-mouth in the vast network of RV'ers. Some RV'ers invite their friends or clubs they are members of to camp with them at Quartzsite. Others, not so well-connected, come to Quartzsite to see what all the fuss is about.

FROM SOCIAL REGENERATION TO SOCIAL RECREATION

That they came at all is the result of the invention of the modern replacement for Hi Jolly's camels, the RV. In retrospect, the development of this self-sufficient beast, capable of hauling a family and enough food and water to sustain it over long distances, seems almost inevitable.

In his 1896 essay "The Frontier in American History," Frederick Jackson Turner, the founder of American Studies, observed that the United States Census Bureau considered the frontier closed by the 1880s. For Jackson, this could only result in an epochal shift in the American psyche. Until then, he argued, Americans could renew themselves in the primitive conditions of the frontier. The loss of a true wilderness experience meant that the individual no longer had a ready place for social regeneration.

The end of social regeneration on the frontier, however, paved the way for a new idea: recreation in exurbia. After Henry Ford built the Model T—his "car for the great multitude"—large numbers of individuals would flee the city on a regular basis in search of a newly domesticated "nature." Ford himself believed that the Model T's principle use would be to enable families to enjoy the blessing of hours of pleasure in God's great open space. Auto camping grew rapidly after World War I; by 1922, the New York Times estimated that of 10.8 million cars, 5 million were in use for camping. Soon "auto-tents" designed to fit the Model T would be available, and trailers that could be towed by the Model T would follow.

At first, campers would simply park in empty fields or by the side of the road. But this led to confrontations with angry rural folk, who saw their lives under threat not only from declining profitability but also from the nascent exurbanites they rightly feared would one day colonize the countryside, undoing rural ways of life. Soon campgrounds or "trailer parks" sprang up to provide places to stay with other campers on the road. Although campers sought nature and escape from a fixed community, they also enjoyed sharing this experience with their brethren. Unlike the metropolis, trailer parks were places of relative homogeneity—campers were generally middle class WASPs—so campers were able to tolerate living in remarkably close quarters.

During the Depression and the Second World War, camper trailers acquired a stigma, coming to be used as temporary shelters to be inhabited while their inhabitants worked transient jobs. By the affluent era of the 1950s, however, Americans once again desired to travel the country in self-sufficient "land yachts," untethered by hotels, inns, or motor courts. But the old campers were increasingly unsuitable. Not only did they have the unpleasant connotation of transient housing to overcome, but, as the sizes of suburban homes increased, earlier campers came to seem small and cramped.

The solution was to integrate the automobile and the trailer, creating the continuous unit now known as the "motor home" or Recreational Vehicle. This new kind of vehicle was generally

PLEASE KEEP HANDS AND
CLOTHING AWAY FROM MACHINE

DER KRUSHEN-KAN
SMACHEN-CHOMPEN
HAULENDUMPER WERKS

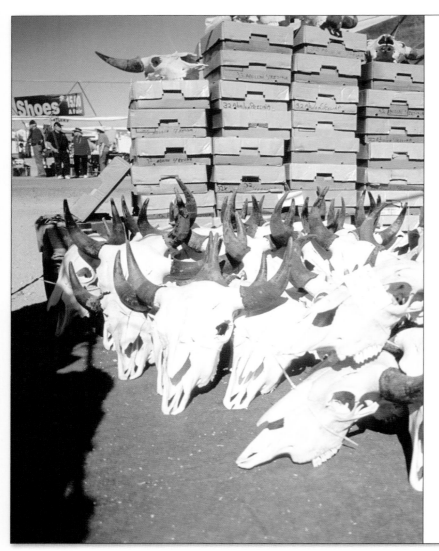

much larger than the campers of old and permitted other activities to take place while the unit was being driven. Moreover, in doing away with the automobile or truck hauling the camper, the RV became a vehicle that could not be employed for traditional forms of work. You cannot drive your RV to a workplace: it exists purely for a lifestyle of leisure and consumption.

RVs have continued to rise in popularity ever since. Today one in ten American vehicle-owning households has one. But the majority of RV owners are in their sixties and seventies now, and spent their formative years in the 1950s, coming of age in the decade that saw the greatest migration in American history as their families moved from city to suburbia.

At Quartzsite, snowbirds annually re-enact the process of settling the suburbs, choosing a vacant spot to inhabit next to others just like themselves, thereby recapturing the treasured anonymity and sameness of that era. Since everyone is in a camper, everyone is equal. Pasts are unimportant and incomes matter little. As in the postwar suburb, architecture is of no importance at Quartzsite. There are different models of RV and even some fundamental differences in RV typology—the full-fledged land yacht, the persistent trailer, the converted van, the converted bus; some units may cost $500,000 while others cost $5,000. Nevertheless, an RV is an RV, a premanufactured unit that is essentially similar to other units of its kind. Like a historic preservation district in a contemporary city, Quartzsite is composed of similar units and individual expression is kept to a Protestant

280

minimum, with just enough variation to relieve monotony. Add a flag, some plastic chairs, even a mat of green Astroturf, but your RV is still just like everyone else's and you are, quite likely, five or ten feet away from your neighbor.

Although the RV might appear to be an ultimate manifestation of American individualism, just like the trailer campers of the 1910s, RV'ers generally see themselves as part of a community. Quartzsite is, after all, the largest gathering of their kind in the nation, assembled purely by the desire to collect together. But it is still a particularly contemporary idea of community. The seventy-odd campsites in Quartzsite are generally privately owned and charge a moderate daily fee for usage. In the private campsite, the RV'er does not participate in any governance, choosing to let the "gated community" of the campground host do the governing.

A sizeable percentage of travelers opt out of these areas, "boondocking" on BLM land where it is possible to stay for free for up to two weeks. Campers frequently form small communities on BLM land on the basis of RV brand, extended family ties, or group membership: Knappers (individuals skilled in striking pieces of flint with other pieces of flint to make primitive tools and ornaments), HAM radio buffs, full-timers who have sold their homes and live only on the road, nudists, or the Rainbow children, attracted to the freedom of Quartzsite as they wander the country re-creating the hippie lifestyle of the early 1970s—all seek the company of others like themselves at Quartzsite. Quartzsite is the exurban city par excellence.

AN URBAN BÜRO LANDSCHAFT

If cities can be treated as communications systems, as Abler proposes, then they also resemble office environments. Informed by Norbert Wiener's theory of cybernetics, during the 1960s business managers sought means to improve the flow of information in the office and to provide for greater flexibility. In this view, offices too became understood as communications systems. Managers turned to theories of Büro Landschaft, or "office landscape," to replace traditional, rigid-wall offices with more fluid and changeable workplaces.

Quartzsite is an urban Büro Landschaft. It stands in stark contrast to traditional, gridded cities like Manhattan. Quartzsite allows for divisions between groups to spontaneously occur, reconfigure at will, and disappear when appropriate. If you don't like your neighbor or you find that you'd rather be across town, you can just pack up your RV and go. Even though Quartzsite is a city and not an office, it is truer to the ideals of Büro Landschaft than any office could be. Offices are ultimately based on hierarchy and exploitation; no matter how hard it tried, Büro Landschaft could not hide this. In its purest form, Büro Landschaft would have even have been a form of Communism. At Quartzsite, the fact that few of its winter inhabitants work makes it a much purer model than any office ever could have been.

Like the world of which Quartzsite is a microcosm, community at Quartzsite is based on trade. Stimulated by the model of the Quartzsite Improvement Association, nine major

gem and mineral shows and more than fifteen general swap meeting shows attract RV'ers to the area. Much like the young hipsters who populate the fashionable districts of cities like New York, San Francisco, and Los Angeles, the mainly senior citizen campers at Quartzsite generally don't work except as full time consumers. Seemingly incongruous juxtapositions of ever more bizarre goods appear throughout the markets: fresh shrimp cocktails hundreds of miles from the ocean are available next to cow skulls and fox furs dangling near street lights. African sculpture is popular, a demonstration of Quartzsite's role in a global network of nomadic trade. Although there may be variation among the objects for sale, year after year it is the presence of the market itself that draws the migratory residents of Quartzsite back. Ritually appearing and disappearing with the seasons, the marketplace staves off banality and boredom.

After wandering for a time at a Quartzsite show like "the Main Event" or the "Tyson Wells Sell-A-Rama," one is gripped by the thought that even the merchants don't come to Quartzsite to make a buck. As more than one sign advertising a merchant's need for a wife makes clear, merchants are more interested in interacting with people than in maximizing profit.

The shopping district at Quartzsite is a critical node for Quartzsite's processes of self-organization. Closed to RV and automotive traffic, the shopping districts serve as the primary conduits for the flow of people and information. Many people—even those who don't spend the night—go to Quartzsite just for this sense of impromptu community. As visitors arrive from around the world and mull over the value of useless objects, interactions between strangers in random configurations occur and knowledge and shared experiences take place. With 1.5 million visitors a year, all of these seemingly random conversations carry an enormous amount of information. Each single one is insignificant, but all of them together can have a vast influence on the community.

Quartzsite's economy is beyond scarcity or affluence. In general, the products sold at Quartzsite's markets are bought and sold to facilitate social relationships, not because they are needed or to establish social status. It's no surprise, then, that the exchange of rocks remains the focal point of the market economy at Quartzsite, remaining a major draw for visitors. Often obtained from the surrounding mountains during leisurely hikes and having had minimal labor applied to their retrieval and processing, Quartzsite's rocks circumvent any notion of labor or scarcity in economy. Nor are these rocks useful. At Quartzsite, the markets teach us of a new nomadic way of life beyond any idea of affluence or material desire.

According to Marx, the social character of a producer's labor is only expressed through the exchange of commodities. But if there is no labor to speak of involved in bringing these valueless rocks to sale, exchanging them is a way for Quartzsite's winter visitors to remind each other that they have escaped the capitalist system into a world in which

they are nothing, make nothing, and do not need to labor. At Quartzsite, the subject finally disappears into the system of objects. But instead of being a source of oppression, as they were in Marx's day, rocks become a source of liberation as they once were in the Potlatch or under the never-realized utopian vision of Communism: "From each according to his abilities, to each according to his needs!"

Social relations can take place via an exchange of rocks or through the way one parks one's RV. As the capital of the multitude, Quartzsite transgresses capitalism itself to incorporate what were once considered obsolete forms of economy: its market economy is largely free of capitalism, dwelling is based on feudalism, and individuals, just wealthy enough to escape the necessity of labor, are free to pursue their desires, as if under Communism.

But Hardt and Negri would be the first to point out that there can be no one capital of the multitude. It is, by definition, everywhere. So it is with Quartzsite as well. For Quartzsite is omnipresent. The recent real estate bubble teaches us that houses have no more intrinsic worth than stocks. We dwell in mobile homes sold for fantastic sums bearing no relation to their physical qualities. Just as the dot.com bubble unloaded any meaning from the stock market, this bubble has unloaded any meaning from architecture. Quartzsite is everywhere today, a transient posturbia absent of any productive capacity, not so much about making money as about enjoying experiences.

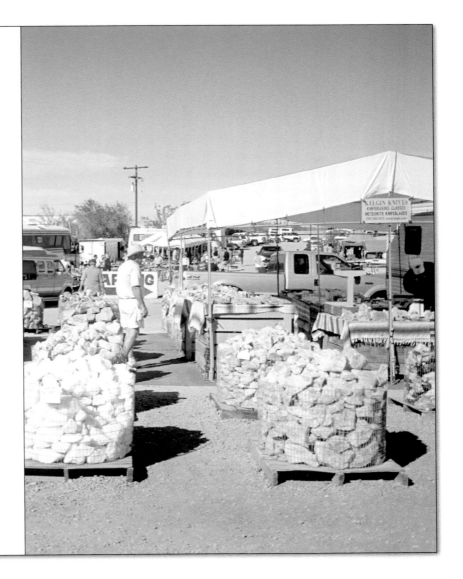

SLAB CITY
Peter Granser (Photos)

Faced with a severe case of "hitch-itch," many adventurous seniors have opted out of their retirement communities and are enjoying their golden years traveling the US in recreational vehicles (RVs). Tremendously popular, a growing population of aging recreational nomads, have formed groups like "Loners on Wheels" and the "Escapees," networks of more than 30,000 individuals. One popular stop is an abandoned military base situated on the shores of the Salton Sea, California.

All that remains of Camp Dunlap (a World War II training camp) are the concrete foundations of long-gone military barracks. Re-christened "Slab City," this desolate section of the Mojave mushrooms into a seasonal community of 5000 residents. These "snowbirds" and "slabbers" come to Slab City to enjoy its temperate winters, living in RV's powered by solar panels or generators. Slab City is altogether unregulated: neither federal nor state governments are interested in maintaining the property. Any improvements are enacted by individual initiative or via volunteer groups like the Slab City Organization. This seemingly provisional community, lacking basic infrastructures such as running water and waste disposal, maintains a Christian Center, ad-hoc library, geothermal bathing pool, and public shower. Residents frequent "The Range," an open-air club/bar/theater that offers patrons the finest comfort in salvaged airplane seating.

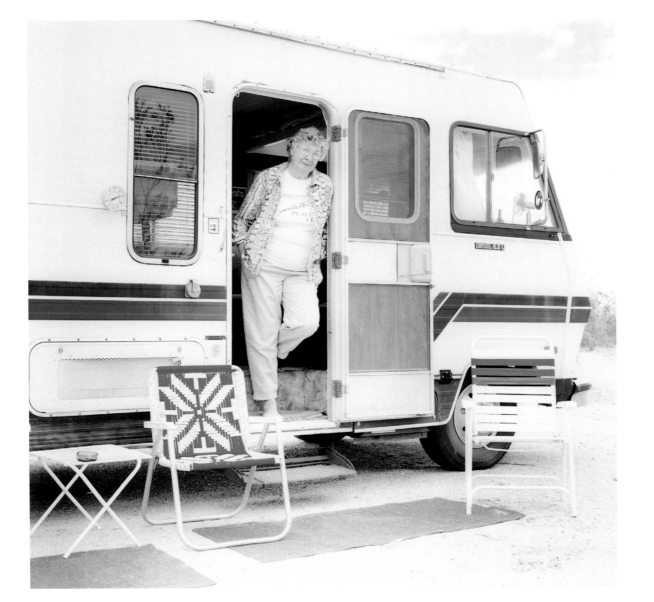

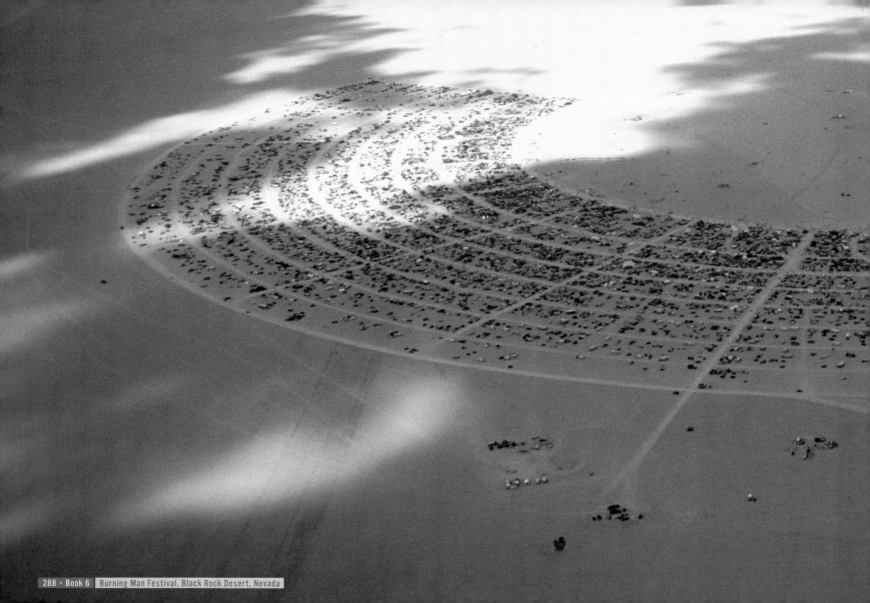

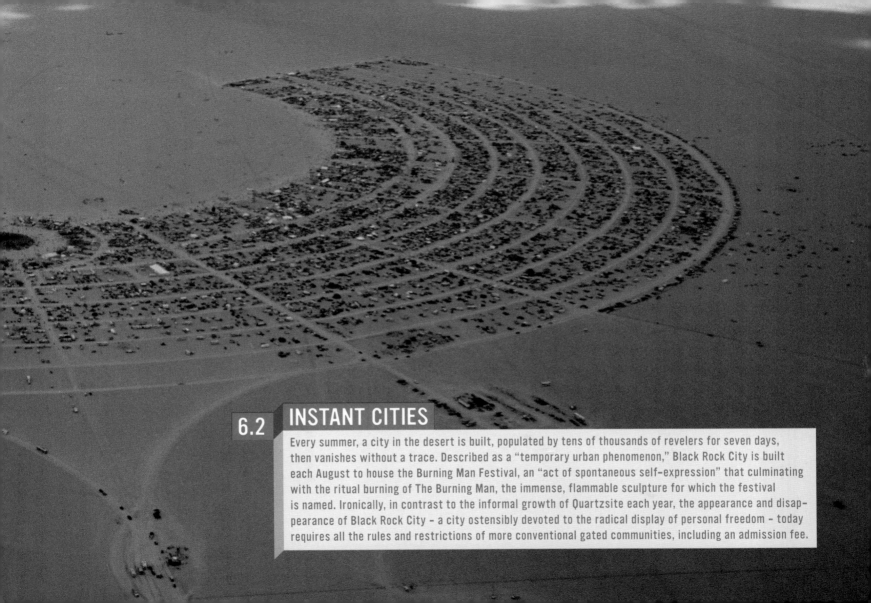

6.2 INSTANT CITIES

Every summer, a city in the desert is built, populated by tens of thousands of revelers for seven days, then vanishes without a trace. Described as a "temporary urban phenomenon," Black Rock City is built each August to house the Burning Man Festival, an "act of spontaneous self-expression" that culminating with the ritual burning of The Burning Man, the immense, flammable sculpture for which the festival is named. Ironically, in contrast to the informal growth of Quartzsite each year, the appearance and disappearance of Black Rock City - a city ostensibly devoted to the radical display of personal freedom - today requires all the rules and restrictions of more conventional gated communities, including an admission fee.

DESIGNING BLACK ROCK CITY

Text from www.burningman.com

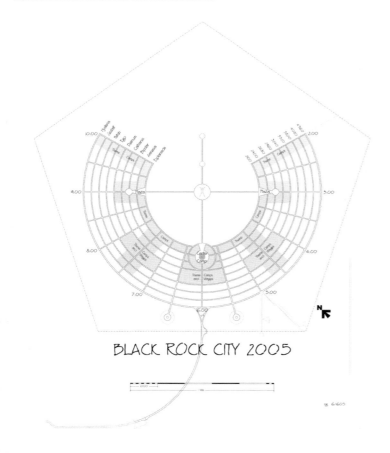

BLACK ROCK CITY 2005

The historic origins of Black Rock City and the functional requirements that have conditioned its design begin with a series of simple plans we used pre-1997. The original form of the city was a circle. This was not planned, but was produced by an instinctive urge to round the wagons in the nearly boundless space of the Black Rock Desert. Later, four avenues were added to the circle to indicate the cardinal directions. This was done for very practical reasons. Not only was it difficulat to find our modest settlement, but also people exiting our village frequently got lost or mired on the margins of the playa. Compass headings added to the circle served our need to orient ourselves in relation to the stark emptiness, which surrounded our site.

At the urging of founder and director Larry Harvey, this circle of camps gradually developed into a civic hub that centralized city services, provided a social gathering place, and created a prominent landmark. By 1996, a second circle called Ring Road surrounded this civic center, and a no camping zone called No Man's Land was established in front of our settlement. This was created to preserve the view of Burning Man. It opened outward from our civic plaza at about a 60-degree angle, much as the feature called the Keyhole does today, and extended to a point beyond the Man.

CHANGES

In 1997 we made our one-time venture off the playa into nearby Hualipai Valley in Washoe County, and Rod Garrett, later to become our city designer, was recruited to create plans in compliance with County regulations. This began the two-year process of developing the basic scheme from which our present city has grown.

290

This site established an external boundary for us. Thick brush and a long irrigation trench bordered the back of the city, fence lines protected our settlement's flanks, and an impassible isolated playa bordered its front. These natural barriers made it possible to create a secure entry point, a 'gate', for the first time.

In order to avoid the costly permits required for use of the adjoining Federal land, we were compelled to build the city on a strip of private land between a zigzagging property line and the narrow shoreline of Hualipai playa. This constrained us to an ungainly arc, which spread out laterally from the civic center. That happenstance form, however, contained a precursory hint of our later development.

NEW BEGINNINGS
In 1997, we had been forced to work completely within the limitations of site, but in 1998 we returned to the blank canvas of the Black Rock Desert. Our new plans were strongly affected by our experience of the previous year. They were also conditioned by our desire to create population densities that would lead to social interactions. We were motivated by the example of 1996 and the disastrous consequences of unchecked urban sprawl. Another goal was to express and abet a sense of communal belonging. We were attempting to recreate some of the intimacy of our original camping circle, but on a much larger civic scale.

We now arranged the city around a geographic center formed by the location of the Burning Man. This position functioned like the fixed point of a drawing compass. From this spot our builders could survey the arc that defined the curve of Black Rock City's concentric streets. These streets formed less than

half a circle and were sub-divided into blocks by a series of radial streets, like spokes projecting outward from the hub of an enormous wheel. The large figure of the Man became a unique identifier of one's position by providing all with a visual bearing at every intersection. Black Rock City, as it seemed, was in orbit around him. In moving the Man to this position, we had created an environment in which it felt as if each participant was co-related while united by some transcendent principal.

DESIGN FACTORS
Except for this qualitative leap of development in 1998, the current form of our city has resulted from the continuous interplay of many factors: historic circumstance, public safety concerns, logistical needs, environmental conditions, politics, social ideals, economic viability, competing or potentially conflicting uses of space within our community, aesthetic perceptions and a need for a kind of spiritual symbolism, and, of course, our own individual inspirations in responding to this complex of concerns. Rod Garrett has functioned as our head designer, and Burning Man's chief organizers, representing various departments, have made several significant contributions to this scheme. In other words, much of the evolution of Black Rock City has proceeded exactly as would the development of any other city.

We began zoning space within our city in 1997 because of the need to locate theme camps in some coherent way. Since then we have gone on to designate various special areas, such as Walk-in camping, our airport, DPW and law enforcement headquarters, and large-scale sound installations at the ends of the city. Various issues caused us to create a zone behind

the Man and beyond the arc of Black Rock City that is reserved for theme-related art installations. As our plan has grown, we have learned how to differentiate and separate various specialized, and potentially conflicting uses. This very much involves an empirical study of our social needs as they've naturally emerged from an increasingly sophisticated social reality.

The site of our city has been largely determined by political considerations, plus health and safety concerns. During the early 90's Black Rock City had been deliberately hidden in the desert vastness. Participants were directed to a station called the gate, and here they were provided with coordinates by which they might locate our settlement. As attendance increased, however, it became apparent that large numbers of vehicles could not safely traverse this space. Frequent whiteouts, occasional drenching thunderstorms and the tendency of drivers to accelerate to unsafe speeds in trackless space dictated a location closer to the county highway. Accordingly, in 1998, we sited Black Rock City near the southern end of the Black Rock Desert a few miles outside the town of Gerlach. The subsequent move to our current location in 2000 was made possible when the Bureau of Land Management constructed a new access road near that year's event site. This access point was designed to avoid interference with other points of public access. The exact placement of the city was determined by a complex negotiation with the BLM, which resulted in an event location that did not interfere with the needs of other recreational land users.

Additionally, there were unresolved factors of security. The pentagram that marks our city's external boundary was dictated by (a) the need to minimize our footprint in the surrounding environment due to the concerns of other recreational land users, (b) the economic need to create one controllable entry point at which we could charge an entrance fee (sorely lacking until '97) and (c) the need to protect our community from the depredations of rogue vehicles. The most efficient and obvious solution was a circle, but that was unworkable in that it lacked straight lines of sight for security. A triangle or square, while requiring the minimum number of vantages for sight lines, enclosed too much unutilized space in its corners and presented too large a perimeter. Six sides required too many security vantage points, so the present shape was the sole option.

Above all, this city needed to work. It was vital that the flow of people and supplies in, out and within were unimpeded. Our design had to provide for basic services. The layout needed to be easily comprehended and negotiated without disorientation. It should also incorporate any familiar features of the previous event sites, and it needed to be scalable for future expansion. The five circumferential streets created in 1997 have now grown to ten, and the arc of our city, originally less than half, now extends two thirds of a circle around the Man. A city designed to accommodate 9,000 participants in 1998 has developed a capacity of well over 30,000 in five years.

AESTHETICS
Aesthetics were not actually a design criterion, but were born out of the process. We found we could often judge the practicality of a solution by whether it added to the geometry. Given the road in and the Man's location, the city's bi-lateral

symmetry provided optimum distribution for vehicular traffic. Even the angles and distances took on significance; the divisions of space were comprised of either round numbered radii or 15° angles, true North ended up 45° off the city's main axis, and so forth.

As previously mentioned, theme related artwork was placed in a zone beyond the precincts of our city. This was meant to lure participants away from our settlement and into the open space. Similarly, the open side to the circular scheme of the city takes on spiritual and psychological importance. Instead of completely circling the wagons, we invite the natural world to intrude. Rather than looking across our claimed tract to see only more settlement on the other side, our vision is spilled outward into the vastness of the greater Black Rock Desert. With this reminder of the infinite we hoped to evoke a connection between the small world we created and the fathomless universe we live in.

SUMMARY

This city of the Burning Man continues to grow in size, and though it develops more each year, our plan of 1998 remains its basic framework. This plan referenced ancient megalithic sites and city-states, as well as various Renaissance and contemporary planning concepts. However, while there may be similarities between this and some current idealized and utopian cities, Black Rock City has a home, a storied history, and a culture ready to inhabit it, albeit fleetingly. It is a very real and yet extremely ephemeral phenomenon, as it must annually arise from nothing, flourish for a week, and then disappear entirely.

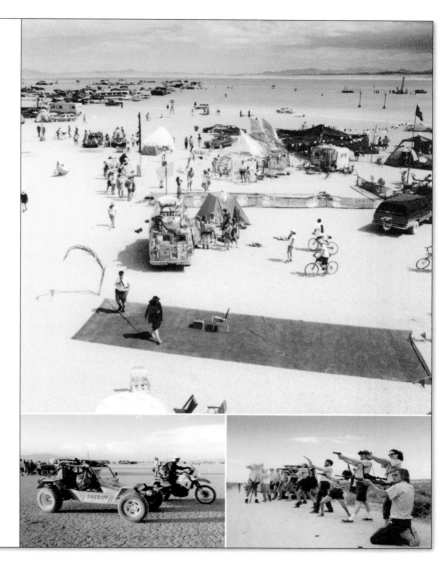

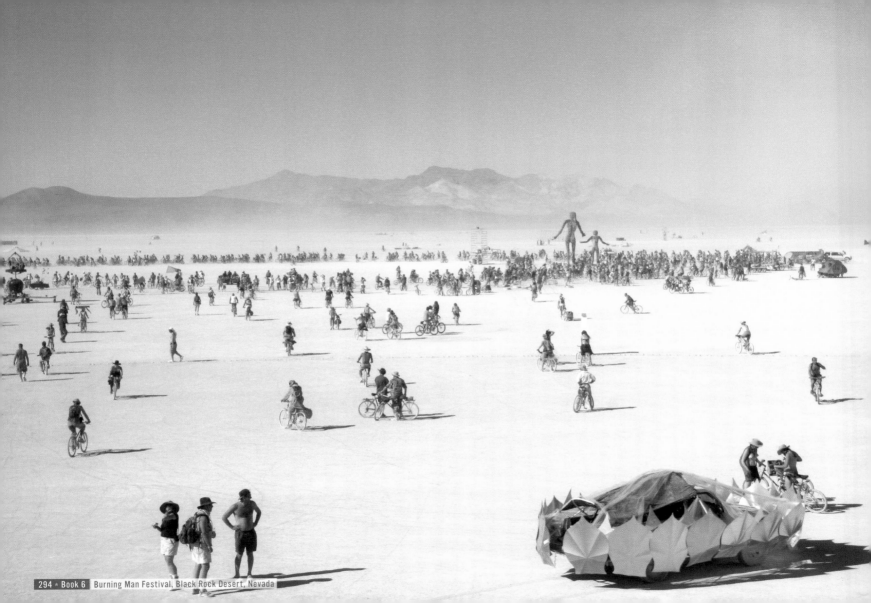

Burning Man Festival, Black Rock Desert, Nevada

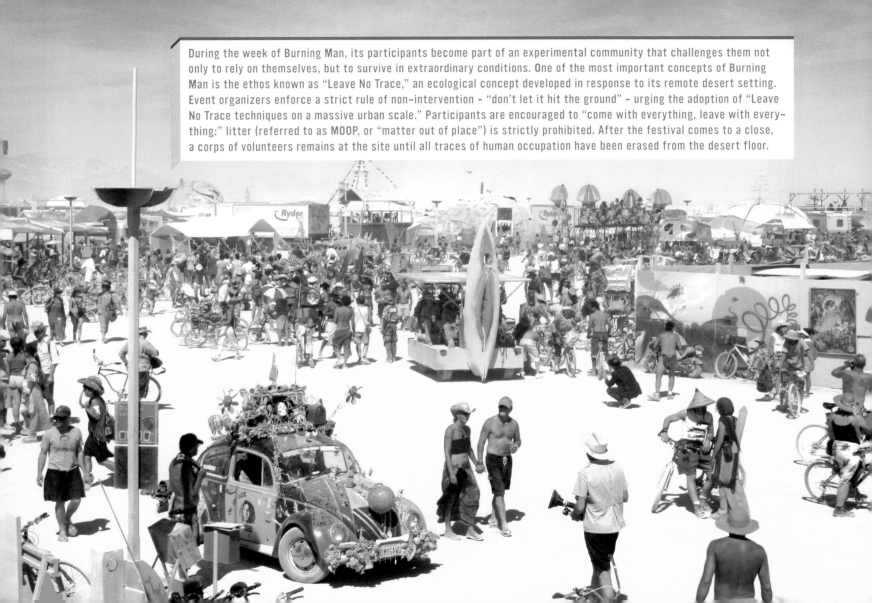

During the week of Burning Man, its participants become part of an experimental community that challenges them not only to rely on themselves, but to survive in extraordinary conditions. One of the most important concepts of Burning Man is the ethos known as "Leave No Trace," an ecological concept developed in response to its remote desert setting. Event organizers enforce a strict rule of non-intervention - "don't let it hit the ground" - urging the adoption of "Leave No Trace techniques on a massive urban scale." Participants are encouraged to "come with everything, leave with everything:" litter (referred to as MOOP, or "matter out of place") is strictly prohibited. After the festival comes to a close, a corps of volunteers remains at the site until all traces of human occupation have been erased from the desert floor.

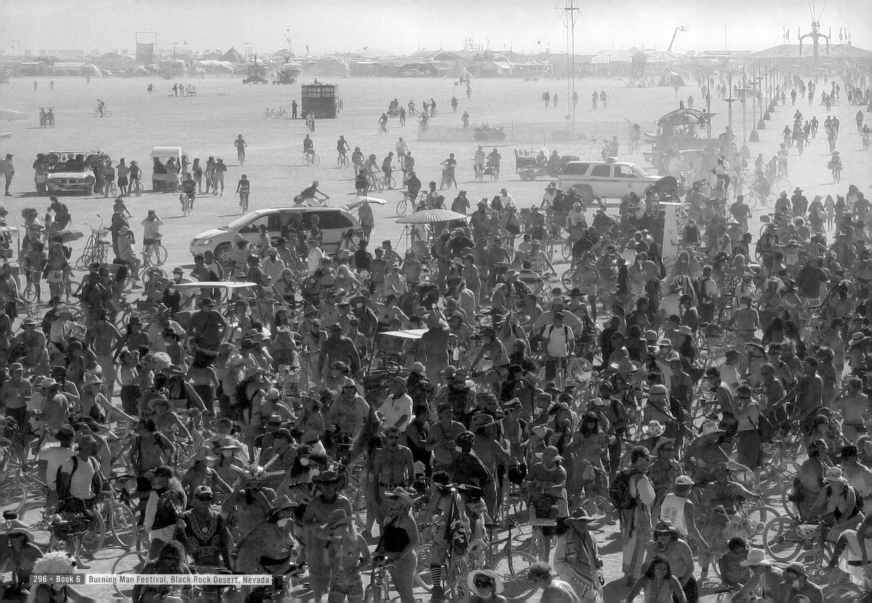

Burning Man Festival, Black Rock Desert, Nevada

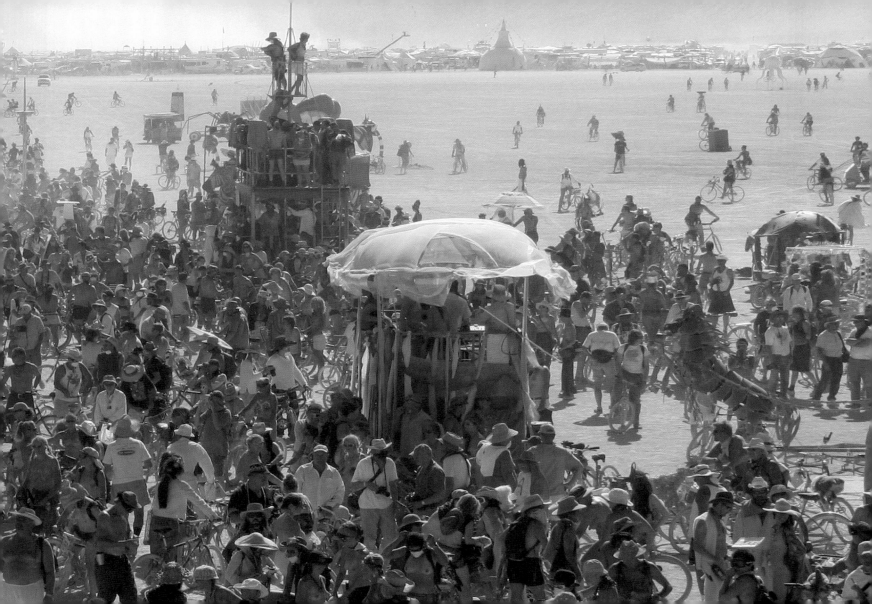

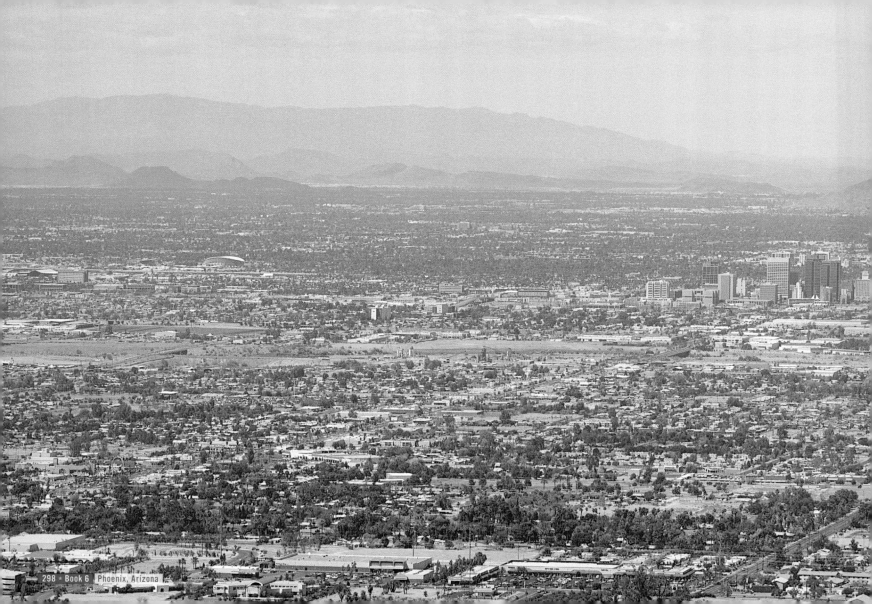

6.3 THE GRID

In its own way, Phoenix represents an American ideal in pure form: a boundless, extensive gridded city that extends unproblematically over the desert plain, leaving a sea of golf courses, gated communities, and parking lots in its wake. The endless spread of the city across the landscape - a solidified form of the rapid growth embodied by sites like Quartzsite - is nothing less than an image of the future of desert urbanism, a look at the pressures of human occupation facing the American desert in the 21st century.

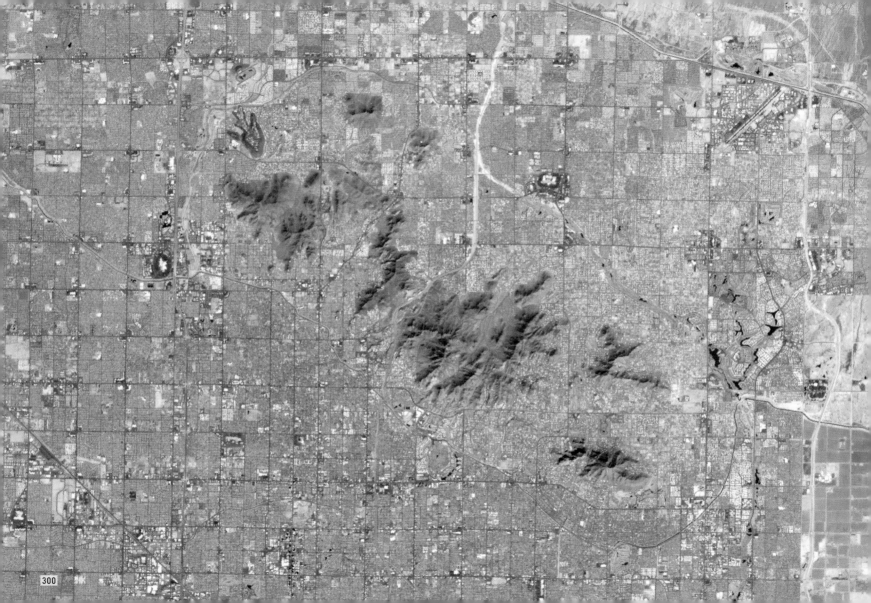

BROADACRE CITY

In its own way, Phoenix is nothing less than the realization of a paradigm of American city planning. Considered the unwitting antecedent of the modern American suburb, Frank Lloyd Wright's Broadacre City proposed a new city that was "everywhere and nowhere," a decentralized settlement that would fuse the city and country, erasing the distinction between rural and urban life. Wright envisioned Broadacre City as a living model of American democracy, one that embraced the potentials of new technology melded with Jeffersonian agrarianism and a distinctly American individuality.

In this community, all individuals would be liberated from the misery of the congested city (the locus of capital power), with families separated by a minimum of one acre per household. The potentially negative consequences of isolation and long distances attached to this new, dispersed lifestyle would be avoided through the large-scale implementation of the new infrastructures of telecommunication and the national interstate highway system.

A mutated version of Wright's dream, Phoenix is the apotheosis of the mid-late 20th century transformation of the American frontier into a suburban nation. Founded in an area of the Sonoran desert that receives only 5-10 inches of rain annually, the city has experienced consistent and sustained population growth for the past three decades, tripling from 1 million to a current population of 3 million residents (a 300% increase). During this period of rapid growth, the settlement density of Phoenix has remained surprisingly consistent: from 2200 to 2700 residents/square miles, a rather unremarkable 27% increase since 1970. (In contrast, New York is ten times denser, with a population density of 26,000 residents per square mile).

So far, the Sonoran Plateau has been able to absorb this expansion, which has claimed 40% of agricultural lands and 32% of the desert. A minority of this new suburban fabric is residential: the majority has been transformed into miles of pavement, an infrastructural landscape cut with roads and topped with acres of parking lots. True to Wright's vision, Phoenix is a city without limits, "stretching across an infinite plane."

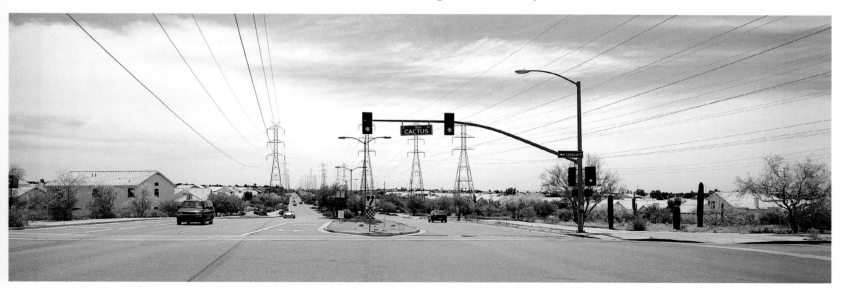

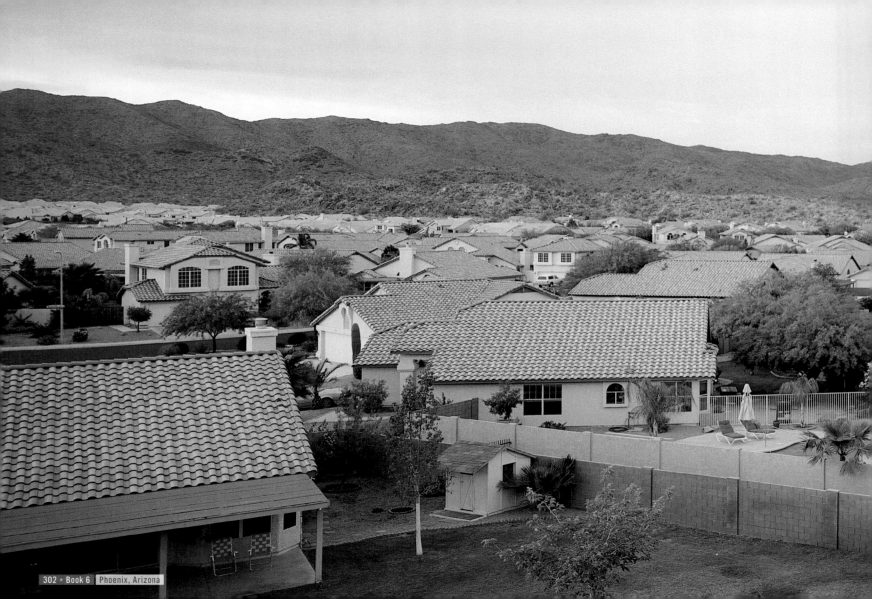

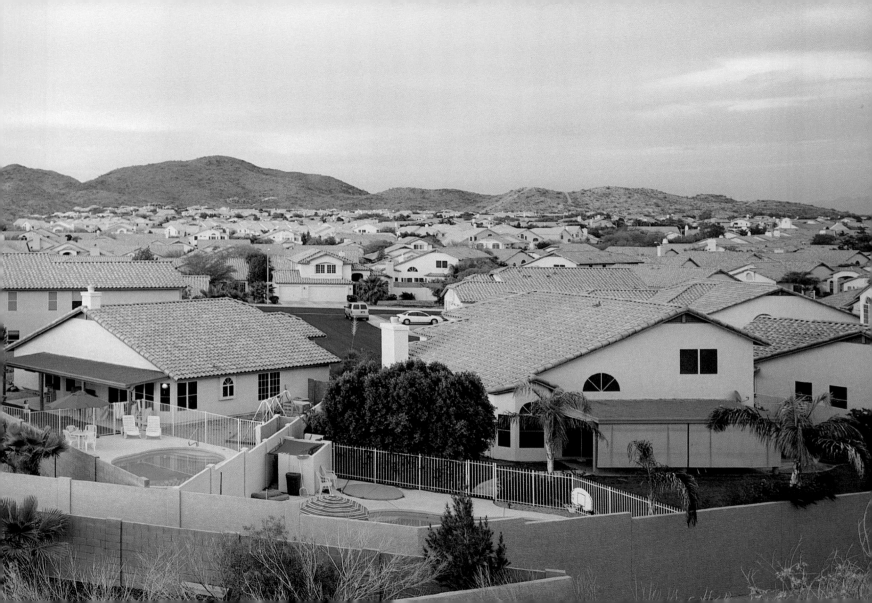

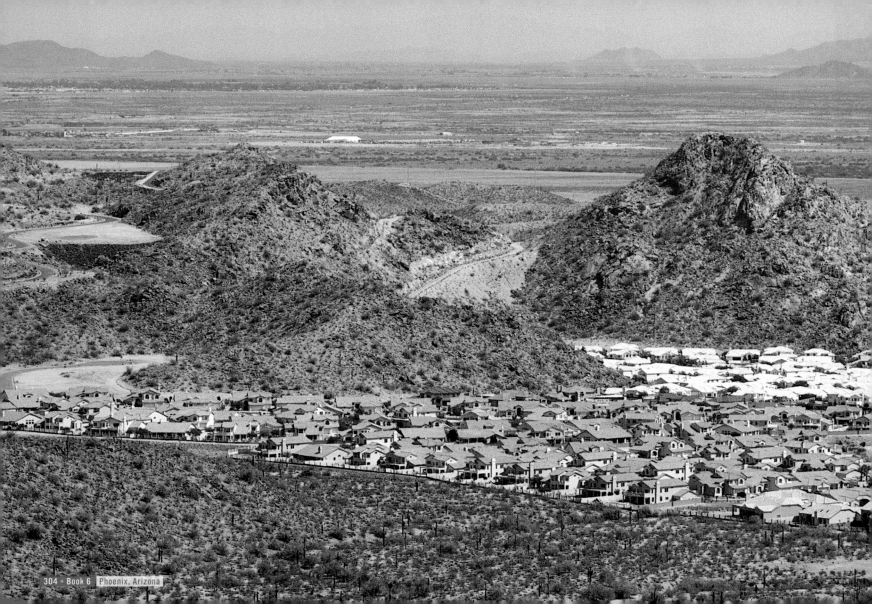

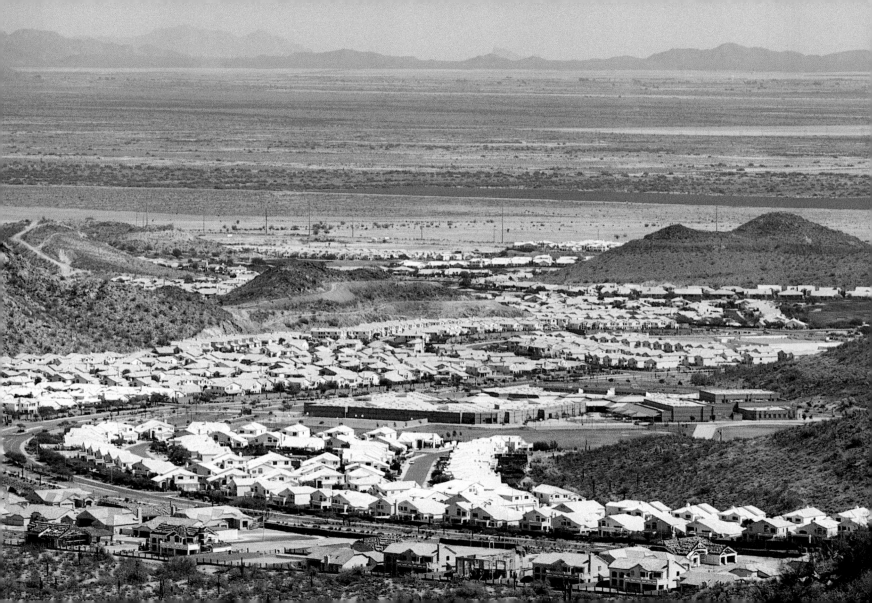

BOOK7 ISOLATION

In spite of the proliferation of technologies, uses, experiments and excesses that fill the desert, its vast scale continues to encompass spaces of profound isolation and natural beauty. The final story of the desert is its enduring fascination as the last refuge of a contemporary idea of the sublime: a space for contemplation, beyond its status as a setting for action.

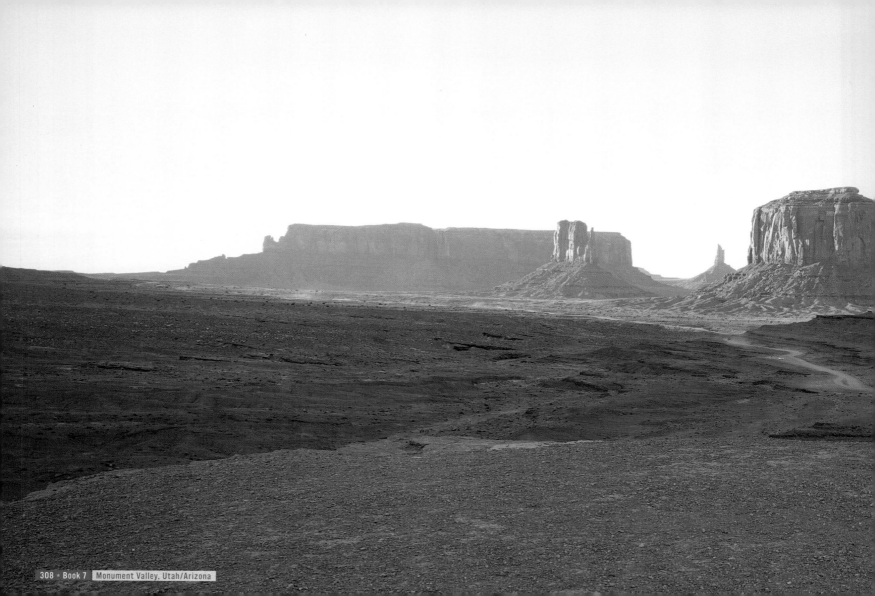

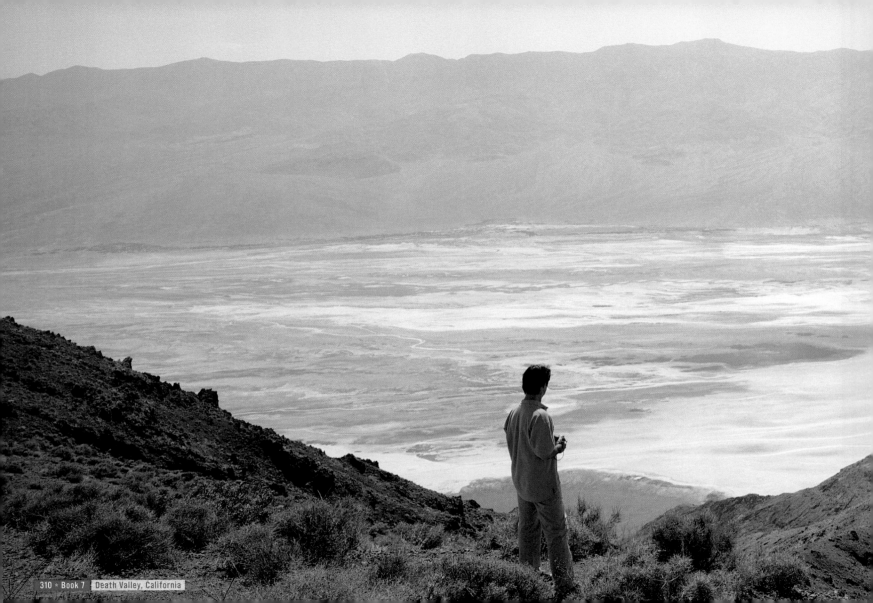

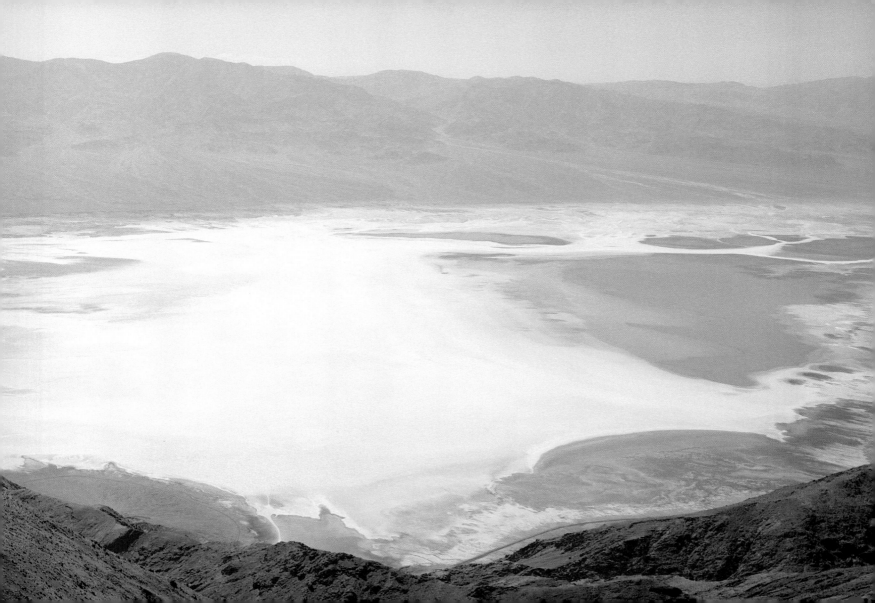

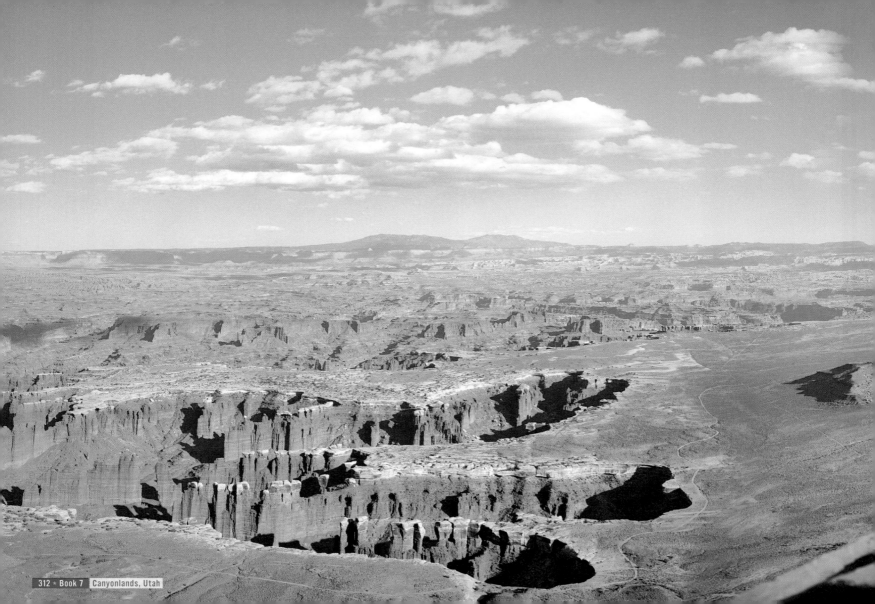

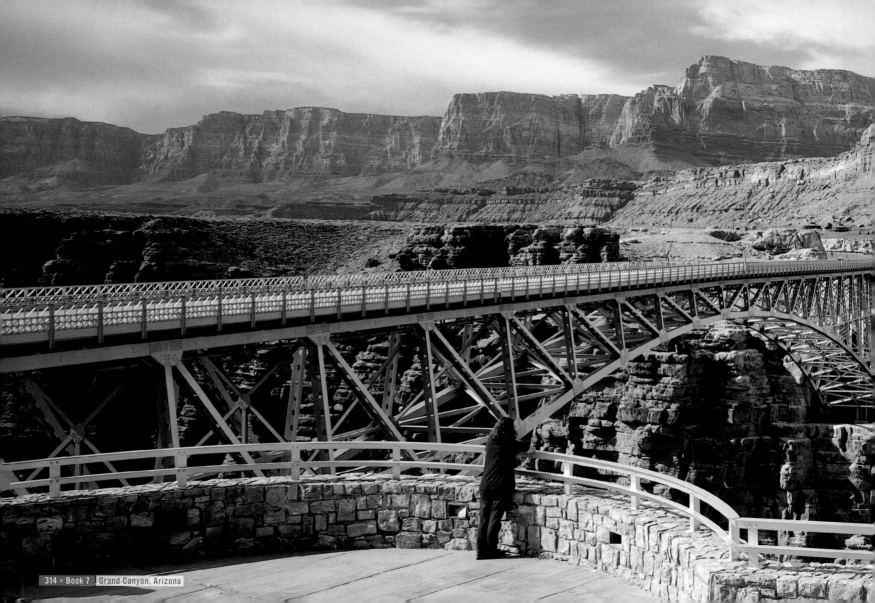

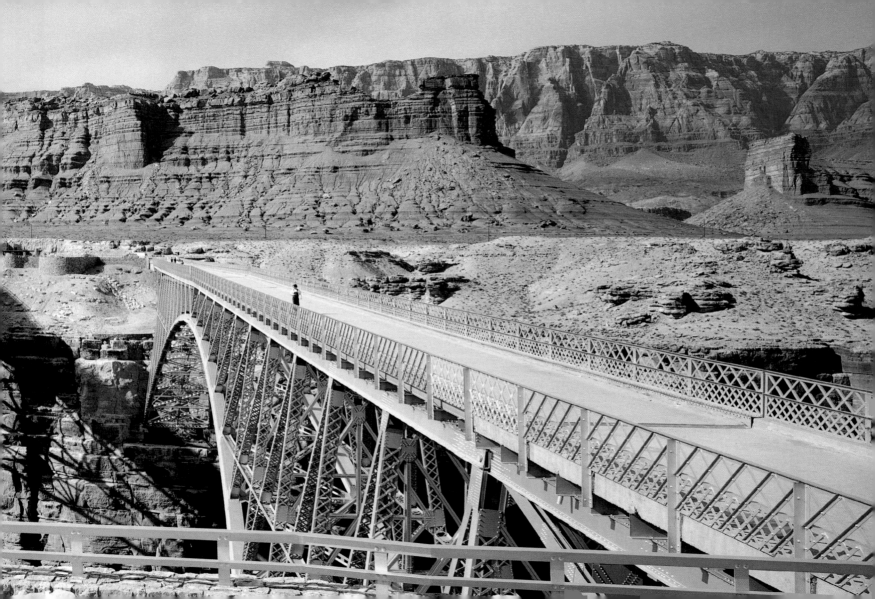

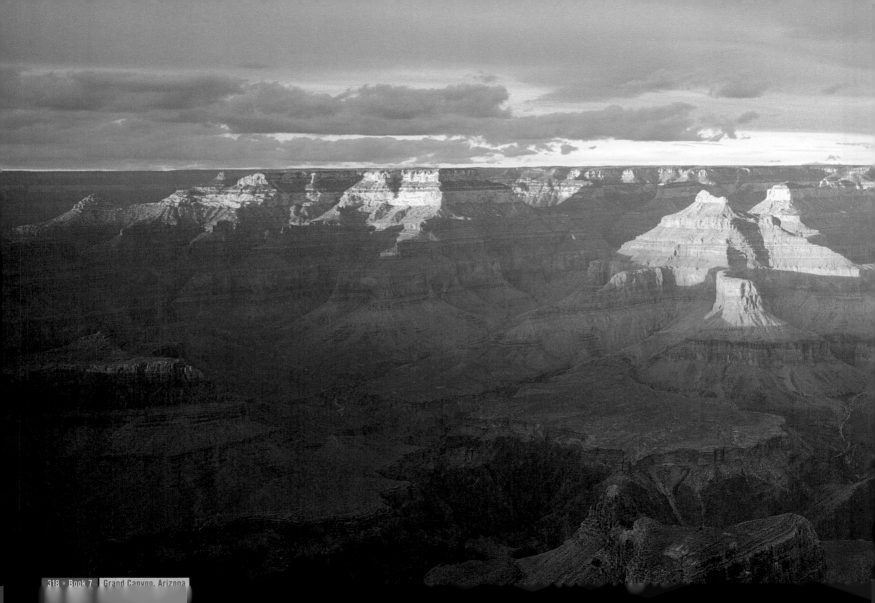

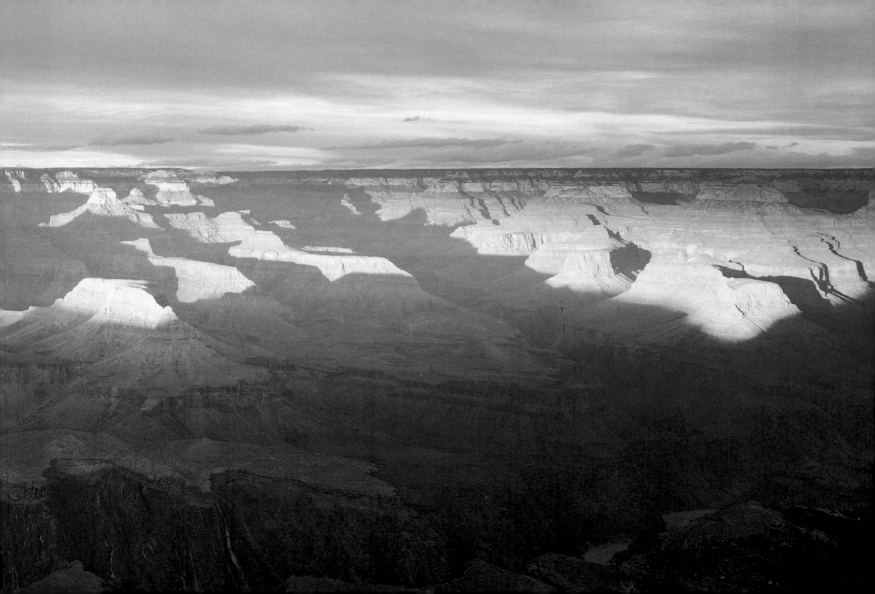

Published by
Actar
info@actar-mail.com

Book Concept
Ramon Prat

Editors
Michael Kubo
Irene Hwang
Jaime Salazar

Editorial collaboration
Anna Tetas

Contributors
Peter Granser
Joseph Masco
Steve Rowell
Tom Vanderbilt
AUDC: Kazys Varnelis +
Robert Sumrell

Graphic design
Reinhard Steger

Digital Production
Oriol Rigat, Carmen Galán

Printing
Ingoprint SL

Distribution
Actar D
Roca i Batlle 2
E-08023 Barcelona
Tel: +34 93 417 49 93
Fax: +34 93 418 67 07
office@actar-d.com
www.actar-d.com

ISBN 84-96540-09-X
DL B-26104-06

Acknowledgements
Special thanks to Steve Rowell and the Center for Land Use Interpretation, for sharing their knowledge and expertise.

Additional thanks to the numerous governmental and private institutions that have generously provided us with materials invaluable in the making of this book: In particular we would like to thank Terry Vanen–Huevel of the United States Air Force, Melodie de Guibert of ATK Thiokol, Inc., Roxanne Day and Leslie Paige of the Lake Mead National Recreation Area, Andie Grace of Black Rock City LLC, Sue Goodman of Humane Borders, and Armando Alarcorn of Paisanos al Rescate.

Finally, we would like to thank everyone who has participated in this project, especially all of our collegues here at Actar.

Image credits

Ramon Prat
2-5, 10-11, 14-15, 20-25, 29-43, 46-47, 50-56, 60-61, 62 (bottom), 63-69, 72-75, 78-100, 101 (bottom), 102-112, 124-141, 158-163, 198-201, 204-205, 207-208, 214-219, 232-239, 232-248, 250-254, 256-259, 268-269, 298-299, 301-305, 306-319

Courtesy of US Library of Congress
12-13, 17

Courtesy of NASA, Visible Earth:
18, 27 (left), 48, 62 (top), 76-77, 115, 255 (bottom), 300

Vincent Musi/Aurora
26

Guillermo Arias/AP
27 (right)

Paisanos al rescate
28 (left)

Courtesy of Humane Borders
28 (right)

Richard Misrach
44-45

Courtesy of Imperial Irrigation District
49

Center for Land Use Interpretation
58, 101, 165 (right top and bottom), 168, 173, 293

Jeff T Alu
53 (right)

Courtesy of Terraserver/ US Geological Society
57, 59, 166-167

Courtesy of US Bureau of Reclamation
70-71

Jim Wark
114

Peter Granser
116-123, 284-287

Steve Rowell
142-153

Carlos Serrano
154-157

Courtesy of National Nuclear Security Administration/ Nevada Site Office
164, 165 (left), 170 (left), 171, 172 (left), 174, 186

Courtesy of National Nuclear Security Administration/ Nevada Site Office (US Department of Energy):
176, 181, 182, 260 (bottom)

Courtesy of the US Department of Defense
170 (right)

Courtesy of Nevada Division of Environmental Projection Bureau of Federal Facilities
172 (right)

Courtesy of the National Park Service (Lake Mead)
73 (right)

Joseph Masco
188

Courtesy of the Liberace Museum
192, 196

Courtesy of the Titan Missile Museum National Historic Landmark Archives
202, 203 (left and bottom)

US Air Force Space and Missle History Office
203 (top)

ATK Thiokol Inc.
206

Chris Slack
210 (top)

Courtesy of the United States Airforce, Davis Monthan AFB, Arizona, AMARC
210 (bottom), 211, 212-213

Kazys Varnelis, Robert Sumrell
220-231

Courtesy of National Radio Astronomy Observatory/ National Science Foundation
239 (right)

Courtesy of National Optical Astronomy Observatory
249

Courtesy Meteor Crater Enterprises
255 (top)

Frank Henriquez
260

Courtesy of NASA/ JPL-Caltech:
261

Courtesy of DARPA Grand Challenge
262-267

AUDC (Kazys Varnelis + Robert Sumrell)
270-283

Gabe Kirchheimer
288-289, 294-297

Black Rock City LLC
290-291